THE
SISTINE
SECRETS

THE
SISTINE
SECRETS

*Michelangelo's Forbidden Messages
in the Heart of the Vatican*

Benjamin Blech *&* Roy Doliner

HarperOne
An Imprint of HarperCollins*Publishers*

For Martha and Marvin Usdin, the two youngest

guardian angels I have ever known

 —Roy Doliner

For my family—the angels God sent me to bring

joy to my journey through life

 —Rabbi Benjamin Blech

FIRST EDITION

Book design by Ralph Fowler / rlf design

Library of Congress Cataloging-in-Publication Data

Blech, Benjamin.
 The Sistine secrets : Michelangelo's forbidden messages in the heart of the Vatican / Benjamin Blech and Roy Doliner. — 1st ed.
 p. cm.
 Includes bibliographical references.
 ISBN-13 978-0-06-146904-6
 1. Michelangelo Buonarroti, 1475–1564—Criticism and interpretation. 2. Cappella Sistina (Vatican Palace, Vatican City). 3. Symbolism in art. 4. Mural painting and decoration, Italian—Vatican City. 5. Mural painting and decoration, Renaissance—Vatican City. I. Doliner, Roy. II. Title.
 ND623.B9B48 2008
 759.5—dc22 2008006580

08 09 10 11 12 RRD (H) 10 9 8 7 6 5 4 3 2 1

CONTENTS

BOOK THREE

Beyond the Ceiling

FOREWORD

*Conoscersi è il miglior modo per capirsi—
capirsi è il solo modo per amarsi*

*(To know each other is the best way to
understand each other——to understand each
other is the only way to love each other.)*

This wise and ancient maxim spoke directly to my heart as soon as I began to read this most fascinating book by Rabbi Benjamin Blech and Roy Doliner.

This adage is a valuable observation not only for relationships between human beings; it speaks perhaps even more profoundly with reference to interactions between religions as well as to dealings among nations.

In order to truly know each other, it is indispensable to know how to listen to each other, and above all to *want* to listen to each other.

It seems to me that one of the important achievements of this groundbreaking book, among many others, is that it powerfully and clearly fulfills this mission. It pierces through the veil of countless puzzlements and hypotheses that, along with indisputable admiration, have always accompanied any visit to the Sistine Chapel. By filling in blanks resulting from a lack of understanding of teachings foreign to Christianity—but well known to Michelangelo—the Sistine Chapel can now speak to us in a way it has never been understood before.

We have always known that Pope Sixtus IV wanted the Sistine Chapel to have the same dimensions as the Temple of Solomon, just as they were recorded by the prophet Samuel in the Bible in the book of Kings I (6:2). In the past, art and religion experts explained that this was purposely done to demonstrate that there is no contradiction between the Old and New Testaments, between the Bible and the Gospels, between the Jewish and the Christian religions.

Only now, through reading this remarkable book, have I learned—with wonder, as an art historian, and with a certain embarrassment and sorrow as a Catholic—that this construction was considered a religious offense by the Jews. The Talmud, the collection and explication of the rabbinic traditions, clearly legislated that no one could build a "functioning" copy of the Holy Temple of Solomon in any location other than the holy Temple Mount in Jerusalem.

It is well to remember that this took place six centuries ago. In more recent times, many outdated insensitivities have thankfully been replaced with understanding and mutual respect. In this light, Pope John Paul II visited the Great Synagogue of Rome on April 13, 1986, and during that historic event the pontiff turned to the Jewish people, calling them for the first time, with respect and love, "our elder brothers and sisters!"

In January 2005, this very same great pontiff, feeling himself nearing the end of his earthly existence, made a gesture as historic as it was unique. He invited to the Vatican one hundred and sixty rabbis and cantors from all over the world. Organizing the encounter was Pave the Way Foundation, an international, interreligious association born out of the idea of creating and reinforcing bridges between the Jewish world and the Christian world. The purpose of the meeting was for the pope to receive a final blessing from the representatives of our "elder brothers and sisters," while at the same time further strengthening the humanitarian ties between the two faiths.

This historic encounter turned out to be the very last audience of Pope Wojtila with any group. Three Jewish religious leaders had the privilege of being the first and only rabbis in the world to give a blessing to a pope in the name of the Jewish people. One of them was

Benjamin Blech, coauthor of this volume, a professor of Talmud at Yeshiva University, an internationally noted teacher, lecturer, spiritual leader, and author of numerous books on spirituality read by people of all faiths.

I had the pleasure to personally meet the other author of this book, Roy Doliner, the day of the world premiere of the film *The Nativity Story*. It was the first time the Vatican had officially granted the use of the majestic Hall of Audiences for an artistic-cultural event.

Because of his profound knowledge of Jewish doctrine and history, and as a noted proponent of Talmudic study, Roy had been selected by the film's producers and its director, Catherine Hardwick, as the official Judaic–religious–historical consultant. For the historical consultant dealing with Rome and the life of Herod the Great, they had chosen yours truly. Through the production of *The Nativity*, Roy and I became friends.

That is how on several occasions Roy and I have been able to visit the Sistine Chapel in a very special way—after closing hours—and each visit has been a chance to see the masterpiece of Michelangelo in a new and different way.

For these reasons, when I was asked to present this book, I accepted with pleasure. Having now read this work I find myself awed not only by the great scholarship of the authors, but also by the enormous and extremely interesting amount of new historic, artistic, and religious ideas contained within.

I had always wondered why, every time I entered the Sistine Chapel, not even one figure from the New Testament appeared on that splendid ceiling. I have finally found the most convincing answers here in this book.

The authors lead us on a true journey of discovery of "other" meanings, of diverse ways of seeing and understanding that which had always been right in front of our eyes and that now seems completely different.

With their guidance, we come to realize that Michelangelo performed an immense and ingenious act of concealment within the Sistine Chapel in order to convey numerous messages, veiled but powerful, that preach reconciliation—reconciliation between reason

and faith, between the Jewish Bible and the New Testament, and between Christian and Jew. Incredibly, we discover how the artist felt the need to communicate these dangerous concepts under perilous conditions at great personal risk to himself.

How was Michelangelo able to accomplish this daring act? The authors reveal that at times, Michelangelo uses codes or symbolic allusions that are partially hidden; at times, signs that can only be picked up and understood by certain religious, political, or esoteric groups. Still other times, all one needs is a mind free from preconceptions and open to new suggestions or ideas in order to understand his messages. It is even more interesting to realize that these symbols and allusions were done without being recognized by his papal patron. They were audaciously conceived in order to alleviate the frustration of the artist who, unable to openly have his say, wanted somehow to "declare" his message.

The book leads us, almost by the hand, in a documented but captivating style, to decode the hidden symbols. It gave me great pleasure to join with them, albeit with a bit of perplexity at the outset. It is certainly not easy to have to take a second look at the reassuring certainties that have accompanied us through life; but we cannot close our eyes, our mind, or our heart to those who have seen, from a different perspective, that which we have always taken for granted. Even if I might not share all of the interesting, intriguing, and at times stupefying new ideas, I am certain that this book is truly a new way to view the Sistine Chapel. It will be appreciated and treasured by all those who are seriously interested in the great ideas of religion, art, and the history of civilization. It will cause heated debates to spread forth for years to come.

The authors alert us to the fact that in order to completely appreciate the miracle that is the Sistine Chapel, the visitor needs to comprehend Michelangelo's motivations, his background, his youthful years of intellectual ferment in the palace of the de' Medicis in Florence, the still little-known ups and downs of his entire career, in addition to his fascination with Neo-Platonism and his interest in Judaism and its mystical teachings.

What has hardly ever been stressed before is an idea that Blech and Doliner demonstrate with brilliant insight. While the Renaissance was certainly influenced by the ancient Greek and Roman myths, we need to at last acknowledge the remarkable influence, especially on Michelangelo, of the hermetic and esoteric traditions of the Jewish Kabbalah.

The event that completely changed the life of the thirteen-year-old Michelangelo—already a genius, but entirely uneducated—occurred around 1488, when Lorenzo de' Medici, admiring the talent of this artistic prodigy, welcomed him into his palace like a son and had him instructed along with his own heirs as a member of the family. In the regal palace of the de' Medicis, the young Michelangelo came into contact with the most brilliant minds of that time, such as Poliziano, Marsilio Ficino, and Pico della Mirandola. Their ideas influenced and shaped the still-pristine mind of the young artist. Neo-Platonism became his new ideal. From Marsilio Ficino, who knew Hebrew and was a scholar of Jewish traditions, and from Pico della Mirandola, humanist and philosopher, and also a great expert in Jewish language and culture, Michelangelo learned his first concepts of esoterica, gained a deep knowledge of the Bible, and also knew the teachings of the Torah, the Kabbalah, the Talmud, and the Midrash, the methods of biblical exegesis.

All of this the authors convincingly show us find powerful echoes in the Sistine. Only with this background can we fully understand Michelangelo's meaning and messages. This becomes all the more evident after the perfect cleaning of the stupendous frescoes of Michelangelo, which had been obscured by centuries of thick smoke, dust, and misguided attempts at preservation. Only today can we fully savor the beauty and the true meaning of the Sistine Chapel.

The "cleaning"—and not the "restoration," as has been erroneously written—not only brought the Chapel back to its original splendor, but also put an end to many ill-informed disputes that dated back to the beginning of the work. I was invited numerous times to climb up on the scaffolding to observe the cleaning labors, and I was able to personally share in the joy of actually seeing the

frescoes from only twenty centimeters (about seven and a half inches) away. Above all, I could bear witness in my books to the accuracy of the work of these specialized technicians, carried out with talent and love. Just think, a team of twelve experts was hard at work for twelve years in order to finish the job!

After the cleaning, we were able to verify that the dirt had covered up not only the colors, but had also hidden the numerous messages that had already been purposely "veiled," left inside the paintings by the great Florentine. Now we can say with assurance that the original plan for the Sistine Chapel by its patron, Pope Julius II, was purposely thwarted. Julius had wanted the Sistine to be the eternal reminder of the extravagant success of the papal family and to feature Jesus, the Virgin Mary, the twelve apostles, and almost certainly John the Baptist.

For the first time in the history of the Sistine, Blech and Doliner make us understand just how Michelangelo was able to subvert the entire project in order to secretly promote his own ideals, especially those linked to humanism, Neo-Platonism, and universal tolerance.

Clearly they explain how this Florentine genius was able to paint the largest fresco in the Catholic world without even a single Christian figure in it and, other than the sibyls, managed to portray only figures from the Hebrew Bible. Even more amazingly, they tell us how he evaded papal censorship of his opinionated work with his private agenda.

It is also significant that the Sistine frescoes are not only faithful to the Hebrew Bible, but even more so to the Kabbalah, the Jewish doctrine of mystical and esoteric character. In this book we find comprehensive replies to most of the questions that for centuries have tormented experts in theology and art history, as well as the average researchers and aficionados.

For example, in the fresco of the *Original Sin*:

- Why does the serpent have arms?

- Why is the forbidden Tree of Knowledge not an apple tree, but a fig tree?

- In the previous panel, why does Eve seem to be emerging from a "side" of Adam, and not from his rib?

The answers are all given by the Kabbalah and described brilliantly in this book.

Another valuable insight demonstrated by the authors is the closeness, if not the admiration, that Michelangelo felt for the Jews. I found particularly fascinating their explanation of a detail that was entirely unknown until now, after the recent cleaning of the frescoes, with the subsequent reappearance of the original colors that had been darkened and covered by soot and dust. Not to give away too much, it involves a yellow circle on the cloak (to be exact, on the left arm) of Aminadab, one of the ancestors of Christ, similar to the yellow badge of shame the Fourth Lateran Council ordered the Jews, in 1215, to sew on their clothing. The incredible and unprecedented photo can be seen in chapter 9. To make this even more relevant, this portrait of Aminadab is positioned right above the place of the papal throne of Julius II.

Almost certainly, some of the instructors in the school of the de' Medicis were rabbis and had explained to Michelangelo about the Hebrew alphabet and the esoteric significance of each letter. This is amply demonstrated by the Hebrew letters that are hidden in the gestures and the stances of many figures in the paintings.

Even in *The Last Judgment,* the influence of Jewish culture is quite evident. The enormous fresco is clearly in the shape of the Tablets of the Law of Moses. This is due not only to the form of the chapel, but also to the fact that Michelangelo, before painting the *Judgment,* had covered over the two windows that were a large part of the wall over the altar, and had a new wall built on top of the original one.

One exquisite final touch: Few if any people have noticed that Michelangelo placed two Jews in Paradise, very close to the powerful figure of Jesus. If you look carefully, over the shoulder of the youthful blond Christ and painted above St. Peter, two Jews are quite clearly displayed—you can see them in the photo at the beginning of chapter 15. They are easily recognizable not only for their

characteristic facial traits, but also because the first man is wearing the typical double-pointed hat that Jewish males were forced to put on, in order to reinforce the medieval prejudice that these people, being the offspring of the devil, had horns. The second man has on the yellow cap that the Jews were forced to wear in public.

At the end of this fascinating reading experience, the readers will realize that Rabbi Benjamin Blech and Roy Doliner have guided us to see in a brand-new light not only the Sistine Chapel but also most of Michelangelo's artwork, including the monument to Julius II, the famous *Moses,* and the various statues of the pietà, scattered about in Italy.

We will come to appreciate, as the authors point out, that the real message of his masterpiece is that Michelangelo created a true bridge between the two faiths of Judaism and Christianity, between humanity and God, and, perhaps most difficult of all, between each person and his or her spiritual self.

Just as the work of Michelangelo in the Sistine Chapel changed forever the world of art, so will this book change forever the way to view and, above all, to understand the work of Michelangelo!

Enrico Bruschini. Professor Bruschini is one of the most esteemed art experts in all of Rome and in the Vatican Museums. He is an international lecturer, consultant, and the author of numerous books on Italian art history, including *In the Footsteps of Popes, Vatican Masterpieces,* and *Rome and the Vatican*—the last two titles published by the Vatican itself. In 1984, he was named Official Art Historian of the United States Embassy in Rome, a lifelong title, and was subsequently appointed Fine Art Curator. In 1989 he was named the Official Guide of Rome and guided Presidents Gerald Ford, Bill Clinton, and George W. Bush during their official visits to Rome and Vatican City. To learn more about him, please visit his site at: www.profenrico.com, or write him at enricobruschini@libero.it.

PREFACE

Every year more than four million visitors from all over the world throng to the Vatican Museums, the most-visited museum complex on earth. They come for one overriding reason—to see the Sistine Chapel, the holiest chapel in the Christian world. Viewers—Christians, Jews, Muslims, atheists, art lovers, and the merely curious— not only marvel at its aesthetic beauty but are moved by its history and its spiritual teachings. The major attraction, without a doubt, is the incomparable vista of frescoes on its ceiling and its altar wall, the work of Michelangelo Buonarroti, universally acknowledged as one of humanity's greatest artists.

But very few of the millions of awestruck spectators who enter the Sistine know that the pope's own chapel, built in the heart of the Vatican, is a full-size copy of the Holy of Holies in Solomon's ancient Temple in Jerusalem.

They would also surely be amazed to discover that Michelangelo himself embedded secret messages inside the chapel. Even more shocking, these messages espoused ideas that struck at the heart of the papacy.

Unknown to most viewers is the dramatic truth that these frescoes contain a lost mystical message of universal love, dangerously contrary to Church doctrine in Michelangelo's day, but true to the original teachings of the Bible as well as to much of contemporary liberal Christian thought.

Driven by the truths he had come to recognize during his years of study in private nontraditional schooling in Florence, truths rooted in his involvement with Judaic texts as well as Kabbalistic training that conflicted with approved Christian doctrine, Michelangelo

needed to find a way to let viewers discern what he truly believed. He could not allow the Church to forever silence his soul. And what the Church would not permit him to communicate openly, he ingeniously found a way to convey to those diligent enough to learn his secret language.

Unfortunately these messages were lost and went unheeded for five centuries. The man famous for defining genius as "eternal patience" must have found solace for his inability to voice his disagreement with the Vatican in the hope that eventually there would be those who would "crack his code" and grasp what he was really saying. Only now, thanks to diligent scholarship as well as the new clarity afforded by the chapel's extensive cleaning, have they been rediscovered and deciphered. Michelangelo spoke truth to power, and his insights, ingeniously concealed in his work, can at last be heard.

All this is not speculative fiction, but, as we will convincingly prove, completely, incredibly, *true*.

This is the startling and provocative thesis that *The Sistine Secrets* will for the first time reveal—and forcefully demonstrate. It will show how Michelangelo incorporated into his religious masterpiece a stunning number of hidden messages to the Church of his time, messages that resonate to this day with their daring appeal for reconciliation between reason and faith, between the Hebrew Bible and the New Testament, and among all those who share a sincere quest for true faith and service of God.

Prepare to unlearn everything that you thought you knew about the Sistine Chapel and Michelangelo's masterpieces. Just as the recent cleaning of the frescoes removed layer after layer of tarnish and darkness accumulated over the centuries, this book will endeavor to remove centuries of prejudice, censorship, and ignorance from one of the world's most famous and beloved art treasures.

We invite you to join us on an incredible journey of discovery.

— The Authors

BOOK ONE

In the Beginning

WHAT IS THE SISTINE CHAPEL?

And let them build for Me a Sanctuary,
that I may dwell in their midst.

—EXODUS 25:8

O N FEBRUARY 18, 1564, the Renaissance died in Rome. Michelangelo di Lodovico Buonarroti Simoni, known to all simply as Michelangelo, passed away at age eighty-nine in his frugal home in what is today Piazza Venezia. His body was prepared to be entombed inside the nearby Basilica of the Holy Apostles. Today, this church, Santissimi Apostoli, is an amalgam of many times and styles: its top floor is from the nineteenth century, the middle floor is seventeenth-century Baroque, and the ground floor is pure Renaissance from the second half of the fifteenth century. But what is most interesting about Michelangelo's intended burial place is that the original part of the church—the only part that existed in 1564—was designed by none other than Baccio Pontelli, the same man who planned the structure of the Sistine Chapel. The church where Michelangelo was supposed to be entombed is important for other reasons as well.

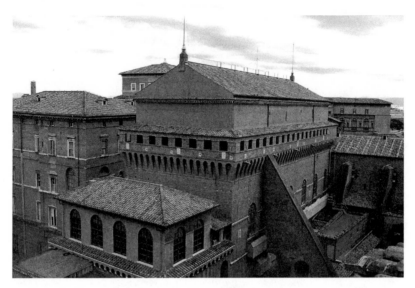

View of the Sistine Chapel from the roof of St. Peter's Cathedral. See Fig. 1 in the insert.

In a crypt beneath the ground-floor level of the church are the tombs of Saints James and Philip, two of the apostles going back to the life of Jesus. Deeper still, if we were allowed to dig beneath the crypt, we would soon come upon remains of ancient Imperial Rome, beneath that, Republican Rome, and finally, perhaps some of Bronze Age Rome.

This makes the church a metaphor for the entire Eternal City: a place of layer upon layer of history, of accumulations of countless cultures, of confrontations between the sacred and the profane, the holy and the pagan—and of multiple hidden secrets.

To understand Rome is to recognize that it is a city swarming with secrets—more than three millennia of mysteries. And nowhere in Rome are there more secrets than in the Vatican.

THE VATICAN

The very name *Vatican* comes from a surprising source. It is neither Latin nor Greek, nor is it of biblical origin. In fact, the word we

associate with the Church has a pagan origin. More than twenty-eight centuries ago, even before the legendary founding of Rome by Romulus and Remus, there was a people called the Etruscans. Much of what we think of as Roman culture and civilization actually comes from the Etruscans. Even though we are still trying to master their very difficult language, we already know a great deal about them. We know that, like the Hebrews and the Romans, the Etruscans did not bury their dead inside the walls of their cities. For that reason, on a hillside slope outside the confines of their ancient city in the area that was destined to become Rome, the Etruscans established a very large cemetery. The name of the pagan Etruscan goddess who guarded this *necropolis,* or city of the dead, was Vatika.

Vatika has several other related meanings in ancient Etruscan. It was the name of a bitter grape that grew wild on the slope, which the peasants made into what became infamous as one of the worst, cheapest wines in the ancient world. The name of this wine, which also referred to the slope where it was produced, was Vatika. It was also the name of a strange weed that grew on the graveyard slope. When chewed, it produced wild hallucinations, much like the effect of peyote mushrooms; thus, *vatika* represented what we would call today a cheap high. In this way, the word passed into Latin as a synonym for "prophetic vision."

Much later, the slope became the *circus,* or stadium, of the mad emperor Nero. It was here, according to Church tradition, that Saint Peter was executed, crucified upside down, and then buried nearby. This became the destination of so many pilgrims that the emperor Constantine, upon becoming half-Christian, founded a shrine on the spot, which the Romans continued to call the Vatican Slope. A century after Constantine, the popes started building the papal palace there.

What does "the Vatican" mean today? Because of its history, the name has a number of different connotations. It can refer to the Basilica of St. Peter; to the Apostolic Palace of the popes with more than fourteen hundred rooms; to the Vatican Museums complex with more than two thousand rooms; to the political/social/religious

hierarchy that is considered the spiritual leadership of about one-fifth of the human race; or to the world's smallest official country of *Città del Vaticano* (Vatican City). It is indeed strange to consider that this tiniest country on earth, which could fit eight times over inside Central Park in New York City, contains within it the world's largest and costliest church, the world's largest and most luxurious palace, and one of the world's largest museums.

REPLACING THE TEMPLE

Most fascinating of all, though, may well be a place within the ancient fortress walls of Vatican City whose symbolic meaning is unknown to almost all its visitors. Its theological significance can best be realized by noting that this Catholic effort was something explicitly forbidden to Jews. In the Talmud, the ancient holy commentaries of the greatest Jewish sages spanning more than five centuries, it is clearly legislated that no one may construct a functioning full-sized copy of the Holy Temple of Jerusalem in any location other than the Temple Mount itself (Tractate Megillah, 10a). This was decreed in order to avoid any possible bloody religious schisms, such as later happened in Christianity (Roman Catholicism; Eastern and Greek Orthodoxy; Protestantism—and their centuries of internecine warfare) and Islam (Sunni and Shi'ite, who are sadly still killing each other around the globe).

Six centuries ago, however, a Catholic architect who was not constrained by Talmudic laws did exactly that. He designed and built an incredible, full-sized copy of the inner sanctum, or the Holy of Holies, of King Solomon's Temple in Jerusalem—right in the middle of Renaissance Rome. To get the measurements and proportions exactly correct, the architect studied the writings of the prophet Samuel in the Hebrew Bible, where Samuel describes the First Holy Temple, cubit by cubit (1 Kings 6:2). This massive reproduction of the *heichal,* or rear section of the First Temple, still exists today. It is called la Cappella Sistina—the Sistine Chapel. And this is where more than four million visitors a year come to view the incredible frescoes of Michelangelo and pay homage to a site sacred to Christianity.

Before the creation of this replica of the Jewish Temple, there had been a chapel on the same spot during the Middle Ages. It was called la Cappella Palatina, or the Palatial Chapel. Since every European ruler had his or her own regal chapel for praying privately with the royal court, it was deemed necessary for the pope also to have one in his own palace. This was to show the power of the Church, which had to be viewed as greater than that of any secular sovereign. It is no coincidence that the word *palatina* comes from the Palatine Hill, the home of the most powerful human beings known to Western history at that point—the pagan emperors of ancient Rome. According to Roman tradition, the Palatine Hill was where Romulus had founded the city on April 21, 753 BCE. Since that time, every ruler of Rome had lived on the Palatine, constructing one spectacular palace after another. The Church was determined to prove that it was the new ruling power in Europe and hoped to spread Christendom, that is, the empire of Christianity, across the globe. This chapel was meant to be a harbinger of this coming triumph and glory, and so the pope wanted its opulence to overshadow that of any other royal chapel on earth.

Aside from the magnificent Palatina, there was also the Niccolina, a private chapel ordained by Pope Nicholas V in 1450 and decorated by the great Renaissance painter Fra Angelico. This was a tiny room in one of the older parts of the papal palace, capable of hosting the pope and a few personal aides. This is why the Palatina also had the nickname of Cappella Maggiore, the Larger Chapel, since it could hold all the papal court and its VIP guests.

The story of the Sistine Chapel, however, begins with a pontiff who wanted the chapel to be even larger and more palatial than la Cappella Palatina.

THE GRAND PLAN OF POPE SIXTUS

Sixtus was born Francesco della Rovere into a humble family in northwestern Italy not far from Genoa. He was a young man with an intellectual bent but no money, so it was only natural that he ended up in the priesthood. He became a Franciscan monk and slowly

worked his way up the rungs of the educational and administrative ladder of the Church, finally becoming a cardinal in Rome in 1467. He was elected without much ado by a conclave of only eighteen cardinals and took the name Sixtus IV, the first pope with that name in more than a thousand years. His first acts had nothing to do with the various crises facing the Vatican, but with supplying his family with titles, estates, and privileges. He made his various and sundry nephews obscenely rich by either ordaining them as cardinals (one at only sixteen years of age) or by marrying them off into wealthy, noble families. This was nothing unusual, though. Throughout the Middle Ages, the Renaissance, and right up to the end of the eighteenth century, it was common practice for a corrupt pope to pick his most decadent nephews to do the dirty work necessary to upgrade their entire family's material status from "well-off" to "astronomically wealthy." The word for "nephew" in Medieval Italian is *nepote,* and this system of absolute power and absolute corruption became known as *nepotismo*—and in modern English today as *nepotism.* One of Sixtus's nephews was Giuliano, who later became Pope Julius II— the man who forced Michelangelo to paint the Sistine ceiling.

When Pope Sixtus IV began his reign in 1471, the Palatine Chapel was falling apart. It was a heavy building resting perilously on the soft soil of the former Etruscan graveyard slope of the Vatican. This was a perfect symbol for the crisis of the Church itself when Sixtus took over. It was rife with plots, scandals, and schisms. Foreign rulers, such as Louis XI of France, were warring with the Vatican over the right to select and assign cardinals and bishops. Whole sections of Italy rejected papal jurisdiction. Worst of all, the Ottoman Turks were on the march. Only eighteen years earlier, Constantinople had fallen to the Muslims, marking the death of the Christian Byzantine Empire. Shock waves reverberated throughout Christian Europe. In 1480 the Ottomans invaded the Italian peninsula itself, seizing the city of Otranto on the southeastern coast, slaughtering the archbishop and many priests in the cathedral, forcibly converting the townspeople, beheading eight hundred who refused to convert, and sawing the bishop in half. After that, they attacked several

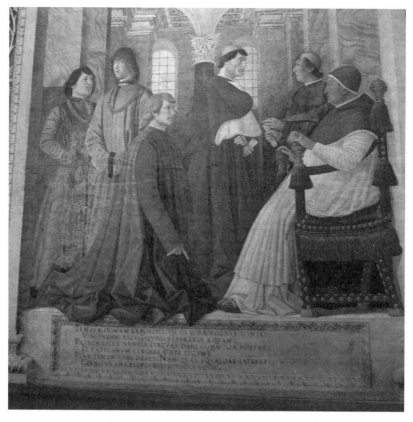

The Founding of the Vatican Library, *fresco by Melozzo da Forlì,*
1477 (Pinacoteca, Vatican Museums). This famous portrait shows Sixtus IV
on his throne, surrounded by some of his favorite nephews, with Platina, the new
head of the library, kneeling before him. The tall, dour-looking nephew facing
the pope is Giuliano, the future Julius II. See Fig. 2 in the insert.

other coastal cities. Many feared that Rome itself would meet the
same doom as Constantinople.

In spite of all these existential threats to Christendom, Sixtus
spent vast amounts of the Vatican's gold on reviving the splendors
of Rome, rebuilding churches, bridges, streets, founding the Vatican Library, and starting an art collection that would become the
Capitoline Museum, the oldest operating museum in the world
today. His most famous project, however, was the rebuilding of the
Palatine Chapel.

Engraving showing how the Sistine Chapel looked at its consecration in 1481

There is so much about the history of the Sistine that seems pre-destined. According to the more reliable sources, work began on renovating the chapel in 1475. In the very same year, in the Tuscan town of Caprese, Michelangelo Buonarroti was born. Their fates would weave ever more tightly together in the years to come.

THE NEW CHAPEL

Pope Sixtus decided not just to rebuild the decaying papal chapel but to enlarge and enrich it. He brought in a young Florentine architect named Bartolomeo ("Baccio") Pontelli. Pontelli's specialty was the construction and reinforcement of fortresses, such as the ones still standing in fine condition in Ostia and Senigallia. This was especially important to Sixtus, since he feared both the Turkish Muslims and the Catholic mobs of Rome. The designs were drawn up for a

huge chapel, larger than most churches, with a fortress lookout bastion on top to defend the Vatican.

We may never know for certain whose idea it was to build the Sistine Chapel as a copy of the Jewish Holy Temple. Sixtus was learned in scripture, so he would have been aware of the exact measurements found in the writings of Samuel the Prophet in 2 Kings. With this in mind, he might have been anxious to give concrete expression to the theological concept of *successionism,* an idea that had already found an important place in Christian thought. Successionism means that one faith can replace a previous one that has ceased to function. In religious terms, it is comparable to what Darwin would later postulate in the theory of evolution: the dinosaurs were replaced by the Neanderthals who were in turn replaced by fully developed *Homo sapiens.* As taught by successionism, the belief is that the Greco-Roman pagan philosophies were replaced by Judaism, which in turn was superseded by the Church Triumphant, the True Faith that rendered all others invalid. The Vatican preached that because the Jews had killed Jesus and rejected his teachings they were punished with the loss of their Holy Temple and the city of Jerusalem, as well as their homeland. In addition, they were damned to wander the earth forever as a divine warning to anyone who might refuse to obey the Church. (It is important to note that this teaching was categorically rejected and forbidden by the Second Vatican Council in 1962.)

Baccio Pontelli, on the other hand, was not a great religious scholar. However, he was a Florentine. Florence was one of the most liberal, open-minded cities in Italy—and indeed, in Europe—at that time. The Jewish community of Florence, though numbering only several hundred, was well accepted and influential in the city's bustling intellectual and cultural activity. Pontelli would have known many artists and architects who were accustomed to incorporating Jewish themes in their work.

Whoever's idea it was, the new Palatine Chapel was designed to replace the ancient Jewish Temple as the New Holy Temple of the New World Order in the New Jerusalem, which would from this time forward be the city of Rome, the capital of Christendom. Its

measurements are 134.28 feet long by 43.99 feet wide by 67.91 feet high—exactly those of the *heichal,* the long, rectangular back section of the First Holy Temple completed by King Solomon and his architect King Hiram of Tyre (Lebanon) in 930 BCE.

More remarkable still, and a fact that most visitors do not realize, is that in keeping with the intent to simulate the sacred site that existed in ancient Jerusalem, the sanctuary was built on two levels. The western half, containing the altar and the private area for the pope and his court, is about six inches higher than the eastern half, originally meant for the common onlookers. This elevated section corresponds to the farthest recess of the original Holy Temple—the *Kodesh Kodoshim,* the Holy of Holies—where only the High Priest could enter and then only once a year, on Yom Kippur, the Day of Atonement. The High Priest would symbolically pass through the *parochet* curtain, referred to in the Gospels as the veil, to perform the all-important prayer of forgiveness and redemption for the people. To show exactly where this veil would have been in the Temple of Jerusalem, a huge white marble partition grill was commissioned, with seven marble "flames" on top, to correspond to the Holy Menorah (seven-branched candelabrum) that glorified the Jewish sanctuary in biblical times.

FROM CEILING TO FLOOR

The original ceiling illustrated a simple theme shared by many synagogues: a night sky, filled with golden stars. This scene is reminiscent of Jacob's dream while sleeping under the stars (Genesis 28:11–19) shortly after fleeing his father's house. It was then that Jacob had a vision of "a ladder with angels ascending and descending," and it was that spot that he named *Beit-El,* the House of God. In Jewish tradition this would be the very location on which the Temple was built. By making symbolic reference to this story, the ceiling expressed yet another connection with the Holy Temple of Jerusalem.

To add to the chapel's uniqueness, great attention was also given to its floor. It is a stunning masterpiece that usually goes unnoticed by the average visitor, since it is obscured by the feet of thousands of people, and overlooked because of the world-famous frescoes above. The floor is a fifteenth-century revival of medieval Cosmatesque mosaic style. The Cosmati family developed their unmistakable technique in Rome in the twelfth and thirteenth centuries. This decorating style was a fantasy of geometric shapes and swirls in cut pieces of colored glass and marble (much of which was "recycled" from pagan Roman palaces and temples). Stunning examples of authentic Cosmati floors and decorations can be found in some of the oldest and most beautiful churches, basilicas, and cloisters in Rome and southern Italy. One of the last Cosmati artisans was brought to London in the thirteenth century to do the mystical floor mosaics in Westminster Abbey.

It is generally acknowledged that these very special floors were esteemed not only for their beauty and the richness of the colors and materials (including the priceless purple porphyry marble), but also for their esoteric spirituality. Much has been written about these mosaics by theologians, architects, and even mathematicians. In part, they give any sanctuary a feeling of space, rhythm, and flowing movement. Undoubtedly, they are also a meditational device, similar to the mazes and labyrinths popular in churches in the Middle Ages. In the Sistine, the flooring is a variant on these Cosmati floors, having been designed two centuries after the famed family finished its last project. The design was based on a few sections that had survived from the earlier chapel, but then took on a style and a meaning of its own.

The appearance of the Sistine pavement was meant to serve four major functions. First, it beautifies the chapel with a special grace. Second, it architecturally helps to define the space while simultaneously stretching it out and giving it a feeling of kinetic flow. Next, it "directs" the movements and order of rites during a papal court mass, showing where the pope would kneel, where the procession would pause during the chanting of certain psalms and hymns,

where officiants would stand, where incense would be swung, and so forth. But last and least known is its additional purpose as a *Kabbalistic meditational device* that thus, in one more way, links it to ancient Jewish sources. Within it is a wide array of mystical symbols: spheres of the Tree of Life, the pathways of the soul, the four layers of the universe, and the triangles of Philo of Alexandria.

Kabbalah (in Hebrew, literally "receiving") refers to the mystical traditions that encompass the secrets of the Torah, the esoteric truths that reveal the most profound understanding of the world, of humankind, and of the Almighty himself. Philo was a Jewish mystic in Alexandria, Egypt, who wrote dissertations on the Kabbalah in the first century of the Christian era. He is commonly considered the central link between Greek philosophy, Judaism, and Christian mysticism. His triangles point either up or down to show the flow of energy between action and reception, male and female, God and humanity, and the upper and lower worlds. In fact, the Latin name for this kind of mosaic decor is *opus alexandrinum* (Alexandrian work) because it is filled with Kabbalistic symbolism originally taught by Philo of Alexandria.

This Latin name is the reason that many art historians and architects mistakenly believe that Cosmati-style flooring originally came from Alexandria, Egypt, or was popularized by Pope Alexander VI Borgia in the late fifteenth century. However, there is no evidence anywhere in ancient Alexandria for this particular kind of design; as for the suggested connection to Pope Alexander VI, Alexander came on the scene more than two hundred years *after* the heyday of Cosmati paving. We believe that the most logical conclusion is that it was the connection with Alexandrian Kabbalah that gave the Cosmatesque design its name.

Yet another link to the Jewish Temple is the remarkable fact that the Seal of Solomon is a recurring symbol in Cosmati floors and found throughout the Sistine paving designs. This symbol was considered the key to the ancient esoteric wisdom of the Jews. The seal, composed of a combination of both triangles of Philo, superimposed one upon the other and therefore pointing up and down, is today

called the *Magen David,* or Star of David. It serves as a nearly universal emblem of Judaism, chosen to highlight the flag of the modern state of Israel. In the late fifteenth century, though, it was not yet the symbol of the Jewish people, but rather of their arcane mystical knowledge. Even Raphael hid a Seal of Solomon in his giant mystical fresco, *The School of Athens.*

Understanding the seal's deeper meaning as part of the Sistine Chapel requires some background. The earliest archaeological evidence for the Jewish use of the symbol comes from an inscription dating to the late seventh century BCE and attributed to Joshua ben Asayahu. The legend behind its association with King Solomon—and hence its other name, Solomon's Seal—is quite fanciful, and almost certainly false. In medieval Jewish, Islamic, and Christian legends, as well as in one of the Arabian Nights stories, the Seal of Solomon with its hexagonal shape was a magical signet ring said to have been possessed by the king, which variously gave him the power to command demons (or *jinni*) and to speak with animals. The reason that this symbol is more commonly attributed to King David, some researchers have theorized, is that the hexagram represents the astrological chart at the time of David's birth or anointment

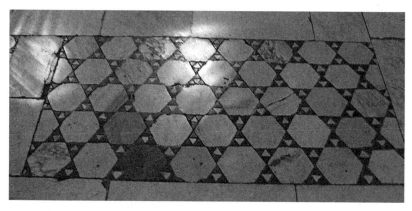

This is a rare photograph, slightly blurry since it was taken in the evening when the Sistine is closed to the public and the lights are low. However, one can clearly see the Seals of Solomon (Stars of David) in the floor of the Sistine. This is the exact spot where the furnace burns the ballots to produce the black smoke and white smoke during the Conclave, the election of a new pope.

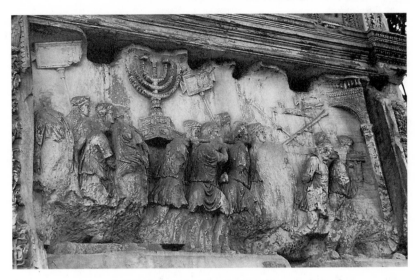

Roman parade of triumph with stolen Temple vessels, depicted
on the inside wall of the Arch of Titus in Rome

as king. But its most profound and almost certainly its correct mean-
ing is the mystical interpretation that links it with the holy number
seven by way of its six points surrounding the center.

The number seven has special religious significance in Judaism.
Going back to creation, we have the six days followed by the sev-
enth, the Sabbath, the day of rest proclaimed holy by God and en-
dowed with singular blessing. Every seventh year is a sabbatical year
in which the land is not to be worked, and after seven cycles of seven
the Jubilee year brings freedom to indentured slaves and the return
of property to its original owners. But most relevant of all for our
understanding of the significance of seven as used in the Sistine's
mosaic floor is its link with the Menorah in the ancient Temple,
whose seven oil lamps rest on three stems branching from each
side of a central pole. It has been strongly suggested that the Star
of David came to be used as a standard symbol in synagogues pre-
cisely because its organization into 3 + 3 + 1—triangle up, triangle
down, and center—corresponds exactly to the menorah. And this
menorah is the very item featured so prominently on the Arch of

Titus commemorating the victory of the Roman Empire over what it considered a defeated people never to be heard from again.

However, thanks to artists like the Cosmatis and Michelangelo, Jewish symbolism was to be seen again and again, through all their most famous works. It is one more bizarre secret of the world's most Catholic chapel that its giant mosaic floor is chock-full of Stars of David.

THE ORIGINAL FIFTEENTH-CENTURY FRESCOES—NOT WHAT THEY SEEM TO BE

The main attraction of the new chapel, however, was neither its floor nor its ceiling, but its walls. Starting at the front altar wall, there began two series of panels—one about the life of Moses, the other about the life of Jesus, much like a pair of Bible stories told in comic-strip format.

To paint so many labor-intensive frescoes, a whole team of the top fresco artists of the fifteenth century were brought in—or to be more accurate, were *sent* in. This is important to know because of *who* sent them. It was none other than Lorenzo de' Medici, the richest man in Florence and its unofficial ruler. He is the same man who would later discover Michelangelo and raise him as one of his own sons.

Pope Sixtus IV hated Lorenzo and his family, having struggled against them for years. Sixtus wanted to seize control of freethinking Florence and its great wealth so that he could then proceed to take over all of central Italy. In 1478 he plotted to eliminate Lorenzo and the entire de' Medici clan in an early version of a Mafia rubout. The only difference is that even the Godfather would not have dared attempt this particular conspiracy. Sixtus planned to have Lorenzo and his brother Giuliano assassinated in the Cathedral of Florence, in front of the main altar, during Easter Mass. More blasphemous still, the chosen signal for the killing was the Elevation of the Host. Even cold-blooded professional killers turned down this job, and

the pope had to enlist the help of a priest and the Archbishop of Pisa. These two plotted out the details along with Sixtus's most corrupt nephew, Girolamo Riario. Sixtus refused to listen to the details, coyly saying, "Do what you must, as long as no one is killed." However, he did order his warlord Federico da Montefeltro, the Duke of Urbino, to amass six hundred troops on the hills outside Florence and wait for the signal of Lorenzo's death. The shameless attack took place as planned . . . up to a point. Giuliano de' Medici died on the spot from nineteen dagger wounds. Lorenzo, though badly wounded, managed to escape into a secret tunnel and survive. The signal to invade Florence was never given. The enraged Florentines, instead of rising up against the de' Medicis as Sixtus had hoped, slaughtered the conspirators. It took personal intercession from Lorenzo himself to stop the citizens from killing Cardinal Raffaele Riario, another nephew of the pope but one who had no involvement in the attempted coup. Two years later, the pope gave up and a truce was declared between the Vatican and Florence. It was just at this time that the new chapel was ready to be decorated.

So, why did Lorenzo send his most talented painters to decorate a chapel glorifying the man who had killed his beloved brother and had tried to butcher him as well? According to the official guide-books, this was a "peace offering," a gesture of forgiveness and reconciliation. But the official explanation is wrong. The real reason is key to understanding the none-too-conciliatory messages of the frescoes.

Lorenzo did indeed send the cream of the crop of artists: Sandro Botticelli, Cosimo Rosselli, Domenico Ghirlandaio (who would later teach Michelangelo for a brief time), and the Umbrian painter Perugino (who would later teach Raphael). Besides covering all four walls of the chapel with the Moses–Jesus cycles, they were commissioned to add an upper strip portraying the first thirty popes, plus a large fresco of the Assumption of the Virgin Mary into Heaven on the front altar wall between the two windows. Faced with so much to fresco, the team later brought in Pinturicchio, Luca Signorelli, Biagio d'Antonio, and some assistants. The list is a who's who of the

top fresco artists of fifteenth-century Italian painting. All of them, with the exception of Perugino and his student Pinturicchio, were proud Florentines.

The pope had planned his own multilayered symbolic design for the chapel. It was meant to illustrate successionism to the world, proving that the Church was the one true inheritor of monotheism by replacing Judaism. To accomplish this, every panel from the Moses cycle was twinned with one from the Jesus cycle. The northern series of fresco panels told the life story of Jesus, from left to right, in Christian order. The southern series told the story of Moses—but from right to left, in Hebrew order. This resulted in eight "pairs":

The Discovery of Baby Moses in the Nile	The Birth of Jesus in the Manger
The Circumcision of Moses's Son	The Baptism of Jesus
Moses's Anger and His Flight from Egypt	The Temptations of Jesus
The Parting of the Red Sea	The Miracle of Jesus on the Water
Moses on Mount Sinai	Jesus's Sermon on the Mount
Revolt of Korach	Jesus Passing the Keys to Peter
Last Discourse and Death of Moses	Last Supper of Jesus
Angels Defending the Grave of Moses	Jesus Resurrected from the Tomb

Some of the "connections" require a stretch of the imagination, but the idea was to show that the life of Moses served only to foreshadow the life of Jesus.

Still another purpose for the pope was to elevate the worship of the Virgin Mary. Sixtus IV wanted the chapel to be dedicated to Mary's Assumption into Heaven, celebrated in the Catholic calendar on August 15. For this reason, Perugino painted the giant fresco of Mary's Ascent on the altar wall, with Pope Sixtus IV himself depicted kneeling before her.

The pope's last intention—and the one probably closest to his heart—was to glorify and solidify the supreme authority of himself and his family, the della Roveres. The papacy was still recovering from centuries of schisms, scandals, antipopes, intrigues, and assassinations. The pontifical court had moved back to Rome only fifty years before, after the so-called Babylonian exile of the popes in Avignon, France. Pope Sixtus was eager to demonstrate not only the supremacy of Christianity over Judaism and the divine authority of the popes over Christendom, but also his personal superiority over all preceding popes. This is why, in accord with his mandate, Aaron, the first high priest of the Jews, and Peter, the first pope, are both clothed in blue and gold, the heraldic colors of the della Rovere family. This is why oak trees and acorns can be seen everywhere in the chapel—della Rovere means "of the oak tree," which was his family crest. This is also why Sixtus had his portrait placed above the cycle of the first thirty popes—right in the center of the front wall, next to the Virgin Mary in Heaven.

With all this in mind, let's return to our question: why did Lorenzo send his best artists to Rome to carry out this job of self-aggrandizement for the man who had plotted against him and his family? Very simply, as we'll demonstrate, to *sabotage* Sixtus's beloved chapel.

Botticelli was most likely the ringleader and team coordinator of the fresco project. Standard official texts on the Sistine claim that it was Perugino, but a quick analysis shows that he—the only non-Florentine—was not in on the plot. Perugino's color scheme and style is completely different from those of all the other panels, and his symbolism contains no antipapal messages, whereas the other artists are having a field day all over the chapel.

Cosimo Rosselli had a little white puppy that became the mascot for the Tuscan artists. We do not know if the dog was allowed to play in the chapel while the artists were painting, but he can be found cavorting in every fresco panel, except for those of the Umbrian Perugino. In the Last Supper, he is sporting at his master's feet. In the Golden Calf fresco, he is actually stepping down from the panel into the chapel.

Granted, other than the possible ritual impurity of a dog in the sanctuary, this is not a major insult. But the Florentines inserted much stronger images in their work to settle old scores with the pope. Botticelli was the one who had the biggest grievance. After the execution of the conspirators who attacked the de' Medicis, Botticelli had made a fresco showing their corpses hanging from the cathedral on public display. The painting bore sarcastic captions attributed to Lorenzo de' Medici himself. As part of the official peace treaty between the Vatican and Florence in 1480, Sixtus insisted that this fresco be utterly destroyed. Botticelli was certainly not likely to forget or forgive that. So, in his panel of Moses's Flight from Egypt, he inserted an oak tree—the symbol of the della Rovere family—over the heads of the pagan bullies that Moses chases away. Near the innocent lambs and the holy vision of the Burning Bush, however, he placed an orange tree bearing an oval of oranges—the family crest of the Florentine de' Medicis. In Korach's Mutiny, Botticelli cloaked the rebellious Korach in the blue and gold of the della Roveres, and in the far background showed two boats: a wrecked one for Rome, and a fine floating one with the flag of Florence proudly waving on top. In the Temptations of Christ, he inserted Sixtus's cherished oak tree twice: a standing oak right next to Satan as he is unmasked and a chopped-up oak about to be burned in the Temple.

Biagio d'Antonio, another proud son of Florence, did not want to be outdone. In his panel, the Parting of the Red Sea, he shows the evil Pharaoh wearing the della Rovere colors and a building looking suspiciously like the chapel itself being flooded by the raging red waters.

The new chapel, still called the Palatine, was consecrated on the Feast of the Holy Assumption, August 15, 1483. The proud pope officiated. He was a happy man, totally unaware of the hidden insults heaped upon him.

Sixtus IV was anything but a great strategist or diplomat. He had made many conflicting and impetuous alliances. He was clearly more concerned with increasing his family's wealth and power than with strengthening the Church. Luckily, the Muslim invasion of Italy was halted by the unexpected death of Mehmed II, the sultan of the Ottoman Empire, in the spring of 1481, but Sixtus took the credit for himself. He died a year later, still blissfully ignorant of how Lorenzo had managed to make a mockery of his attempt to have the chapel serve his egomania.

In retrospect, it is remarkable to see how much the first artists got away with inside the Sistine Chapel. However, the real master of hidden messages would show up a generation later . . . and with much, much more to say.

THE LOST LANGUAGE
OF ART

. . . and the understanding of their
prudent men shall be hidden.

— ISAIAH 29:14

HAT LORENZO'S ARTISTS were able to carry off in the Sistine Chapel is a powerful example of a practice with many parallels, even in modern times.

During the Second World War, the Allied forces faced a grave threat in the Pacific theater of operations. The Japanese cryptographers were incomparably skilled at breaking every single code that the Air Force, Navy, and Marines could devise. The situation seemed lost, until the Allies hit upon two ingenious solutions.

The first was to bring in a team of Native Americans from the Navaho tribe—the famous "wind talkers"—to translate all radio messages into their native tongue, a language completely unknown to the Japanese. The other took advantage of Japanese ignorance of American cultural trivia. To transmit numerical codes, the instructions began: "Take Jack Benny's age, and then . . ." Only someone

who had grown up in the United States, listening to the well-known comedian's popular radio show, would be in on the reference. Jack Benny's stage persona was known by all to be a tightwad, a horrible violin player, and a vain man—especially about his age. Even though the former vaudevillian was already in his middle years at that time, he would always claim that he was "only thirty-nine." The Japanese secret services went out of their minds trying to figure out who this Jack Benny was, and then attempting to pin down his actual chronological age, whereas every American soldier knew instantly that no matter what year it was, the answer would forever be "thirty-nine."

Thankfully, neither of these codes was cracked. An almost unknown language and a bit of Americana "insider info" helped win the war by masking essential information so that only the intended audience could comprehend it.

USING CODES IN ART

Codes proved their value many times over in wartime. Far less obvious, though, is the way hidden messages found a place in another setting with universal significance. Here the intent was not to deceive an enemy but to intensify a sense of mystery, not to achieve military conquest but to produce greater appreciation. It is in art and in some of its most famous expressions that we readily realize an important truth: *artistic geniuses often produced their greatest works when they incorporated concealed meanings in their masterpieces.*

Art—at least great art—by its very nature has varying levels, or layers, of meaning. In fact, a masterpiece comes to be considered a masterpiece because we know instinctively, even subconsciously, that there is much more to the work than meets the eye. We don't love the Mona Lisa because she is beautiful (in fact, in today's aesthetic, she would be considered plain by many), but because she is *mysterious.* That is the key to the world's fascination with her for the last five centuries. We know that there is something else there beneath the surface, beneath that smile, and we can't quite figure it out.

It is hard for us in the twenty-first century to appreciate how much it was taken for granted in the Renaissance and Baroque periods that artists *always* incorporated multiple layers of meaning in their work. We have to realize art's function at a time when people lacked the myriad sensory stimuli we encounter every day, all day. In a world without cable channels and satellite television, videos and DVDs, movies and the Internet, an artist's creation was the one ever-present object that had to serve as a source of pleasure and inspiration over and over again, year after year, without becoming stale. If an artist of the caliber of Leonardo or Michelangelo was paid a hefty commission for a new private piece of art, that artwork had to be a constant delight and stimulus for the rest of the patron's life, and then usually go on to become a family heirloom. If an artwork was commissioned by the government, it had to serve as a permanent expression of that society's ethos and values. And, as we saw in the preceding chapter, a major motivation for someone like Pope Sixtus IV to commission the expensive original decorations of the Sistine was the fact that serving as patron for the creation of fine art was at that time also the greatest demonstration of power and wealth.

The biggest patron of the arts throughout this time was of course the Catholic Church. But for the clergy, art served yet another function. Church art was meant not only to glorify a place of worship or to inspire the faithful; it was also designed to teach the masses, who were almost entirely illiterate. Thus, captivating, textless illustrations of important stories from the Gospels and the lives of the saints were needed to "enlighten the benighted," to instruct the next generation in the ways and the history of Christendom. This explains why so many medieval and Renaissance churches have incredibly colorful and intricate fresco cycles, sometimes narrating an entire biblical book. (Ironically enough, this tradition is considered by many to be the origin of today's comic book and graphic novel.)

For people at that time, just as today in many corners of the world, going to mass, aside from fulfilling one's religious obligations, was the only vehicle for socializing and entertainment. Even in the free-thinking Florence of Michelangelo's youth, people would flock to

the churches to mingle, to hear a sermon from a talented popular orator, and to enjoy the latest artwork. Religious ceremonies of the era were anything but brief. A mass, especially a papal one, could last for hours. How to maintain the proper mood and not bore the congregation to sleep? Art was the answer. But not just pretty pictures that required only a short glance. It had to be art that would serve as an ever-unfolding, mesmerizing element of the religious ambience. That is another reason that the art in Michelangelo's day was so complex—it had to bear hundreds of repeated viewings of long duration. The audience had to believe that it was always possible to discover in it new meanings and insights.

Thus, generation by generation, art—both private and public—became more and more complex and multilayered. Just as Shakespeare filled his works with straightforward storylines, sex, violence, and bawdy jokes for the "groundlings" (the uneducated peasants who stood or sat on the ground) while at the same time creating gorgeous poetry with profound levels of meaning for the wealthy and cultured patrons in the upper seats, artists in Michelangelo's era were creating amazing pieces that would speak to every level of intelligence. The common folk would see pretty pictures and statues and listen to a cleric's narration of their meaning. For those of sufficient background, however, there were far more treasures to be gleaned from delving into each work.

Every single element of Renaissance art has an inner significance: the choice of subject and protagonists, the faces selected for different characters in the work, the colors used, the species of flowers or trees shown, the kinds of animals portrayed, the positions, stances, gestures, and juxtapositions of the characters in the scene, even the location and landscape itself—all have hidden meanings. For endlessly creative geniuses like Leonardo and Michelangelo, this made each new work an extremely exhilarating—and exhausting—journey deep into the piece and thus deep into their own souls.

The greatest challenge arose, however, when the artist felt he had to hide his real message out of fear, knowing that his ideas were unacceptable to the establishment or perhaps even prohibited. In times

of intolerance and religious persecution, art very often did not dare openly declare what the artist so urgently wanted to communicate. Codes, hidden allusions, symbols, and veiled references comprehensible to only a very limited circle of peers were the only recourse available to those who broke with the traditional dogmas of their age—especially if the artist knew his ideas would be anathema to his patron or to the authorities.

This, as we will see, is what makes Michelangelo and his work in the Sistine Chapel so fascinating. Michelangelo may well be the paradigm of the great artist whose work reflects a passion for both aesthetic perfection and intellectual persuasion. More than anything, he wanted to create works of art that would endure not only because of their beauty but also for their daring—and at the time subversive—statements to people both inside and outside the Church. Although Michelangelo knew that a majority of his contemporaries would not see beneath the superficial, he had faith that somehow his "coded" allusions would surely be exposed by diligent scholars. Michelangelo was certain that history would take the trouble to decipher his true meaning—because hiding dangerous thoughts in works of art was common practice to a great many of his colleagues, a practice with an ancient pedigree.

FROM THE BIBLE TO THE RENAISSANCE

The first recorded instance of a hidden message in artwork goes back almost four thousand years, to a story recorded in the biblical book of Genesis. Joseph, the heir and favored son of the last patriarch, Jacob, is sold into Egyptian slavery by his jealous brothers. The conspiring brothers then take Joseph's fancy cloak of many colors, rip it, dip it in blood, and tell their father, Jacob, that Joseph has been devoured by a savage beast. Joseph, thanks to his God-given talents and ingenuity, grows up to become the Pharaoh's vizier, the second most powerful man on earth at that time. At the end of the tale, Joseph is reunited with his brothers and he sends the Pharaoh's

highly decorated royal carriages and wagons to Canaan to take precious gifts to his beloved father and to transport the patriarch in style to Egypt, along with the rest of his large family. Jacob, who has been inconsolable through all the long years since Joseph's "death," cannot bring himself to hope that Joseph might not only still be alive, but also have risen to the highest echelons of power in mighty Egypt. The text says at this point: "And [the brothers] told him [Jacob], saying, Joseph is yet alive, and he is governor over all the land of Egypt. And Jacob's heart grew faint, for he believed them not. And they told him all the words of Joseph, which he had said to them; and when he saw the wagons which Joseph had sent to carry him, the spirit of Jacob their father revived; And Israel said, It is enough; Joseph my son is yet alive; I will go and see him before I die" (Genesis 45:26–28).

The ancient Jewish commentators point out that it is only when the doubting patriarch sees the wagons that he at last believes that his son Joseph is alive and governing Egypt. Why? Because Jacob understood the coded message Joseph had sent him on the artistic adornments of the wagons. Pharaoh's carriages of the time were as a matter of course covered with pagan Egyptian art, colorful carvings and paintings depicting the various gods and goddesses of the idolatrous death-worshiping cult that controlled Egypt. According to the Midrash, the Jewish oral lore connected to the biblical text, Joseph painted over and disfigured these pagan images on the royal vehicles. This conveyed two hidden meanings to his father: one, that only someone in the highest ranks of power would dare to deface the king's carriages; and two, that it must have been a member of his own family, someone who believed in but one God, that was responsible for this covert insult to the pagan symbols that epitomized artwork in ancient Egypt.

From the biblical Joseph's wagon to the twentieth century's Jack Benny, we've had countless examples of codes relying on cultural references known only to the initiated, the "insiders," to convey an important message meant for but a select few.

Serious scholars have increasingly become aware that many of the best-known artworks of the Renaissance and Baroque periods

(especially from the late 1400s through the mid-1600s) are similarly filled with hidden ideas and covert codes. Some require fairly little work to decipher. It doesn't take all that much effort, for example, to figure out the great artists' references to Greco-Roman mythology and medieval legends, to observe their use of the heraldic colors and crests of the powerful families that controlled Italy and the Vatican, and even to identify many of the faces of then-famous individuals in their frescoes.

Somewhat more elusive, though, are the secret symbols ordered by the patron commissioning the work. Renaissance and Baroque art teems with this type of hidden message: portraits of the patron and his family members or inner circle who just happen to be present at the Nativity or the Crucifixion, family crests that appear as decorations in architectural details from ancient Rome, and even puns based on the patron's name. In 1475, for example, the year of Michelangelo's birth, Botticelli painted Lorenzo de' Medici and his Renaissance court present as witnesses at the Adoration of the Magi. Much later, Michelangelo similarly festooned the entire ceiling fresco of the Sistine Chapel in garlands of oak leaves and acorns, to remind the public of both Pope Sixtus IV who had commissioned the building of the chapel and of Pope Julius II, Michelangelo's contentious patron. Both popes, uncle and nephew, were from the della Rovere clan, whose name means "of the oak tree."

CODED PROTESTS AND INSULTS

Far more intriguing, though, are the secret symbols embedded in the artwork by the artist without the knowledge or permission of the commissioning patron. This occurs less often than authorized symbolism in Renaissance and Baroque art, because it was clearly a dangerous practice, given the power or potential anger of the person paying for the piece. Yet it was far from uncommon in spite of its peril.

This prompts the question, why did prominent artists run the risk of incurring their patron's ire? There are many answers.

First, there was the anger or at least the righteous indignation of many of the creative geniuses forced to humble themselves before their financial supporters. In those times, artists were considered merely hired help. Federico Zeri, an internationally respected art historian, vice-president of the Italian Consiglio Nazionale dei Beni Culturali, and a member of the illustrious Academie des Beaux-Arts of Paris, writes in his book on Titian's masterpiece, *Sacred and Profane Love:* "One need not forget that in the 1500's, in the middle of the Italian Renaissance, the painters—even the great ones—were considered no more than artisans on call: well-paid, but deprived of any such freedom that would allow them to refuse labors that today would seem very demeaning."[1] The first artist to break through all this and become his own master—indeed, to refuse commissions even from the pope himself—was none other than Michelangelo Buonarroti. Moreover, like many other mistreated artists, Michelangelo often slipped in sexual allusions and rude insults to his patrons—obviously without their knowledge—whenever he needed to release his pent-up frustrations. Some of these are part of the secrets of the Sistine Chapel that we will discuss more fully later.

Artists of the era were encumbered and limited by many prohibitions. Perhaps foremost among these was that they were not allowed to sign their works. However, the patron paying for the piece would have his name or image or family symbol prominently displayed. This is the reason that so many artists would somehow manage to insert their own face somewhere in the work. Sometimes, as in the case of Botticelli and Raphael, it would be obvious, since they enjoyed their patrons' consent; at other times, it would be less apparent. Michelangelo inserted his face into his works on several occasions, sometimes quite openly, but more often slipped in as a secret sign of protest. This will show up again and again as we explain the secrets of the Sistine ceiling and other of his later works.

Raphael, even though he was allowed to interpose his face clearly in many of his most famous pieces, was still not permitted to sign his name. That's why, when he completed his most famous masterpiece

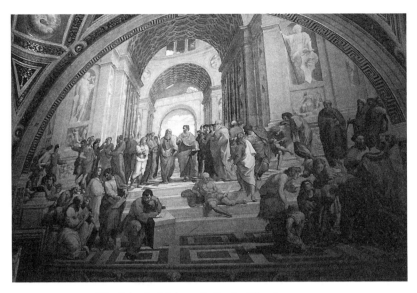

The School of Athens, *by Raphael Sanzio, 1510–12*
(Vatican Museums). See Fig. 3 in the insert.

of all, the huge fresco of *The School of Athens* (a work that has so many secrets in it that whole books have been written about it), he added a last tiny detail. On the lower front on the right side, the great sage Euclid is bent over a slate, explaining to his students one of his geometrical theorems. On the back of his golden embroidered collar, under close scrutiny, four tiny initials appear: R.U.S.M. This stands for *Raphael Urbinas Sua Manu,* Latin for "Raphael of Urbino, by his own hand." (By the way, dressed up as Euclid is none other than Raphael's conspiratorial "godfather" in the Vatican, the architect Bramante. More on this later as well . . .)

CONCEALING FORBIDDEN KNOWLEDGE

Another strong limitation on Renaissance artists was the prohibition on dissecting corpses. Scientists wanted to dissect the corpses of executed criminals in order to increase their knowledge of anatomy and also to try to reclaim the lost medical knowledge of the ancients.

Artists wanted to learn all they could about the inner structure of the human body in order to come up to the level of expertise of the ancient Greco-Roman artists in representing the human form. The Church had forbidden any such dissections, since it considered the human body a divine mystery. In addition, it was still leery of perfect representations of human and mythological figures, which it thought might lead to a sort of spiritual recidivism, a return to pagan idolatry. This is the reason that medieval portrayals of the human figure seem so flat and unnatural compared to those found in Classical and Renaissance artwork. The only place in medieval and Renaissance Italy where occasional scientific dissections were allowed was the University of Bologna. However, for those ambitious artists who could not get to Bologna or for whom these rare occasions did not suffice, frustration led them very often to illegal efforts. They hired professional body snatchers, common criminals who would steal the fresh corpses of executed convicts out of their graves and smuggle them under cover of night to secret laboratories where the artists would dissect and explore the bodies, sketch every detail that they could by candlelight, and then get rid of the evidence before dawn.

The great Renaissance genius par excellence, Leonardo da Vinci, was brought to the Vatican in 1513 by the new pope, Leo X, and given a list of commissions to create for the greater glory of the pope and his family. After three years of living in the papal palace and exploring Rome, the great Leonardo had produced almost nothing. The furious Pope Leo decided to have a surprise showdown with the capricious artist and intimidate him into completing some of his commissions. In the middle of the night, surrounded by several imposing Swiss Guardsmen, the pope burst through the door to Leonardo's private palace chambers, thinking to shake him out of a sound sleep. Instead, he was horrified to find Leonardo wide awake, with a pair of grave robbers, in the midst of dissecting a freshly stolen corpse—right under the pope's own roof. Pope Leo let out a nonregal scream and had the Swiss soldiers immediately pack up Leonardo's belongings and throw them and the divine

Leonardo himself outside the fortress wall of the Vatican, never to return again. Shortly afterward, Leonardo decided it was probably healthier to get out of Italy and move to France, where he spent the rest of his days. This, by the way, is why the great Italian genius's most famous oil paintings, including the Mona Lisa, are all in Paris, in the Louvre museum.

Sandro Botticelli, even though the favorite artist of the liberal de' Medici family in Florence a generation before Michelangelo, was still not allowed openly to explore the human body. In one of his most famous—and also one of his most mysterious—paintings, he hides several secrets. The painting is the allegorical work *Primavera* (Spring). Just as in the case of Raphael's *School of Athens,* whole books have been written about it, each one promoting a different interpretation of the masterpiece. It is set in a mystical forest clearing, and the action moves from right to left, starting with the mythological Zephyr, the wind of Spring, who transforms the forest nymph Cloris into the figure of Flora, the symbol of Spring and its fertility. Then, in the central position in front of two odd openings in the canopy of

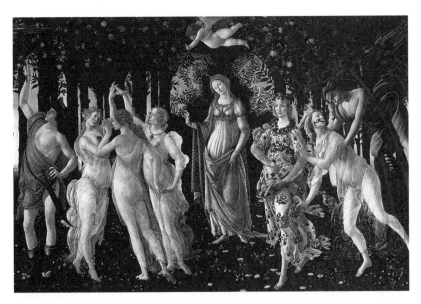

Primavera, *by Sandro Botticelli, 1481 (Uffizi Galleries, Florence)*

branches above, is Venus, the goddess of Love. Hovering over her head is the blindfolded Cupid, about to shoot his phallic arrow at the central woman of the three Graces, the figure of Chastity. The last figure, on the far left and detached from the rest, is Mercury, the god of change and hidden wisdom, stirring up the clouds. No one before has discussed the strange gaps in the branches in the center of the work, but it is exactly there that Botticelli embedded his biggest secret in the painting, one that is the key to understanding the whole work. If you look carefully at the shape, angle, and juxtaposition of the two openings, a very clear anatomical image appears—a pair of human lungs, just as they would appear during an illegal dissection in a secret Renaissance laboratory.

The painting, a wedding gift, is celebrating the cycle of life that was originally created, according to Judaic and Kabbalistic lore, by *ruach HaShem,* the Divine Wind, or Breath—the same breath of life that created Adam, the first human. If one could take the painting out of its frame and curl it into a cylinder so that the two edges met, one would see that the clouds that Mercury/Hermes stirs up on the left become Zephyr on the right, showing that the Divine Wind, the Breath of Life, has no beginning and no end. In the exact middle, framing Venus and her heart-red pendant, are the two lungs, to reaffirm the connection of Love and Life. Thus, this famous masterpiece is an early example of secret Neoplatonic imagery, which was just taking form at that time in freethinking Florence under the de' Medicis, the commissioning patrons of this painting.

DECIPHERING THE ESOTERIC

Our next category of secret symbolism in Renaissance works, of prime importance for deciphering Michelangelo's hidden messages in the Sistine Chapel, is the use of "esoteric knowledge"—images, symbols, and codes known only to a few initiates—to pass on a hidden message not intended for the masses. Some of these have since been revealed, such as Mozart's use of Masonic symbolism in his

opera *The Magic Flute,* and the seventeenth-century Baroque architect Borromini's use of Masonic-Kabbalistic symbols in his Church of Sant'Ivo in Rome. Others have still not been deciphered, such as the "dark Lady" of Shakespeare's sonnets and the "Enigma Variations" symphony of Edward Elgar.

A very recent example of decoding hidden symbols in well-known artwork is that of the designs of what we in the Occident call Oriental carpets: the beautiful, intricate carpets found all along the ancient Silk Road, from Turkey through India and on to China. According to the Textilia Institute's findings, presented in its exhibit and catalogue in Rome and New York in 2005, *Il giardino dei melograni* (The garden of the pomegranates), Jews fleeing the deadly persecutions of the Holy Inquisition in Spain in 1492 were searching for a way to preserve the arcane knowledge of the Kabbalah and its practice of mystical meditations. Upon finding refuge in the East, they discovered the art of carpet weaving. Soon thereafter, these carpets, either designed and commissioned by Jews or woven by Jewish artisans themselves, took on a whole new look. This innovative fashion incorporated pomegranates, Jacob's Ladders, Gardens of Eden, and Trees of Life into the rugs in order to make them vehicles for transmitting the forbidden wisdom of the Kabbalah, as well as to serve as devices for Kabbalistic meditation. These carpets, even though not understood by the masses, were greatly esteemed and were found in very unexpected places. Thus, the unsuspecting Muslim Mogul rulers of northern India had Jewish Kabbalistic carpets hanging in their royal palaces and the Confucian emperors of China had the same secret symbolism in huge carpets decorating the Royal Pavilion in the heart of the Forbidden City.

Another fascinating example of esoteric knowledge adopted by the informed to communicate secretly was the use of sign language for the deaf. Unknown to most people today, Renaissance Italian artists had no difficulties working with their hearing-impaired friends and colleagues. Even today, especially in southern Italy, there is a deeply engrained tradition of expressing oneself through nonverbal communication, using hand gestures, facial expressions, and body

language in general. Leonardo da Vinci, in his day, encouraged other hearing artists to learn from the expressivity of the deaf.

We know of two successful deaf artists in Renaissance Italy. One is Pinturicchio, whose frescoes from the fifteenth century appear in some of the most prestigious settings in Rome, including the Sistine Chapel. The other is Cristoforo de Pretis, who collaborated with his hearing half-brother Ambrogio de Pretis. The brothers, who worked together in sign language, were among the first to welcome Leonardo da Vinci when he moved to Milan in 1483. They were a great influence on Leonardo and when, in the same year, he created his first work in his new location, he wanted to thank the brothers in their own language that he had grown to admire. There are even some art historians who say that Ambrogio de Pretis actually worked on the piece with Leonardo. This painting, called *The Madonna of the Rocks,* can be found today in the Louvre in Paris. It depicts the Virgin Mary inside a dark cavern, with two infants at her feet, commonly interpreted as the infant John the Baptist and the baby Jesus. She is embracing the infant on her right while blessing the other with her left hand. Next to her left hand is a mysterious angel who protects that child while pointing across the painting to the infant on Mary's other side. The baby under the hands of Mary and the angel is holding up his own hand in a two-fingered blessing toward the other child. Obviously fresh from the excitement of his discovery of sign language, Leonardo incorporated a number of hand gestures in this work. What most observers and even art experts do not know is that Leonardo signed this work—by "signing" his name. The vertical alignment of the three hands on the right side of the painting forms a straight downward line—Mary → angel → infant Jesus. Mary's hand is in the archaic finger-spelling formation for the letter *L*. The angel's hand is the letter *D*. The baby Jesus's hand is the letter *V.* LDV—Leonardo da Vinci.

Skeptical readers who doubt that Mary's hand is the letter *L* need look no further than the gigantic sculpture of Abraham Lincoln in the Lincoln Memorial in Washington, DC. It was created by Daniel French, the same artist who made the sculpture of Thomas

Left: Madonna of the Rocks, *by Leonardo da Vinci, 1483 (Louvre Museum, Paris).*
Right: Lincoln, *by Daniel French, 1920 (Lincoln Memorial, Washington, DC)*

Gallaudet, the founder of the eponymous university for the deaf in Washington, teaching finger spelling to a little girl by way of the signed letter *A*. In French's monumental sculpture of Lincoln, the Great Emancipator's hands (his left and right, respectively) sign his initials, *A* and *L*, using the identical kind of old-fashioned *L* that Leonardo painted centuries before.

THE MAGIC OF SPECIAL EFFECTS

Yet another strategy for encoding in Renaissance works involved environmental "special effects." Messages were ingeniously inserted so that they could be viewed only when one was in situ, in the very spot where the artist intended for the viewer to receive his true intent. Often this would be determined by how light coming from an actual window at the site would stream into the painting, thus

literally and figuratively *illuminating* the piece. Leonardo did this with the light in his *Last Supper* fresco, and in the seventeenth century Caravaggio became world-famous for this special effect. Later on, we will see how Michelangelo based the entire concept, design, and revision of his *Moses* sculpture on its interaction with the light source in its predetermined setting.

Somewhat similar is another effect called anamorphosis. This is an amazing technique that makes an image literally "morph" into another shape or image when the viewer looks at it from a different angle. Only highly skilled artists who had also mastered optics could create this effect. Of course, Leonardo da Vinci was one of these. His early work *The Annunciation,* which now hangs in the Uffizi Galleries in Florence, was until recently considered highly flawed because the Virgin's right arm is disproportionately long, her legs seem mixed up with the bench on which she is strangely seated, and the angel is so far from Mary that they seem to be in two different paintings. In fact, when viewed normally or in any book of prints, the whole piece seems to be stretched out of shape. Only a few people who realized that Leonardo had concealed a giant anamorphosis were able to prove that this is indeed a unique masterpiece. In the brand-new guide to the Uffizi, Francesca Marini reveals: "Only by considering that the painting in its original setting would have to have been viewed from below, on the right side, the disconcerting anomalies fall away, to demonstrate an accord—which at that time was an uncommon study—of the perspective messages in the artwork in relationship to the location for which it was destined."[2]

The only way to experience what Leonardo is saying in *The Annunciation* is to interact with the actual painting. When one stands to the right of the painting as close to the wall as possible and views the painting out of the corner of one's eye, the whole work comes to astounding life. Mary's arm is the proper length, the angel is much closer to her, and Mary's legs are together—while her stomach appears to be much smaller and flatter; in other words, a true virgin. As one walks from right to left in front of the painting, her legs seem to open and her stomach seems to swell. By the time the viewer

The Annunciation, *by Leonardo da Vinci, 1472 (Uffizi Galleries, Florence). See Fig. 4 in the insert.*

is on the left side of the painting, the angel has backed away from Mary, and the now-very-pregnant woman's skirt resembles a birthing trough or the rough crib in the manger. We will see later on how Michelangelo used anamorphosis for one of his secret messages in the Sistine.

The last special effect that we need to explore here is trompe l'oeuil, French for "deceive the eye." Simply put, it is the highly difficult technique of making a two-dimensional image, such as a painting or a fresco, seem to be three-dimensional. A trompe l'oeuil can be a false perspective, drawing the viewer's sense of vision through the surface of the painting and deeper into the space beyond, sometimes seeming to go off into infinity. All of the niches of the popes painted in the original fifteenth-century decoration of the Sistine are this kind of optical illusion. Indeed, many visitors are surprised to learn that they are not real architectural niches.

Trompe l'oeuil can also be a protruding illusion, making the image seem to pop out of the surface of the wall or canvas. This is even more difficult to achieve, and thus there are only rare examples. One of the triumphs of this technique is Michelangelo's *Jonah,* in a place of honor at the front of the Sistine. The effect he achieved cannot be perceived or appreciated or understood in any reproduction; it becomes clear only when the original is viewed inside the chapel

itself. What it is, and why Michelangelo did it, will be explained when we discuss the Judaic secrets of the Sistine.

Since all these special effects required much extra time and energy, the artist would usually incorporate them into a piece of art for more than just a mere show of virtuosity. Careful study almost always leads us to an unexpected message contained within the image—again, for those in the know. Sometimes this would be to sneak in the artist's signature, his lover, a sexual allusion or a joke, a rude insult to his patron or to those in power; sometimes to make a statement that was far more profound, usually forbidden, and thus far more dangerous.

We have taken this tour into the secret world of codes in art for one primary reason: to demonstrate that Michelangelo was following in the footsteps of Botticelli, Leonardo, and many other contemporaries when he filled his work with secret symbols. Michelangelo had many reasons to cloak dangerous ideas and camouflage daring messages, reasons we will amply clarify. But what makes this all the more fascinating and relevant to our theme is that the one place where he slipped in the greatest number of these hidden messages was also the most unexpected and perilous place in the world for such subversive acts—the private chapel of the papal court in the Vatican Palace, the Sistine Chapel.

Here Michelangelo best proved his genius. For the masses his frescoes provided—and still provide to this day—delights of incomparable beauty. However, for those perceptive enough to grasp the deeper messages imbedded in his multilayered masterpiece, there are far greater rewards in store.

Chapter Three

A REBEL IS BORN

I live and love in God's peculiar light.

— MICHELANGELO

WHAT SHAPES A CHILD of fifteenth-century Italy to become the most revolutionary artist and the most artistic revolutionary of his time? Is the answer determined by family, by one's name, or is it fated by horoscope?

Those who stress heredity must acknowledge that, sometimes, the fruit does indeed fall far away from the tree. The Buonarroti family tree was filled with anything but artistic types. An early ancestor had been a city councilman in Florence, another a Dominican monk, yet another a moneylender, and then there was a great-grandfather, Simone di Buonarrota, who was a wool trader and money changer. This Simone was perhaps the loftiest branch on the tree: he became rich and was a social success, gaining many honors for the family by lending money to the Florentine city government. His son Lionardo, however, was the undoing of the family. He was not a great businessman, and sired so many daughters that their wedding dowries more or less bankrupted the family. They lost their prestigious home in Florence, and Lionardo, in order to pay his debts,

had to accept demeaning magistrate positions in rural villages far
from the fashionable streets of Florence. His son, Ludovico, inher-
ited his bad luck and poor business acumen. He was relegated to
being the local magistrate for far-flung Caprese, high in the rocky
Tuscan mountains near Arezzo. Caprese means "goat-filled," since
the rustic area probably had more mountain goats than human in-
habitants. This represented a precipitous drop in the status of the
once-wealthy Buonarroti line.

It was here, amid the rough stony mountains and the rough, stoic
stonecutters who toiled there, that Ludovico's wife, Francesca di
Neri, gave birth to their first son in the predawn hours of a winter's
day. Ludovico, ever the precise functionary, diligently recorded:
"Note as today, the 6th of March 1474, there was born to me a male
child, and I have placed upon him the name of Michelagnolo. . . .
Note that the 6th of March 1474 is according to the Florentine calen-
dar, which counts from the Incarnation, and according to the Roman
calendar, which counts from the Nativity, it is 1475." Even at what
would normally be a time of elation for a new parent, Ludovico was
evidently still very much concerned with demonstrating his "noble"
Florentine roots.

Florence and Rome have always had two very divergent men-
talities, but it was especially so in the Middle Ages and during the
Renaissance. Back then, the Florentines based the year one of their
calendar on the Incarnation, when according to Church tradition
the Holy Spirit impregnated the Virgin Mary, thus uniting the di-
vine Jesus with the human Jesus in her womb. The Roman calendar,
however, was based on the Nativity, or the birth year of Jesus, just
as it is today. This is an apt metaphor for the two ways of thinking
in the time of Michelangelo: Renaissance Florence was a place of
inclusionary, humanistic philosophy (e.g., the union of the holy and
the carnal in the womb), whereas Rome was the center of exclusion-
ary, supremacist teaching (e.g., the *partum,* the baby being separated
from the womb). Even at birth, Michelangelo was already caught in
the middle between these two cities and their two mind-sets.

Ludovico does not even mention his wife, the boy's mother. It was obviously a difficult birth, as were most back then. The choice of the newborn's name is a clue. The archangel Michael was considered in the Catholic tradition to be the angel of healing and to hold the keys to life and death. Naming the baby Michelagnolo (the Florentine dialect for "Michelangelo") meant that the mother's health—indeed probably her life—was in question. What Ludovico probably did not know is that Jewish tradition teaches that Mikha-el ha-Malakh, the angel Michael, is the defender of the Jewish people from its deadly enemies. Michelangelo undoubtedly learned this later on in Florence, and, as we shall see, it had a deeply resounding effect on the rest of his long life.

Ludovico quickly turned the infant over to a wet nurse, a young village woman from a local family of stonecutters. Decades later, Michelangelo would joke with his friend and biographer, the artist Giorgio Vasari: "Giorgio, if I have any intelligence at all, it has come from being born in the pure air of your native Arezzo, and also because I took the hammer and chisels with which I carve my figures from my wet-nurse's milk."[1]

Michelangelo was raised with little affection from his family. His father was distant, and his sickly mother died when he was only six. Michelangelo would remain forever obsessed with the idea of family, without ever being emotionally close to his father, his stepmother, or his siblings. The only connection he felt with them stemmed from the stories he had heard of the family's supposed ancestral glory. For the rest of his life, he would spend his considerable earnings on restoring his family's lost fortune, properties, and social standing. This would put him into direct competition with his own father as the acting head of the family, and would be a constant source of friction between them.

According to Vasari, even the stars and planets had marked Michelangelo for a unique destiny. Vasari's opening of Michelangelo's biography sounds almost like the Gospel of John describing the birth of Jesus. Vasari depicts the Holy One gazing down from heaven

upon all the world's artists, poets, and architects laboring in error, and mercifully deciding to send down a spirit of truth, talent, and wisdom to show them the way. No wonder that in the sixteenth century, people talked and wrote about the "divine Michelangelo." The biographer points out that Michelangelo was born under the sign of Jupiter (i.e., a Pisces), with Mercury and Venus ascendant. There is also a Jewish oral tradition about the influence of the stars and planets. According to the Aggadah, the legends of the sages, one born on the second day of the week (Monday, when Michelangelo was born) will have a bad temper, since it was on the second day of creation that the waters were divided and division is a sign of disputation and animosity. It goes on to say that one born under Jupiter (named *Tzedek,* or "righteousness," in Hebrew) will be a *tzadkan,* a righteous seeker of justice, while Venus's influence imparts wealth and sensuality, and Mercury brings perception and wisdom. This is an accurate prediction of Michelangelo's life and career: he had a hot temper, would often stand up for the underdog, became wealthy and famous from his sensual portrayals of the nude (most often male) body, and showed a deep understanding of esoteric spiritual truths.

Two other vital traits help us understand the inner Michelangelo. He had both an extraordinary visual memory (today we would call it photographic recall) and a rock-solid emotional tenacity. This last characteristic made him a loyal friend, a passionate artist, and a long-suffering romantic. In Talmudic and Kabbalistic thinking, almost everything has a positive and a negative aspect. The ancient sages would often say, "On the one hand . . . on the other hand . . ." In Michelangelo's case, on the one hand, his unbreakable ties to cherished ideas, people, and images would make him an unparalleled artist and a lifelong seeker of Truth. On the other hand, the same unbreakable ties would make him a lonely, melancholy, obsessive neurotic.

At only thirteen years of age, Michelangelo was already in a war of wills with his father. Ludovico wanted him to learn grammar and accounting so that he could become a member and official of the Florence wool and silk guilds—not a high ambition in

life, but something respectable that the family could rely on. But Michelangelo's love of the visual had already led to a fixation on the stonecutter's craft, and he spent his time in the classroom sketching instead of doing his grammar and math exercises. Ludovico often punished and beat the boy but to no avail—little Michelagnolo could think of nothing other than becoming an artist. His disgusted father gave up and took him to Florence, to have him accepted as a fledgling apprentice in the *bottega,* or artists' workshop, of Domenico Ghirlandaio, who had already been part of the team that had frescoed the new Sistine Chapel for Pope Sixtus IV. Ludovico's only consolation was that his son would get twenty-four gold coins (florins) over his three-year apprenticeship, and that he himself received a small payment on the day he delivered his son to the *bottega.* It was a sort of paid servitude, but at least this boy who refused to learn a "useful profession" would bring a little bit of income into the family.

At thirteen, at an age when Jewish boys take on the religious responsibilities of an adult, the young Catholic Michelagnolo Buonarroti's childhood ended. For the next several years, he was contracted to grind colors, mix plaster and paints, fix brushes, haul ladders, and do whatever else his masters required of him. His family had cast him out for a few coins. However, to his great good fortune he was now in Florence. In fifteenth-century Europe, he had arrived in the exact center of the world of culture, art, and ideas. He was entering into the heart of the Renaissance. On the one hand, his journey had just begun. On the other hand, he was home.

Chapter Four

A VERY SPECIAL
EDUCATION

I am still learning.

— MICHELANGELO

T WO THOUSAND YEARS AGO, the ancient Romans came across a low-lying area north of Rome that was cradled between two rivers. The flowing streams blessed the surrounding land with such lush vegetation that they named the place Florentia, or "flowering." Long before Michelangelo's arrival there, the name had evolved into Firenze—what we today know in English as the city of Florence.

The flowing together of two rivers is described by a special word in English: *confluence.* According to the *Merriam-Webster Diction- ary,* confluence has two principal meanings:

1 : a coming or flowing together, meeting, or gathering at one point [a happy confluence of weather and scenery]

2 a : the flowing together of two or more streams b : the place of meeting of two streams c : the combined stream formed by conjunction

Both of these explanations aptly describe the uniqueness of medieval Florence. True, to be precise, the two rivers, the Mugnone and the much more famous Arno, do not quite meet inside Florence. However, in this one city, at one time, there flowed together so many great minds and talents that the combined streams of inspiration brought about the rebirth of Western civilization—the Renaissance.

Florence's historic center is so small that you can still stroll across its entire length—from Santa Maria Novella to Santa Croce—in about twenty minutes. Yet, the fortuitous coming together of so many extraordinary personalities and events in this tiny area brought forth a flowering of the arts, sciences, and philosophy that still influences our world to this day.

The totally unpredictable confluence of events that set the stage for this remarkable moment in history is a fascinating story. Strangely enough, a significant part of it had its roots in Rome.

THE EXILE OF THE PAPACY AND THE RETURN TO ROME

In 1304 Pope Benedict IV, according to reliable reports of the day, was poisoned by a platter of figs served to him by a beautiful young boy dressed as a girl. If true, the figs were probably sent by Charles II, the king of France, who had been trying for some time to take over the Catholic Church and thereby obtain unchallenged rule over all Christendom. What we know for certain is that the very next pope, Clement V, immediately moved the papal court to France. He set up his new palace in Avignon, where the papacy would have its headquarters for the next seventy-three years. This period is referred to by the Italians as the Vatican's "Babylonian exile."

The poet Dante Alighieri, furious at this perceived betrayal of Italy, placed Clement and other pro-French popes in hell in his epic poem *Inferno*. There he describes Clement as *"un pastor sanza legge"*—an illegitimate pastor—and his supporters as always ready to *"puttaneggiar coi regi"*—to prostitute themselves to earthly kings. In fact, Dante likens Pope Clement to Jason, the illegitimate ruler

of Israel, crowned by the pagan Seleucid enemies of the Jews, as described in the book of the Maccabees.

This period of the Avignon popes was one of the lowest points in the history of the Church, tarnished by horrendous scandals, violence, intrigues, and assassinations. Finally, in 1377 Pope Gregory XI brought the papacy back to Rome. Still, the French royalty tried to force the Church back to Avignon, continuing their political intrigues and poisonings and elections of French popes (called the antipopes by Rome) until the middle of the next century. In addition to these problems, plagues, and scandals, the growth of the Turkish Muslim Empire seriously threatened the future of the Vatican.

Renewed hope came with the papacy of Pope Sixtus IV della Rovere (1414–1484), the uncle of the future Pope Julius II, who started the rebuilding of Rome. Even though Sixtus's motives were to glorify himself and his family—and to make all his clan obscenely wealthy along the way—he was the first to begin a serious urban renewal of Rome since the fall of the empire about a thousand years before. From Sixtus onward, Rome would be considered the undisputed capital of the Catholic world.

It was during this period of frenetic construction that many treasures of ancient pagan Rome were accidentally rediscovered. Just from the excavations for new foundations in one area of Rome, two priceless statues were found: the *Belvedere Torso* and the *Belvedere Apollo,* both of which were destined to have an enormous impact on the young Michelangelo. By bringing lost works like these back to light, the rebuilding of Rome also brought back the Classical arts to the Western world. Soon, among the wealthy and powerful, there was a mania for anything of ancient Greco-Roman design. The next logical step was finding talents who could approximate the beauty of the original artworks, but within the rigorous confines of acceptable Christian thought.

THE FALL OF BYZANTIUM

The last vestige of the vast Roman Empire in the Middle Ages was Constantinople (today Istanbul, Turkey), founded by the emperor

Constantine. Constantine had proclaimed Christianity a state-sponsored religion in the year 313, when he reunited the empire and became the one unchallenged emperor. In spite of church legends, according to most Christian historians, Constantine himself never became completely Christian, remaining part pagan until being baptized against his wishes on his deathbed in 337 CE. Ironically, he chose to make the empire reflect his somewhat schizophrenic religious life. He permanently split it into the Christian West, ruled spiritually by Rome and the pope, and the pagan Orient (East), ruled politically and militarily from his new Christian capital city Constantinopolis (Constantinople), named for himself. Less than a century later, the barbarian hordes overran Rome in the horrific sack of 410. Rome never recovered from this trauma, but staggered along until its absolute end in September 476, when a young emperor was forced by a barbarian king to abdicate the throne. Through an ironic twist of fate, this very last emperor was called Romulus, after the founder of Rome. Thus the history of Rome came full circle after thirteen centuries.

Thankfully, in the Orient, Constantinople survived and kept the flame of Western civilization going, in spite of much infighting and political intrigue. The Eastern empire took the name Byzantium. In a reflection of its torturous history, when we today want to refer to deep corruption mixed with double- and triple-crossing political schemes, we use the adjective *byzantine*. (Not surprisingly, this word is also often used to describe the Vatican court during the time of Michelangelo.)

Strangely enough, it was the Church itself that dealt one of the worst blows to Christian Constantinople. The Western knights of the Fourth Crusade, under the direction of the autocratic Pope Innocent III, sacked the city and ripped it to shreds in the early thirteenth century, as part of the pope's plan for absolute world domination by the Vatican. Weakened by Rome, rotted on the inside by corruption, Byzantine Constantinople limped onward until the Turkish Muslim conquest of 1453. Again, history was playing tricks with the protagonists' names. The Muslim conqueror of Byzantium was Mohammed II, and its last Christian emperor was another Constantine.

The Turks' sacking of the doomed city lasted many days. The raping and butchering of the Christians so horrified the West that it is still a burning memory for many, even serving as a battle call in the twentieth and twenty-first centuries in parts of Eastern Europe. Every intellectual, scientist, and artist who could flee to the West did so, bringing with them many precious relics and artifacts and, most important, priceless texts and key ancient documents that represented the very best of Classical thought.

Two of these texts, thanks to many risks and even more bribes, made it out of the new Ottoman Islamic Empire and had a huge effect on the Renaissance and its art, including what we see today in the Sistine Chapel. One of these salvaged texts was the *Corpus Hermeticus,* the writings of the Egyptian mystic Hermes Trismegistus. The other was a collection of writings of the great Greek philosopher Plato. The man who paid a fortune for these texts and had them smuggled into Italy was one of the richest men in Europe, Cosimo de' Medici. His rise and the achievements of his family are the next thread in this historic tapestry of Florence in the time of Michelangelo.

ENTER THE DE' MEDICIS

On the one hand, it would seem that the de' Medici family had much in common with Michelangelo's family, the Buonarrotis. They were both very old Florentine clans, and although they had no real roots in nobility, both families liked to believe they did and actively pined for social acceptance on that exalted level. On the other hand, that is where the similarities end. Whereas the Buonarrotis were for the most part inept at business and finance, the de' Medicis quickly rose from wool dealers to moneylenders to the top bankers of their day—indeed, according to many, they were the richest family in all Europe. The founder of the family fortune was Cosimo the Elder. He also set the family on its path of unofficially ruling the city of Florence and of collecting and commissioning great works of art.

Michelangelo's family never learned how to navigate in high society, and—except for the artist himself—regarded the arts as a frivolous waste of time and money. It was Cosimo the Elder who discovered the great artists Donatello and Botticelli, sponsored the brilliant but eccentric architect Brunelleschi and his amazing dome for the

Detail from The Journey of the Magi, *by Benozzo Gozzoli, 1459 (Palazzo Medici-Riccardi, Florence). Cosimo is dressed in royal purple, riding humbly like Christ on a donkey, but with his "exotic" manservant and his bow of power by his side. While he firmly holds on to the reins of control, his entourage, including his two sons Lorenzo and Giuliano, their teachers, and several dignified Jewish figures, follow him. Se Fig. 6 in the insert.*

cathedral (still an engineering wonder after six centuries), and also paid for the two aforementioned ancient texts to reach Florence.

Cosimo took the young scholar Marsilio Ficino under his wing, entrusting him with translating both Hermes Trismegistus and Plato into Latin. Ficino not only did this under Cosimo's patronage, he also became a philosopher in his own right, founding in Florence his own version of the ancient Platonic Academy, otherwise known as the School of Athens—all of this under the patronage of the de' Medicis.

Cosimo accomplished one other important feat, almost entirely unknown today, but extremely controversial in his own time. It would have great significance for Florence, for the vigor of its intellectual climate and content, and eventually for the education of Michelangelo. Cosimo brought the Jews into Florence.

A CONFLUENCE OF CULTURES

Up until Cosimo de' Medici, the Republic of Florence had barred Jews from working or living there. The only exceptions were a handful of physicians and translators. The rich, Catholic money-lending families, such as the Strozzi and the Pazzi, kept the Jewish money changers and lenders out of town, not only because of religious prejudices but also for fear of competition. Since the Church frowned on usury among Roman Catholics, the Tuscan Christian banking families specialized in lending only to foreign royalty and international business concerns. This left the field wide open for Jews to lend to the common people and the poor. The Florentine upper crust had no interest in working with the "little people," but they did not want anyone else to do business with them, either.

In 1437 Cosimo took over the city—not by force, but by finance and strength of personality. He went along with the pretext that Florence was still a republic run by wealthy noble families and the great guilds (such as the wool merchants), but in reality he ruled the town as a sort of benign philosopher-king, much as Plato envisioned in his utopian book, entitled ironically enough *The Republic*.

By bringing in the Jews, Cosimo won the hearts of the common Florentines. They could now get loans like the "big shots," giving them the long dreamed of opportunity to pay off crushing debts, buy homes, start up or expand their businesses, or invest in the businesses of others. As for the Jews, from this point on, their fate in Florence would be forever linked to that of the de' Medici family. When, in two different eras, the de' Medicis were chased out of town by their enemies (supported by the Vatican), the Jews would leave with them. When the de' Medicis took back control of the city, the Jews moved right back in with them.

Besides easy financing for the common people, the Jews brought with them a much more enduring gift—their culture and esoteric wisdom. As much as Cosimo and Ficino and their intellectual circle were excited to be able to study Plato, they were absolutely ecstatic about obtaining access to a body of deep wisdom that long predated him. Not only that, but Jewish spiritual and esoteric knowledge could be learned from living representatives of that culture. This was far more stimulating and inspiring than translating texts from a long-dead society.

In no time at all, Jews could be found studying Plato and harmonizing his ideas with Judaism, just as Maimonides had done with Aristotle's concepts three centuries earlier. Catholic Florentines set about studying Hebrew, Torah, Talmud, Midrash, and—their favorite—the mystical Kabbalah. As Professor Roberto G. Salvadori recounts in his history of the Jews in Florence: "Recent studies have revealed what was hidden or unknown until a short time ago: the vivacity and variety of Jewish cultural manifestations in many Italian cities in the 15th and 16th centuries, which reached their apex in Florence. . . . The Florentine humanists—and particularly those gathered around the famous Platonic Academy—were strongly attracted to Judaism [and] to the Hebrew language as a vehicle of values that they considered extremely important."[1] Jews were sought after for private tutoring and for public debates, salons, parties, lectures, and intellectual retreats. The Dominicans in Florence and the Vatican in Rome were scandalized, and now had one more reason to want the whole de' Medici clan dead.

Jewish wisdom was even sought out by the great Christian paint-
ers and sculptors—in spite of the fact that Jews themselves, fol-
lowing the law of the Torah, did not create that kind of art. In a
recent prestigious series on art history, *Losapevi dell'arte: Simboli e
allegorie-prima parte,* it is stated in the Introduction: "The symbolic
images of the 15th and 16th Centuries were profoundly influenced
not only by ancient Greco-Roman myths, but also by the philosophy
of Plato and by the hermetic and esoteric traditions derived from the
Jewish Kabbalah."[2] This thrilling, fermenting brew of cultures and
ideas became a confluence of art, science, spiritual philosophy, and
liberated creative impulses that changed the world. Four centuries
later, in 1860, the great historian Jacob Burckhardt would name this
amazing period "The Renaissance."

LORENZO "THE MAGNIFICENT"

After Cosimo de' Medici died, his son Piero the Gouty did very little
except host great banquets of rich foods. Fortunately for the family's
future, Piero died only five years after Cosimo—of gout, naturally.
He left behind the family's international network of banks and other
businesses, all in a state of disorder. The family also had an array
of deadly enemies, such as the ancient and wealthy noble Floren-
tine clans of the Strozzi and the Pazzi, who had already attempted
in vain to assassinate Cosimo years before. The weight of all these
problems and responsibilities fell on the shoulders of Lorenzo, the
older of Piero's two sons.

Lorenzo was only about twenty years old at the time and would
have much preferred to party and write poetry, but he immediately
threw himself into the dual roles of family patriarch and unofficial
godfather of Florence. He made sure that his door was always open
to the common people, granting favors to all who came in friend-
ship. This was a political and security investment that would pay
off in the future. He continued in his grandfather Cosimo's tra-
dition of surrounding himself with great art and artists. Lorenzo

Lorenzo and the Artists of His Court, *by Ottavio Vannini, 1685 (Pitti Palace, Florence). Even though surrounded by the best and brightest teachers, philosophers, painters, engineers, and scientists, Lorenzo is only gazing at and indicating his favorite, the young Michelangelo, who is presenting him with the bust of a faun.*

had also recently married Clarice Orsini, from an ancient line of Roman nobility, thus raising the House of Medici several rungs on the social ladder and gaining political, commercial, and even military support from the upper class. The wedding, a sumptuous affair fit for a Roman emperor, reinforced the public perception of the de' Medicis as the "royal family" of Florence. The attractive, cultured, fashionable, and extremely charismatic young couple surrounded themselves with their modern, vivacious, sophisticated family and their "imperial court" of the best and brightest artists, thinkers, and writers in Europe. They gave Florence the feeling of a new golden age, comparable in many ways to the popular spirit in the United States five centuries later when the Kennedy family brought the feeling of "Camelot" to Washington.

Two groups in Florence, however, were not happy with the rise of the House of Medici. One was its old rivals, the Pazzi clan. The other was the fanatical Dominican monks who ran the Church of San Marco, only a few steps from the liberal, secular, fun-loving palace of the de' Medicis right in the center of town. Both groups were destined to cast a dark shadow on the lives of Lorenzo and his circle of family and friends.

In 1471 Lorenzo went on behalf of his family and Florence to pay tribute to the newly elected pope, none other than Sixtus IV, the founder of the Sistine Chapel. There, in the Apostolic Palace, Lorenzo was inspired not by the religious rituals but by the pope's outstanding collection of ancient pagan Roman sculpture pieces. The pontiff, seeking to impress the rich young "lord of Florence" even more, gave him two Roman statues, both broken but still incomparably beautiful.

When Lorenzo got home, following Ficino's suggestions, he founded an artists' *bottega* (workshop and studio) in the Garden of San Marco, right under the noses of the indignant Dominicans in the church and monastery next door. At its helm he placed an elderly sculptor-painter named Bertoldo di Giovanni, one of the last students of the great Donatello, from the time of Lorenzo's grandfather. In this garden, along with his own growing collection of ancient pieces, Lorenzo placed the two Roman statues given to him by Pope Sixtus. A few years later, these statues would help inspire an adolescent apprentice named Michelagnolo Buonarroti.

This sculpture *bottega,* otherwise known as the Garden of San Marco, soon became part of the popular image of Lorenzo, whom the Florentines called *Il Magnifico,* the Magnificent. This honorific had nothing to do with divinity or political power, but rather was a Tuscan variant on "munificent," denoting one who knew how to spend his money well, a great philanthropist or great patron of the arts. Soon, the *bottega* became a vital destination for artists, philosophers, poets, and scientists—in short, a hotbed of liberal, intellectual activity. The greatest minds were known to frequent the garden, often giving lectures there—and almost none of it having to do with

sculpture. Today, there is a heated debate among many Renaissance historians about the nature of the sculpture Garden of San Marco: was it just a workshop for teaching stone carving—or was it a secret, subversive school for studying works that were being devalued or suppressed by Rome, such as Plato (as opposed to the Church-approved Aristotle) and Judaic wisdom and mysticism? In a recent book, Ross King refers to Lorenzo de' Medici's garden *bottega* as one in which he trained his handpicked artists in "both sculpture and the liberal arts."[3] The fact that they were learning anything liberal under the nose of the Inquisition is proof enough that the true nature of the school had to remain a secret. As the French minister of culture Jack Lang has written, the de' Medici influence on Florence was indeed a "cultural revolution."[4]

Camelots never last long, however, and Lorenzo's bright dream of an Athens-on-the-Arno took a dark turn in 1476 when Pope Sixtus, seeking to destroy the de' Medici family, took away its contract with the Vatican for alum (a huge income, since in that era alum was a key ingredient in paper production, leather tanning, and fabric dyeing). The pope then gave the lucrative contract to the de' Medicis' deadly rivals, the Pazzi clan. In 1478 the aforementioned assassination plot by Sixtus (commonly and misleadingly called the Pazzi Conspiracy) resulted in Lorenzo's beloved younger brother, Giuliano, being slain before his eyes. Ten years after that, Lorenzo's wife, Clarice, died, leaving him to care for their adolescent and teen-aged children. Lorenzo threw himself into repairing the family's finances, international network, and morale. He invested more than ever in great art, both collecting ancient masterpieces and providing for the creation of new ones.

In 1489 he discovered a young apprentice who was working under Ghirlandaio. It seemed that this mere boy from the mountains could carve stone better than any adult. Realizing that there was a potential prodigy to be molded and instructed, Lorenzo took the rebellious lad off of Ghirlandaio's hands. There is a story that the first piece that Michelangelo sculpted for Lorenzo was the head of an aged, grinning faun, a mythological forest spirit. Lorenzo was

astonished at the mature mastery of the work but happened to mention in passing that the faun, being so old, would probably not have all his teeth. As soon as Lorenzo had left, Michelangelo immediately chiseled out a tooth and even drilled a hole in the marble gum of the faun, making the bust seem even more perfectly real. When Lorenzo saw what he had done, Il Magnifico laughed and proudly showed the grinning faun to his family and friends. He took a great personal liking to the boy and instead of having him lodge in crowded students' rooms, he informally adopted the uncouth lad and brought him to live in the grand de' Medici palace. Thus, Michelangelo, at the age of about thirteen or fourteen, suddenly found himself being raised with the richest offspring in Europe, taking all his meals with them and studying with the best private tutors in Italy. This would always be the happiest time in his very long life—and change his way of viewing God, religion, and art forever. It would also have a profound effect on the messages Michelangelo would eventually impart in his masterwork on the ceiling of the Sistine Chapel.

THE *FORMAZIONE* OF MICHELANGELO

In Italian, the word for education is *formazione,* in the sense of "shaping, molding, forming" a young mind. It is a perfect word to describe the training of the young genius in the care of Lorenzo. Michelangelo's experiences in Florence in his early teens would indeed shape his talent and mold his thinking for the rest of his long life and career. Through his artistic apprenticeships, his privileged private tutoring in the palace, his encounters with the greatest geniuses of his day, and his extraordinary daily life as part of the court of Lorenzo the Magnificent, he underwent an incredibly broad *formazione* that was not only unique for the fifteenth century but would be so even in our own time. It would be this wide range of cultural sources and references that he drew on when painting the Sistine Chapel. Its amazingly all-encompassing scope may well be one of the reasons that it has taken us all of five centuries to figure out what he was really saying in his magnificent frescoes.

Ghirlandaio was Michelangelo's first *maestro,* or master teacher. Even though Michelangelo would say years later that the great painter had taught him nothing, we can easily assume that at least he taught the boy the basics of making and mixing paints, of color and composition, and of the great development of fifteenth-century Florentine artwork—perspective. It is interesting to note, however, that we cannot find any "Michelangelesque" contributions in the frescoes that Ghirlandaio painted at that time. Once Michelangelo was transferred to the Garden of San Marco, Bertoldo did instruct him in some of the basics of the art of sculpture, but the prodigy surpassed his master in no time at all. Young Buonarroti really took his lessons from the great masters of the past, whose works could be seen and studied all over Florence: the frescoes of Fra Angelico and Masaccio, the sculptures of Donatello, the architecture of Brunelleschi and Alberti. Above all, he fell in love with pagan Greco-Roman art and design. He loved it for its simplicity, its kinetic quality, and its celebration of the muscular male nude. Between the sculptures in the garden and in the Palazzo de' Medici, and the masterpieces all over town, Michelangelo's voracious curiosity and photographic memory were exercised to their peak, and would serve him well to the end of his days.

Combined with his artistic development, Michelangelo's liberal arts education moved ahead at a prodigious pace. In the Florentine Republic in the fifteenth century, a well-rounded education was considered vital for every young man. A generation before Michelangelo, the ultimate example of the Florentine "Renaissance man" was the architect-painter-writer-athlete-musician-lawyer Leon Battista Alberti (1404–1472). Alberti wrote: "The artist in this social context must not be a simple artisan, but rather an intellectual prepared in all disciplines and all fields." Lorenzo firmly believed in this, and wanted his young sculpture prodigy to have the very best *formazione* that money could buy. Lorenzo's children had been tutored from an early age by the great humanist poet and classicist Angelo Ambrogini of Montepulciano, better known as Poliziano. Poliziano had been orphaned at a tender age and brought to Florence, where he was taken in and cared for by the de' Medici family. He remained deeply

attached to the entire family and stayed with them most of his life. However, his most passionate devotion was to Lorenzo, as evidenced in Botticelli's *Adoration of the Magi,* in which Lorenzo's entire court views the manger scene. Poliziano is virtually draped over Lorenzo, in what most art books describe as a sign of "great friendship."

Poliziano was famous in his time as an elegant poet in Latin, but also as the supreme expert in Ancient Greek. He claimed to be as fluent in the language as Aristotle and Socrates, and contemporary reports seem to prove that this was no empty boast. These talents made the young scholar a perfect choice to teach the de' Medici offspring the classics, an indispensable part of the education of any gentleman or lady of the period. Some art historians think

Adoration of the Magi, by Sandro Botticelli, 1476–77 (Uffizi Galleries, Florence). In the lower left corner, we see the proud Lorenzo being embraced by Poliziano, while Pico della Mirandola speaks to them both. In the opposite corner, gazing out at us, is Botticelli himself.

that Poliziano must have been Michelangelo's main tutor as well; however, by the time the teenaged Buonarroti moved into the palace, Lorenzo's children were also teenagers and had been studying privately with Poliziano since 1475. When Michelangelo arrived in 1489, they were ready to move on to other teachers in other disciplines. Even though Poliziano would suggest some reading and artistic sources to him, Michelangelo showed little or no interest in Greek or Latin linguistic studies, while being greatly drawn to philosophy and spiritual subjects taught by others. This would explain why Michelangelo's Latin was never up to par, and why he wrote his poems only in Tuscan Italian. In fact, he studied Dante only while in hiding many years later.

MICHELANGELO'S TWO MASTER TUTORS

Far more influential in Michelangelo's *formazione* than Poliziano were two remarkable scholars commonly acknowledged as the greatest masters of philosophy in Florence: Marsilio Ficino and the childhood prodigy Count Giovanni Pico della Mirandola. The combined influence of these two teachers is clearly evident in much of Michelangelo's life work.

Ficino's translations, his teachings on Plato and Neoplatonism, and his Platonic Academy were already well known and esteemed throughout Europe by the time Michelangelo became his student. From Ficino, Michelangelo absorbed the daring ideas of this philosophic school of thought. But, as we will see, it was young Pico della Mirandola who played the most significant role in Michelangelo's development. Pico was the charismatic architect of an intellectual and theological bridge between ancient mysticism, Greek philosophy, Judaism, and Christianity. He inspired freethinkers everywhere, enraged the Vatican, and deeply affected the passionate, impressionable Michelangelo. In fact, two decades later, Michelangelo would secretly turn the ceiling of the Sistine into a permanent testimony to Pico's unique—and heretical—teachings.

The first of these master tutors, Marsilio Ficino, was the son of Cosimo de' Medici's doctor. After Cosimo came into possession of the ancient writings of Plato and Hermes Trismegistus, he learned that the twenty-year-old Marsilio showed brilliant promise at translation. Since he already had the scholar's father on retainer as his private physician, it was not difficult to put the son on the family payroll as well. Marsilio's Greek and Latin studies were subsidized by Cosimo, who also paid for the foundation of a Platonic Academy, under Ficino's direction. Cosimo, ever sensitive about his nonpatrician roots, wanted to be perceived as the new Solon, leading Florence into a world-famous golden age.

Ficino set up his "School of Athens" in the de' Medici palace, in the family's country villa, and in the Garden of San Marco. Thanks to his growing reputation as the leading expert on Plato—plus the de' Medici name and patronage—he was quickly able to attract a circle of intellectuals, artists, philosophers, teachers, and freethinkers. Soon he was engaged in a flood of intellectual correspondence with great minds all over Europe. Cosimo was happy, as this brought him more fame worldwide than any possible business transaction could do.

After Sixtus IV's ascent to the papal throne, Ficino became a priest. It is said that he took the vows as a result of recovering from a severe illness. More likely, it was at the de' Medici family's suggestion, as he could then be a useful link to any maneuvers going on in the papal court. At the same time, Marsilio was developing his own system of philosophy, based on Platonism, Neoplatonism, and humanism.

While it is clearly impossible in these pages to do justice to this school of thought, we can at the very least highlight some of its key points, especially as they will help in understanding Michelangelo's Sistine frescoes. In essence, Ficino's philosophy elevated the liberal arts, pure scientific research, and the centrality of the individual and his or her immortal soul's redemption through beauty and love. It taught that there are absolute concepts that exist outside of human variations and distortions, among them the concepts of Absolute Good, Absolute Love, and Absolute Beauty.

This is almost certainly what Michelangelo had in mind when in later life he explained, "In every block of marble I see a statue as plain as though it stood before me, shaped and perfect in attitude and in action. I have only to hew away the rough walls that imprison the lovely apparition to reveal it to the other eyes as mine see it."[5] For Michelangelo, imbued with this Platonic mind-set, art was not creating as much as it was uncovering hidden preexistent absolute beauty. "I saw the angel in the marble," he said, "and I carved until I set him free."[6]

Neoplatonists also believed that the vast variety of human thought, if traced back to the One Source—what Leonardo da Vinci called the Prime Mover—would lead to spiritual enlightenment and ultimately to God. This and the mystical texts that Ficino was translating led him to attempt a fusion of all mystical beliefs, from Greek gnosticism to Egyptian hermeneutics to Christian cosmology—and to Jewish Kabbalah.

One of Ficino's influences was a well-known work called *Fons Vitae* (Fountain of life), one of the first European Neoplatonic texts, by an eleventh-century philosopher from Spain named Avicebron. Little did Ficino know that this was a translation of the Arabic translation of an original Hebrew text written by the great Jewish poet-philosopher Solomon Ibn Gavirol (died c. 1058). The idea of harmonizing monotheism with Platonic thought gripped Ficino and led him to attempt the construction of a universal faith, by which all humanity could achieve individual redemption. Of course, now that Jews had just been permitted to settle in Florence, he longed to work Judaic thought into his master plan of the universe. Ficino did study Hebrew with Jews like Elijah del Medigo and Jochanan ben Yitzchak Alemanno, but it seems his talent for Greek and Latin did not help him in this case. In his writings, he is limited to some (sometimes faulty) quotes from the Hebrew Scriptures and great commentators such as Rashi, Maimonides, Gersonides, and Sa'adia Ha-Gaon.

Ficino did, however, pick up the Judaic idea of the sacredness of human love and its capacity to lead to greater closeness to the Divine. The Hebrew Bible, speaking of the first sexual encounter

between Adam and Eve, says that "Adam *knew*" his mate. Remark-ably, the Hebrew word *l-da'at,* "to know," means also to love or to make love. Sex, on the deepest level, transcends the physical and con-notes spiritual union. A seemingly carnal act is invested with dignity and sanctity. The ideal of lovemaking is true intimacy—not merely of intertwining bodies but of mutually understanding souls. To be intimate on this level is to "know" the other person's essence—his or her divine image—which is but another way of gaining greater kin-ship with God. Viewed in this light, lovemaking is meant not just for the single objective of procreation, as the Church then taught, but also to foster this ultimate sense of knowing. As the Kabbalah daringly puts it, when a couple "know" each other in a complete sexual-romantic-spiritual act, they actually unite heaven as well.

Ficino preached this concept to his circle as "Platonic love," a love that is not only body-to-body but also soul-to-soul. It was only later in history that "platonic" love came to mean a deep relationship de-void of sexual content. Since Ficino's Neoplatonism emphasized the centrality of Man and appreciation of his beauty, it was only natu-ral that his academy was very popular with men who loved other men. Back then, there was no concept of homosexuality, just the Church's emphasis on procreation and its condemnation of what it called "sodomy," the performance of anal sex, especially (but not ex-clusively) between two males. The categories of heterosexual and ho-mosexual were only established—in fact, the words were coined—in Germany in the late nineteenth century.

Still, Rome was horrified by all this. The Vatican had "Chris-tianized" the teachings of Aristotle, and not Plato. It preached that redemption could come only through the One Church. These Flor-entine ideas about the individual, about Art and Science, about universality, and about Greek and Jewish love were anathema and blasphemy ... but they all resonated deeply in the mind of Michelangelo. At last he had found a philosophy that would vali-date his feelings about beauty, about art—and about the sacredness of sex and the perfection of the human body, especially of the men whose physical form so appealed to him.

The Church, however, soon found itself far more concerned with the views of Michelangelo's other teacher. Count Giovanni Pico della Mirandola was as much a child prodigy as Michelangelo. In addition to being blessed with great genius, a gift for languages, and an insatiable curiosity, Pico was the scion of a wealthy family of princes; in other words, he was what we would today call a trust-fund baby. By the age of thirteen or fourteen, he was already studying canon law in Bologna, then moving on to the other great learning centers in Ferrara, Padua, and Pavia. In 1484, at only twenty-one years of age, he ended up in Florence to join the circle already led by Poliziano, Ficino, and Lorenzo de' Medici himself.

At that time, Ficino was promoting the study of his beloved Plato by trying to discredit the philosophies of Aristotle and Averroes. Pico, building on Ficino's concept of universalizing faith, tried to harmonize them instead. Pico also wanted to include and emphasize in the mix his own favorite stream of thought—Judaic wisdom and mysticism. With his family's money, he spent his short life paying for the best Jewish minds in Italy to tutor him in Hebrew and Aramaic and to help him navigate the sea of Jewish wisdom in the Torah, the Talmud, the Midrash, and the Kabbalah. His Jewish teachers and intimate friends included great thinkers and writers like Elijah del Medigo, Jochanan Alemanno, and the mysterious Rabbi Abraham, among others. Pico, unlike Poliziano or Ficino, became quite fluent in these languages and deeply knowledgeable in Judaism. His writings and teachings are permeated with Jewish thought. One example is his *Heptalus,* in which he narrates the biblical story of creation by way of a full Kabbalistic interpretation.

Young Michelangelo, with a mind thirsting for new knowledge and eyes eager to behold all the beauty to be found, was completely immersed in this exciting, dizzying world of liberal thought and high-flying discussions. It was all the more thrilling for other reasons. He had come from a cold, unaffectionate family with no use for artistic or intellectual pursuits, and here he was being embraced by the most sophisticated court in Europe. He was also just starting to get in touch with his romantic and physical attraction to other

men. Whether this resulted from his having a distant father and a mother who died young, or whether it was simply his innate nature, we will never know. What we do know is that he was in the city and the social circles where one man's love for another was common and accepted by almost everyone—except the Church. In fact, male-to-male love and sex were so common there that they were referred to in the rest of Italy as "that Florentine tendency." We also know that many of the men associated with Lorenzo's Platonic Academy and Garden of San Marco were lovers of men. Poliziano, Ficino, and Pico all fit into this category. In 1494 Poliziano and Pico died within weeks of each other from a mysterious illness. Judging from their symptoms, it is quite likely that they were two of the first victims when the first wave of syphilis struck Florence in that year. We do know for certain that Pico della Mirandola was buried in a double grave, as married couples were, with his longtime companion, the poet Girolamo Benivieni. Their tomb is inside the Church of San Marco, where no doubt the fanatical Dominican monks of the time are busy spinning in their graves.

Another reason that this intellectual confluence must have been so exciting to the teenaged Michelangelo was its "sinful" aspect. The Holy Inquisition was actively trying to eradicate Jewish knowledge like the Talmud and the Kabbalistic book of the Zohar, the very books his teachers were imparting to him. Also, Rome was actively trying to separate Jews and Christians while Florence was trying to unite them. In 1487, only a year or so before Michelangelo arrived in Lorenzo's court, Pico della Mirandola amassed more than nine hundred theses that he had composed to prove that Egyptian mysticism, Platonic philosophy, and Judaism all led to the same deity worshiped by the Catholic Church. He offered to sponsor out of his own pocket an international conference to be held at the Vatican to discuss and celebrate this new universality and harmony between the faiths. The Vatican, upon reading his writings, immediately declared them blasphemous and ordered him arrested for heresy. Pico was forced to recant his ideas, but soon after denied his retraction and had to flee to France. The long arm of the Vatican had him

arrested there, and it was only through Lorenzo's deep pockets and international connections that Pico was released and spirited back to Florence, where he gratefully remained inside the protection of the de' Medici palace for the rest of his brief life.

This heady whirl of art, love, and forbidden fruit made an indelible impact on young Michelangelo, who would remain passionately influenced by these teachings for the rest of his life and career. We will see how much it permeates almost all his artwork—and reaches its peak in the frescoes of the Sistine Chapel.

WHAT EXACTLY DID MICHELANGELO LEARN?

Normally, a young Florentine's *formazione* would start with Italian grammar, Latin, sometimes Greek, and the poetry of Virgil and Dante. There would be Greco-Roman mythology, some of it based on Ovid's *Metamorphoses,* some of it transmitted orally. Also in the oral tradition would be the stories of the Christian saints and the teachings of the Church. The Jewish stories from what the Church called the Old Testament would be recounted, but only as a proof of the validity of the New Testament. For young men from the upper classes, especially the nobility, there would be instruction in swordsmanship, equestrian skills, music, elocution, and dance—in short, all the proper grooming for war, high society, and future leadership.

Also extremely popular in this preparation was the ethical instruction of the ancient Greek text of Pseudo-Phocylides. This primer in morality is an epic poem of about 250 verses and aphorisms, which most scholars today define as the outreach teachings of a Jew in the Hellenistic period. The anonymous Jewish poet, pretending to be a well-respected Greek philosopher, uses thinly disguised quotes from the Hebrew prophets and the Torah to woo the pagan gentiles away from their way of life, and to observe the Seven Basic Commandments of Noah—the universal covenant of law preceding the giving of the Torah to the Jews on Mount Sinai. To avoid revealing his identity as

a Jew, he does not blatantly condemn idol worship per se, only the be-
havior and society around it. By the time of Pico and Michelangelo,
this cunning forgery had long been accepted and passed along as an
authentic ancient Greek work, and was woven into another, simi-
lar forgery, the so-called *Sibyllines,* supposed to be the twelve books
of the mysterious female seers of the Classical world. In this way,
the impressionable young apprentice was taught that ethical behav-
ior came from yet another confluence, the teachings of the Jewish
prophets and the pagan sibyls, all mixed together. This would show
up years later—on the ceiling of the Sistine Chapel.

Making Michelangelo's education unique were the lessons he was
taught by Ficino and Pico. Daring, innovative, philo-Semitic, often
branded heretical, they would explain why, when allowed to design
an artwork of his own choosing, Michelangelo would often select a
Jewish theme rather than the standard Christian and mythological
images of the day. It also explains why, when commissioned by the
pope to create works of art as homage to Jesus and the Church—in-
cluding the Sistine Chapel—Michelangelo would brilliantly hide
inside these works antipapal messages more in keeping with his true
universalistic feelings.

THE JEWISH INFLUENCES: MIDRASH, TALMUD, AND KABBALAH

Because Ficino and, more particularly, Pico were powerfully inspired
by Jewish thought and transmitted it to their prize student, we need
to clarify the areas of that thought that most affected Michelangelo
and much of his later artwork.

First, we should mention the Midrash. Not the name of one book,
it rather refers to many collections of stories, legends, and biblical
commentaries from the hands of different scholars at about the be-
ginning of the common era (i.e., after the year one in the common
calendar). According to Jewish tradition, these are part of an oral
tradition of transmitted knowledge going back many centuries,

some even from the time of Moses. Unlike the Talmud, Midrash is more interested in theology than law, in concepts rather than commandments. It has been well said that the Talmud speaks to humanity's mind but the Midrash is directed to its soul.

We know that Michelangelo studied Midrash with his masters because so many of its insights appear in his depictions of biblical scenes. An excellent example is the panel in the Sistine ceiling known as *The Garden of Eden*. There we find Adam and Eve standing before the Tree of Knowledge. Throughout the Middle Ages, in every cultural tradition but one, the fruit of that tree was thought to be an apple. Indeed, the Latin word for apple reflected its infamous past—*male,* which means evil. (In modern Italian the vowels have been reversed, and we now call it *mela*.) In the fourth century CE, the word *malum* appeared in the Latin Vulgate translation of Genesis in the phrase "the tree of knowledge of good and evil," formally codifying the association between the apple and the forbidden fruit. There was only one exception to this commonly held belief: the Jewish tradition. According to a mystical principle, God never presents us with a problem unless he has already created its solution within the problem itself. When Adam and Eve sin by eating the forbidden fruit, they are stricken with shame from their new awareness of their nudity. The Bible tells us that their immediate solution was to cover themselves with fig leaves. According to the Midrash, the Tree of Knowledge was a fig tree, since a compassionate God had provided a cure for the consequence of their sin within the self-same object that caused it. It is hard to imagine any Christian being aware of this, either in Michelangelo's era or even today. Only someone who had studied the Midrash could have known such a thing. Yet, sure enough, there in the panel of *Original Sin,* Michelangelo's forbidden Tree of Knowledge is *a fig tree.*

When we tour the Sistine in the upcoming chapters, only a strong familiarity with this body of Jewish knowledge will permit us to grasp the countless Midrashic allusions that Michelangelo worked into his frescoes—something unfortunately almost completely unknown and ignored by contemporary scholars.

Pico, as indicated by his library, also greatly admired the Talmud, a vast compendium of Jewish law and commentary composed over a five-hundred-year period beginning roughly at the time of Jesus. What sets this work apart from almost all other books of the time is its unique system of thought, what is even today referred to as "Talmudic logic." It conditions us to see the universe and to think in a multilayered way, as opposed to the Church's uncritical, linear, and unanalytical approach. Its predominant theme is to question. It links reason to faith. It values logic as a prime good and allows for the legitimacy of conflicting opinions. It also places great stress on the ability to harmonize seeming opposites. These were hardly ideals for the Church, which therefore sought to suppress it. But Michelangelo, while not able to study the Talmud in depth, learned from his teachers to incorporate at least some of its values into his outlook and its multiple levels of meaning into his artwork.

The Judaic study that had the greatest impact on Michelangelo was the one for which Pico is perhaps best remembered. Pico had the largest Judaic library of any gentile in Europe, and—more striking still—holds the record for the biggest private library of Kabbalistic materials gathered in one place anywhere. Kabbalah was Pico's passion. In fact, his dedication to this branch of Jewish knowledge may well explain his very positive feelings toward Jews and Judaism.

Kabbalah, comprising the esoteric and mystical tradition of Judaism, is supposed to have its origin in the secrets the angels dared to transmit to Adam. *Kabbalah* is a Hebrew word that literally means "received." Because its teachings are extremely complex and deal with subjects not everyone is capable of handling, it is ideally taught only to those mature enough to "receive" its hidden knowledge, by way of a master to a select chosen disciple. But the Zohar, which first appeared in Spain in the thirteenth century published by a Jewish writer named Moses de Leon—ostensibly as a manuscript he found dating back to the Talmudic era—and other Kabbalistic works were available for study, and Pico took full advantage.

What fascinated Pico so? And what was it in Kabbalah that captivated Michelangelo to the extent that almost every part of the Sistine

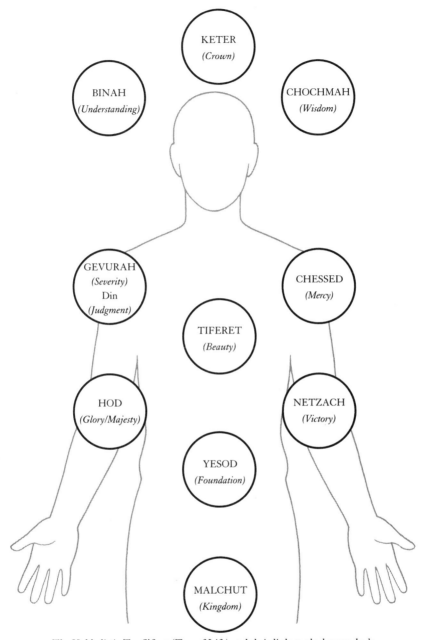

The Kabbalistic Ten S'firot (Tree of Life) and their links to the human body

ceiling bears traces of its teachings? We can only hint at some of the answers.

Surely part of the answer lies in the major premise of Kabbalah that beneath the surface of every object are hidden "emanations" of God. Things are far more than they seem to the naked eye. What a provocative concept for an artist—especially one whose credo was "Every block of stone has a statue inside of it and it is the task of the sculptor to discover it." These emanations of the Divine, known as the Ten S'firot (ten communications), represent the "series of intermediate stages" that make the creation of the finite world possible—almost like the steps necessary for an artist to bring his ideas to life. Moreover, these Ten S'firot, representing all of God's attributes, have a direct correspondence with the physical body of a person. God is imminent in the corporeal; the body has sparks of the Divine. And that of course makes even the nudes that preoccupied Michelangelo holy.

Kabbalah allowed its students, as we've already noted, to think positively about sex. It also provided for a totally different way of viewing male/female distinctions. Both are equal parts of divinity because *God himself/herself is a perfect blending of both characteristics—God is man and woman.*

Harmonizing these two seemingly disparate aspects is a Kabbalistic concept that finds expression not only in God's sexuality but in almost every other aspect of life. What we today call the positive and negative forces of atoms was a secret long known by Kabbalists, although they used different language. Harmonizing opposites, balancing extremes, grasping the power of the hidden inner essence of objects certainly could have strong appeal not only to the religious mind of old but to the artistic—and even the scientific—minds of all times.

Not to be ignored in this list is Kabbalah's fascination with numbers and the Hebrew alphabet. The Hebrew letters have both a numerical and a spiritual value. According to Kabbalah, God created the universe with the twenty-two letters of the Hebrew alphabet. Numbers are also connected to specific ideas. Just as we have seen

the number seven conveying a host of interconnected concepts, every other number has its message and its link to a mental category. Understanding this will allow us to recognize why Michelangelo used exactly the number of prophets he chose for the ceiling, as well as other significant objects—and why he even hid Hebrew letters up there.

Perhaps most powerful of all, Michelangelo's immersion in Kabbalistic study gave him the key to how he could accept the pope's mandate to beautify the Sistine Chapel although he strongly disagreed with much of the Church's thinking at that time: truths, Michelangelo realized, could be conveyed by way of the covert approach of Kabbalah, making the hidden message underneath more important than the images on the surface.

Still, the young artist had much more *formazione* to shape him on his life's journey before the Prime Mover would lead him to his destiny inside the Sistine . . .

Chapter Five

OUT OF THE GARDEN AND INTO THE WORLD

It is well with me only when I have a chisel in my hand.

— MICHELANGELO

BEYOND HIS FORMAL STUDIES, Michelangelo could not avoid that other *formazione:* harsh experiences and encounters with the real world, commonly referred to as the school of hard knocks. Indeed, a very early lesson he learned was a literal hard knock that stayed with him for the rest of his life.

When he arrived in the Garden of San Marco to study under Bertoldo, Michelangelo found another student already there, also selected to pursue a career in sculpture. The other youth was Pietro Torrigiano. Pietro was everything that Michelangelo was not: from a true noble family, well-off financially, and extremely handsome. Michelangelo, however, had the superior talent. Both boys had hot artistic temperaments and egos; in other words, a dispute was just waiting to happen.

The fateful fight occurred a short time after the arrival of Michelangelo. Both students were in the chapel of Santa Maria del Carmine, sketching the artwork there, when apparently Michelangelo made fun of Pietro's drawings. The infuriated Torrigiano hauled off and gave Michelangelo a punch so intense that it crushed the bone and cartilage of his nose. For the rest of his life, while creating so much beauty, Michelangelo himself would look like a retired boxer with a flattened nose. Lorenzo de' Medici was so distraught about the ruination of his young favorite's face that he immediately exiled Torrigiano from Florence.

Buonarroti, who even before this had not been especially good-looking, felt terribly ugly from then on. He overcompensated by throwing himself into his work and career, often shying away from romantic possibilities as a defense against heartbreak. He became more and more of a perfectionist and an egotist. Psychologists have

Statue of Michelangelo outside the Uffizi, Florence. Note the crushed nose and embarrassed expression.

a term for this behavior. They call it *grandiosity,* covering up deep feelings of inadequacy with arrogant or overbearing behavior. Unfortunately, for the rest of his life only a few beloved friends and companions would be able to see through this façade of grandiosity to get close to the lonely, sensitive, love-starved dreamer beneath.

FIRST SIGNS OF GENIUS

As we have seen, a great deal is known about Michelangelo's intellectual growth at this time under the tutelage of Ficino and Pico della Mirandola. Oddly enough, though, we have very little information about any artistic technique he was learning from Bertoldo. Even Professor Howard Hibbard, one of Michelangelo's noted biographers, admitted: "We still do not know how he learned to carve marble."[1]

The first examples that we do have are a Madonna nursing a very muscular baby Jesus, and a battle of the centaurs, both from when Michelangelo was between fifteen and seventeen years old. These clearly demonstrate how the young sculptor, from the very beginning of his career, was caught between the market for Christian art and his personal love for classicism and the male body.

The Madonna, called *Madonna della Scala* (*Madonna of the Stairs*), is loosely but clearly inspired by an earlier work of Donatello that Michelangelo had been studying in Florence. Even this very first work (from 1490) is mysterious and has been the subject of many varying interpretations down through the centuries. Maria (Mary) is nursing the infant Jesus next to a stairway of five steps, upon which three little boys, perhaps angels, are playing. Maria, while in profile in the foreground, seems to be staring almost eye to eye with one angel leaning on the railing in the middle ground. At the top of the stairs, the other two childlike figures are blurred in the background and appear to be either embracing or wrestling; a fourth is almost hidden behind Maria, pulling on a cloth. Amazingly, Michelangelo at fifteen was making solid marble seem like a modern photograph

Madonna della Scala, *by Michelangelo, 1490s (Casa Buonarroti, Florence)*

with extremely differentiated depth-of-field focus: the foreground is crystal-clear while the figures in the background are actually blurry.

To explain Michelangelo's depiction of precisely five steps, some art historians have linked the number to the five letters of the name Maria, since certain arcane medieval and Renaissance theologians called the Virgin "The Stairway," representing the link between heaven and earth. This seems to be a bit of a stretch, though; considering his unique education, it is quite possible that Michelangelo had something else in mind. Under the influence of his teacher, Michelangelo was aware of a far more profound significance to the number five. Marsilio Ficino often taught about the five levels of the human soul as a central part of his Neoplatonic philosophy. This is based on the Kabbalistic concept of the five levels of the soul: *nefesh, ruach, neshamah, chayah,* and *yechidah.* These are, respectively, the basic material life force, the emotional soul, the human soul, the

spiritual or God-seeking soul, and the transcendent unifying soul that is integrated with God and the wholeness of the universe. For a Neoplatonist and Kabbalist like Michelangelo, this set of five would be the most fundamental series in the soul's quest for union with the Divine—a sort of stairway to God. Wouldn't this more logically be what Michelangelo was trying to convey? The Talmud teaches that King David's character and spirituality were infused in him through his mother's milk. The sculptor himself said that his uncanny skill with marble came to him through his wet nurse's milk. Is Michelangelo perhaps also suggesting that the Madonna, while yet nursing her baby, foresees that her child's destiny is to transcend all five stages of the human soul? In this, one of his earliest pieces, is Michelangelo already achieving Neoplatonic harmony—linking Greco-Roman design with Jewish mysticism in a Christian artwork? The only thing that we know for sure is that this talented teenaged artist was already experimenting with groundbreaking sculpting techniques and very sophisticated, ambiguous, and *multilayered* art themes.

About a year later, instead of drawing inspiration from a Christian Renaissance sculpture, he based his work on an ancient pagan Roman sarcophagus. This time, his theme was clearly mythological: the battle of the centaurs, the legendary creatures with a human upper form and the lower body of a horse. Even though limited to a small, thin piece of marble, Michelangelo managed to create an amazingly intricate mass of struggling bodies that seem to fade back into infinity.

In this work, we can find even more hints of what he would eventually do inside the Sistine. First and foremost, there is his love for the male body, very muscular and always nude, in a variety of positions. In fact, he is so enamored of his nude male studies that he depicts only one token part of a horse at the bottom to suggest the idea of centaurs, and then carves the rest consisting entirely of naked men. There is only one female form in this large tangle of flesh. She is Hippodameia, the pagan princess kidnapped by the drunken, bestial centaurs, and, in the legend, the cause of all this bloodshed.

Battle of the Centaurs,
*by Michelangelo, 1490s
(Casa Buonarroti,
Florence)*

Since Michelangelo had no female models, and also showed no great interest in the female body, he portrays the princess only from the back; unless you are purposefully looking for her in the sculpture, you would assume that this piece was composed exclusively of male nudes. It is strange but true—this consummate artist would never master depicting the female body, as we will see later in the Sistine frescoes.

Most important in the *Battle of the Centaurs* is its underlying theme, which will resonate more powerfully in Michelangelo's later work—and especially in the Sistine. It captures the essence of a mystical Jewish concept: the struggle of the animalistic, amoral soul against the human, spiritual soul. In Kabbalah, this is highlighted as the ultimate test of humanity in "the battle between the Two Inclinations": the *yetzer ha-tov* (the Good Inclination) versus the *yetzer ha-ra* (the Evil Inclination). Michelangelo wrote often about this struggle within himself (without using the formal Hebrew terminology) in his letters, and especially in his poetry. Even in his sixties, he worked it into a madrigal he apparently wrote for a friend who was suffering from an unrequited passion for a beautiful woman.

Since Buonarroti did not feel this same passion for women, he indulged in more spiritual terms instead when writing the lyric on his friend's behalf.

He writes of "half of me that is of Heaven, / And that turns back towards there with great desire" while the desire for "a sole woman of Beauty . . . keeps me torn between two contrary halves, / So that each one takes from the other / The Goodness I should have, were I not so divided."

This challenge of the Two Inclinations will appear later in the panel of the *Original Sin* in the Sistine ceiling frescoes.

THE SCOURGE FROM FERRARA

In 1491 darkness started creeping into Michelangelo's Florence. His teacher Pico della Mirandola, rescued by Lorenzo from exile and threat of death for writings that the Vatican deemed heresies, had an inexplicable and bizarre idea. He urged Lorenzo to bring the fanatical Dominican preacher Girolamo Savonarola back into Florence.

Who was this Savonarola? He came from Ferrara, in the region of Emilia-Romagna, from a normal family. As a young man, he showed a great aptitude for philosophy and studied the ancient Greek thinkers, with a definite preference for what existed at that time of the writings of Plato. In fact, he completed a commentary on Plato—before suddenly feeling that Christ had called him as his special messenger on earth. He destroyed his thesis on Plato and devoted his energies to the Church-approved Aristotle. He became a Dominican monk and began preaching around central Italy, with very little success. Savonarola next came to Florence to preach against the liberal, hedonistic society there. When he started condemning the de' Medici family from the pulpit, Lorenzo had him thrown out of town. Why, then, did a great humanist thinker like Pico advise Lorenzo to bring him back to Florence and install him as the regular preacher in the family church of San Lorenzo? Historians are perplexed to this day. Perhaps, all things considered, it

was for a laugh—after all, the Florentines previously had made fun of the heavy Emilian accent of this monk from Ferrara. Savonarola was also exceptionally ugly, a skeletal figure with a huge nose and slobbering lips. It is possible that Pico thought his presence would actually undermine the Church's influence in Florence, by presenting the masses with such an unappetizing image from the pulpit. Perhaps, too, Pico had been worn down by years of fighting and fleeing the Vatican's power, and now wanted to make peace with the Church. We do know that in the year before he died, Pico convinced Savonarola to make him a Dominican as well. Was it a case of more intrigue or true repentance? We will probably never know.

Whatever the reason, Lorenzo and his court soon stopped laughing. Savonarola and his bizarre outbursts were gaining a loyal audience, much as certain television evangelists have done in our own times. In response, Lorenzo sponsored a more moderate mainstream preacher to counterbalance Savonarola, but the damage was already done—the mobs were firmly on the side of the ugly Dominican and his apocalyptic visions of fire and brimstone. From an insecure, unexciting backwoods cleric, Savonarola had become a fiery public orator who could whip the crowds into a frenzy with his delirious visions of Florence as the Whore of Babylon, doomed to eternal damnation for its lust for Beauty and the senses. His main target of hate was the House of Medici, their court, and all that they represented.

Michelangelo attended some of Savonarola's hysterical sermons against his happy oasis of Art, Beauty, freethinking, and love between men. Even in his old age, the artist would confide that he could never get the sound of Savonarola's voice out of his head. In fact, more than forty years later, Michelangelo would depict him in his *Last Judgment* in the Sistine. The fanatical preacher is shown in all his ugliness, at the very bottom of the painting, either emerging from the ground to go to a heavenly reward, or sinking into hell. It is striking that there are no other souls or angels to help him, as there are for almost all the other worthy dead in the giant fresco.

Within a year, it seemed that the wild-eyed preacher's ominous prophecies were coming true. A freak lightning storm broke over

Detail from The Last Judgment, *Sistine Chapel, showing Savonarola stuck in the dirt*

the city in April 1492 and shattered the lantern turret atop the famous dome of the cathedral. The charred pieces fell down on the side facing the Palazzo de' Medici. Three days later, Lorenzo was stricken with a mysterious ailment. Instead of allowing himself to be treated by the Jewish physicians, Lorenzo called in some superstitious quacks, who tried to save him by dosing him with a potion made of mashed pearls and precious stones. This only increased his agony, and in extremis, Lorenzo actually sent for his nemesis Savonarola to give him a final absolution and blessing for his soul. There is no written record of the actual words that transpired at the bedside, but it seems that Savonarola, ever intransigent, cursed Lorenzo to damnation instead and stalked out. The Magnificent died in agony shortly thereafter.

This pushed the frightened Florentines over the brink. Crowds flooded Savonarola's sermons and begged for forgiveness. Soon, he set up squads of fanatical youths and hooligans to harass and beat up

anyone on the streets of Florence for wearing jewelry, makeup, luxurious clothing, or for just having too much of a good time—much like in Iran after the Ayatollah Khomeini's revolution in 1979.

The House of Medici was in deep trouble. Lorenzo's older son, Piero, a young man of twenty, took over. However, whereas Lorenzo at twenty had been shaped and toughened to be the dynamic head of the clan, Piero was soft, weak, and spoiled. He merely wanted to party and ignore the fact that Camelot-on-the-Arno was collapsing around him. Piero did not even know how suitably to use his artists' talents. Under his governance, Michelangelo was not prodded to produce a single enduring artwork for his patron family. The only thing that comes down to us from these two empty years is the story of a record snowfall in Florence in the winter after Lorenzo's death. Piero ordered Michelangelo to make a giant statue of Hercules—out of *snow*. The Florentines flocked to see this marvel for a few days before it finally melted—an unintended but nonetheless powerful symbol of the ephemeral state to which the de' Medici family had declined.

TAKING UP THE CROSS— A HIDDEN HEBREW MESSAGE

Michelangelo's eager hands could not stand to be idle. He struck up a friendship with the prior in charge of the Church of Santo Spirito. Why a priest, especially one in a smaller church? The reason was that this cleric had access, through the hospital adjoining the church, to the corpses of the poor, of criminals, and of the anonymous dead. In the ancient world, not only doctors but also artists would dissect the bodies of executed criminals in order to gain deeper knowledge of the inner human body. In this way, the Classical master artists learned to portray it more perfectly in Greco-Roman sculpture. The discovery of more and more of these ancient masterpieces, unearthed in the fourteenth, fifteenth, and sixteenth centuries, inspired the renaissance of art. The great masters such as Pollaiuolo,

Leonardo, and many others all yearned to be able to match the level of these ancient works. There was a major obstacle, however. As we have already seen, the Vatican had forbidden anyone to dissect the human body for any reason. The only place that was exempted was the University of Bologna, where the medical school had special permission to dissect the cadavers of executed criminals, for teaching purposes only.

The most famous names of the Renaissance broke the law. They hired grave robbers (in England, called body snatchers) to steal the bodies of freshly executed criminals and deliver them to secret laboratories in the middle of the night. There, the artists would dissect the cadavers by the light of a dim candle, sketch down everything as accurately and as fast as possible, and then rid themselves of the evidence before dawn.

The subversive prior of Santo Spirito, out of either friendship or love, abetted Michelangelo in breaking this law. He gave him access to corpses from the hospital awaiting burial. The gruesome work of midnight dissections nauseated the young sculptor, but his passion to perfect his art overcame his queasy stomach. In this way, Michelangelo learned the inner secrets of the human body better than almost any other artist or even physician of his time. This amazing level of knowledge and the forbidden way in which he obtained it would both figure prominently in the Sistine frescoes, including stunning hidden images that have only been discovered in our era.

To thank his secret benefactor, Michelangelo made the one artwork that has come down to us from this part of his life—a painted wooden crucifix. Long thought lost forever, it was only recently found in a hallway of the church and definitively attributed to Buonarroti just a short time ago.

Legend has it that the impassioned artist actually crucified a fresh corpse to see exactly how the muscles in the hands and the rest of the body would react. What we now know for sure is that anatomically it is an astoundingly accurate crucifix for the late fifteenth century.

There are three facts about this piece that have escaped almost all viewers, perhaps because they are only noticeable very close up.

Crucifix, *by Michelangelo, 1493*
(Santo Spirito, Florence)

One is that Michelangelo, so enamored of the male body, *actually painted fine hairs on the chest and even in the armpits of this Jesus.* This had the effect of making him much more human than the normal completely hairless representations to which we are accustomed. The second is that Michelangelo even made the backside of the body perfectly accurate and fully fleshed, even though the piece would be hung high on a wall in the church. The third truth, however, is by far the most shocking. On the *titulus,* which in the Gospels is the mocking sign that the pagan Roman soldiers nailed on the cross over Jesus's head, Michelangelo did not inscribe the standard four letters I.N.R.I. (*Iesus Nazarenus, Rex Iudeorum*—Jesus the Nazarene, King of the Jews). Instead, he wrote out the full phrase three times, in Hebrew, Greek, and Latin. What is most striking, though, is that Michelangelo wrote the Hebrew in the top position in the perfect right-to-left order of the Hebrew language, with excellent calligraphy, and then below that the Greek and the Latin *backward,* as if in a

mirror, in order to follow the Hebrew. The almost certain explanation rests on the fact that, in that same year, a relic had been discovered hidden in a wall of the Church of Santa Croce in Gerusalemme in Rome. It was a piece of an ancient wooden inscription that seemed to be the original *titulus* of the Crucifixion (but proved by carbon dating in the year 2002 to be wood from the eleventh century, not the first). The broken, worn segment contains only the words "Jesus the Nazarene"—with the additional "King of the Jews" reference broken off near the beginning of the phrase—in all three languages, with the Greek and Latin backward and under the Hebrew. Word of this discovery must have reached Michelangelo, who was trying to make his crucifix as authentic as possible. More than that, this trilingual inscription would have been especially appealing to someone who was part of the inner circle of Neoplatonists. Indeed, Ficino and Pico had made this concept a central tenet of their teaching, that it was possible to harmonize the three worlds of thought: Hebrew mysticism, Greek philosophy, and the Roman Church. Buonarroti, always seeking to build bridges between Judaism, Christianity, and the Classical world, was clearly delighted to reflect this discovery in his new work.

Michelangelo could not resist the temptation to leave yet another hidden message in this crucifix. Although his Latin and Greek inscriptions are flawed, his Hebrew is fine—with but one exception that seems to have been done on purpose. The phrase "King of the Jews," described in the Gospels and appearing in so many Crucifixion scenes, is not on the relic discovered in Rome—it is broken off. In Hebrew it would normally read *Melech ha-Yehudim*. But Michelangelo wrote *Melech me-Yehudim*. By changing just one letter from the accepted phrase, he was saying "a king *from* the Jews." And that makes quite a difference.

With the death of Lorenzo, the future of the Jews of Florence looked grim. Savonarola and his followers disapproved of how much the Florentine Christians fraternized and studied with the Jews, and the families who had originally opposed their entry into Florence were now taking back control of the city. Michelangelo

wanted to remind people of intelligence, culture, and learning that *the Jesus worshiped by the Church was a Jew, come forth from the Jewish people and the Jewish religion*—the very same people and faith that the Church was then persecuting. That very year, the Inquisition expelled all the Jews from Spain. The death march across Spain, in which thousands of Jews died on their way to the deportation boats, horrified all people of good conscience in Europe at that time. Michelangelo was one of them. He was not a public orator, not a writer or a teacher or a politician—he was an artist. His response was to leave a permanent protest embedded in his work. At only seventeen or eighteen years of age, Michelangelo had started down the path of subversive, hidden art with a message—a path he would follow all the way into the Sistine Chapel.

BOLOGNA

With the inept Piero in charge of the de' Medici family fortunes, the brewing backlash of the other powerful clans in town after decades of living under the control of the de' Medicis (whom many had never forgiven for bringing the Jews into Florence), and religious fanaticism on the march, Michelangelo saw the writing on the wall. Two of his most cherished tutors, Poliziano and Pico della Mirandola, died within weeks of each other. A military alliance was formed between France and Milan, which was launching a successful invasion into the heart of Italy, shattering the generation of peace in which Michelangelo had grown up. With the premonition of a series of awful nightmares, he suddenly packed his bag and fled. Like Adam in the Sistine ceiling, he was forced out of his Paradise. (His instincts and nightmares had served him well, however: within a year, the rival clans, supported by Savonarola's mob, literally chased Piero and the entire de' Medici court out of Florence. The Jews quickly left with them.)

First, the nineteen-year-old fled to the popular refuge for many on the run in Italian history—the lagoon of Venice. After a short,

unproductive stay there, he went back southward to Bologna and in no time at all was in trouble with the authorities there, because he didn't have money to pay the fee at the tollgate. Only the last-minute appearance of Gianfrancesco Aldrovandi, a relative of the ruling family of Bologna and a longtime ally of the de' Medici clan, saved Michelangelo from a stay in prison. Aldrovandi sheltered him under his roof for a year. During that time, he noticed that the teen had missed out on basic *formazione* in the writings of Dante, Plutarch, and Ovid. The Bolognese nobleman made him read these classics every night, and especially loved to hear the young Florentine recite Dante in his authentic Tuscan accent. This was when Michelangelo acquired his lifelong passion for Dante. He would quote him and imitate his writing style from then on. His knowledge of Ovid and Virgil would later guide him in determining which sibyls to include—and to exclude—in the Sistine ceiling frescoes. Aldrovandi even got the young sculptor his first paying commissions: a few minor statues to finish off the tomb of Saint Dominic. Michelangelo also created for his new patron a beautiful young Apollo with his quiver of arrows, which could bring either intellect and inspiration or plague and death. Apollo was also known for his physical beauty and his beautiful lovers, both male and female. This statue, also long considered lost, was finally definitely recognized in 1996, located in the French embassy in New York City. It is fascinating to note that this pagan Apollo has exactly the same lithe nude body as the Jesus on the cross in Santo Spirito that the young artist had made two or three years before.

Michelangelo never learned to like Bologna, and in the winter of 1495–96 he went back to Florence. His boyhood Camelot was no more. Savonarola and his fanatical minions had taken over the city, keeping it in a continuous grip of terror. Women would be assaulted in the street for wearing makeup or jewelry. Men were beaten or killed for sodomy. Savonarola had instituted a new public event called the Bonfire of the Vanities, which frightened and repentant Florentines attended to toss their luxurious clothing, jewels, art, and non-Christian books into the flames. Botticelli, either out of fear or religious brainwashing, personally threw some of his own precious

paintings into the blaze. Michelangelo needed to find a way out. His art was the key.

To keep his hands busy, and to amuse his few remaining friends, he carved a copy of an ancient Roman statue of a sleeping Cupid that he recalled from the Garden of San Marco or from the Palazzo de' Medici. His friends said that it was so convincing, it could easily be taken for an authentic artifact from Classical Rome. For a lark, they artificially aged the piece and sent it off to Rome with an antiquities dealer of questionable ethics. Sure enough, he was soon able to sell it to Cardinal Riario, a wealthy nephew of the late Pope Sixtus. Michelangelo must have loved the idea of conning money out of a member of the same corrupt family that had tried to assassinate Lorenzo. He was happy, that is, until he learned that he had received only thirty ducats out of the two hundred that the cardinal had paid to the middleman. Outraged that someone else should profit so much from his hard work and talent, and probably also as an excuse to get out of Florence and see the wonders of Rome, Michelangelo packed his bag and headed for the Eternal City.

The headstrong young man was taking a huge risk. He was a mere artist, with no family or protector in Rome, a former member of the exiled House of Medici, and a Florentine—from a city that was detested by Rome and the Vatican. Still, taking courage from his anger, Michelangelo met with the cardinal and confessed the deception. The cardinal, seeing that he could now have the artist and not just the one artwork, forgave him. He commissioned him to sculpt a drunken Bacchus. This was Michelangelo's introduction to Rome— a supposedly holy clergyman, vowed to a life of both poverty and chastity, paying a hefty amount of money for him to create an erotic statue of the pagan deity of drunken orgies. However, the new pope on the throne at this time was none other than Rodrigo Borgia, Pope Alexander VI, possibly the most scandalous, corrupt, and disgraceful pope of the entire Renaissance—and that is saying a great deal. While Florence was being scourged by Savonarola for art, jewelry, and cosmetics, the Vatican itself had become one big bacchanalia. The drunken Bacchus was the perfect symbol of this hypocrisy.

Bacchus, *by Michelangelo, 1496–97 (Bargello Museum, Florence)*

Michelangelo gave Cardinal Riario exactly what he wanted. The *Bacchus* could easily pass for an authentic ancient pagan masterpiece. The young deity's hair is made up of clusters of juicy grapes, and his sensual pose accentuates both his nudity and a stomach slightly bloated from alcohol. The viewer, encountering this Bacchus head-on, receives a toast from the tipsy god. Then, upon circling the statue, one finds a young faun hidden behind Bacchus, holding and eating a grape cluster in a suggestive, sexual manner.

Two asides about this sculpture bear mention. The faun has symbolic goat horns that appear very authentic and naturalistic. This is the only time that Michelangelo put horns on a figure; the universal misconception that the protrusions on the head of his *Moses* are horns can be easily disproved just by simple visual comparison with this statue, as we shall see later. The other point of interest is that seventy-five years later, this Bacchus was purchased and brought to Florence by none other than the de' Medici family.

THE PIETÀ

Fate was now about to give the young artist a giant push in the direction of the Sistine. Cardinal Riario, although very pleased with his new Bacchus, was more than a bit embarrassed by the statue's frank sexuality. He quickly gave it to a close friend, Jacopo Galli, to become the centerpiece of Galli's garden of antique Roman statuary, where undoubtedly it was explained to visitors as a pagan artifact. Galli must have, however, told the truth to his friend Cardinal Bilhères de Lagraulas, the French king's ambassador to the Holy See. In no time at all, the cardinal was commissioning Michelangelo to create a private work—this time something with a decidedly Christian theme, a pietà. The pietà was already a common iconographic scene in Christian art. The word *pietà* does not translate into English, but oddly enough it corresponds perfectly to the Hebrew word *rachmanut,* which denotes a combination of compassion, loving-kindness, pity, consolation, grief, sorrow, and care. It is the

precise moment in the Passion of Jesus when his dead body is taken down from the cross and laid on the lap of his grieving mother, Mary. It was a huge challenge for any artist, since the scene was quite awkward to portray: the limp body of a fully grown dead man stretched over his middle-aged mother's lap. Previous pietà works had seemed ungainly and unbalanced.

Galli, who acted as the middleman, promised the French cardinal that he would receive the most beautiful sculpture in marble in all of Rome, something that no other living artist could create. Although it might have seemed like no more than southern Italian hyperbole at the time, Galli's promise turned out to be prophetic.

Michelangelo had the wealthy cardinal order an extremely expensive block of the highest-quality Carrara marble. He knew that this one commission was to be his big calling card to Rome, a work that could either make or break his career. He took an entire year carving the statue, even spending several months just buffing it over and over by hand until the body of Jesus seemed to glow from within. By the time he finished the piece in 1499, he was twenty-four years old.

As already mentioned, no artist was allowed to sign works for the hierarchy in the Church. The purpose ostensibly was to keep the artists in their place and to "protect" them from the sin of pride— this despite the fact that popes and cardinals had no problem putting their names, faces, and family crests all over the buildings and artworks of the day. Michelangelo, after more than a year of putting his heart, energy, talent, and soul into this pietà, could not sign it.

Even before it was unveiled, the statue changed ownership. Cardinal Bilhères de Lagraulas died before the work was finished, either from natural causes or perhaps with a bit of assistance from the Borgias' endless supply of poisons. The *Pietà* was appropriated by Pope Alexander VI Borgia himself. One theory is that the theme of the statue touched him greatly because his son, the Duke of Gandia (one of the countless children that he had sired as a supposedly chaste man of the cloth, and one of the very few that he acknowledged as his), had been recently assassinated.

According to the story, on the day the statue was unveiled Michelangelo hid himself behind a column in St. Peter's Basilica, awaiting the applause of the crowd and the praise of his name by the critics. Instead, he overheard people saying that this marvelous new work had to be from a great talent from Rome or from Lombardy—anywhere but from Florence.

Enraged, Michelangelo risked his life that night by breaking into the cathedral, climbing up on his masterpiece, and rapidly carving on the sash across Mary's chest: "Michelangelo Buonarroti, Florentine, made this." He escaped before the Swiss Guardsmen, who most likely would have decapitated any intruder on the spot, could catch him.

Recent laser scans of the surface of the *Pietà* bear out the story. Apparently, one person buffed the whole statue with a constant motion for months; then the inscription on the sash was carved very quickly by someone with a nervous, slightly shaky hand. The writing also bears witness. It is filled with errors, owing to Michelangelo's quite

Closeup of Michelangelo's signature on the Pietà
(plaster copy in the Pinacoteca, Vatican Museums)

understandable frightened rush at the time. For example, instead of *Michelangelus,* he first wrote *Michelaglus,* then went back and stuck the *e* inside the *g.* He inserted other forgotten letters as he went along. This was not to save space, since instead of the correct, shorter word *fecit* (the standard Latin inscription for "made this"), he put the incorrect *faciebat,* "was making this." Obviously, Michelangelo's Hebrew was better than his Latin—at least in his artwork.

When the inscription was discovered, Michelangelo had to be pardoned by the pope, and most likely had to promise not to sign another work again. We do know that in eighty-nine years, this is the only work that bears his name.

There is another secret of this famous work. When it was first revealed to the public in 1499, the critics and art experts of the era praised it as the finest sculpture in marble since the fall of ancient Rome a thousand years earlier. However, all the critics voiced one important complaint: the face of Mary was wrong—it was far too young for the mother of a thirty-three-year-old son. Most Christian historians place Mary in her fifties at the time of Jesus's crucifixion. All earlier artworks had shown her at this age in Passion scenes. Some writers thought that Michelangelo had taken one obscure line from Dante's *Paradiso* that calls Mary the daughter of her own son, or that he had decided to show the new mother Mary cradling Baby Jesus but having a dreadful vision of the end of his life while he is on her lap. Many years later, Michelangelo admitted to his biographer Condivi that there had been much criticism of Mary's strangely youthful face in the *Pietà.* He gave Condivi the same excuse that he had used in 1499, that a virgin does not show her age. Buonarroti himself must have known how flimsy a rationale this was, since he undoubtedly saw nuns and old maids every day, and they did not age very well in his day, with or without a sex life.

So, why would he do such an odd thing in such an important work? Michelangelo was aware that he was sculpting not only the holy mother of the Christian faith but a Jewish mother as well. A way to emphasize this would be to go back to the original holy Jewish matriarch, Sarah. In the book of Genesis, Sarah is the deeply pious

wife of Abraham, who finally gives birth to their son Isaac, the second Hebrew patriarch, at 90 years of age. When she dies from shock 37 years later, believing that Isaac has been sacrificed, she is 127. The Torah does not give her age directly, however. The original Hebrew says: "And the life of Sarah was 100 years and 20 years and 7 years, the years of Sarah's life." Rashi, the great Torah commentator from France in the eleventh century, explained this unusual phrasing with a well-known midrash, an expansion of the biblical narrative. According to Rashi, the Torah means that Sarah, at only 7 years old, was as fully developed spiritually and intellectually as a full-grown woman of 20—and at 100, she was still so spiritually pure that she appeared as young as a woman of 20. Indeed, she was known as the most beautiful woman of her era, and in the Bible, she is kidnapped twice by pagan rulers to become part of their sexual harems—once in her sixties and again in her eighties. Since Rashi was eagerly studied and taught by both Marsilio Ficino and Pico della Mirandola, it is highly likely that Michelangelo had learned this midrash back in Florence. It is also quite probable that he decided to take this touching story of the mother of the Jewish religion and transpose it onto the face of the mother of the Christian religion. If this is indeed the case, it means that the world's most famous Christian statue has a Jewish secret hidden within it.

An additional secret was disclosed by the Vatican itself in 1973. A madman attacked the statue in 1972, damaging Mary's left arm, eyelid, and nose. During the repairs, the world's top art restorers found that Michelangelo had hidden a capital *M* in her left palm, disguised as her palm lines, a plaintive attempt to ensure that posterity would not forget the name of the *Pietà*'s creator.

A NEW COLOSSUS

Soon after finishing the *Pietà*, in spite of his now-growing fame, Michelangelo wanted to get out of Rome. The Borgia clan had decided to conquer central Italy for their own profit, and were busy

poisoning both relatives and rivals—anyone who stood in their path. While he had been happily lost in his work sculpting the *Pietà*, Florence had gone through yet another changeover. The fanatical Savonarola, believing himself to be a biblical prophet, had turned on the pope and the Vatican, denouncing Rome as the new Whore of Babylon, the new Sodom and Gomorrah. Both the pope and the Florentines had had enough of the monk's bleak condemnations, and in 1498 he and his inner circle were hanged and burned in the town square, on exactly the spot where he had proudly overseen the Bonfire of the Vanities. Now Florence was a republic again, and wanted to celebrate the fact.

Michelangelo used the excuse of a commission in Siena to beat a hasty exit from Rome, and once more went back to work in Florence.

At this time, the Florentine city council decided to put two new oversized sculptures by two local artists high up on the cathedral buttresses to watch over the city, and to celebrate its recent liberation from the French and the fanatical Dominicans. Their choices were decidedly in the Neoplatonic Florentine style: a Hercules and a David—nothing from the standard Church repertoire of imagery. Hercules was to be shown defeating the giant Cacus, while David would of course be the usual image of the mighty hero standing with the severed head of the giant Goliath under his foot.

Michelangelo, with his love of the Hebrew Scriptures, was a natural choice for the sculptor of the *David*. Of course, it didn't hurt that in the new position of Gonfaloniere (a sort of mayor-for-life) was Piero Soderini, an old friend of his. While Bandinelli, the artist chosen to make the Hercules, was given a fresh block of marble, Michelangelo selected a used piece. It was a huge but shallow block already heavily scarred by previous sculptors who had given up on carving this particularly difficult stone. Skeptics doubted that anyone could produce anything worthwhile from this battered and overworked chunk of marble, but Michelangelo saw something within it that nobody else could see. He set up a high scaffold around it, draped it all in heavy cloth, and set to work.

While making some preparatory sketches for the piece, Michelangelo wrote his first fragment of poetry that has come down to us today. Next to a design of David's mighty right arm, he wrote:

Davicte cholla fromba
e io chollarcho—
Michelagniolo
Rocte lalta cholonna el ver . . .

Even in his first stab at creative writing, Michelangelo at twenty-seven is utilizing a kind of code. The lines, in a Tuscan dialect that reads just as he probably would have pronounced it, say:

David with his slingshot
And I with my bow—
Michelangelo
Broken is the tall column and the gree(n) . . .

An *arco*—in the second line's word *chollarcho*—meant an archer's weapon, or a violinist's bow, but Buonarroti was neither an archer nor a musician. The last line is a quote from a well-known poem by Petrarch that begins, "Broken is the high column, and the green laurel [in Italian, *laura*] has fallen," Petrarch's ode of grief at the death of his beloved Laura. Michelangelo had learned Petrarch during his sojourn in Bologna, but why quote him here? And what does Petrarch's mourning for his lady love have to do with the *David*?

The modern biographer of Michelangelo, Howard Hibbard, solves the puzzle by citing Charles Seymour's explanation of the "*arco*." A stonecutter or sculptor in the Renaissance would use a running drill to make the eyes and other fine holes in the marble. A running drill is a thin, pointed rod that spins into the stone thanks to a stringed bow that rotates it at a high speed, much like the bow used by Boy and Girl Scouts to make a fire in the wild. This is undoubtedly the kind of drill that Michelangelo would have used to create David's unforgettable eyes. Michelangelo is giving himself a

sort of "pep talk," claiming that just as David, armed only with a sling, defeated his enemy, he (Michelangelo) would defeat all his foes with his talent. The "tall column" is the high block of scarred marble that his rivals could not conquer; but he, the ugly, broken-nosed Buonarroti, would show them all by "breaking" (taming or overcoming) the tall stone and winning the green laurel wreath of Victory.

And triumph he did. The David that he produced is nothing short of miraculous. It also broke with all traditional images. Instead of showing Goliath's defeat, Michelangelo chose to depict the young shepherd boy at the exact moment of decision. His look is of concern but also of conviction. He is stark naked and unarmed except for a sling and pebbles. Goliath is nowhere to be seen. David is caught, as if in a snapshot, at the instant in which his faith in the Almighty is about to lead him into a battle that will change his life and the life of his people. He is in the act of turning toward the giant Philistine, which also allowed the sculptor to show off his deep knowledge of the male anatomy.

Particularly shocking to viewers at the time—and, in fact, to many visitors to the Accademia in Florence to this day—was Michelangelo's addition of bushy pubic hair to David. In the Greco-Roman world, heroes were always displayed as hairless and with diminished genitalia, as a sign of their dignity and purity of spirit. Michelangelo was accentuating David's crotch and calling attention to the fact that he was giving him a normal endowment. Perhaps this was an act of revenge against Savonarola's puritanical reign of terror; perhaps it was to show the newly regained power of a cosmopolitan Florence. It definitely demonstrates Michelangelo's love of the nude male. Indeed, the whole statue is a paean to the beauty of the masculine body.

Of course, this brings up the question: if he was so enamored of Jewish teaching, why didn't Michelangelo give his David an au-thentic circumcised organ? There are several theories. The simplest explanation is that he quite likely had never seen a circumcised penis and did not want to portray anything that would probably

be incorrect. More important, since the Inquisition was still going strong he did not want to be accused of the crime called Judaizing—propagating the Jewish faith and traditions. Furthermore, the commission expected the *David* to represent the city of Florence, not the only recently returned Jewish community.

David did indeed symbolize Florence. Michelangelo designed him to go high up on the buttress facing toward Rome, as a silent sentinel watching over Florence and warning the Roman Church not even to think of threatening its newfound freedom. He made the hands, feet, and head oversized in order to show strength, especially when viewed from below on ground level.

Not commonly known is the remarkable secret about the eyes of David. Michelangelo drilled them extra deep and slightly too far apart. Yes, the great *David* is walleyed—but it was done on purpose, a brilliant way to make his gaze seem to go on into infinity. The extra depth of the eyes was also meant to catch the rays of the sun at just the right angle on that buttress perch, in order to make the statue seem truly alive, a sort of Hollywood special effect.

Michelangelo's designs for his statue were undone by his talent. The city officials decided that the statue was too beautiful to be merely a part of twinned decorations high up on the cathedral. So, a special commission was formed to select a special place of honor for Florence's new symbol. One of the experts called upon was none other than Leonardo da Vinci. The committee concluded that it had to go on a pedestal in front of the entrance to the city hall, where a well-known copy stands today. This was a great honor for Buonarroti, but the end of all his special effects hidden in the statue, meant to take advantage of its original location. Even today, when viewed inside the Accademia, the hands, feet, and eyes all seem strange and disproportionate to the puzzled viewers who are unaware of Michelangelo's intent, which could only be realized where the *David* was supposed to be placed.

Ironically, even before it was unveiled in 1504, the statue had its share of troubles. According to his biographer Giorgio Vasari, Michelangelo was just putting some last touches on the statue when

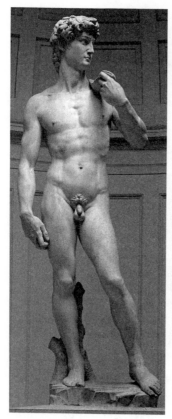

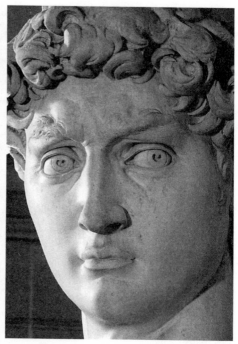

Left: Full view of David, *by Michelangelo, 1501–1504 (Galleria dell'Accademia, Florence). Above: Closeup of the face of* David, *by Michelangelo, 1501–1504 (Galleria dell'Accademia, Florence)*

the Gonfaloniere Piero Soderini came inside the enclosure of the scaffolding for a private preview. To the headstrong artist, it didn't matter if a person was the head of government or even a pope—he just wanted to be left alone with his artwork. Soderini viewed his commission with the presumption of one who knows nothing about the subject he is critiquing, and then announced to Michelangelo that something had to be done about the nose—it was too thick. (He might have meant that it looked too Jewish. Michelangelo's *David,* like his Jesus in the Vatican *Pietà,* has decidedly Semitic features.) Michelangelo calmly took his hammer and chisel in his left hand and climbed the ladder up to the colossal statue's face. As he ascended, he gathered marble chips and dust in his right hand, out of Soderini's view. When he reached David's nose, he hammered loudly on the

chisel, without touching the statue's surface at all, while letting a flurry of chips and dust rain down on the ruler's head below. He then came back down to join Soderini, who proudly declared: "Ah, that did it—now you have brought it to life." Michelangelo and his friends laughed about this (in private) for a long time.

The other trouble was far more serious. As the *David* was slowly being transported in a special conveyance to its place of honor, the statue was stoned and attacked by unknown assailants. Were they upset by its nudity or its Jewish theme? We will never know. We do know that in later political upheavals, the *David* was knocked off its perch and its right arm broken. Fortunately, another artist and supporter of Michelangelo salvaged the pieces and had the statue repaired when social order was restored. Finally, in 1873 it was decided that the *David* would be safer indoors, and a copy was set in its place.

A PAINTING?

The period in which Michelangelo carved the *David* was an extremely productive time for him. Although that statue alone would have kept any other artist fully occupied, Buonarroti still found time to carve four statues of saints to fulfill his contract with the Cathedral of Siena, plus a Madonna for the Church of Notre-Dame in Bruges, Belgium. All five pieces seem to have been partly done by assistants and are quite austere, straight up-and-down, and unemotional for a Michelangelo work. The definite Buonarroti touches are the heavily pleated clothes and the fact that all the figures are carrying a book. We shall see this proof of Michelangelo's love of learning in the Prophets and Sibyls section of the Sistine as well.

He also did something quite out of character for him at the time—a painting.

Michelangelo—who would become one of the most famous painters who ever lived, thanks to the Sistine frescoes—actually hated the art form. He only appreciated the three-dimensional arts of metalcasting, sculpture, and architecture, and regarded daubing colors on

a flat surface as both boring and inferior. He often signed his business letters "*Michelangelo, ischultore*"—Michelangelo, sculptor.

Why, then, did he accept a commission for a *painting* in the midst of so much other work? Quite simply, it was an offer he couldn't refuse: the commission came from two of the most powerful families in Florence—the Doni and the Strozzi, the longtime rivals of the de' Medicis. If anyone, especially an artist, wanted to stay in Florence and pursue a successful career, he did not want to incur the anger of either of these clans.

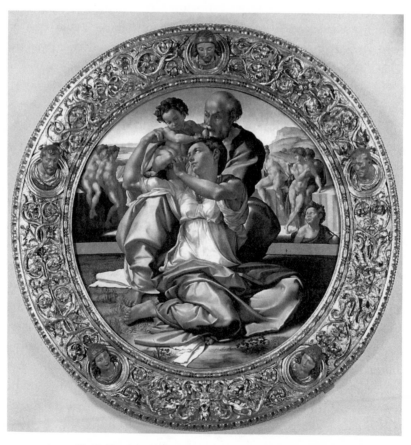

Tondo Doni, by Michelangelo, 1503–1504 (Uffizi Galleries, Florence). See Fig. 5 in the insert.

To celebrate a marriage uniting the two families, Michelangelo was hired to paint a Holy Family. There was a fifteenth-century Holy Family painting in the de' Medici palace where he had grown up, done by Luca Signorelli, one of the original fresco painters of the Sistine. It was round and had nude boys in the background. Buonarroti's prodigious visual memory served him well, and he made a similar round painting with nudes in the background. However, it was impossible for him to be a mere imitator. What he created is a controversial work that still puzzles, inspires, and offends to this day.

Here, in this painting, we can already see the Michelangelo that we know from the Sistine ceiling: the bright, almost metallic clothing; the muscular, masculine woman—a Virgin Mary who looks like a pagan sibyl who has been pumping iron; males who are more naked than nude, in affectionate, playful, almost erotic poses; a Neoplatonic balancing act of pagan boys in the background; an infant John the Baptist who looks more like a mythological faun than a Christian icon; a Jewish Joseph in the middle ground handing baby Jesus to Mary in the foreground—or taking him from her, depending literally on your point of view. Michelangelo is up to new tricks. He intertwines Mary's and Joseph's limbs in such a stylized, unnatural manner that at first glance it is almost impossible to distinguish whose limb is whose. Even in the frame, which many experts believe he designed, there is a circle of Hebrew prophets, Greco-Roman sibyls, and Jesus. Above all, there is the feeling that we are seeing painted *sculpture,* and not merely flat figures. It is almost as if fate has the artist unwittingly preparing for his work in the Sistine Chapel.

And sure enough, as if on cue, a call came forth from the Vatican. There had been a new pope on the throne since 1503, none other than the dour nephew of Sixtus IV—Giuliano della Rovere, now crowned as Pope Julius II. He desired that the artist Buonarroti return at once to Rome, for a most important project. Neither ruler nor rebel was yet aware of what destiny had in store for them.

Chapter Six

AS FATE WOULD
HAVE IT

A true artist paints with his brains and not with his hands.

— MICHELANGELO

URING THE RENAISSANCE, the popes were very much
like the pharaohs of ancient Egypt in at least three ways.
As soon as a pharaoh ascended the throne, the nation's
calendar would be turned back to the year one, the new ruler would
immediately start planning his own glorious tomb (such as a pyra-
mid), and plans would be laid for his mummification after death.
The same was true for a pope. Even to this day, when a new pope
is elected, the Vatican begins counting papal years. On papal monu-
ments all over Rome, one can find the two dates of A.D. (*anno Do-
mini*—in the year of the Lord) and A.P. (*anno papalis*—in the year of
the pope). Popes were also *mummified.* Following an ancient Kab-
balistic belief that the bodies of the *tzaddikim* (truly righteous souls)
do not decompose in the grave, the Church declared the same to be
true for Catholic saints. The Vatican was anxious to preserve the
bodies of deceased pontiffs in case of future sainthood, and since

the art of embalming had not yet been sufficiently developed (this did not happen until the early twentieth century), all popes were mummified, following the arcane process of ancient Egypt. Finally, every pope who lasted long enough on the throne spent an enormous amount of time and money planning his impressive final resting place.

"*IL PAPA TERRIBILE*"

For the new pope, Julius II, planning his final resting place became a major obsession. He was not the type to be satisfied with a mere sarcophagus or wall decoration, no matter how fancily constructed. This was a man with an eye on eternity and an ego that knew no limits. He had already become accustomed to power as a member of his uncle Sixtus IV's corrupt papal court. As Cardinal Giuliano della Rovere, he was one of the scheming *nepoti* (nephews, in archaic Italian) for whom the word *nepotism* was coined. When the Borgias took over the Vatican, Pope Alexander VI had stripped him of all power within the Vatican and had even tried to poison him. Giuliano had been forced to flee to Avignon for the duration of the Borgia reign of terror. When Alexander VI died in 1503, his son Cesare Borgia did not want to relinquish the family's grip on the Vatican. Only personal illness, frantic diplomacy, bribery, and group pressure from all the cardinals convinced him to leave Rome. During the conclave, or top-secret election of the next pope, Giuliano rigged the voting—for long-range political motives—to crown not himself, but Pius III, himself the nephew of another pope. Pius III was quite ill, with one very gouty foot already in the grave. Giuliano della Rovere had him declare war on the Borgias, in order to frighten the rest of their minions out of Rome. It probably worked, but Pius lasted only twenty-six days on the throne. It was either the gout or, more likely, one last departing henchman of the former pope whose poison sped the suffering new pontiff to his reward. With the dirty work done, Giuliano spread enough bribes, threats, and promises

Portrait of Julius II, by Raphael,
1512 (National Gallery, London).
Note the acorns on the chair posts,
for the della Rovere family (of the
oak). Even though near the end of
his life and sick with syphilis, the
pope firmly grasps the throne with
his left (sinister) hand and holds
a linen cloth like a pharaoh in his
bejeweled right hand.

around the College of Cardinals to win the next conclave without opposition. He is one of the few popes in history to have been elected within twenty-four hours on the first ballot. He was crowned at the age of sixty on October 31, 1503. His raging ego and violent temper soon earned him the nickname of *Il Papa Terribile*—the frightening pope.

As the new Pontifex Maximus Julius II della Rovere, he quickly picked up where his uncle Sixtus IV had left off in 1484. He appointed Donato Bramante, a talented painter and architect from Urbino (on the eastern coast of Italy), as the official papal architect. Bramante was given a long list of projects, with the objective of transforming Rome into the new Christian *caput mundi,* head of the world. The Apostolic Palace was enlarged, seemingly endless hallways were added, an elegant private spiral staircase was constructed for the pope's private use, a new riverside street (Via Giulia) was carved through the city, and on and on. What proved to be of greatest historic interest, however, were two other special projects inside

the Vatican walls—projects that would affect Michelangelo for the rest of his life.

One was the repair of the Sistine Chapel. The heavy building, set on ancient graveyard soil, had settled and was threatening to collapse. Bramante quickly buttressed the southern wall, thus saving the chapel. However, the massive ceiling had a huge crack running through it. Bricks and mortar were inserted as a sort of architectural bandage, but the repairs left an ugly white scar that ruined the starry canopy of the della Roveres' royal chapel. Julius began considering who would be the right person to redo the ceiling of his uncle's chapel.

The other project dwarfed all others—the plan for Julius II's tomb. A megalomaniac and micromanager, Julius wanted to make sure that his final resting place would outshine that of any other pope in history. He actually envisioned a gigantic pyramidal structure, covered with more than forty large statues on all four sides, with two angels carrying him on a bier at the top of the heap of marble. His over-the-top design was so enormous that it would not fit inside St. Peter's Basilica. Anyone else would have scaled down his plans, but not Julius. He decreed that Bramante *demolish* the old basilica and build an entirely new one fit for Julius's new Catholic empire, and large enough to contain his massive tomb—in the center, right under the dome, where normally the main altar should be. Bramante's ruthless destruction of the old sanctuary (including the tombs of many earlier popes) earned him the nickname of *Bramante er Ruinante* (the wrecker) in Rome.

Before selecting the right artist for the new Sistine ceiling, Julius already had in mind the perfect sculptor for his tomb: Michelangelo of Florence. Julius had for a while been Bishop of Bologna before fleeing Italy, and had seen firsthand the beautiful works that Michelangelo had carved in rapid succession for the cathedral there. He, of course, had also seen the *Bacchus* and the *Pietà* in Rome. Despite his many personal and spiritual failings, Julius had one strong point that would earn him eternal recognition: an eye for artistic talent. His ego, his feeling of competing with Florence, his

need to make Rome an imperial capital again, all contributed to his one lasting achievement—he moved the center of the Renaissance from Florence to Rome. All that was missing from his "collection" was the world's greatest sculptor, and what Julius wanted, Julius *got.*

For Michelangelo, the invitation from the Vatican could not have come at a better time. While he had been finishing the *David,* painting the Doni Holy Family, and overseeing all the other sculptures coming out of his workshop, the Gonfaloniere Soderini and the city council had gotten another bright idea—a public showdown between the two top artists in Florence. Leonardo da Vinci and the much younger Michelangelo had often made it clear that they had no respect for each other's craft. Leonardo disparaged the new trend for portraying overly muscular male nudes—he said it was like looking at "sacks filled with nuts"—and unfavorably compared the messy, noisy workshop of a sculptor where everything and everyone was covered in marble chips, dust, and sweat with the quiet, clean, orderly studio of a painter "where one can listen to fine music" while working. Michelangelo, on the other hand, made no effort to disguise his dislike for the two-dimensional "falsity" of painting.

So in 1503 Soderini decided to commission both of them simultaneously to paint two giant fresco murals, side by side, in the Great Hall of the Palazzo della Signoria (the city hall). In order to glorify the new independent form of government, the theme would be Florence's victories in two historic battles: Leonardo would tackle the battle of Anghiari, while Michelangelo would do the battle of Cascina. It looked as if it would be a fascinating duel: Leonardo was renowned as a painter, and Michelangelo (thanks to his *Battle of the Centaurs* and the *David*) was known for portraying male warriors. It took them over a year just to prepare their concepts and designs. Each fresco was to be more than 1,400 square feet. In 1504 gigantic sheets of paper (a very expensive commodity in the sixteenth century) were bought and prepared for the full-sized *cartoni,* or "cartoons," the charcoal drawings used for transferring the outlines of the figures onto the fresh plaster of the fresco. Both artists got carried away by their special interests: Leonardo concentrated on the

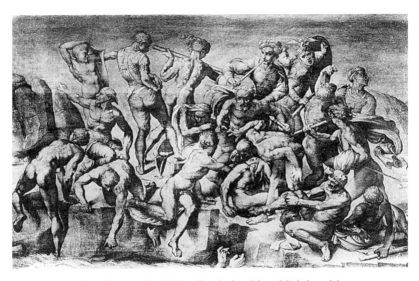

Copy by Aristotile da Sangallo of a detail from Michelangelo's
cartoon for the Battle of Cascina, *c. 1505*

anatomy of the horses in the battle, while Michelangelo—as you might have guessed—filled his scene with muscular male nudes in every possible position.

The Florentine public didn't care. When the full-sized preparatory cartoons were displayed, the entire city went into ecstasy over both works. This was the sign that the repressive days of Savonarola were really and truly gone for good, that Art and Beauty had come back home at last.

Now came the part that Buonarroti had been dreading—actually having to *paint* the fresco. He knew that he was out of his element. He had never executed a fresco painting in his entire life, and now he was up against the top painter in the world.

It was just at this point that the new pope called for him to *sculpt*—and Michelangelo used this as his excuse never even to start the fresco process. He made a hasty return to Rome, leaving behind the *Battle* cartoon and several other commissions, never to be carried out.

Pope Julius II, if nothing else, was an extremely decisive man. He and Michelangelo were two sides of the same coin: egotistic,

stubborn, and determined to have things their way. Perhaps because of this, they understood each other better than most others could. This allowed them to settle on the tomb design and all the details in record time. Within a month, Michelangelo had a contract in hand and the funding to send for the first shipment of marble to be quarried from Carrara and brought to Rome. He went to Carrara himself to supervise personally the selection and cutting of the blocks, a process that took more than eight months. When he returned to Rome to await the arrival by boat of these precious stones, three surprises were in store for him.

The first was a happy one. In early 1506 a peasant had been fixing up his vineyard near the Colosseum when he accidentally opened up a hole in the ground. There, he discovered a large statue of humans being slaughtered by giant serpents. Word reached the Vatican almost immediately. Experts were sent for, including Michelangelo. The statue was identified as the long-lost *Laocoön,* the most beloved statue in pagan Rome, thought destroyed by the barbarian hordes in the fifth century. It was originally commissioned by the victorious Greeks after they destroyed Troy. It shows the moment of death of Laocoön, the high priest of Troy, being killed by supernatural snakes sent by the Greek gods to prevent him and his sons from warning the Trojans not to bring the famous Trojan horse inside the city walls. Laocoön is best known for his warning: "Beware of Greeks bearing gifts." After the serpents killed him and his sons, the Trojans did indeed bring the giant wooden horse into their city. When the hidden Greek soldiers came out of its hollow belly that night, it spelled the end of both Troy and the Trojans. Later, when the victorious Roman legions brought a close to the Greek Empire, they brought home the *Laocoön* as one of their favorite war trophies.

The pope paid the lucky farmer a fortune for the piece, which was then cleaned up and paraded around the city before being set in a place of honor in the pope's octagonal courtyard, where it still sits today. The instant popularity of this one statue convinced the pope to open up his private collection to the public, thus starting the Vatican Museums, today the most important art collection in the world. The top jewel in the crown of this collection is the Sistine Chapel.

Laocoön, *by Polydoros, Hagesandros, and Athenodoros,*
first century BCE (Vatican Museums)

Michelangelo was entranced by this ancient masterpiece, the re-
sult of three top Greek sculptors working as a team on the island
of Rhodes. Out of his esteem for this piece, he inserted the bodies
of the two dying sons of Laocoön as nudes on the Sistine ceiling,
and the torso of Laocoön himself as the torso of the Almighty in
the first *Creation* panel. Besides the statue's impressive muscula-
ture, Michelangelo must have loved it for the story of the Trojan
horse, a "peace offering" with a vengeful surprise hidden inside. He
must have been aware of what his fellow Florentines had gotten
away with in the fifteenth-century wall frescoes for the Sistine—in

Lorenzo de' Medici's supposed "peace offering" to Pope Sixtus IV that was in reality filled with insults to the pope, his family, and Rome—a lesson that would find powerful echoes very soon in his own work.

The second surprise awaiting Michelangelo was Bramante, the pope's head architect and close confidant. To accommodate Julius's mountainous funeral monument, Bramante had begun his work of razing the original basilica and beginning the construction of the largest church in the world. This proved to be a gargantuan task that was overwhelming all other projects, including the pope's own tomb—which was the reason for the new church construction in the first place. Bramante had definitively distracted the pope from Michelangelo's project. From then on, the two of them would behave like two students vying for their teacher's attention, trying to win back and maintain the pope's focus and his favor.

The preparation for the new cathedral was sucking up all the funds in the Vatican. This led to Buonarroti's third and most unpleasant surprise. One day, while within earshot of the pope, he heard a jeweler visit His Holiness, trying to sell him some new rings studded with gems. Julius declaimed, loudly enough for Michelangelo to hear him clearly: "Not a single coin more for any more stones—neither the small kind nor the large kind." Michelangelo understood that to mean that his funding for the tomb project was suddenly cut off completely. Outraged, he stormed out of the papal chambers. The long roller-coaster ride that the artist would later call "the tragedy of the tomb" had just begun.

Even though the practice of astrology was taboo for the Catholic Church, Pope Julius's private astrologer advised him when to lay the cornerstone for the new cathedral—April 18, 1506. Michelangelo left Rome the day before—furious at his project being upstaged, and probably to avoid having to see Bramante's day of glory as well. He went back home to Florence to sulk. He toyed with the idea of returning to his commission to carve the Twelve Apostles for the Florentine cathedral, or even to accept the invitation of the Sultan of Turkey to build the world's longest bridge, to connect East and West.

Previous page, Fig. 1:
View of the Sistine Chapel
from the roof of St. Peter's
Cathedral. Right, Fig. 2:
The Founding of the
Vatican Library, *by*
Melozzo da Forlì. Below,
Fig. 3: The School of
Athens, *by Raphael Sanzio.*

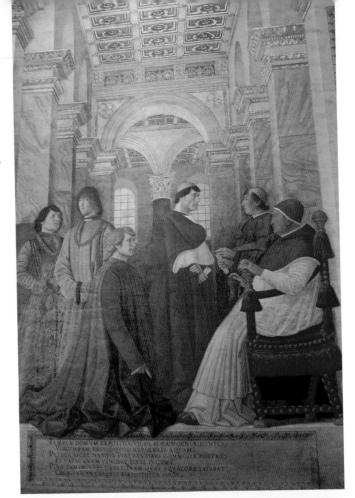

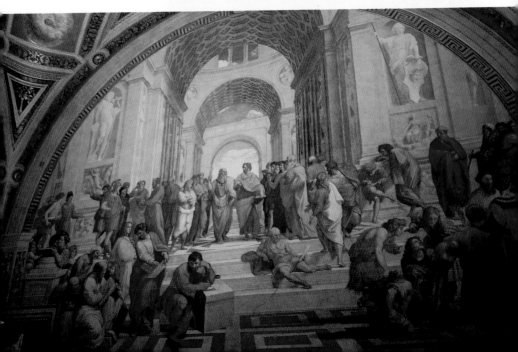

Top, Fig. 4: The Annunciation, *by Leonardo da Vinci.*
Above, Fig. 5: Tondo Doni (The Holy Family), *by Michelangelo.*

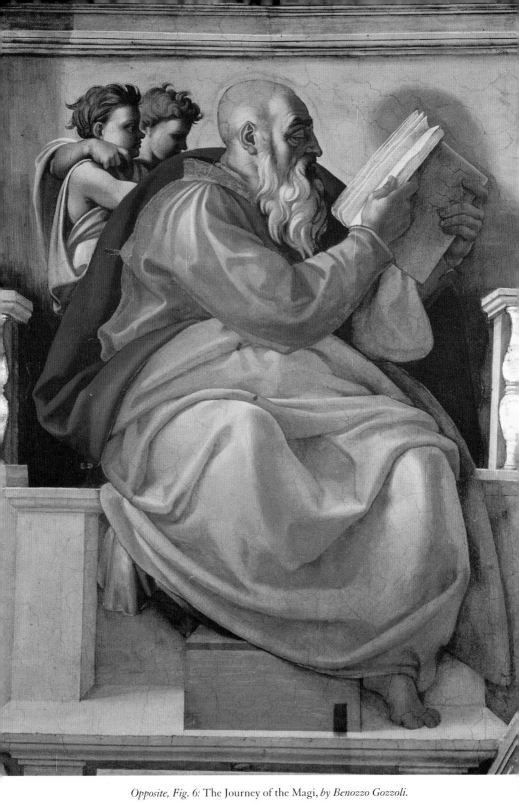

Opposite, Fig. 6: The Journey of the Magi, *by Benozzo Gozzoli.*
Above, Fig. 7: The prophet Zechariah.

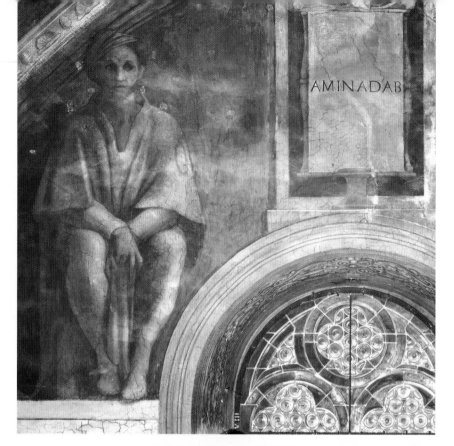

AMINADAB

Above, Fig. 8: Detail of Aminadab *with a yellow ring on his sleeve (pre-restoration). Right, Fig. 9: Detail from* Judith and Holofernes *panel.*

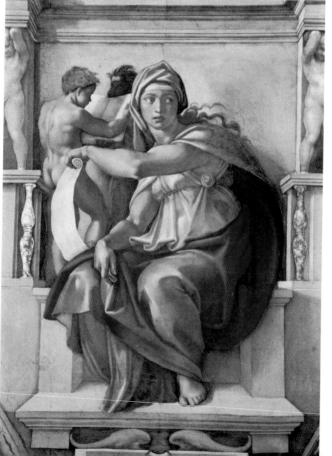

Above, Fig. 10:
Detail from David
and Goliath *panel.*
Left, Fig. 11: The
Delphic sibyl.

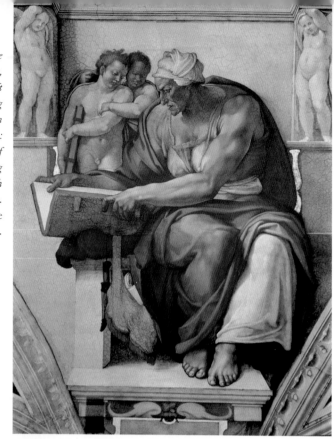

Right, Fig. 12: The Cumaean sibyl. Below, left, Fig. 13: Detail from the left of the Flood *panel showing the Roman colors with an ass. Below, right, Fig. 14: Detail from the right of the* Flood *panel showing the doomed sinners with the same Roman colors. Opposite, Fig. 15: The Creation of Adam.*

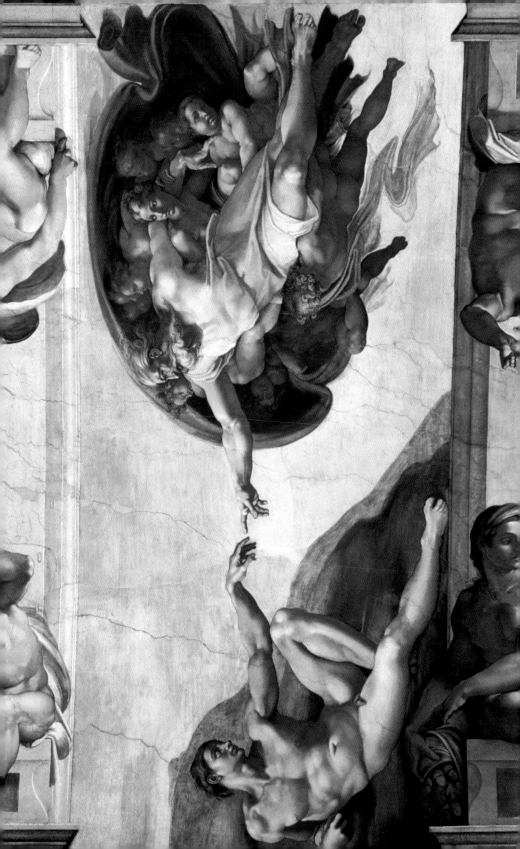

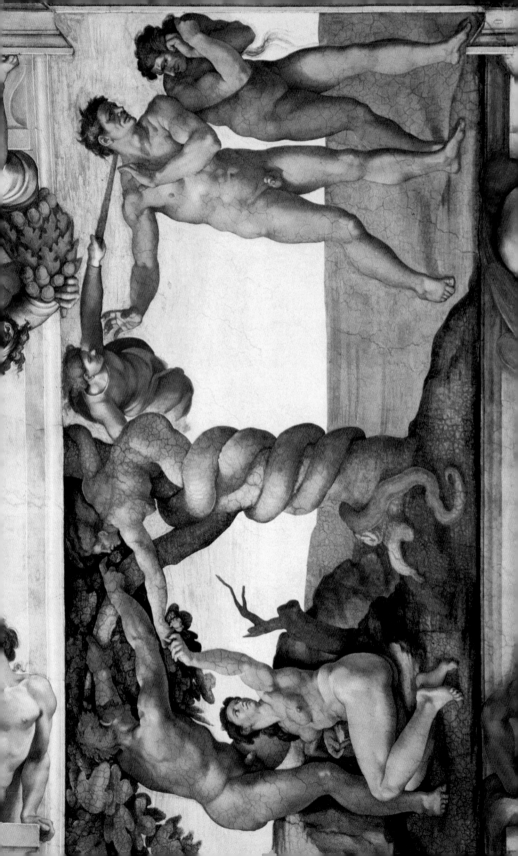

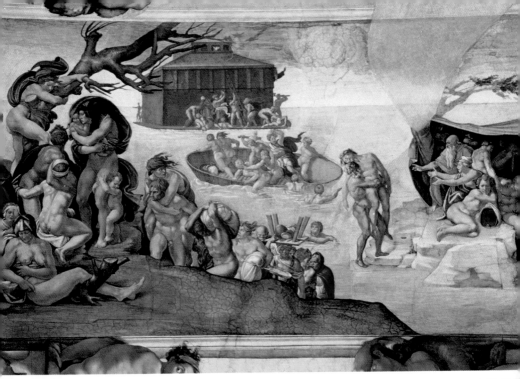

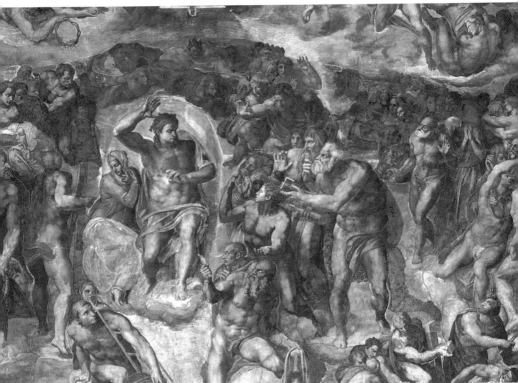

Opposite, Fig. 16: The Forbidden Fruit and Exile from Eden *panel.*
Top, Fig. 17: The Flood *panel. Above, Fig. 18: Detail of* The Last Judgment
(pre-restoration): Two Jews and Pico della Mirandola in Heaven.

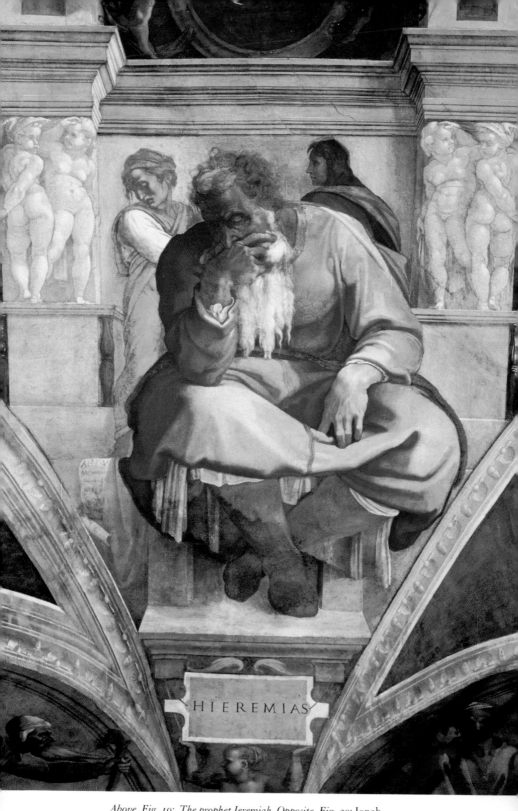

HIEREMIAS

Above, Fig. 19: The prophet Jeremiah. Opposite, Fig. 20: Jonah.

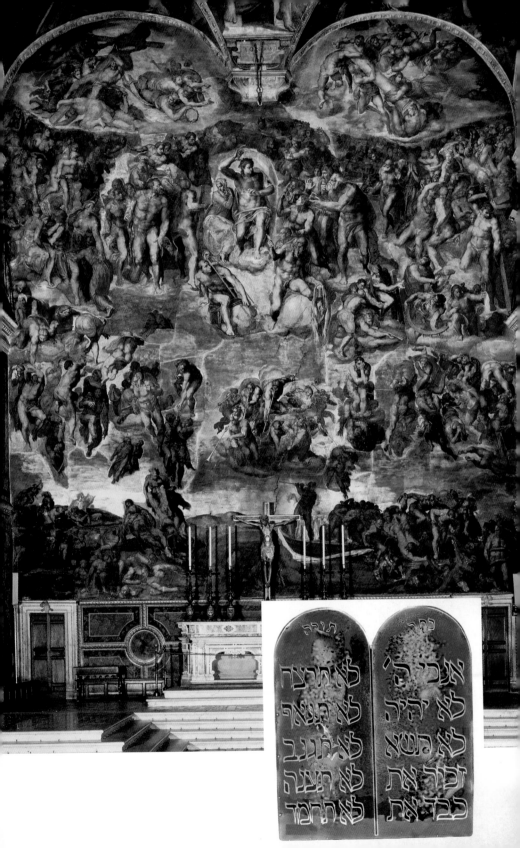

Opposite, Figs. 21 and 21a: The Last Judgment (pre-restoration) compared with the traditional shape of the Ten Commandments. Left, Fig. 22: Detail of The Last Judgment (pre-restoration): The Male Elect. Below, Fig. 23: Detail of The Last Judgment (pre-restoration): Jesus and Mary with the saints Lawrence and Bartholomew.

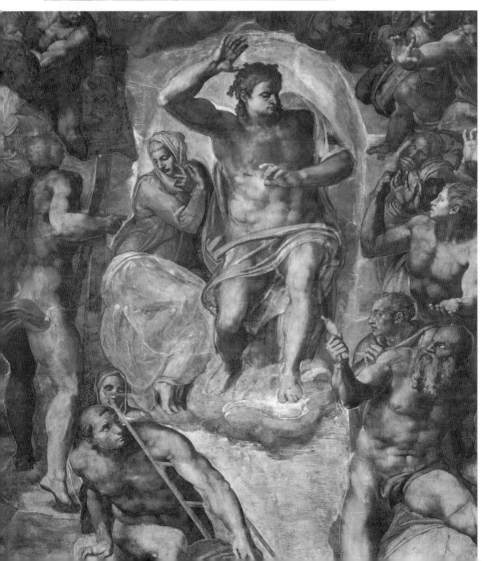

Right, Fig. 24:
Detail of The Last
Judgment *(pre-*
restoration): *Simony*
and Lust dragged
down to Hell. Below,
Fig. 25: Detail of
The Last Judgment
(pre-restoration):
King Minos (with
the face of Biagio da
Cesena).

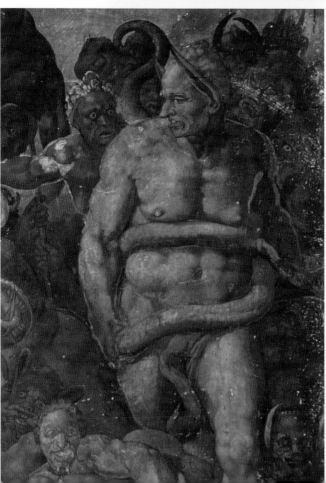

The pope sent him messages, asking him to return to work. Michelangelo replied through friends that he was fine in Florence, and that if His Holiness did indeed intend to have him carve his tomb, he would do it better, more efficiently, more economically, and with more love if he were to stay in Florence. He wrote almost paranoically to one friend that if he, Michelangelo, were to go back to Rome "the first tomb that would have to be made would be mine, before that of the pope." Soon thereafter, though, *Il Papa Terribile* strapped on a sword and went off to reconquer lost papal states—territories under the Vatican's military control that had paid it hefty tributes in gold and supplies. He desperately needed the renewed influx of gold to finance his construction and artistic projects. First he retook the rebellious mountaintop city of Perugia without a shot, and then marched on the center of secession from the Vatican's sway—Bologna. The frightened populace swung open the gates of the city and gave the pope a triumphal welcome worthy of any emperor. This is when Julius truly started to believe his own propaganda that he was the new savior of Christendom. The victorious "Warrior Pope" commanded Buonarroti to present himself at Bologna at once. The words *or else* were not mentioned—they didn't need to be.

Michelangelo, comforted by assurances from mutual contacts that the pope would do him no harm, went to the pontiff's headquarters in Bologna and presented himself on his knees to plead forgiveness. Julius grumbled: "You should have come to Us, but you waited for Us to come to you." One bishop, standing next to Julius, said: "Your Holiness should not recall his errors, since he erred through ignorance. Outside of their craft, all artists are just like this." The pope, enraged, screamed at the unfortunate bishop: "YOU are the ignorant one, not him. Now get out of here and go to the Devil." The dumbstruck bishop did not move fast enough and Julius beat him and ran him out of the room, thus taking out all his pent-up anger on the cleric and not on the sculptor.

Julius forgave Michelangelo for his flight—but on one condition. First the artist had to make a colossal bronze statue of Julius II as the triumphant Warrior Pope with sword in hand, to be erected over

the door of the Cathedral of Bologna as a reminder to the rebellious Bolognesi of who was the real boss. Michelangelo protested that this was not his field—once again he was being forced to create in a medium that he had neither studied nor practiced. Julius, at the peak of his glory and power, did not take no for an answer. So, an unhappy Michelangelo had to move back to one of his least-favorite places, Bologna, in order to struggle with one of his least-favorite art forms. Bronze-casting was extremely difficult, risky, and time-consuming. Now he was charged with the task of creating what would be the largest bronze statue cast since the fall of the Roman Empire.

He set up a workshop and brought in Florentine colleagues and friends experienced in bronze work. Michelangelo was so obsessed with finishing this job and getting out of town that he barely ate a meal and literally slept in his clothes many nights, often just caving in from exhaustion. Once again, destiny was carving his life to prepare him for another herculean, unfamiliar task. This is exactly how he would later tackle the frescoing of the Sistine. Casting the gigantic bronze statue involved a lot of trial and expensive errors. While he was desperately struggling with this task, the plague broke out in Bologna. Michelangelo complained in a letter about the crowded living conditions, the rain, the hellish heat, and the overpriced wine that was "as bad as it can be, just like everything else here." It was also at about this time that he began complaining of swollen, aching feet and back pains. It could not have been the royal (or papal) disease of gout, since he ate irregularly and very simply. Michelangelo once said: "I feast on wine and bread, and feasts they are." According to a recent report in *Kidney International*,[1] this painful retaining of water and lower-back pain could very well have been the early symptoms of kidney problems. This previously unknown ailment of Michelangelo's bears noting because it will make a surprising appearance on the Sistine ceiling.

After more than a year of sweat, frustration, and expensive mistakes, Michelangelo successfully cast the huge statue, finishing it in February 1508. He joyfully returned home to Florence to take care of family business and to get back to his beloved sculpting. His joy would be of extremely short duration.

THE CANOPY OF HEAVEN—AND HELL

The ambitious pope had already discussed the Sistine ceiling with Michelangelo in 1506, probably while they were together in Bologna. No doubt Julius, an art lover, had heard of the huge success of the twin cartoons for the city hall frescoes in Florence. It is very likely that his summons to Michelangelo was also a way for the jealous Roman pontiff to sabotage the Florentine fresco project. We do know that Michelangelo never went back to that job.*

Julius, probably on the strength of the reviews for Buonarroti's cartoon for the fourteen-hundred-square-foot wall fresco in Florence, got it into his head that the artist would have no problem with a *ceiling* fresco that would eventually cover more than *twelve thousand* square feet. Bramante, the papal art and architecture adviser, made a show of protesting that Michelangelo would not be up to the job. This only prodded Michelangelo's friends in the Vatican to redouble their efforts to convince the pope that the Florentine was the perfect man for the job. Of course, with Michelangelo trapped for years up at the ceiling (which before his work on the Sistine was considered anything but a prestigious commission), he would not be able to upstage Bramante with the tomb sculptures or second-guess his cathedral plans. Whether it was a scheme or not, Bramante soon gave his approval and Julius and his advisers eagerly began telling Michelangelo what to put up on the ceiling.

Besides Bramante, the pope's two closest advisers were Cardinal Francesco Alidosi and a preacher named Egidio da Viterbo. Although

*An extra secret, this time about Leonardo: he tried to do his half of the mural project but, after making a beautiful central section, could not resist experimenting with a new fresco mixture that ruined the rest of the work. He gave up and went away to do additional anatomical studies—obviously more impressed by Michelangelo's nudes than he would admit. The entire failed project was covered by a fairly banal battle scene by Giorgio Vasari, who would then go on to become the biographer of both Leonardo and Michelangelo. Only recently, respected art experts have discovered secret signals in the Vasari fresco that lead them to believe that Vasari actually put up an *extra wall* to preserve Leonardo's work underneath. As we write, scientific investigations are under way.

Egidio had studied a bit of Kabbalah, he was anything but a human-istic Neoplatonist. He was a raging anti-Semite who believed only in the supremacy of the One True Church. Alidosi and Egidio were the pope's chosen theologians, and Egidio was known to preach for hours, retelling the story of the creation and the universe as leading in a direct line up through the damnation of the Jews to the corona-tion of Pope Julius II. There was even a third person to deal with, as far as anything that took place in the Sistine Chapel. He was the official Inquisitor of Heresies, a fanatical Dominican friar named Giovanni Rafanelli, who had the right even to interrupt priests in the middle of their sermons if he found any of their statements not 100 percent in line with the Vatican. A critical reason, therefore, that many of Michelangelo's messages in the frescoes had to be so subtle was that they had to get past the scrutiny of these three ecclesiastical censors.

Julius, following recommendations from Alidosi and Egidio, presented Michelangelo with a full plan for the ceiling project. Over the front door should most likely be Jesus, to bless the entrance of the pope and his retinue. In the twelve triangles around the edge of the ceiling would go the apostles. In the middle, to keep things neat and simple, and to avoid competition with the fifteenth-century masterpieces on the lower walls, would be a figureless geometrical pattern composed of diamonds and rectangles, such as was to be found in the remains of many palaces from Imperial Rome. The pope's fawning adviser Egidio da Viterbo wanted the entire ceiling to proclaim that His Holiness Julius II had been specially ordained by God to rule the world. According to some accounts, even when Michelangelo obtained permission from the pope for a design in-cluding images from the Jewish Bible, Egidio proposed a discon-certing list of suggested scenes from the Old Testament—mostly from the book of Kings—and the Apocrypha. Most of them were violent and all shared the concept of divine authority being estab-lished either by grace or by heavenly revenge. This intrusion into Michelangelo's design would have distorted the whole feeling of the project, diverting it from the artist's personal spiritual vision to

yet one more glorification of the della Rovere popes. Obviously, this scheme did not sit well with Michelangelo.

The project seemed like a series of insurmountable challenges:

- It would be the largest fresco on earth—there would be more than twelve thousand square feet to cover.

- He had never frescoed before.

- His competition would be staring him in the face every day—the *Moses* and *Jesus* wall panels, world-class master-pieces created by the top fresco artists in the world—including his own first maestro, Ghirlandaio. When and *if* he ever finished the ceiling, his beginner's work would be compared with these.

- The chapel was in constant use, more than twenty times per month. The scaffolding could not be of the traditional kind, which would require too much wood and thus block up the chapel and render it unusable for years.

- The pope's rigid and unimaginative concept for the ceiling stood against everything Michelangelo believed in, both as a spiritual seeker and as an artist.

- The pope's advisers would be trying to catch him at any changes or "heresies" that he might insert in the work.

- The pope and Bramante had given him a large number of Roman assistants to help with the plaster and paint—but Michelangelo knew very well that their other job would be to spy on his work.

First, Michelangelo spoke privately with the pope, pleading with him that as an artist it was his duty to say that His Holiness's design for the ceiling would be "a poor thing." According to Michelangelo's version of the story, the pope merely shrugged and told him to do it as he pleased. More likely, the artist must have played up to Julius's ego, promising him a handsome portrait to rule over the whole

chapel, just as his sculpted tomb would have his image reigning over the whole cathedral. As we can see today in the Raphael Rooms, Julius never tired of seeing his portrait everywhere he went—he appears on almost every wall that was painted while he was pope.

Michelangelo then summarily fired his Roman staff of assistants. He next sent for five longtime friends, all artists with experience in fresco work, to come in from Florence for the duration of the project. Some would later on be replaced, but Buonarroti hired only Florentine helpers with tightly closed lips, so that none of the Roman spies could find out what he was *really* putting up on the Sistine ceiling.

For the scaffolding that would allow usage of the chapel, the papal architect Bramante took charge. He first proposed hanging scaffolding, suspended from ropes that would be anchored through big holes in the ceiling. Michelangelo convinced the pope that these holes would ruin both the ceiling and the design. Bramante then put forward another solution, an impressive-looking scaffolding with very few poles touching the floor. It collapsed before being used for even one day. All Bramante had succeeded in doing was embarrassing himself in front of the pope. Michelangelo, who had already spent much time studying Roman architecture in the ruins, proposed a revolutionary "flying bow bridge" scaffold. It was based on the principles of the Roman arch, whose weight presses out against the sides it is spanning. This ingenious structure could be inserted in just a few small holes made in the side walls, since all its pressure would flow there, and none down to the floor. It would also allow Michelangelo to fresco the ceiling a whole strip at a time, moving to the next strip as soon as one was finished, and thus progressing across the length of the chapel. He got approval to construct it, and it was an instant success, allowing the papal court to have its regular processions under it without any obstruction.

On the underside of his flying arch bridge, Michelangelo affixed a thick drop cloth, presumably to prevent any paint or plaster from dripping on the papal processions (or on the fifteenth-century masterworks on the lower walls). A far more important reason, of course, was to prevent any snooping eyes from seeing what he was putting on the ceiling.

While all this was going on, the rebellious artist was busy day and night developing his very personal design for the frescoes. Normally, the decoration of a ceiling was a perfunctory job for an artist. Giving this commission to someone of Michelangelo's status was vaguely insulting, and surely Bramante was aware of that. Buonarroti wanted to turn this situation around to his own advantage and create not just another pretty decoration for a chapel, but a testament to his own talent instead. He also wanted to register his disgust at all the hypocrisy and abuses of power that he witnessed daily inside the Vatican of the Renaissance, but to express it in such a way that he would escape being jailed or executed in the process.

Michelangelo's earlier studies of Kabbalah, Talmud, and Midrash afforded him considerable material to incorporate into his plans. Yet we still have to wonder, did Michelangelo come up with every one of his Jewish symbols and mystical references all by himself? We will never know for sure, but it seems likely that two kindred spirits inside the Vatican walls played a role and shared some of their learning with him. One was Tommaso Inghirami, a Christian Neoplatonist who knew a bit of Kabbalah. He was the adviser to young Raphael in planning the many layers of meaning in his famous fresco *The School of Athens* for Pope Julius II's office. The other possible "suspect" would be Schmuel Sarfati, the Jewish physician to the pope. It is a little-known fact that, even through the centuries of Church persecutions when Jews were not allowed to treat Christian patients, almost every pope had a Jewish doctor. Sarfati, besides being a trusted physician and anatomist, was also an extremely cultured man. In addition to being a poet and a scholar of Torah and Talmud, he was well versed in Kabbalah and in Jewish literature. His Latin was of such high quality that he was chosen to formally address the pope in Latin on behalf of the Jewish community of Rome—even though, like Michelangelo, Sarfati was from Florence. Although we have no written documentation of any meeting between him and Buonarroti, it would be quite odd if these two Florentine Renaissance geniuses, both working inside the papal palace, had *not* struck up an acquaintance, given all the things that they had in common.

According to local accounts, in 1511, while Michelangelo was deep in the process of painting the ceiling, the pope fell gravely ill, probably from his years of being infected with syphilis. When he could no longer eat or even speak, it looked as if this was the end of the *"papa terribile."* If the pope died while the fresco project was unfinished, there was a good chance that his successor might cancel or destroy the entire work-in-progress. While the rest of the papal attendants and medical consultants are said to have been busy looting the papal private bedroom as Julius lay inert in bed, his head doctor boiled some peaches and made him suck on their softened pulp. As the story goes, the doctor was able, bit by bit, to nurse the pope back to health, and in no time at all, Julius was back on his feet, terrorizing the palace and being as *terribile* as ever. This doctor would most likely have been his Jewish physician Schmuel Sarfati. And if all of this is true, it would mean that Julius's Jewish doctor helped save the Sistine Chapel ceiling of Michelangelo.

But no matter if someone advised him or not, it was Michelangelo who risked inserting all his secret messages in the frescoes, and it was his talent alone that guaranteed their survival for five centuries.

We need not dwell here on the long, arduous, argumentative process of painting the ceiling, told and retold in books and films. It is true that Michelangelo painted the bulk of it alone, with only assistants for preparing the plaster and paints. It is true that he often argued with Julius, who once even struck him with his pastoral staff in public. It is true that he was so obsessed with getting this job done and returning to his beloved sculpting that he often would go for days without washing or changing his clothes. It is not true that he painted flat on his back the whole time. We have a self-caricature sketched onto a private letter, next to a sadly comic poem about his sufferings up on the scaffolding. This sketch and the sonnet it accompanies testify that it was much worse for poor Michelangelo, up there for four and a half dreadful years of contorting his body.

In the poem, addressed to a close humanist friend of his, Michelangelo sardonically describes how his body is being distorted beyond recognition during this torturous process: swollen up with retained fluids, head forced back unnaturally . . .

Detail from private letter written by Michelangelo, 1510 (Casa Buonarroti, Florence). Note the angry, childlike caricature of the pope's face on the ceiling.

. . . and my brush, always above and dribbling o'er,
Turns my face into a fancy floor.
My loins have gone up into my gut,
While my butt is scrunched up like a horse's rump as a
counterweight . . .

He ends the poem on a very despondent note, which tells us just how much he hated this job:

> *My dead painting and my honor, Giovanni, by now only you*
> *can defend—*
> *Since I'm not in a nice spot, nor even a painter in the end.*

Michelangelo was so frantic to escape from this "not so nice spot" that as he neared the end of the ceiling, he used fewer and fewer preparatory cartoons and outlines to guide his brush in the wet plaster, and started doing something that no other artist had dared to do: *he was frescoing freehand.* In fact, whereas many of the early panels were the products of month after month of intensive labor, the *Creation* panel above the altar wall was painted completely freehand in only one day.

It was not only a case of rushing to get back to sculpting. He knew that his physical health was in jeopardy if he stayed at this job much longer. As it was, by the time he finished, he had scoliosis, incipient rheumatism, respiratory problems, more water retention and possible kidney stones, and vision complaints. For a year afterward, until his eyes finally refocused, he could read a letter or look at a drawing only by holding it high over his head, as if he were still painting the ceiling.

When he finished in the fall of 1512, the first thing that Michelangelo did was destroy his incomparable flying arch bridge and then burn all of his notebooks and private sketches for the ceiling. What those sheets of expensive paper, covered with his true intentions for the frescoes, might have told us—we will never know. However, the very fact that he felt compelled to destroy the evidence gives us an idea that the papal censors would not have approved.

Before the great unveiling, Pope Julius came for a private preview. He gave his gruff acceptance of the work, but with one complaint. He informed Michelangelo that the job was not done, that he would have to reassemble both his crew and the scaffolding. Julius wanted to see more of the della Rovere family colors up on the ceiling—royal blue and gold. These were the two costliest colors

for any fresco painter, since gold meant real gold leaf and royal blue was made from pure, imported lapis lazuli, a semiprecious gem. Since the pope had made the artist pay for the materials out of his own earnings, there was precious little of either color on the ceiling. Buonarroti wearily but stubbornly replied that the project was finished and impossible to start up again, and that the colors were as they should be. The haughty pontiff sarcastically threw the artist's original complaint back in his face: "Well, then it shall be a very 'poor thing.'" Michelangelo got the last word: "The holy people we see up there—they were very poor, too."

The lavish celebration occurred on the anniversary of the pope's coronation—October 31, 1512. On that day, Western painting changed forever. Michelangelo, the sculptor, had painted over three hundred figures that seemed to be sculpted on the two-dimensional ceiling. Artists and art lovers flocked from all over the world to gawk in astonishment and sheer admiration at this superhuman feat. Five centuries later, they still do. Michelangelo, in spite of a sea of challenges, obstacles, and doubts, had triumphed.

Less than four months later, the Warrior Pope died peacefully in bed. Michelangelo, the sculptor, turned his talents back to the project that had brought him to Rome, carving Julius II's giant tomb.

THE OFFICIAL STORY

There are many books, theses, and articles dedicated to various interpretations of the Sistine ceiling frescoes, but the most widely accepted view over the centuries has naturally been that of the Vatican. How, then, does the Church officially explain Michelangelo's untraditional and often confusing design?

In the Vatican Museums' official publication *The Sistine Chapel,* Fabrizio Mancinelli writes that the *Genesis* panels in the middle are "intended to illustrate the origins of man, his fall, his first reconciliation with God and the promise of future redemption."[2] The problem with this oft-repeated interpretation is that the strip ends with Noah getting drunk and exposing himself, while his son Ham laughs at

him and his other sons try to cover him up. Is this really a promise of future redemption? If so, it is a very muddled one. Of the unusual mix of prophets and sibyls, the book says that they "in a more or less clear manner foretold the coming of the Redeemer of Humanity." It does not bring up the mix of prophets and sibyls that most young men of the time would have studied in Pseudo-Phocylides, as discussed in the chapter on Michelangelo's *formazione*. The rest of this official explanation of the ceiling is rife with phrases such as "not completely clear from the thematic point of view," "no real structural connection," and so on.

Basically, the Church explains the huge fresco as simply "the promise of Redemption through Christ and his Church." In other words, the creation of the universe, the Original Sin, the Flood, Noah's sin of drunkenness, the pagan sibyls, the Hebrew prophets, the Jewish ancestors all lead up to the coming of the Savior and his One True Church under the divinely inspired guidance of His Holiness Pope Julius II della Rovere. Even the vastly popular Wikipedia, the online interactive encyclopedia, says:

> *The subject matter of the ceiling is the doctrine of humanity's need for Salvation as offered by God through Jesus.*
>
> *In other words, the ceiling illustrates that God made the World as a perfect creation and put humanity into it, humanity fell into disgrace and was punished by death, and by separation from God. God sent Prophets and Sibyls to tell humanity that the Saviour or Christ, Jesus, would bring them redemption. God prepared a lineage of people, all the way from Adam, through various characters written of in the Old Testament, such as King David, to the Virgin Mary through whom the Saviour of humanity, Jesus, would come. The various components of the ceiling are linked to this doctrine.*[3]

Clear and simple ... except—if this is such a deeply religious work, why does Michelangelo hide at least three vulgar gestures aimed at the pope? If this is such a deeply Catholic work, why in more than three hundred figures is there not even a single Christian one? As we will see, other than a series of barely noticeable names

that bounce around the room, going from Abraham to Joseph, the Jewish father of Jesus, there is nothing Christian at all up there, and definitely no Christian symbols or figures. With twelve thousand square feet to cover, it is doubtful that Michelangelo ran out of room. And where are Jesus and Mary? They are nowhere to be found in the whole work. About 5 percent of this famous ceiling is composed of pagan symbolism and the rest—about 95 percent of it—is all Jewish themes, heroes, and heroines. Many guides and commentators claim, as does the Wikipedia article above, that Michelangelo's concept for the work culminates in the final redemption of Jesus—that is, *The Last Judgment* on the front wall. The problem with this common explanation is that Buonarroti left the chapel in 1512, hoping never to have to paint another brushstroke in there again. He was forced by another pope *twenty-two years later* to create that front-wall fresco. Hardly an organically thought-out design.

Extremely strained explanations have been put forth by the Vatican down through the years. Several have claimed that Michelangelo must have been following long, arcane preachings on the history of Jesus's salvation—either from Egidio da Viterbo, in a long-winded homily on the history of the world that he gave in Rome in *1502* (while Buonarroti was still living in Florence), or by other more obscure theologians that the artist would never have met or read, or even a series of sermons by none other than the fanatical Savonarola. Buonarroti had been so traumatized by the monk's rantings that the artist claimed even in old age that he could still hear the Dominican's voice in his head. Some art historians think that this is a testament to Michelangelo's deep-rooted Catholicism and love for the Church . . . and even for Savonarola.

Let us give the artist himself the final say here. Right after completing the debilitating task of frescoing the ceiling, he wrote another angry poem to his friend, describing the Vatican in 1512:

Here they make helmets and swords from chalices
And by the handful sell the blood of Christ;
His cross and thorns are made into lances and shields;
Yet even so Christ's patience still rains down.

But let him come no more into these parts;
His blood would rise up as far as the stars;
Since now in Rome his flesh is being sold;
And every road to virtue here is closed.[4]

The man who penned these lines would not have toiled four and a half years under horrible conditions in order to create a paean of praise and glory to the holiness of the Church under Pope Julius. In the following chapters, we are going to take you on an unprecedented private tour—a step-by-step explanation of what Michelangelo *really* put up on that ceiling.

A Private Tour
of the Sistine Temple

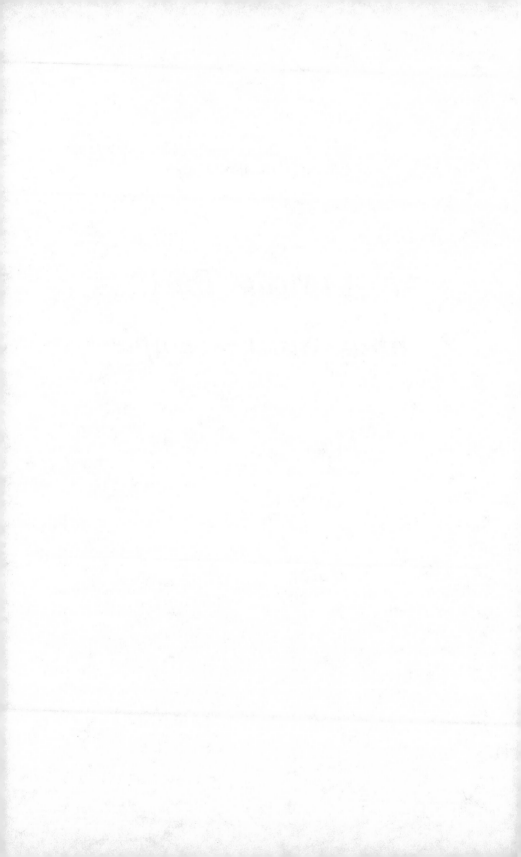

CROSSING THE THRESHOLD

Without having seen the Sistine Chapel
one can form no appreciable idea of what
one man is capable of achieving.

— GOETHE

YOU DON'T ENTER the same way anymore.
Today, your first view of the magnificent frescoes is far from what Michelangelo had in mind. The great portal of the pontiffs is closed to the average visitor. Instead, you pass through a narrow acolytes' doorway at the far end of the hall. If you have a moment to look back, you will notice that you have just passed beneath the family crest of Alexander Borgia, the "poisoner pope," and under the crotch of King Minos, condemned to have his genitals chewed eternally by a poisonous serpent in the fresco of *The Last Judgment.*

Harried guards immediately direct you to get off the altar area. You are unceremoniously hustled onto the main floor, which is completely filled by the feet of thousands of tired visitors who have

just made it through the labyrinth of the Vatican Museums complex. You are immersed in a mob of overwhelmed tourists and pilgrims, harsh cries of "Silence ... No photos, no video" from the staff, and arrogant visitors who nonetheless insist on taking photos and videos. You look up and crane your neck to try to grasp visually what you have only seen in photographs and illustrations, but you are simply overwhelmed by the hundreds of swirling figures, shapes, and bright colors.

You last perhaps ten or fifteen minutes in the presence of this massive sensory overload before you exit—having seen most of it upside down and backward from the direction of Michelangelo's design.

And this is the way that most visitors experience the great Sistine Chapel.

Small wonder, then, that most of the profound meaning and messages of Michelangelo remain unnoticed by the average tourist. Even scholars have misinterpreted or overlooked many of the ceiling's secrets for centuries. To appreciate fully the miracle that is Michelangelo's Sistine Chapel, a viewer needs to understand Michelangelo's motivations, his background, his early years of intellectual ferment with private tutors in the Palazzo de' Medici in Florence, and—perhaps the most unrecognized influence on his entire career—his fascination with Judaism and the mystical teachings of the Kabbalah. Did he himself come up with every bit of this forbidden knowledge that he then incorporated into the Sistine? We have already indicated some potential "suspects," such as the pope's Jewish physician Schmuel Sarfati and the Christian Kabbalist Tommaso Inghirami, but we will never know for sure. What we do know is that Pope Julius II, ill with syphilis and burdened with other affairs, finally did leave the design of the ceiling project to the argumentative Michelangelo. In a private letter eleven years after the project was finished, Michelangelo recounted that when he and the pope could not agree about the design ("It seemed it would not turn out well"), Julius finally capitulated—the first time in history that a pope had yielded to a painter. Surprisingly, Julius granted

Buonarroti "a new commission that I should do what I wanted." Whatever his source of Jewish knowledge—his own studies or advice from others behind the scenes—it was the sculptor-turned-painter-under-duress who ultimately risked his art and his very life by choosing and embedding these messages in his master plan.

What is this plan, then? What does the great ceiling really mean? To understand it fully, we have to experience it the way that Michelangelo created it and meant it to be interpreted: step by step, layer by layer.

It is important to keep in mind that originally all visitors to the chapel entered through the front door, to experience the sanctuary as an organic whole, first seeing the entire length of the hall from the portal and then slowly immersing themselves in the imagery, step by step. Michelangelo's purpose was twofold: On the one hand, the impact of the large-scale all-encompassing view served as powerful inspiration; one could not help but be overwhelmed, both visually and emotionally. But there is another function—a brilliant technique to conceal the deeper and more dangerous messages in his work. Michelangelo put so many different ingredients into the mix that the average viewer is distracted, unsettled, and ultimately disoriented.

To give you an idea of how much Michelangelo included in the chapel ceiling, here is just a small list of its major components:

- Trompe l'oeuil architecture
- The four salvations of the Jews
- The genealogy of the ancestral Jews
- Prophets
- Sibyls
- Medallions
- Garlands
- Giant nudes
- Bronze nudes

- Putti

- The first two Torah sections of the book of Genesis—
 event by event

There is so much information and decoration that this, the world's largest fresco painting at about twelve thousand square feet, seems overstuffed and overdone. Let us be clear: it *is*—and on purpose. Think of a master magician performing sleight-of-hand tricks. The prestidigitator will be making so many flourishes, grandiose gestures, and distracting movements with one hand that you will never notice the real operation happening in the other hand. So it is with the artwork in the Sistine Chapel.

Of course, one can find significance in every element in the frescoes, but even the most casual comparison with the austere simplicity of Michelangelo's sculpture and architecture—for example, the *David,* the Campidoglio Piazza, the *Pietà,* and the de' Medici Chapel—suggests that the sensory overload of the Sistine is the result of a conscious decision on the part of the artist. Michelangelo's genius was in allowing the viewer to see a great deal—in order *not* to show what is best left secret, except to the knowledgeable few. In other words, he put in so many trees that we cannot see the forest.

To view the chapel ceiling in the private way that the artist intended for his inner circle, imagine that you enter with your eyes closed, that someone guides you down the altar steps and across the length of the room, through the marble partition, to the far end where you turn around and open your eyes. This is an apt image, since to understand all of Michelangelo's secret messages, you will need to close your eyes to the standard interpretations, go bravely forward, turn your mindset around, and open your eyes to a new reality.

To unveil and understand the Sistine secrets, we will need to proceed with care, in a Neoplatonic, Kabbalistic way: starting from the edges and working our way in, element by element, toward the central core of meaning.

Turn your gaze now directly over the large wooden *portone* (great door) of the pope and you will see the first of seven Jewish prophets on the ceiling—Zechariah. Whenever the pope enters the chapel

through the main entrance, Zechariah is sitting right over his head, *in the very spot where Pope Julius II had wanted Michelangelo to place Jesus.*

Why one of the later, lesser-known Jewish prophets over the front door of the Sistine? Michelangelo must have selected Zechariah for a variety of reasons—again, there are multiple layers of meaning, so integral to Talmudic and Kabbalistic thought, and so dear to Michelangelo. First of all, Zechariah warned the corrupt priesthood of the Second Holy Temple: "Open your doors, O Lebanon, that the fire may devour your cedars" (Zechariah 11:1). This was a prophecy that if the priesthood did not cease its corrupt, unspiritual behavior, the doors of the sanctuary would be broken open by attacking foes and the Temple, built partly of cedarwood from Lebanon, would be burned down. And here is the author of that warning, right over the doors of Pope Julius's sanctuary.

Zechariah is also the prophet of consolation and redemption. He is the one who urges the Jews to rebuild Jerusalem and the Holy Temple: "Thus says the Lord of hosts; My cities shall again overflow with prosperity; and the Lord shall yet comfort Zion, and shall yet choose Jerusalem" (Zechariah 1:17). In his own way, Buonarroti is clueing us in on the fact that he knows what the Sistine is—a full-sized copy of the *heichal,* the long rectangular back end of the Jewish Holy Temple. At the same time, however, he is letting us know that he does not subscribe to the Church's theology of successionism; he does not believe that Jerusalem can be replaced by a copy of the Temple in a foreign land.

Another vision of Zechariah involves "four horns" that will afflict Israel. These are four exiles under oppressive foreign regimes: Egypt, which had already ended; Babylon, which was just ending during Zechariah's time; Persia, which had just conquered Babylon; and finally Greece. These four horns are reflected in the four curved panels in the corners of the ceiling, which surround Zechariah and which contain so many secrets that they merit an upcoming chapter.

Zechariah also had another prophetic vision, of the Holy Menorah, or golden seven-branched candelabra, in the Temple. Even

though it had seven branches, they were all made from a single piece of beaten gold, and all their lights leaned together toward the center. This is the reason that the original partition grill in the Sistine had seven candle flames of marble sculpted on top—it symbolized the Menorah, placed right before the image of Zechariah. These seven lights, according to his prophecy, are "the eyes of the Lord" (4:10) that watch over the whole of creation.

This symbol of all the different branches stemming from a single piece of gold is the core of Zechariah's teaching, and also of Michelangelo's message. It means that even though there are many various branches of belief, and many names for God, all come together in the end, to one common Light. No one People of the Book has the right to try to dominate, subdue, invalidate, or convert another. "'Not by might, nor by power, but by My Spirit, says the Lord

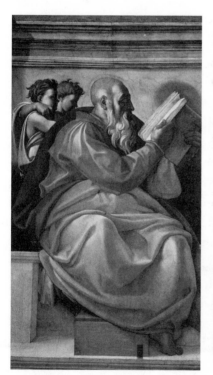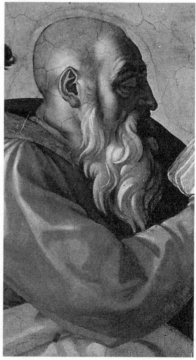

Left: Zechariah—*directly over the papal entrance.* Right: *Detail of* Zechariah *showing Pope Julius's face. See Fig. 7 in the insert.*

of hosts,' proclaims the prophet" (Zechariah 4:6). Right at the outset of decorating the pope's supremacist, exclusionary sanctuary of the One True Church, Michelangelo painted one of the most universalist, inclusionary figures of the Hebrew Scriptures, in the hope that one day his message would be heard and heeded even in the Vatican's Sistine Chapel: ". . . and on that day the Lord shall be One, and His Name—One" (Zechariah 14:9).

Still, the rebellious artist had placed a minor Jewish prophet in the important spot where the pope had wanted Jesus. How did Michelangelo imagine he would avoid the pope's wrath in openly defying his wishes? Replacing Jesus with a minor prophet might have doomed any other commissioned artist, but Michelangelo found a brilliant way to appease his patron. The *Zechariah* panel is not simply an idealized portrait of a biblical figure. Michelangelo superimposed a portrait of Pope Julius II on the ancient Hebrew prophet. Not only that, but Michelangelo portrayed Zechariah dressed in a mantle of royal blue and gold—the traditional colors of the della Rovere clan, the family of both Pope Sixtus IV and his nephew Pope Julius II. Replacing the image of Jesus Christ with a portrait of the pontiff? This was no problem for the egomaniacal Julius. It placed his visage permanently over the entrance to this glorious new sanctuary for all future popes and commemorated his family's role as its builders.

The juxtaposition of Julius over the royal entranceway was a masterful psychological stroke by Michelangelo. At the very beginning of the great project, it must have helped ease the pope's fears about the rebellious artist's behavior. It is not hard to imagine that Michelangelo counted on this sop to the pope's gigantic ego to help gain him pardon for subsequently abandoning the pope's design of an entirely Christian ceiling.

But Michelangelo couldn't entirely subdue his true feelings toward his patron. He was distraught at the prospect of several lonely years up on ladders and scaffolding, doing the type of art he most disdained—painting—and not being able to pursue his greatest passion in life—sculpting. So he incorporated yet another message in

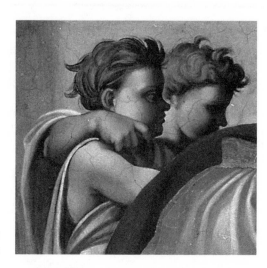

*Two putti "giving the fig" to
Pope Julius's portrait*

the supposed tribute to the pope that leaves us with a totally differ-
ent perspective.

The putti, or little angelic figures, in the panel with Zechariah
serve as "supporting characters," created by Michelangelo to "whis-
per" subtly to the informed viewer the real thoughts of the artist.
In this case, they are looking over the prophet's shoulder, casually
reading his book. One angel leans on his companion; they look for
all the world like two modern Italian soccer fans reading the latest
match results in someone else's newspaper on the subway. What is
very hard to see is that the little innocent golden-haired angel who
is resting on the other is making an extremely obscene hand gesture
at the back of Pope Julius's head. He has made a fist, with his thumb
stuck between his index and middle fingers. This is called "making
the fig"—and it is the medieval and Renaissance version of what we
would call today "giving someone the finger" or more colloquially,
"flipping the bird." It is a bit blurred and shadowy on purpose, since
if the elderly pope had seen it clearly, Michelangelo's career—and
most probably his life—would have ended right there.

True, hardly anyone realizes it, but to this day when a papal pro-
cession enters through the giant portal for a rare mass in the chapel,
the pontiff passes right under a portrait of his predecessor getting
the finger from Michelangelo.

THE VAULT OF HEAVEN

As below, so above: as above, so below.

— KABBALISTIC PROVERB

O NE OF MICHELANGELO's many objections to painting the Sistine ceiling was its lack of Classic architectural details. The chapel, even though it follows the exact measurements and proportions of the original Holy Temple, has a simple, medieval feel. The ceiling is a plain barrel vault, its austerity relieved only by the twelve triangles around the edge. This was entirely the opposite of Michelangelo's taste. He loved pagan Roman design: the Pantheon, the muscular male Greco-Roman statues being discovered all over Rome, the details from broken cornices found in the Forum, and the coffered ceilings of the Basilica of Maxentius, just to name a few examples. A barrel-vault design from the Middle Ages would not have suited his taste at all.

There is a story told about him when he was very old, famous, and wealthy. A cardinal was passing by in a fancy carriage on a snowy winter day and noticed the great artist trudging through the slush

and mud, heading toward the Colosseum and the Forum. (Back then, the Forum was called the *campus bovinus,* the "cow field," since only a few of the tallest remnants of the ancient glories of Rome were sticking up through the dirt.) The cardinal ordered his coachman to pull up alongside Michelangelo and offered him a ride. The proud Florentine refused the offer, saying, "Thank you, but I am on my way to school." "School?" replied the puzzled cardinal. "You are the great Buonarroti. What school could possibly have anything to teach you?" Michelangelo pointed to the Colosseum and the few battered remains of the Forum. "This," he answered, "this is my school."

When Michelangelo planned the great ceiling project, one of the first parts of his concept was a trompe l'oeuil architectural structure, not only to appear to hold up the vault, but also to frame the huge variety of panels and images, much like an art gallery sixty-five feet up in the air. The faux structure has several other functions as well. In spite of seeming to be heavy marble, it lightens up the massive barrel-vault ceiling and appears to lift it toward the heavens. When you stand at the main entrance to the chapel, in front of the great *portone* of the popes, the ceiling does not seem flat, but rather like an airplane taking off into the sky. To add to this effect, Michelangelo inserted two tiny slits of faux sky at either end of the vault, subliminally making the viewer feel as if the whole fresco were an open, airy framework. It also signals the viewer that the ceiling is not a "minestrone" of floating bits of unrelated images, but a true unified, organic system of thought, much like the Neoplatonic unifying philosophy that had so absorbed Michelangelo in his youth.

The school of Neoplatonism offers us a clear explanation for the faux Roman architecture that forms the skeletal frame of Michelangelo's work. Pico della Mirandola and the other teachers of the de' Medici circle were enamored of Philo of Alexandria, an early Jewish philosopher who developed a profoundly influential system of Kabbalistic thought early in the first century CE. In fact, many theologians and religious historians credit Philo's writings with having a major formative effect on the beginnings of Christianity. In one of his better-known works, *De Opificio Mundi* (On the

creation of the world), Philo describes God as the "Great Architect" of the universe.

When any city is founded through the exceeding ambition of some king or leader who lays claim to absolute authority, and is at the same time a man of brilliant imagination, eager to display his good fortune, then it happens at times that some man coming up who, from his education, is skillful in architecture, and he, seeing the advantageous character and beauty of the situation, first of all sketches out in his own mind nearly all the parts of the city which is about to be completed. . . . then having received in his own mind, as on a waxen tablet, the form of each building, he carries in his heart the image of a city. . . . like a good workman, keeping his eyes fixed on his model, he begins to raise the city of stones and wood, making the corporeal substances to resemble each of the incorporeal ideas. Now, we must form a somewhat similar opinion of God, Who, having determined to found a mighty state (the Universe), first of all conceived its form in his mind, according to which form he made a world perceptible only by the intellect, and then completed one visible to the external senses, using the first one as a model.[1]

This beautifully describes not only the process for an architect, but also for a Renaissance artist, particularly one preparing to create a fresco. The painter first had to conceive of the entire project, mapping it out in his head, then making sketches and preparatory full-size drawings on paper, which were then finally transferred onto the permanent plaster surface.

Michelangelo's project surely brought Philo's all-incorporating philosophy to mind. Just as the Divine Architect mapped out the entire master plan of the creation, the artist must first map out the planned unity of his project.

In Michelangelo's study of Midrash, the collection of oral lore connected to the Jewish Scriptures, he almost certainly came upon the famous dictum that "The Creator used the Torah as the blueprint of the universe." In the order of creation, the Torah came first. "I

was in the mind of the Holy One," the Torah is quoted as saying, "like the overall design in the mind of a craftsman." The Midrash continues: "In the way of the world, when a king of flesh and blood builds a palace, he builds it not according to his own whim, but according to the idea of an architect. Moreover, the architect does not build it out of his own head; he has [a design]—plans and diagrams to know how to lay out the chambers and where to put in wicket doors. Even so the Holy One looked into the Torah as He created the world" (B'resheet Rabbah, 1:2).

Architectural design as a metaphor is so important in classic Jewish thought—later adopted by the Neoplatonic school—that it is linked with the beginning of monotheism and Abraham's discovery of God. How did Abraham come to the startling conclusion that there must be a single, unique Creator? The Midrash explains that Abraham, living in a pagan world, at first could not conceive of a Higher Power. One day, however, "Abraham passed a palace with beautifully constructed rooms, magnificently tended lawns and intricately planned surroundings and suddenly said to himself, 'Is it possible that all this came into being on its own without builder or architect? Of course that is absurd. And so too must be the case with this world. Its ingenious design bespeaks a Designer'" (B'resheet Rabbah, 39:1). It was the concept of a Divine Architect that brought the idea of One God to humanity.

For Michelangelo the faux architectural framework he created for the Sistine ceiling allowed him to express not only a correspondence between the divine and the human architect but also to illustrate an important principle of Kabbalistic harmonizing unity. It is yet another secret that almost no visitor to the Sistine knows. To demonstrate Philo's philosophy that all faiths and cultures come from One Source and lead to One Source, Michelangelo pulled off the most amazing feat of perspective in the Renaissance. The large panels on the central strip of the ceiling are framed by giant naked youths, the *ignudi*. These ignudi are seated with their feet or toes resting on square trompe l'oeuil pedestals with pairs of small naked putti carved into the stone. When anyone looks at the square bases all

over the vault, their angles are askew. No matter where you stand in the chapel, the pedestals seem to pop out at many disorderly angles.

There is one spot, however, on the smallest but most central of the porphyry disks in the middle of the mosaic floor, that creates a different perspective. Stand on precisely that spot and all the square bases suddenly align themselves perfectly and point *directly at your head.*

What is truly amazing is that Michelangelo executed this so perfectly from sixty-five feet above the chapel floor, visualizing the sight lines through an obstacle course of scaffolding and canvas drop cloths, over a period of four long years and without the aid of computers or laser aligning devices.

Why did Michelangelo pick this particular porphyry disk on the floor for this fantastic effect? This was the disk upon which the pope himself knelt during many rites in the chapel. Back then, the white marble grill was in the center of the chapel, immediately *after* this disk when one entered from the great portal. This was another reminder from the original designers of the chapel, marking the exact spot in Solomon's Temple in Jerusalem where the High Priest passed through the Veil to enter the Holy of Holies. Just before

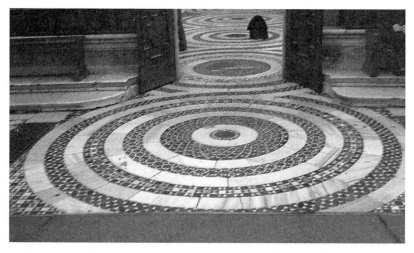

Another rare photograph, taken under the same conditions as the one on page 15. Still, it is easy to see the papal disk with ten concentric "spheres" on the Sistine floor.

crossing through the Sistine's partition and entering the inner part of the sanctuary, the ruler of the Catholic Church would have to kneel down on the last of the ceremonial disks, the small central core of ten concentric circles, akin to the Ten S'firot (spheres of the universe) of the Kabbalistic Tree of Life. Michelangelo, in his fresco, added the crowning touch. If the pope looked up, the entire unity of the Alexandrian architecture would bear down on his head, a truly humbling experience for those in the know who have actually stood on this spot. (However, knowing Julius II's ego, he probably thought it was proof that the entire universe revolved around him.)

Whether the visual effect was meant to be humbling or exalting, Michelangelo almost magically pulled together the earlier paving of the sanctuary with his sixteenth-century ceiling. In fact, this is just about the only spot where one can experience the chapel as a harmonized whole instead of an overwhelming visual bombardment. In this way, Michelangelo managed to join the preexisting flooring with his new ceiling design into a unique statement. The result was an uncanny illustration of the ancient Kabbalistic tenet "As below, so above; as above, so below." In other words, the spiritual design of the floor reflected the spiritual design of the ceiling, and vice versa. Michelangelo had fully absorbed the mystical teaching from ancient Judaic sources that our actions on earth, whether good or evil, can indeed influence the universe. Here was a concept that appealed to Michelangelo as a disciple of the school of Neoplatonism as well.

In his biography of Plotinus, Porphyry records the last words of his teacher to his students: "Strive to bring back the god in yourselves to the God in the All."[2] That final legacy of the master of Neoplatonic philosophy left its mark in Michelangelo's incredible unification of the lower and upper spheres in the Sistine Chapel.

Years after Michelangelo had created this effect in the Sistine, the same as-below-so-above reflection was echoed in other great structures in Rome. Two prime examples are the Palazzo Farnese (in which Buonarroti himself had a hand) and the Church of Sant'Ivo by the Baroque architect Borromini, who in the seventeenth century followed in Michelangelo's footsteps by embedding a great deal of

hidden Kabbalistic and even Masonic imagery in his works for the church. In this case, the shapes of both the floor of Sant'Ivo and the cupola above contain the same camouflaged design—the Kabbalistic Seal of Solomon, better known today as the Star of David. As in the Renaissance, so in the Baroque.

So far, we have looked at only the underlying faux architectural "foundation" of the ceiling and the very first panel over the front door. Already Michelangelo has used ancient Kabbalistic design to unify the chapel, has buttered up the dangerous Julius II to his face and cursed him behind his back ... and the cunning artist is just getting warmed up.

At this point, your eyes are being drawn ever more strongly to the famous panels in the center of the ceiling, but as Buonarroti himself said, "Genius is in eternal patience." We need to proceed *a cipolla*—onion-style, layer by layer. The next elements are among the most ignored parts of the giant fresco, but they hold the keys to some of the biggest secrets in the whole Sistine.

THE HOUSE
OF DAVID

A sign between Me and you throughout
your generations . . .

—EXODUS 31:13

Y OU WILL REMEMBER that the original commission for the
ceiling was a plan designed by the pope and his closest ad-
visers. Jesus was to have been the focal point of the project,
surrounded by his apostles and probably also Mary and John the Bap-
tist. This commission was especially dear to the pope's heart, since
the chapel had originally been built by his uncle Sixtus IV and would
be an eternal monument to their family's glory. Now Michelangelo
was about to subvert the entire project to secretly promote his own
beliefs, especially those of humanism, Neoplatonism, and univer-
sal tolerance. He had already somewhat appeased the pope with his
ploy of putting him in the place of Jesus—but how was he going to
get the pope to pay for the world's largest Catholic fresco without a
single Christian figure in it? And how would he get his design past
the papal censors? The Vatican explains the underlying concept for

the ceiling—indeed the whole chapel—as all of earlier religious history, composed of paganism and Judaism, leading up to the coming of Jesus the Messiah. In fact, though, it is the *Hebrew* Bible's heroes and heroines who have the starring roles on the ceiling.

To resolve this dilemma, Michelangelo created the panels known as *The Ancestors,* set in the walls beneath the central ceiling frescoes. Here Michelangelo at least minimally fulfilled the terms of his contract by tracing the lineage of Christ according to the Gospel of Matthew, the first verses of the Christian Bible. This genealogy follows the Vulgate, the Latinized version of the original names in the text, and is arguably the only Christian element in the entire work, even though it is just a barely noticeable series of names without any Christian imagery. Yet even with his choice of Christian *text,* the antiestablishment artist was already blazing his own trail. Up until Michelangelo, the preferred source for the lineage of Jesus was the Gospel of Luke, which begins with Adam, not Abraham. Indeed, many medieval and Renaissance images of the Crucifixion show the skull of Adam at the foot of the cross, symbolizing that Christ's sacrifice had graced humanity with a way to expiate the Original Sin of the first man and woman. In the Sistine, though, the people named in Jesus's family tree are all Jews.

These little off-white plaques, a seemingly minor element overlooked by all but the most informed viewer, in fact saved the entire ceiling project—and probably the artist's life as well. Remember that the pope's commission to Michelangelo was a series of portraits of Jesus and his apostles—a contract the rebellious artist broke on the very first day of painting.

The "ancestors," with their plaques of names, do not proceed in order. Originally the names of the Jewish patriarchs Abraham, Isaac, and Jacob were on the front wall over the high altar—where everyone's attention would naturally be drawn during mass. The all-important final names in the line of descent are those of Jacob and Joseph, Jesus's grandfather and father. According to the Church's explanation, Michelangelo was painting in chronological order, as he did with the Genesis scenes in the middle strip. However, these

final names are practically lost, tucked away on the back wall in the right corner, a place usually darkened by shadow and naturally ignored by the average visitor. If indeed the goal of the ceiling project was to show all ancient history as leading up to the coming of Christ, then this final panel should have had a much more central (and noticeable) place of honor.

Matthew's aim in his Gospel was to demonstrate a direct line of descent from Abraham to Joseph, the father of Jesus. But what is strange about Michelangelo's method is that, if this were the case, Michelangelo should have simply painted the names in straight chronological order. He did not, but instead somewhat followed the strange zigzagging order of the trompe l'oeuil niches of early popes, frescoed there in the previous century by Botticelli and his overwhelmingly Florentine team of artists. Then, more than two decades later, Michelangelo did not hesitate to eradicate the two important plaques of Abraham-Isaac-Jacob-Judah and of Phares-Esrom-Aram from the front wall over the altar to make way for his *Last Judgment* fresco . . . and, in the process, disrupt forever the chain of Jesus's lineage in the chapel decorations.

Michelangelo's order (or better, disorder) in the line of descent in the name tablets is thus very difficult to follow. Fortunately, though, for his own future and for the future of Western art, he was still able to convince Julius and his advisers that this, the "evolution" of the pre-Christian world leading directly up to Jesus, was his one and only message in the whole ceiling design. If they had been aware of all the artist's real messages concealed in the images, one wonders if the ceiling would still be with us today.

Analyzing *The Ancestors,* we soon notice that above each of these family-tree "name cards" are eight triangles (called *severies*) showing vague family groupings in biblical clothing. Even the most traditional Vatican interpreters of the Sistine have indicated that the identities of these figures are at best only guesswork and impossible to pin down with total assurance. Most Church commentators simply say that these are melancholy, tired families symbolic of the historic Jews languishing in their miserable state of eternal exile, sadly awaiting the return of Jesus to redeem them.

There is an obvious problem with this interpretation, however. Most of the Jews in the triangles do not seem particularly melancholy. They are indeed all confined in their small triangular spaces, but of the eight groups, only one seems to be sad—the family above the names of Jesse, David, and Solomon, the Jewish ancestors of the Messiah. Even in this case, on closer inspection, the central mother figure is not at all downcast, but merely peacefully sleeping. The overriding feeling in all the triangles of the Jewish ancestors is that of patiently watching, waiting, and persevering. In each and every one of them, the small family scene is completely dominated by the maternal figure. The mother is the one upon whom the family, and the whole family of the children of Israel, depends for its continuation and survival. In the severy over the names of Ozias, Joatham, and Achaz, the mother is calmly nursing her baby while holding a loaf of bread, the staff of life. As we saw in his very first work, the *Madonna of the Stairs,* nursing a baby held a very uplifting spiritual significance for Michelangelo.

In the panel over Zorobabel, the Jewish mother is watching like a sentinel while her husband and child sleep peacefully. In one of the

last triangles, the one over the names of Salmon, Booz, and Obeth, and over the area of the pope's throne, the mother is actually smiling and using a pair of scissors to open a hem in her mantle. Usually, this would be done by Jews traveling in hostile territory, in order to hide their valuables inside their clothing, or to take them out later to bribe someone or to celebrate the safe end of their journey. In this case, the mother's serene smile tells us that they have arrived safely at their destination—a sure symbol of redemption.

One good look at the triangles of the ancestors quickly disputes the "official story" of the sad Jews waiting for Jesus, the descendant of the men of the kingly line of Judah. Populating the triangles above the name plaques, these anonymous rank-and-file Jews seem to be serenely carrying on the faith in healthy traditional family units, all nurtured and protected by and centered on the maternal figure.

Michelangelo is making a clear visual statement that it is the mother who keeps the faith and the family tree going. He is also concealing here a reminder of the Kabbalistic concept of the need for harmonizing the male and female aspects of God, of the universe, and of ourselves.

The Ten S'firot, the spheres of creation on the Kabbalistic Tree of Life, are divided equally between male and female characteristics. These two sides of the tree are called Chessed—Mercy, the nurturing, female traits—and G'vurah—Strength, the strict, judgmental, powerful male traits. These two sides of the tree must be balanced to ensure harmony in the universe and spiritual growth in the individual. Here, in *The Ancestors,* Michelangelo balances the spiritual growth of the family of humanity between its mothers and fathers, creating a perfectly balanced figure by way of the shape most revered by Kabbalists and Neoplatonists—the triangle.

Below the triangles of the mothers are the lunettes, the arches of the ancestors. These panels are in the shape of upside-down U's, bearing the aforementioned name tablets of the ancestors, flanked on both sides by their imagined portraits. Even here, art experts and Church historians have had to say that the figures are not easily matched up with the names. Your eye, however, will tell you

immediately that these arches are linked with the smaller "mother" triangles above them. The top point of each smaller triangle forms a perfect isosceles triangle (sides of equal length) when connected to the two bottom outer points of each lunette. The artist is sending a direct message to your subconscious "inner eye" that the anonymous maternal figures above and the smaller figures of the well-known, important ancestors (several of them kings and leaders) below are *all the same family*. This is part of Michelangelo's even greater message in the Sistine: Jew, gentile, man, woman, king, commoner—we are all the same family. This might seem like a banal platitude, but back then it was a dangerous philosophy to voice in public. Up until the modern era, royalty and their dynasties—the so-called bluebloods— were assumed to exist by divine right, special beings superior to mere mortals and appointed by God. Whites were considered genetically superior to people of color, men superior to women, Aryans superior to Jews, and on and on. Even today, there are certain separatist fanatics who want to ban *The Diary of Anne Frank* from American public school libraries. Why? At the end of her inspiring journal, just before the Nazis take her away, young Anne writes: "I keep my ideals, because in spite of everything I still believe that people are really good at heart." *All* people, and not just one supremacist group—still a threatening message to narrow minds. Imagine how much more daring this universalist kind of message must have been in the early sixteenth century in the papal court of Julius II.

There is also a bit of mystical "gender-bending" on the part of the artist. According to Philo of Alexandria and other Kabbalistic traditions, the upward-pointing triangle is the male symbol, while the downward-pointing triangle is the symbol of the female. Here, Buonarroti places the powerful mother figures in the upward "male" version of the triangle. Ever the Neoplatonic Kabbalist, Michelangelo is balancing the father and the mother, the male and female, the active and receptive.

Again, the standard explanation of these portraits is the sad wait of the pre-Christian ancestors, in a sort of limbo until the return of Christ. This notion, however, does not accord with conventional

Church teaching. According to Catholic tradition, Jesus descended to hell after death in order to free the Jewish patriarchs and other non-Christian prophets and holy teachers from limbo. In the year 2006, Pope Benedict XVI declared the concept of limbo invalid. So, if the Jews portrayed in the lunettes and triangles are not in a sort of limbo, what are they doing here? Michelangelo has embedded several clues in these figures to let us know his true intentions.

First to be recognized are the faces. In most Christian imagery of the Middle Ages and Renaissance, the suffering, damned Jews were portrayed as unsympathetic caricatures. This was an extremely important part of Church teaching for centuries, that the Jews, for having rejected the word of salvation from Jesus, were summarily rejected by God. The proof for this was the destruction of the Holy Temple, Jerusalem, and the entire Jewish kingdom. This is the root of the legend of the eternally wandering Jews, whose only reason for still existing was to serve as a warning, a negative example to Christians to illustrate the cursed fate that awaits those who reject the true Messiah. Yet here, Michelangelo's Jews are anything but caricatures of a cursed people.

Historians are fairly certain that Buonarroti spent much time in the Jewish parts of Rome, using the authentic features of real Jews for his images. We can see the proof of that here. Except for the exaggerated features of the quarrelsome Salmon-Booz-Obeth figure, fighting with his own image carved into the head of his walking stick, all the faces of the Jewish ancestors bespeak great intelligence and even a sort of spiritual nobility. (It is interesting to note that this one negative, bearded, argumentative portrait is on the wall right above the platform for the throne of the bearded, argumentative Pope Julius.) The portrait of Asa has very clearly Semitic features, the stereotypical kind that would please a Goebbels; however, Michelangelo shows him as a real person and imbues him with a sense of grace and culture that elevates the man, instead of debasing him.

The profile of Achim is undeniably Jewish, but with a majesty comparable to Michelangelo's portrayals of Moses and even of God himself. Zorobabel, the Jewish king who was blinded by the

Top: Asa *(pre-restoration)*
Bottom: Achim, *full
lunette (pre-restoration)*

Babylonian conqueror Nebuchadnezzar, is shown as a handsome, vital man, but with his eyes blacked out. The women, too, exhibit a high level of grace, intelligence, strength, and beauty. Meshullemet, the mother of Amon, is depicted as young and beautiful, contentedly and lovingly singing her babies to sleep.

There is also a wide range of Jewish facial characteristics. Since the horrors of the Inquisition had forced countless Jews from all over the world to seek refuge in Rome, Michelangelo was able to meet exiles from many different backgrounds and cultures. Some of the Jews he depicts are obviously Ashkenazi, from Eastern European lands. Others are Sephardic, from France, Greece, and the

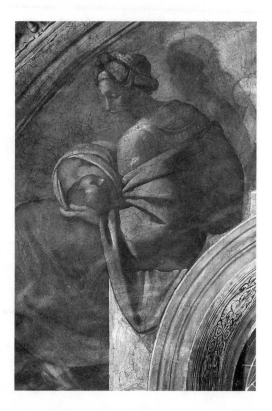

Meshullemet
with her baby
(pre-restoration)

Iberian Peninsula. Still others are from the Middle East, together with a smattering of native Roman Jews.

For all of these, Michelangelo found artistic compassion and sympathy. It required a truly open mind and heart to depict Jews in the early sixteenth century with so much authenticity and understanding. To appreciate the enormous significance of this fact, simply consider how Jews were portrayed in Europe up through the 1940s, and how they are still portrayed today in many Arab Muslim countries.

Also demonstrating both Michelangelo's familiarity with the Jews and his friendship for them is the range of clothing styles in which he portrays them, reflecting the native lands of all these different Jews who had found their way to Rome. Back in Florence, Michelangelo's family had been involved in the fabric trade that had made his hometown wealthy. He was well aware of the different materials and styles worn by Christians and Jews from around the world. Many art experts have written at length about his

imaginative play with changing colors in the clothes of the ancestors, often saying that he used swaths of color to form the shape of the body underneath. This is only partially true. Edward Maeder, the curator of costumes and textiles from the Los Angeles County Museum of Art, discovered another secret after the great fresco was cleaned and restored. Michelangelo's Jews are wearing a special kind of textile called variously *cangiante* (shot silk) and sarscenet (since the Crusaders brought it back to Europe from the Middle East, or Saracen lands). Today we would call this "iridescent" clothing, which changes color and tone with every movement and every fold.

In Maeder's groundbreaking essay,[1] he proves beyond doubt that not only does Buonarroti portray the Jewish ancestors in a completely authentic array of garb, but he also clothes them in this very prestigious fabric, often used for weddings, dowries, and special celebrations—especially by people of royal blood. Obviously, Michelangelo's Jews are not all damned and suffering.

For all of Michelangelo's positive feelings toward the Jews, it must be noted that during his time the Talmud and other sacred texts of the Jews were being burned all over Europe. Even though Jews had not yet been forced into ghettos (the first ghetto was established in Venice in 1515), they were at best second-class citizens and had few civil rights in most countries. As early as 1215, the Fourth Lateran Council had decreed that Jews were to wear a special badge of shame to keep them separate from good Christians. Furthermore, no matter what the country or the manner of clothing, the badge had to be yellow.

This was a decree with an ancient precedent. In the ninth century, a Muslim ruler of Sicily first forced the Jews there to wear yellow circles and shawls in public. Why yellow? In the Muslim tradition, it is the color of urine and of prostitutes. This was then revived by the Church in the Middle Ages, ultimately to make yet another appearance in modern times by way of the Nazis with their yellow Star of David for Jews during the Holocaust.

With this in mind, we can appreciate an incredible detail that has just recently come to light with the cleaning of the Sistine ceiling.

Near the end of his four and a half torturous years of toiling on the ceiling, Michelangelo was painting right over the elevated area where the pope would sit on his gilded throne. There he placed the portrait of Aminadab, known in the Talmud as a truly pious father of meritorious children. The best known of his children was Nachshon, a leader famous for his demonstration of great faith. When the children of Israel were trapped by Pharaoh's army at the Red Sea, it was not just the raised staff of Moses that parted the waters. According to the Midrash, God waited until the instant when Nachshon son of Aminadab threw himself into the sea, shouting, "Who is like you, O God?" and only in that moment did the Almighty divide the waters. Nachshon, with his literal leap of faith, taught humanity to trust that God would—and will—fulfill his promise of deliverance. First to fearlessly enter the Red Sea, Nachshon was also the first tribal prince to offer sacrifices at the consecration of the Holy Altar.

The sages of the Talmud credit Nachshon's great spirituality and leadership to the education he received from his father, Aminadab. Aminadab is portrayed by Michelangelo as a vital young man in Eastern dress, with an unruly mop of curly red hair. He has an expression of rage and his eyes are darkened from crying. He is also one of the extremely rare figures in the artist's entire career who was painted sitting perfectly straightforward, a definite signal by the artist to his peers to "pay attention to this."

The great poet and Bible commentator Ibn Ezra wrote that exile caused the Jews' eyes to darken from anger and sorrow. We can clearly see that this is the case with Aminadab. It was also the case with Buonarroti himself. His marathon painting over his head, with the paint and plaster dust often getting in his eyes, was wreaking havoc on his vision. In fact, after the four and a half years of toiling on the ceiling, his eyesight would never be the same again. The artist must have been furious at the time he made this portrait, since we can see, almost hidden in shadow, that the angry Jewish youth is subtly making "devil's horns" with his fingers, pointing down toward where the ceremonial canopy would have been, over Julius's papal throne.

On Aminadab's upper left arm (on the viewer's right), cleaning has revealed a bright yellow circle, a ring of cloth that has been sewn onto his garment. This is the exact badge of shame that the Fourth Lateran Council and the Inquisition had forced on the Jews of Europe. Aminadab's Hebrew name means "from my people, a prince," referring to his son Nachshon. However, to the Church, a "prince of the Jews" would mean only one person—Jesus. Here, directly over the head of the pope, the Vicar of Christ, Michelangelo is pointing out exactly how the Catholic Church was treating the family of Christ in his day: with hatred and persecution.

Imagine an artist hired to paint the holy ancestors of Jesus in a cathedral in Nazi Germany in the 1940s and, instead of portraying the

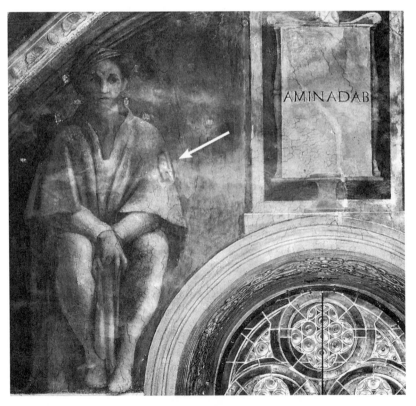

Aminadab—*before the restoration. Arrow added to indicate yellow ring (today much more visible) on his cloak. See Fig. 8 in the insert.*

standard Aryan haloed saint, the artist depicted a handsome, strong, angry, nonstereotypical Jew wearing a yellow star over the heads of the top dignitaries of the Third Reich. That will give you an idea of Michelangelo's daring. He is saying to the sixteenth-century papal court: "Is this how you treat the family of our Lord?"

What protected both the artist and his secret was the fact that this tiny ring of yellow is about sixty-five feet up in the air, hard enough to spot even if you were not distracted by the pope, his retinue, the liturgy, the crowds, and the huge mass of swirling, distracting images all over the ceiling and walls. From the floor level, it would have been impossible for the pope and his inner circle to see it, since they had the papal canopy over their heads. Because of accumulated candle soot and dirt, it was truly impossible for anyone to see it for generations until the recent cleaning and restoration.

Even though this subtle message was undiscovered for centuries, Michelangelo's cause was not forgotten. In 1962 Pope John XXIII convened the extraordinary Second Vatican Council, commonly called Vatican II. Among the many historic decrees to come out of this watershed convocation was putting an end forever to the Church's anti-Judaic teachings. No longer would the mass include prayers for the conversion of the cursed Jews; no longer would the Church repeat the long disproved accusation of the Jews as the killers of Jesus. From now on, the Jews would be referred to by the Catholic Church as "our elder brothers and sisters"—in other words, as the *family* of Jesus, just as Michelangelo was saying in his hidden messages five centuries ago. Four decades after his death, Pope John XXIII himself underwent a name change. He is now officially *Saint* John XXIII, but he has another unofficial title that springs directly from the hearts of the common people. The Italians call him simply *Il Papa Buono,* the Good Pope.

Poor Michelangelo, however, had to contend with *Il Papa Terribile,* Julius II—and the papal censors. He had to hide his pro-Judaic feelings in every corner of the Sistine frescoes. That is where we must explore now: some of the most misunderstood images in the Sistine—the four corners of the ceiling.

Chapter Ten

THE FOUR CORNERS OF
THE UNIVERSE

... you shall call your walls Salvation.

—ISAIAH 60:18

O NE OF MICHELANGELO's most amazing technical achieve-
ments on the Sistine ceiling is also one of his most profound
series of statements—and one of the most overlooked ele-
ments of the whole fresco: the four corners.

The four spandrels (in Italian, *pennacchi*) are the fan-shaped
curved panels where the walls of the chapel meet the ceiling. In ar-
chitectural terms they are called pendentives, since they resemble
hanging triangles. These were the hardest sections to paint because
of their shape and location, not to mention their imperfect, concave
surface. Michelangelo had no previous experience at frescoing any-
thing like this, but his photographic memory came to his rescue.
When he was about thirteen years old and a beginning apprentice
in Florence, he had helped his teacher Ghirlandaio (by coincidence,
one of the original fifteenth-century fresco artists in the Sistine) for
a very brief period with some similarly shaped panels. These were

the tympana, or *flat* triangular panels, in the Cappella Tornabuoni in the Church of Santa Maria Novella. In order to counterbalance the irregular shape, Ghirlandaio had inserted large vertical effects in the center, with smaller images on each side.

Michelangelo, in spite of having no previous experience composing frescoes—plus the double challenge of a triangular shape with a deep inner *curve*—pulled off the same technique brilliantly in all four corners of the Sistine over two decades later. Because of the vertical visual emphasis on the center of each spandrel, they have the appearance of being flat, instead of deeply indented—another of the great artist's optical tricks in the Sistine. It is not merely a technical solution, however; it is where he hid layer upon layer of his true messages.

At the far end of the chapel, where we started our tour with the image of Zechariah, we see the prophet flanked by the first two spandrels. These two are much simpler in design than the other two he will paint four years later, since Michelangelo is learning as he goes. On the left, we see the story of Judith, who beheaded the pagan enemy general Holofernes. On the right we see the climax of the battle between David and Goliath.

These panels have an important theme in common. They are both instances of a merciless, seemingly invincible enemy of the Jews being decapitated by outwardly weak and defenseless Hebrews. Remarkably, one incident highlights the heroic role of a woman, Judith; the other, the small shepherd boy David. As an adolescent apprentice, Michelangelo had seen Donatello's statues of Judith and David in the courtyard of the de' Medici palace—however, here in the Sistine, he would change their images completely, in order to conceal his forbidden messages.

On the western end of the chapel, over the altar wall, the other two spandrels tell the story of Esther and Haman in the left corner, and of the copper serpent of Moses on the right. Again, we have one male and one female hero saving the Jewish people from certain doom. Why, though, did Michelangelo choose these four particular stories and why did he paint them in these particular locations?

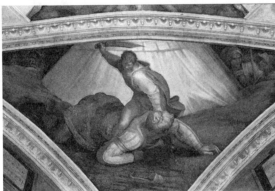

Top: Judith and Holofernes *spandrel, northeastern corner of the chapel. See Fig. 9 in the insert. Bottom:* David and Goliath *spandrel, southeastern corner of the chapel. See Fig. 10 in the insert.*

First, let's quickly review the stories.

The book of Judith is from the Apocrypha, the collection of religious stories canonized in the Catholic Bible but not in the Jewish one, but nevertheless important to both faiths. The Apocrypha thus serves as a bridge between the two religions, something that would obviously have been greatly appreciated by Michelangelo. The book of Judith is linked by Jewish tradition to the book of Maccabees, which relates the war of religious liberation fought by Judah Maccabee against the Greco-Assyrian Hellenists, a victory today celebrated as the story of Hanukkah. Judith is a beautiful Jewish widow, defenseless in her city, Bethulia, in Israel as Holofernes

prepares to annihilate it as a first step toward destroying Jerusalem. The terrified populace declares a public fast and prays for the Almighty's deliverance. Judith plots a daring strategy; she adorns herself in her most enticing finery and leaves the city, accompanied only by her trusted handmaiden, entirely unarmed. Unarmed, that is, except for her faith, beauty, and wisdom. They are quickly stopped

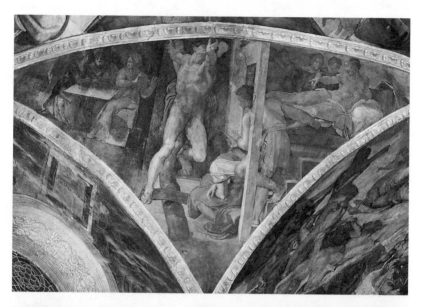

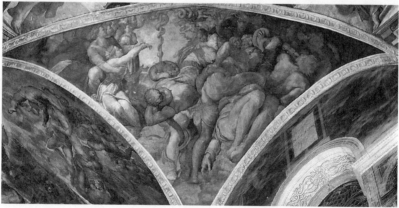

Top: Esther and Haman *spandrel, southwestern corner of the chapel.*
Above: Moses and the Plague of Serpents *spandrel, northwestern corner of the chapel*

by Holofernes' soldiers, who would surely have raped and killed them both but for Judith's offer to submit sexually to Holofernes, as well as to provide him with secret information that will help the Hellenist army take the city without losing a single man. This convinces the armed men to take the two women directly to the tent of their leader. He immediately is seduced by Judith's great beauty and charm. Holofernes declares an anticipatory victory celebration for his men, and a private erotic dinner for two in his tent. Judith makes him and his bodyguards drink so many toasts to the destruction of the Jews that they all pass out. She then prays for strength and, using Holofernes' own battle sword, cuts off his head while he lies unconscious on his bed. She and her handmaiden then conceal the head in a basket and bring it back to their city. She displays it to her people, who rejoice and regain their spirit. The head is then hung

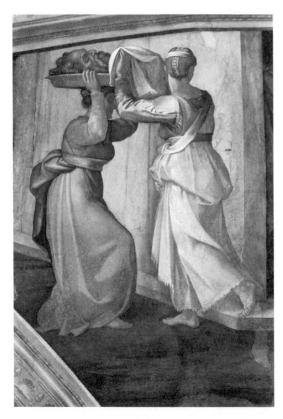

Detail from Judith and Holofernes *spandrel. See Fig. 9 in the insert.*

on the front wall of the city. When the Greco-Assyrian troops see their leader's head thus impaled, they lose all courage and flee. The Jews pursue them and vanquish them so completely that it takes several days to collect all the spoils of battle from the once-mighty Hellenistic army.

The David story, from the biblical book of 1 Samuel 17, begins as the Jews are being soundly trounced on the field of battle by their pagan neighbors, the Philistines. The deadliest weapon of the Philistines is their giant warrior, Goliath, undefeated in battle. He mocks the Hebrews, who cower in fear before him, and even slanders their God. David, a small shepherd boy who has come to bring food to his father and older brothers in the Hebrew army, cannot stand to hear the enemy giant blaspheming the Lord. He begs to be allowed to go into one-on-one battle with the terrifying giant. He refuses to put on armor or use a conventional weapon, depending instead on his faith and his dexterity. As a young shepherd protecting his flock from ravenous wolves, he had become an expert with a slingshot. David faces Goliath with only this frail weapon, five smooth pebbles, and his faith in the One God. Miraculously, he fells the giant with a single blow to the forehead, and then beheads Goliath with his own battle sword. In Michelangelo's version, Goliath, at the last moment, is looking desperately back toward his fellow pagan warriors to come to his aid. They are frozen in their tracks, preferring to remain in the dark shadows rather than face the lone shepherd boy. The terrified Philistines, just like the Greco-Assyrians in the story of Judith, are useless without their "head" and are completely routed by the revitalized Jewish army.

Over the front altar wall, we see the spandrel of Esther and Haman. This story is found in both Hebrew and Christian Bibles in the book of Esther. It is read in full every year by the Jews on Purim, the holiday that celebrates the salvation of the Jews in the ancient Persian Empire, the largest community of Jews in the Diaspora at that time. The emperor Achashverosh, whom some historians think might be Xerxes II, rules over his vast empire from his capital of Shushan (Susa in modern Iran) but cannot run his personal life very well. He holds enormous marathon banquets and orgies with his decadent

pagan wife, Vashti. According to the unexpurgated Talmudic version, he has her killed after she refuses to dance nude for his guests.

The Persian emperor's vizier, or right-hand man—indeed, he practically runs the empire for him—is Haman, a power-hungry egomaniac who yearns to be as mighty as the emperor himself. He advises the newly widowed ruler to hold a sort of "beauty pageant" to find the most desirable woman in Persia to be his next wife. Esther, a beautiful young Jewess, wins the pageant and is crowned queen of Persia. However, she doesn't tell anyone in the palace—especially the emperor or Haman—that she is a Jew. Later in the story, Haman decides to massacre all the Jews in the empire and dupes Achashverosh into validating the decree. At the last minute, Esther finds enough faith and courage to tell the king that she is a Jew, condemned to die because of Haman's evil machinations. The emperor has Haman strung up high on the very tree upon which he wanted to hang the leaders of the Jews. In an ironic way, the wicked vizier gets his wish, being elevated high above the common crowd.

Here in the Sistine, Haman is depicted as stripped of his golden clothing and nailed up on the twisted tree, instead of merely hanging from a noose. A hanging body would not have allowed the artist to exercise his talent for portraying seemingly sculpted human musculature in a flat fresco. Michelangelo, exploring the technique of trompe l'oeuil, has the evil Persian vizier's left arm extend seemingly straight out of the painting and into the room.

In the standard Vatican explanation of this portrayal of Haman's death, it is supposed to prefigure the crucifixion of Jesus, whose personal sacrifice will vicariously atone for the sins of the world. However, that would mean that Michelangelo, a deeply spiritual Christian, selected a pagan who was one of the worst genocidal maniacs in the Bible to symbolize Jesus. This is doubtful, to say the least. Furthermore, the tree upon which Haman hangs is dead, with its branches cut or broken off, symbolizing that his evil family and aspirations have reached the end of the line. This, too, hardly seems a likely image for the coming Savior in the holiest chapel in Christendom.

The scene depicted in the last spandrel comes from Numbers 21:4–10, in the fourth book of the Bible. The Bible records how the

camp of the wandering Israelites is stricken with a plague of poison-
ous snakes that threaten to exterminate them before they can reach
the Promised Land. Moses has just hung a copper image of a snake
on a high wooden pole. The Israelites look upward to the copper
serpent, thus lifting their thoughts toward the Divine, and are saved.
However, strangely enough, the hero of this story—Moses—is no-
where to be seen. Why?

In the Haggadah, the annual Passover recounting of the Exodus,
the name of Moses is similarly strikingly absent. The ancient sages
say that this is in recognition of his great humility, as well as to em-
phasize that human redemption comes only from the Almighty, not
from a person, no matter how charismatic he or she might be. In
Michelangelo's version, too, Moses is not to be seen. We are being
put in the place of the Israelites, in the middle of two choices. As
God says later on in the Torah: "I have set before you life and death,
a blessing and a curse; therefore, choose life" (Deuteronomy 30:19).
On the left, going into the light, are the Israelites choosing life by
looking up toward the Divine. On the right, going into the dark-
ness, are those being killed by the snakes.

What, then, is the unifying theme, if any, of these four different
corner panels that might account for their selection by Michelangelo?
The obvious answer is that these four scenes represent four major
salvations of the Jewish people in moments when they appeared
doomed. Is it mere coincidence, though, that each facing set of span-
drels depicts scenes that complement the heroism of male and fe-
male figures? Judith is flanked by David. Moses is set alongside the
story of the courageous Queen Esther.

In Kabbalistic thought, much emphasis is placed on the duality
of God's sexual identity. Without reference to physical form, God
is both male and female. The spiritual aspects of the two genders
express the characteristics of the God of Justice who is also the God
of Mercy. Masculine strength combined with maternal compassion
comprises the perfect balance without which divine rule cannot
function. Mystics constantly emphasize the need for perfect bal-
ance between these two polar forces. Michelangelo depicts for us

the human personification of the divine sexual harmony—a mystical equilibrium that is the key to heavenly perfection according to the Kabbalah.

The positioning of the stories is also well planned. On the eastern wall, in the direction of the Holy Land, are the two salvations that take place in Israel. On the western wall, away from Israel, are the two stories that take place in Persia and in the wilderness, both outside the Promised Land.

Yet these four moments of divine deliverance share a more powerful bond, a connection noted long before Michelangelo chose them for "starring roles" in the corners of the Sistine Chapel. For those who know the Midrash it surely seems more than coincidental that both the artist and the rabbis of old linked just these particular stories. In Deuteronomy 26:8, Moses recalls for the Jews that God redeems them with "a mighty hand, an outstretched arm, with great fear, and with signs and wonders." The seeming redundancy of these phrases is explained by the Jewish commentators in a remarkable manner: Only the last of these expressions relates to an event the children of Israel have already witnessed. The rest refer prophetically to moments still in the future. All together they are to be understood as four ultimate instances of divine intervention. For this very reason, Jews recite this biblical verse at the seder, the Passover festive meal commemorating the deliverance from Egypt, and drink four cups of wine, one for each of the times that God ensured their salvation.

With the four pendentives, Michelangelo seems to be recalling these very same redemptions alluded to in the verse in Deuteronomy.

What is the significance of the promise of redemption in the phrase "with a mighty hand"? The Midrash notes that in the book of Judith, the heroine prays fervently, "Give to me, a widow, *a mighty hand* to do what I plan" (Judith 9:9; emphasis added). The expression is an exact parallel of the verse in the Torah. Indeed, it was the divine response to her impassioned plea, the mighty hand that enabled Judith to chop off the head of her enemy, that allowed for the miracle of the Hanukkah story and the Jewish deliverance from Greek annihilation.

The sages related the next phrase, "outstretched arm," to the sword of David. It is captured in the central image of the David spandrel by way of the boy's outstretched arm holding the sword of Goliath. Here Michelangelo chooses a powerfully symbolic way to stress the role of divine aid to the small shepherd boy's arm. Strength in Kabbalah is the sphere of G'vurah, symbolized by the Hebrew letter gimel: ‎ג. Looking at the outline of the vertical image of the sword, David, and the inverted V of Goliath's head and arms, one can see the shape of this Hebrew letter, which supplies the strength to the boy's outstretched arm.

The deeper meaning of the next words in the prophetic verse, "great fear," prefigures the story of Esther. The connection is predicated on three arguments. First, the Talmud says that the *fear* of Haman's genocidal plan brought more Jews back to the proper path of faith than all the prophets put together. This is a Talmudic variation on the old proverb that "There are no atheists in foxholes." Second, according to the biblical text, when Esther finally discloses to the Persian king that someone wants to murder her and all her people, Achashverosh demands: "Who is he, and where is he, that doth presume in his heart to do so?" Haman, the scheming social climber, had even invited himself to be sitting at the royal banquet table at the time, right near the king. At this point, the Talmud adds

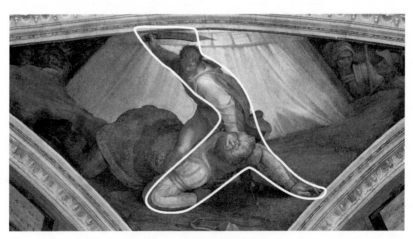

The David *panel, with the hidden Hebrew letter gimel formed by David and Goliath. See Fig. 10 in the insert.*

that an angel of the Lord came along to guide Esther's hand to indicate the wicked vizier. This is exactly the moment that Michelangelo illustrated in the left part of the spandrel. (The angel, like Moses in the *Plague of Serpents* panel, is felt but not seen.) The Scripture simply says: "Then Haman was *afraid* before the King and Queen." Finally, in chapters 8 and 9 when the Jews are allowed by the king to defend themselves and fight back, the book of Esther says three times that the pagan Persians had *fear* of the Jews.

Finally, the sages explain that "with signs and wonders" refers to the rod of Moses, as God said to Moses in Exodus 4:17: "Take this rod in your hand, with which you will do *signs.*" In Michelangelo's pendentive of the *Plague of Serpents,* the central image is in fact the rod upon which Moses hangs the redemptive *sign* of the copper serpent.

Only if we know how Michelangelo used Talmud and Midrash can we understand the otherwise inexplicable linkage of these unusual images. The four corners of Christianity's holiest chapel and the four cups of the Passover seder have found common voice to proclaim God's ongoing role in the major moments of history.

There is still one final layer of meaning. The corner scenes near the papal entrance represent two existential threats, Holofernes and Goliath, whose common fate was to be cut down. At the altar side, two other deadly foes, Haman and the serpents, in the end are raised up. Here, too, is a magnificent example of counterpoint. Evil can be destroyed in either direction. Some are meant to be cast down. Others rise, but their elevation is meant to bring about their downfall. Underlying all, as the very cornerstone of human existence, is a universal message of hope to all people, never to give up even when the future looks bleakest. That is why these four corners of faith seem to hold up the whole ceiling, another classic subliminal and powerful message from Michelangelo.

As we get further and further into the frescoes, Michelangelo seems to be taking us deeper and deeper into his private beliefs: humanism, Neoplatonism, Judaism, Talmud, and Kabbalah. With this in mind, let's move on to the next layer, the one that has challenged art experts for centuries—a baffling assortment of sibyls and prophets.

A COMPANY OF
PROPHETS

With all forms of wisdom has she built her house,
she carved out its seven pillars.

—PROVERBS 9:1

T HEY LOOM OVER US, sixty-five feet in the air, these giant
figures from the ancient world. They are not looking
down at us, though. They have something much more
important on their minds: the future. They are a strangely assorted
group: pagan female fortune-tellers and Jewish male prophets. In
a sense, they are polar opposites. The empires represented by the
sibyls—Egyptian, Babylonian, Persian, Greek, Roman—tried, one
after another, to wipe out the Jews and Judaism. Conversely, the
seven selected Hebrew prophets preached fervently for the eradica-
tion of pagan worship within the borders of the Holy Land of Israel
in order to ensure the preservation of the Jewish people.

What could they possibly have in common? Combining the im-
ages of pagan seeresses and Hebrew prophets, although not unheard
of, was not a common practice in Christian art. It wasn't, that is,

until Michelangelo. Here he is, in his work on the Sistine ceiling, showing us his roots in Neoplatonism and in Talmud by creating a whole new genre of art that is both inclusionary and multilayered in meaning. After he painted the ceiling, this combination became a trend in Renaissance painting, copied by many artists of the day, including Raphael. However, no one—including Buonarroti's beloved Tommaso dei Cavalieri and his closest surviving assistant, Daniele da Volterra—chose to portray the same five sibyls that we find on the Sistine ceiling. Obviously, Michelangelo had a secret reason for these choices. What was it?

Our first clue, included in each of the Sistine portraits of the sibyls and prophets—save one—is a scroll or a book, symbolizing literacy. Through his use of books and writing, Michelangelo is showing us that he believes these seers were the intellectuals of their respective times and places. In fact, the Latin root of the word *literacy* is the same as for the word *intellect: leggere,* "to read." The source for the word *intellectual* also gives us its true meaning: *inter-leggere,* "to read between." An intellectual is defined by an ability to read between the lines, to analyze and to think critically, to understand things on many levels at the same time. This is exactly what we must do to appreciate fully the works of Michelangelo and his fellow Renaissance artists.

Let's read between the lines here, since there is probably yet another reason that Michelangelo put books and scrolls in the hands of these seers. Only months earlier he had completed a hated task, the casting of the large bronze statue of Julius II for the Cathedral of Bologna, the Warrior Pope's symbolic seal on his dominion over the rebellious citizenry. Buonarroti loathed everything about the job: working in bronze, doing a banal portrait, having to cope with Bologna's rainy climate and even its wine, which did not get along with his Florentine stomach. The lowest point occurred when he had to obtain papal approval to begin the project.

Showing Julius a clay model of the proposed design for the statue, Michelangelo asked the pope if he would like to be shown holding a book. "What, a *book?*" sneered *Il Papa Terribile.* "A *sword.* Me, I

am no scholar." Michelangelo, for once (as far as we know), dutifully complied. (Four years later, just as Buonarroti was finishing the ceiling frescoes, the independent-minded Bolognesi rose up against the pope and melted down his bronze likeness. They reused the metal to make a huge cannon to be used in their continuing struggle for freedom, sarcastically christening the weapon with the name Julia.)

Michelangelo's very next commission after the bronze statue was the Sistine ceiling project. The pope's dismissive attitude toward literature and scholarship undoubtedly was still fresh in Buonarroti's mind as he conceived what the art historian Professor Howard Hibbard calls his "interpenetrating levels of meaning." To distinguish the wise seers of yore from the antiintellectual pope, the artist showed all the sibyls and prophets (save Jonah) with books and writings—a subtle and barely concealed put-down that must have given Michelangelo pleasure during his long labors up on the ceiling.

We can now analyze Michelangelo's selection of subjects, as we follow the mandate of "ladies first" by beginning with the five sibyls.

Some say that the word *sibyl* comes from the ancient Greek word *sibylla,* which means "prophetess," but it far more likely derives from the earlier Babylonian/Aramaic *sabba-il,* "ancient one of God." Sibyls are technically not the same as prophetesses. A sibyl, or oracle, would only respond to a question submitted to her, whereas a prophet is a messenger or mouthpiece for heaven, speaking, blessing, cursing, and predicting the future without human prompting.

There were ten sibyls in the Classical world, with two more added later in Christian medieval lore. Their names and locations varied from nation to nation, and from writer to writer. However, the best-known ones, and the ones that Michelangelo was most likely to know about, were: Libyan, Persian, Hellespontine, Tiburtine, Cumaean, Delphic, Eritrean, Cimmerian, Phrygian, Samian, and Marpessan. The three pagan sibyls that were the commonly accepted prophesiers of the Church were the Tiburtine, the Hellespontine, and the Samian, which made them the top choices for sibyls

on those infrequent occasions when they were portrayed in medieval art. The Tiburtine sibyl, from Tivoli near Rome, predicted to Augustus Caesar the Advent of Jesus, as well as revealing that the future emperor Constantine would convert to Christianity and that the Antichrist would be a Jew from the tribe of Dan (a legend often exploited by the anti-Semites of the day). The Hellespontine sibyl foretold the Crucifixion and for this reason is always portrayed with the cross. The Samian sibyl held an especially important place of honor for her very specific prediction that Jesus would be born in a stable. It is telling and quite remarkable that, despite the renown of these three, *Michelangelo refused to use a single one of these images in his work in the Sistine.*

So, who are the five sibyls that Michelangelo chose instead to weave into his ceiling? And what was the reason for their selection in place of the seemingly far more logical choices? Let us follow the order in which he painted them, starting from the entrance wall of the chapel. The sequence we see is the Delphic sibyl, the Eritrean, the Cumaean, the Persian, and the Libyan.

THE DELPHIC SIBYL

The Delphic sibyl is at once both breathtakingly beautiful and very sexually ambiguous. If it were not for the quite unconvincing breasts and the few strands of hair that trail out from under her veil, she could easily be mistaken for a teenaged boy. (In fact, Michelangelo used well-built young men as models for all the sibyls.) Her expensively dyed clothes, when you see the actual fresco, have an almost metallic sheen to them—an amazing technical feat in plaster and paint five hundred years ago.

She is one of the earliest sibyls, from Delphi, in ancient Greece. She is not, however, to be confused with Pythia, the priestess of Apollo, who was most famous as the Oracle of Delphi, often a major character in Greek epics and tragedies. Michelangelo's Delphic sibyl, like the other four sibyls in the Sistine, has no specific name; her identity

The Delphic sibyl.
See Fig. 11 in the insert.

is restricted to her geographic location. Her simple classic Grecian outfit underlines her origins. Her strands of golden hair show that she is supposed to be a daughter of the sun god Apollo. In Classical literature, as symbolized by the scroll she holds, she appears in Virgil's epic poem the *Aeneid*.

THE ERITREAN SIBYL

The Eritrean sibyl (or as Michelangelo spelled it, Erythraea) is actually Babylonian, born in Chaldea—the same land in which Abraham, the founder of Judaism, was born. Today, this area is part of Iraq. Like the Delphic sibyl, Eritrea is very masculine. Her arms would be the envy of any bodybuilder. Her right arm is reminiscent of the *David*'s in Florence (next page, on the right). It seems that Michelangelo, missing his beloved life of sculpting while painting the ceiling, kept dreaming of his favorite works in marble.

Some historians credit the Eritrean sibyl with inventing the acrostic, since she wrote her prophesies on leaves. When put in the proper order, the first letters of the leaves would spell out a key word to understanding her prediction. In Michelangelo's version, the leaf of the book that she is holding begins with a large illuminated letter *Q*.

THE PERSIAN SIBYL

Little is known of the Persian sibyl except that she supposedly foresaw the exploits of Alexander the Great. In Michelangelo's rendering, she is shown as aged and having to squint closely to read her book. The putti below her and her book are dumbstruck in darkness. Even though she is very old, she has an incredibly muscular, masculine arm that seems to belong more to a male statue than to a painting of an aged woman—a typical paradoxical Michelangelo touch.

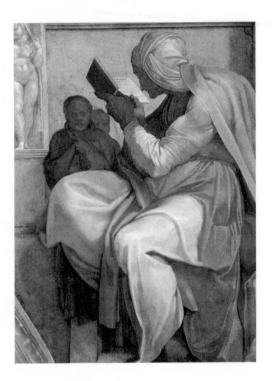

The Persian sibyl.

THE LIBYAN SIBYL

In spite of her name the Libyan sibyl was from Egypt, specifically from an oasis in the area called the Libyan Desert. She is known in many ancient accounts, but certainly a version that Michelangelo would have seen was that of Plutarch. In that account, Alexander the Great came to consult her and she foretold that he would be a great conqueror and become the ruler of Egypt.

In her panel, the artist portrays her either picking up or putting away a large book, but one of the putti next to her is holding a scroll as well. The Libyan sibyl is especially famous for her quote about the "coming of the day when that which is hidden shall be revealed." As he was painting her, Michelangelo may very well have been contemplating the day when his hidden messages in the Sistine would also finally be brought to light.

Michelangelo assuredly felt a strong kinship with Alexander the Great on many counts. Alexander, like Michelangelo, was friendly

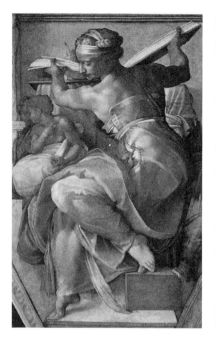 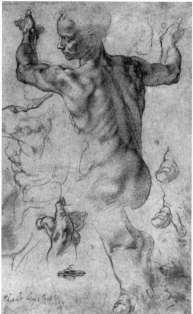

with the Jews and fascinated by their religion and culture. Through his passions for learning and conquest, Alexander was able to bridge pagan Greek, Egyptian, and Jewish culture. And on a personal level, both the artist and the ancient conqueror were lovers of men.

As an interesting aside, we have a rare surviving sketch from Michelangelo (see above right), made while he was preparing the Libyan sibyl panel, that proves he used only well-built young men to model for these women.

THE CUMAEAN SIBYL

We have saved the Cumaean sibyl for last, since she is the oldest and most famous of all the sibyls. Although Cumaea was located near modern-day Naples, she is considered the sibyl of Rome. It was Cumaea who wrote the Sibylline Books and sold them to Lucius Tarquinius the Proud, one of the legendary kings of Rome. As the story goes, every time she offered to sell him the books of prophecies about the future of Rome, he complained that the price was too

high. Cumaea was an even tougher negotiator than the king. Each time he refused to buy, she burned some of the irreplaceable scrolls and then upped her asking price. By the time Tarquinius the Proud finally caved in, she sold him the surviving one-third of the books for four times the original price.

The Cumaean sibyl did have her comeuppance, however. The mythological god Apollo desired her for her beauty and wisdom. She asked him for a favor first: gathering up a fistful of sand, she told Apollo that she wanted to live as many years as the grains of sand in her hand. He granted her wish, but she then refused his advances. Apollo replied, "Very well, but you forgot to ask me to grant you extended youth along with extended life." As the centuries passed, Cumaea held on to life but grew older and older, shrinking so much with age that she eventually fit inside an oil jar. Michelangelo portrays her—in spite of a massively muscular male body—as an ugly old crone whose head has already shrunk so that it is far too small for her body.

The real Sibylline Books, if they ever existed, were destroyed in a fire in 83 BCE. This means that the so-called Sibylline Books, blended together with the ancient ethical teachings of Pseudo-Phocylides that were studied at the time of Michelangelo, were medieval inventions. This did not stop the Church, though, from spreading the idea that Cumaea had prophesied about both the coming of Jesus and the divine choice of Julius II for pope. This is why Buonarroti, wanting to keep *Il Papa Terribile* appeased during this touchy project, gave the Roman sibyl's clothing the della Rovere family colors of royal blue and gold, and placed her right in the middle of the wall across from the papal throne area. Cumaea is symbolizing Julius, the Vatican, and Rome. Yet, unable to completely contain his true feelings about the pope, Michelangelo inserted a not-so-angelic putto (the singular form of *putti*) giving the old lady "the fig" gesture, just as he did in the panel of Zechariah over the front door. This daring personal insult was so subtly placed that it was only discovered recently, during the cleaning and restoration of the Sistine. Now, five centuries later, we can see that the angry artist succeeded, amazingly

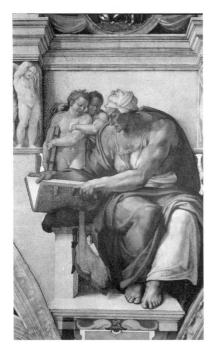

Left: The Cumaean sibyl. See Fig. 12 in the insert. Right: Detail of obscene "angelic" gesture.

enough, in giving Pope Julius II the finger not once, but *twice*—from his very own commissioned ceiling project.

The location of each of the sibyls has significance and helps to explain its message. Let us see where the other four are set.

As you will recall, the four fan-shaped panels in the chapel's corners represent the four exiles that the Jews are fated to endure, according to predictions in the book of Daniel: Egypt, Babylon, Persia, and Greece. It is for these four exiles and subsequent redemptions that, according to many interpretations, Jews drink the four ceremonial cups of wine during the Passover seder. On the ceiling, Michelangelo juxtaposed each sibyl nearest the exile it represents. The Delphic sibyl is the symbol of Greek dominance; she is next to the Judith-and-Holofernes corner, which deals with the Hanukkah story in the book of Maccabees that recalls the liberation of the Jewish people from Greek (Hellenistic) dominance. Libya, who Buonarroti (thanks to his studies of Plutarch) surely knew was really from

Egypt, is next to the corner panel of Moses's copper serpent saving the Jews who had just been redeemed from Egypt.

Persia, naturally, is nearest to the corner dealing with the story of Esther, who saves the Jews of Persia from the genocidal Haman. Eritrea, who was really from Babylon, posed a problem to Michelangelo's plan. The Babylonian exile was ended by Persian military conquest, not by a Jewish heroine or hero. This would have made for a confusing and not very religiously inspiring scene and would have disrupted the theme of Jewish redemption by a Jewish spiritual hero or heroine in all four corners. So, the next best spiritual symbol that the artist could choose was the liberation from the other oppressive Middle Eastern pagan nation that bordered ancient Israel—the Philistines. Thus, closest to Eritrea, the Middle Eastern sibyl, he depicts the Jewish hero David defeating Goliath, the Philistine giant.

This leaves us with Cumaea, the symbol of Rome. In Michelangelo's lifetime, the Jews of the West were considered still to be in Roman exile, since they were living under the domination of the Church. This is why he shows the putto making an obscene gesture at Cumaea. She is a symbol of everything that Michelangelo detested about the abuses of power, the intolerance, and the hypocrisy of the Vatican. As he described it in his poem, the Vatican of his day had distorted and betrayed both Christ and Christianity. This is why he had to be so cunning and careful about hiding his messages in the Sistine. Michelangelo had promised the pope and his advisers that his theme for the ceiling would be the redemption of the world through the Church. Instead, he masterfully inserted his personal longing for the future redemption of the world *from* the dominance of the Church's corrupt leadership of his day.

THE HEBREW PROPHETS

Now, let's take a close look at the seven male Hebrew prophets. The first point is why Michelangelo chose this number. By now we know that there must be many symbolic reasons for just this number, since we are dealing with an artwork designed to express secretly a

multilayered way of viewing the universe, as alluded to in the Talmud and the Kabbalah. What immediately comes to mind, of course, are the seven days of creation. According to Kabbalah, not only the material universe, but also Reality itself was brought into being during these seven days. This would certainly be appropriate for Michelangelo to emphasize in his ceiling design, which he hoped would create a new universal reality of spirit. All seven of these Jewish prophets were perfectly suited for this message as they foretold a future spiritual redemption, not just for the Jews but for all humanity.

Another key meaning to the number seven is its connection with the seven "lights" of the Holy Menorah, the golden seven-branched candelabra that was inside the Temple of Jerusalem. Even though there were already seven marble flames on top of the marble partition grill from the original fifteenth-century design of the Sistine, Michelangelo wanted to add his own version of the Menorah to this full-sized copy of the Holy Temple. It is a good thing that he did, considering that a generation after Michelangelo finished the ceiling, another pope would add an eighth marble flame to the partition, purposely ruining its correspondence to the Menorah. The prophet Zechariah envisioned the seven lights of the Holy Menorah as the "eyes of God," looking in all directions. That is surely why Buonarroti spread out his seven prophets all over the ceiling, looking in all directions, to serve as the eyes of God witnessing what goes on in the Sistine and in the world at large. Similarly, the prophets are also reminiscent of the Midrash that identifies seven clouds of glory that protected the children of Israel while they wandered through the wilderness. Kabbalah explains that we are threatened from seven sides: east, west, north, and south, above and below—and finally from within our selves.

Yet another explanation is that the prophets represent the Seven Middot, the seven characteristics of the seven lower *s'firot,* or spheres (in the singular, *s'firah*), on the Kabbalistic Tree of Life. These Seven Middot, in ascending order toward the Divine Unity, are:

1. Malchut—"empire, kingdom." This is the material world and the desire for material comfort and success.

2. Yesod—"foundation." This is the beginning or basis of the soul's desire for something beyond the material world. It is the foundation of spirituality and religion, and the basic link between heaven and earth.

3. Hod—"glory, splendor." This is the ability to maintain one's faith in the face of adversity, sadness, and defeat. This *s'firah* is perseverance, the capacity to accept divine will and to keep one's word to God, no matter what.

4. Netzach—"victory, eternity." This is the other side of perseverance, to strive continually for success, whether material (through ethical means, of course) or spiritual. It is the ability, as African-American spiritual leaders put it during the struggle for civil rights in the 1960s, to "keep your eyes on the prize."

5. Tiferet—"beauty." This is the central *s'firah* of the Seven Middot and of the Tree of Life. It represents balance, the unifying and harmonizing of seeming opposites.

6. G'vurah—"strength, power." This is on the same "side column" of the Tree of Life as Hod. It is the masculine, forceful side of the tree. This *s'firah* is also sometimes called Din, or Judgment, since G'vurah's strength comes from setting parameters and clear boundaries. Spiritual people draw on the energy of G'vurah and Din when they make faith-based judgments and limitations, such as between right and wrong, the pure versus the impure, and the holy versus the profane.

7. Chessed—"mercy, compassion, loving-kindness." This is on the same column of the tree as Netzach—the feminine, nurturing side of the tree. Chessed, even though seemingly more passive and flexible than G'vurah, is actually stronger, since mercy and compassion can ultimately overcome mere power by going above and beyond its rigid boundaries.

How are the seven prophets on the Sistine ceiling related to the Seven Middot? The Seven Middot are also considered to be seven spiritual "steps" to bring us ever closer to God. Moving from east to west, across the length of the ceiling, we have:

1. Zechariah, whose name means "God has remembered." His message emphasizes all the empires in the material world that sought to wipe out the Judaic faith. In each case, God remembered and redeemed the Jewish people, as depicted in all four corners of the frescoes. Thus, Zechariah represents the attribute of Malchut.

2. Joel—"God is God." His name tells us to link everything in the material world to the spiritual, to recall that behind everything perceived by our five senses, there is always God. He is Yesod, the link with our sense of spirituality.

3. Isaiah—"God is my salvation." He warned of the horrifying defeats and sufferings that the Jews would have to

Left: Joel. *Right:* Isaiah.

endure, but also encouraged them to keep the faith. In his panel, Michelangelo painted two anxious-looking putti, one of whom is pointing back in the direction of the destroyed Jerusalem and the Temple. Isaiah seems to be listening to their sad news, but he is not closing his book entirely—he is keeping his place in it, for a time in the future when he will open it again. He is in the place of Hod.

4. Ezekiel—"God is my strength." He is shown interrupted in the middle of his scroll, with one frightened putto on his left (negative) side, and he seems to be asking advice from the angel on his right. This angel is calmly holding up his right arm of power (and incidentally showing a nice strong left bicep as well), while his right hand points up to the source of his strength to win—up toward the Almighty One. Ezekiel told the suffering Jews that, in the end, they would win back Jerusalem and build the Third Holy Temple there. He represents perseverance to stay the path until the final victory, and so is in the place of Netzach.

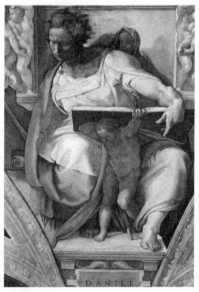

Left: Ezekiel. *Right:* Daniel.

5. Daniel—"God has judged." Daniel was one of the
 most beautiful and intelligent youths taken captive by
 Nebuchadnezzar when he conquered ancient Israel and
 took much of the nation into the Babylonian exile. As de-
 scribed in Daniel 5:1–28, during an orgiastic banquet in
 the king's palace, the pagans used holy vessels pillaged
 from the Temple of Solomon as mere serving dishes. God
 wrote on the wall over their heads "Mene Mene Tekel
 Ufarsin." Daniel, the only one able to interpret this, in-
 formed the tyrant Nebuchadnezzar that Babylon has been
 counted and weighed in the heavenly balance and found
 wanting. Soon afterward, the evil regime fell and the Jewish
 people were reunited with their Holy Land. Daniel is an
 important symbol of future redemption to both Jews and
 Christians, so he is well suited to sit in the central position
 of Tiferet.

6. Jeremiah—"God has exalted me" or "I have exalted God."
 He was the harshest orator of all the prophets, severely
 chastising the corruption he found in the priesthood as well
 as in the national leaders. Even today, speeches that lash out
 harshly against the establishment are called *jeremiads*. Just
 as Jeremiah warned, God exalted himself by way of strict
 judgment and powerful punishment of Israel, as Babylon
 destroyed Jerusalem, torched the Holy Temple, and took
 the populace into captivity and exile. He is, naturally, in the
 place of G'vurah/Din.

7. Jonah—"God will answer." His very name connotes heav-
 enly mercy, the attribute of Chessed. Jonah is given the
 frightening command to preach repentance to the huge,
 corrupt, pagan city of Nineveh. He is astonished when they
 immediately heed him and God shows divine compassion
 for them. The very last words of his book are from God,
 telling Jonah why it was vital to have mercy on this vast city,
 no matter if they were gentile or Jewish.

There are many more layers of meaning to Jeremiah and Jonah. Since they were painted near the end of Michelangelo's long labors on the ceiling, he filled them with the most messages—and so we will come back to them again, at the end of our private tour.

What cannot be ignored is that just as Michelangelo had omitted the standard "Christianized" sibyls used by the Church as precursors for the coming of Christ, he also left out some far more obvious choices for Hebrew prophets. It is true that the Church interpreted some of the included prophets as major spokesmen for the validity of Jesus as the Messiah; however, if that had been the artist's real intent in these frescoes, he undoubtedly would also have selected Micah, Ezra, Hosea, Amos, or Malachi—all more frequently quoted by the Church—in place of comparatively irrelevant choices like Jeremiah and Joel.

Michelangelo must have been well aware of the Vatican's tendency to reinterpret images. He had seen pagan statues slightly altered and renamed after Catholic saints. (In fact, even a century after Buonarroti, the Baroque artist Bernini ordered this done to dozens of ancient statues, in order to fill out the ranks of the 140 saints that line the top of his beautiful colonnades encircling St. Peter's Square in the Vatican.) So, to make sure that at some future date the Church did not try to change the identities of his pagan sibyls and Jewish prophets on the ceiling, Michelangelo carefully *captioned* each and every one with their proper names. It is a good thing that he did, since it is through their very names and identities that his hidden messages are able to reach us today.

The canny artist wanted to ensure that his Kabbalistic message would be rediscovered and believed, so he left one last clue for the skeptical. Having now learned the Seven Middot and their meaning, you will be able to grasp another very telling clue in a panel we previously analyzed. Recall that in the corner *David* panel, there is a hidden Hebrew letter gimel, formed by the outline of David and Goliath's bodies. Gimel stands for G'vurah, the forceful, male side of the Tree of Life, always located on the left side of the tree. Looking back at the other corner panel—of Judith and Holofernes—we

can see very clearly that the two bodies of Judith and her handmaid, bridged over by their arms and the basket carrying the enemy general's head, form the distinct outline of another Hebrew letter. It is the chet, which looks like this: ‏ח‎.

Note that Buonarroti was careful to darken the rear hem of the handmaid's yellow dress, so as to crop it out, thereby clarifying the form of the letter chet. Why did he want this letter to appear in the *Judith* corner? Chet is the letter that symbolizes Chessed, which is the nurturing, female side of the Tree of Life. It is always the right side of the tree.

When you stand at the end of the Sistine where the public entered in Michelangelo's day, at the papal portal, the *David* with the gimel is on the left side, for G'vurah. On the right side for Chessed is the chet imbedded in the *Judith* panel. Those who share Michelangelo's familiarity with Hebrew letters and Kabbalistic concepts have no difficulty in perceiving how the artist took the Judaic teachings he had learned from his private tutors in the de' Medici palace and

brilliantly incorporated them into the very heart of Christendom's most sacred chapel.

It is no accident that these messages were placed high up on the ceiling. In fact, Michelangelo designed his multilayered project so well that the higher we go and the more hidden from casual view, the more frequent and the more daring are the veiled messages we find. Indeed, at the very top of the ceiling—the central strip that runs the length of the Sistine Temple—he saved the best for last . . .

THE MIDDLE PATH

Each beauty which is seen here by people of
perception resembles more than anything else that
celestial Source from which we all come.

— MICHELANGELO

W E HAVE FINALLY ARRIVED at the core of the painting—
the central strip. This is undoubtedly the most famous
part of the frescoes, the section that most people have
in their mind's eye when they think of the Sistine ceiling. In the orig-
inal commission given to Michelangelo by the pope and his advisers,
he was supposed to have simply painted an imitation of a geometric
pattern found on the ceilings of the remains of many pagan Roman
palaces. The standard practice would have been for the artist to
"crown" the center of the ceiling with the symbols of the pope's sov-
ereignty—the crossed skeleton keys and the triple tiara—along with
his family crest and perhaps his name inscribed there as well. This
della Rovere oak-tree crest can be seen all over the original decora-
tions of the chapel, by order of Julius's uncle, Pope Sixtus IV. Not
only is there a large three-dimensional one directly over the papal
entranceway, but hundreds of them are worked into the "fabric"

The central panels of the Sistine ceiling

of the trompe l'oeuil draperies painted over the lower walls. This was the accepted norm for almost all papal ceilings down through the centuries, not only throughout the Apostolic Palace, but also in Castel Sant'Angelo (the best known of the several papal castles) and in other palaces, villas, and churches around Italy.

Michelangelo was neither an imitator nor a sycophant. This kind of project—following a banal standard prototype—was something he simply, by his very nature, could never do. If he had to slave on any project for several years of his life, even if it was an unwanted painting project, his pride would not allow him to do something mediocre—it had to be a project so extraordinary that only *he* could conceive and carry it out. This is the reason he preferred to work alone whenever possible—he always pushed himself to go above and beyond all previous boundaries, even beyond his own. So, too, with the Sistine frescoes—although from the outset the idea of a ceiling painting was distasteful to him, he could not do any less than his best. Instead of limiting himself to a cluster of pretty shapes and patterns and a stereotypical salute to his patron's power, he decided to fill the middle of the ceiling with what he, the artist, regarded as the central message of God's connection with humanity. This was the first time (and one of the only times) that a painter vetoed a pope's concept for an artwork in the Vatican.

As we have indicated, Michelangelo set up the seven Hebrew prophets to correspond to the Seven Middot, the lower part of the Kabbalistic Tree of Life. They balance the Sistine Temple between the column of G'vurah (strength and justice) on the left side and the column of Chessed (mercy and loving-kindness) on the right side. But what about the middle column, the central trunk of the tree? That, as Professor Gershom Scholem informs us in his classic work *On the Kabbalah and Its Symbolism,* is the Middle Path, the path of the *tzaddikim,* the truly righteous and holy.[1] These few souls are so pious and pure that they do not require all the struggles and ups and downs of life that a regular seeker must endure on her or his spiritual path. This is also called the lightning path, since it such a direct "express lane" to enlightenment. What did Michelangelo choose to illustrate this surest and most direct path to God? What, according

to him, is the real center of power in the world? For Michelangelo it was the original Torah, otherwise known as the Pentateuch or the Five Books of Moses. The Torah, composed of the five books Genesis, Exodus, Leviticus, Numbers, and Deuteronomy, is the core both of the Jewish Bible and of the Church's version of the Hebrew Scriptures called the Old Testament.* Interestingly enough, the five books are broken down into reading segments according to *two* different systems. The one known to most people, and accepted and used by all when quoting and referencing the Torah (as in this book), is an arrangement of chapters and verses. This has given rise to the expression "they quoted chapter and verse" to describe the use of precise or unequivocal language. This is the system that was developed by Catholic clergy centuries ago. The other method of segmenting the Torah is the Jewish division into *par'shiyot,* the weekly portions read in synagogues throughout the world every Sabbath to complete the study of the entire Torah once a year. This system is well over two thousand years old, canonized by the sages of the Talmud. The Torah *par'shiyot* are known and used almost exclusively by Jews today—and certainly that would have been the case in Catholic Italy five hundred years ago. However, that is exactly what Michelangelo chose to paint in his Middle Path on the ceiling—the first two Jewish Torah portions, or *par'shiyot,* called B'resheet ("in the beginning") and Noach ("Noah").

Buonarroti's plan is all the more dazzling when you realize that he had to execute the whole thing *backward,* starting from the eastern wall of the chapel and slowing inching his way west toward the altar wall, arriving at the beginning of the Torah narrative only after more than four years of backbreaking and mind-numbing labor. What most "official" explanations of the Torah strip misunderstand is why he ended it with the *Drunkenness of Noah* panel. Standard Vatican

*Something that most people do not know: the Jewish Bible and the Old Testament are not the same thing. The Old Testament is a Church-ordained reediting of the original order of the Jewish Bible; it realigns the books of the Prophets and the Holy Writings to heighten the impression that the Hebrew Scriptures seem to be anticipating the coming of Christ. In fact, there are even many differences between the Catholic Bible and the Protestant one.

guidebooks say that this is not only to show humanity's tendency toward sin, but also to foreshadow its coming redemption through Christ. However, it seems a very strange choice for an ending to the central narrative—both anticlimactic and downbeat. Considering how inspirational most of the other panels are, it doesn't appear to make much sense. These common explanations overlook one simple factor, though. The whole ceiling project was done in *two* phases. In the first phase, it is obvious that Michelangelo had planned to do the Torah panels as *triptychs,* that is, as a three-panel recounting of each major story in the strip. We can still see today that there are three panels for the pre-humanity creation story, three panels for the story of Adam and Eve, and then the last three for Noah. In a classic triptych, the climactic part is always the larger central panel, with the "supporting" parts of the story shown in the two smaller side panels. A quick glance back at the *Esther* corner fresco will give you an idea of how this worked: there is the big climax of Haman's execution in the large middle section, with the events leading up to it—Esther's accusation and the king's recollection of Mordechai's help—flanking Haman's corpse on either side. Michelangelo started this triptych style with Noah: the climax of his story is the Flood, which is the largest panel in the middle. This is flanked on both sides (above and below) by two lesser-known events after the Flood—the first altar ever built, to give thanks for surviving the deluge, and Noah's invention of the vineyard with his subsequent drunkenness.

We know from letters and from his contemporaries that Michelangelo encountered many problems while doing the *Noah* panels. He must have been working on them in the summertime, when Rome, especially in areas near the Tiber River (such as the Vatican), can be extremely humid and muggy. His first *Noah* frescoes had to be almost completely hacked out of the ceiling because they became crumbly and covered with mildew from the humidity. One Florentine friend and assistant named Jacopo l'Indaco came up with a brand-new formula for the fresco plaster (called *intonaco*), which was mildew and mold resistant, and thus saved the day. Because of this and other early problems—remember that Michelangelo had never frescoed before and was learning as he went along—just doing

the ceiling up to the third *Noah* panel took one and a half years. By the time the *Noah* triptych was done, Pope Julius was extremely eager to preview the work and also to show it off. Buonarroti argued furiously against this as much as he could, since no artist wants the public to see work not yet completed. Julius, who was not sure that he would live long enough to see the completed ceiling, would not be dissuaded. In 1510 the pope ordered the scaffolding dismantled and the first part of the fresco displayed to an eager public. The ecstatic reactions from artists and laymen alike helped overcome any complaints from the clergy and censors. Michelangelo won the right to proceed with the rest of the project without further (or with lessened, shall we say) interference. This was also his chance to stand on the ground level and see what the work looked like up there, about sixty-five feet above. He realized then that he was being too timid with the figures, that he had been making them too numerous and too small. We can immediately see the difference in the central panels after the *Noah* section: they are simplified and the figures are much larger and more "sculpted." Even the prophets and sibyls increase in size from that point onward. He had allowed his helpers to paint some of the Flood scene, and was unsatisfied with their contributions. From then on, he decided, he would do all the major panels and images himself—alone. This would slow down the job greatly, but it was his only assurance of maintaining his vision and his quality throughout. Michelangelo also realized that his original concept of triptych stories would not work. Even though his intent was that the biggest panel of the *Noah* triptych, that of the Flood, would be the final dramatic highlight of the ceiling, he could see that the viewer's gaze would naturally follow the simple linear order of the panels, ending in the relatively anticlimactic and downbeat Drunkenness scene. This triptych layout would have been even more confusing when it came to portraying the first days of creation. So, the plain truth is that the artist *changed his mind.* For the rest of the central Torah strip, he painted the narrative in straight linear order. With this in mind, let us now go straight to the Beginning, where Michelangelo actually *ended* the work.

PAR'SHAT B'RESHEET—THE CREATION PORTION

The creation story was one that Michelangelo would surely have known from the Jewish mystical perspective, since his teacher Pico della Mirandola had researched and written about it in a book entitled the *Heptaplus,* or the "Sevenfold explanation of the six days of creation." In the first panel, we see the very first verse of the Torah: "In the beginning, God created the Heavens and the Earth." In this depiction, the Almighty is twisted around in a serpentine manner, much like the contorted positions the artist himself was assuming to create the fresco. With his hands, God is seen as actually separating the heavens. In this gesture, Michelangelo shows that he understands a key concept of the Hebrew text: in the Jewish Bible, God creates the universe by way of separating and differentiating. God separates light from darkness, day from night, the waters from the dry land, and so on. To imitate this divine formula, the Jewish people will, later in the Torah, be commanded to separate and differentiate as well: between the Sabbath and the workdays, between kosher and nonkosher foods, between pure and impure sacrifices, between good and immoral actions, and on and on.

There is another reason why God's body is twisted in just this manner. If you look closely at the great statue of *Laocoön,* discovered only two years before Michelangelo started the ceiling project, you will see that the sculptor could not resist giving God the same magnificent torso as the Greek masterpiece.

All of Michelangelo's tutors in the Palazzo de' Medici were fascinated with the Hebrew biblical commentaries of the great sage Rashi, who lived in Troyes, France, in the eleventh century. Pico della Mirandola, especially, delved deeply into Rashi for his studies on the creation. Viewing this first panel on the ceiling, we may almost certainly infer that Michelangelo was taught some of Rashi's commentary. In the first chapter of Genesis, at the end of each day of creation, the text says: "And there was evening and there was

Left: First Creation *panel. Right:* Laocoön—*detail of torso.*

morning, the second/third/fourth/fifth/sixth day." However, oddly enough, at the end of the very first day, the Hebrew says: "And there was evening and there was morning, *one day.*" How can we explain this phrasing, which seems linguistically incorrect when compared with the way the other days are counted? It would be far more proper for the text to say "the first day." Rashi offers us an intriguing explanation: the Almighty wanted to ensure that humanity would properly understand the concept of the oneness of God, so he made clear that the first day was really the day of "the One" alone, with no angels or any other heavenly beings yet in existence. Sure enough, on the Sistine ceiling Michelangelo portrays God on day one as One alone, and it is the only panel of the first three sections in which there is not a single angel to be seen.

One last amazing fact about this panel: it was painted near the end of Buonarroti's sufferings up on the ceiling. He was in a desperate rush to finish, both for his personal health and because there was concern that the pope, who had been very ill, might not live to see the project completed. If Julius had died before it was done, the next pontiff might have cancelled the artist's contract, and perhaps

have changed or abandoned the work as well. In creating this panel, Michelangelo coincidentally worked without *his* "angels," his assistants who would prepare the full-size cartoons to transfer the outlines of the figures to be painted into the wet plaster *intonaco*. In fact, this sculptor who had said of himself "I am no painter" painted this entire panel *in one day—totally freehand,* something few highly experienced fresco artists would ever dare attempt.

The second panel is the *Separation of Day and Night,* when God creates "the Sun for the day and the Moon for the night." There are two secrets of this panel that bear mentioning. One is that the moon on the right side of the scene was painted without paint—it is the actual color of the *intonaco* itself, left bare on purpose by Buonarroti for a special otherworldly effect. The other secret is another *sfogo* or "letting off steam" of the angry artist. At this point, he had been up on the scaffolding for four awful years instead of pursuing his cherished craft of sculpting. He would have loved to insult Pope Julius in public, but of course that would probably have cost him his life or

Detail of the Creator's backside from the Separation of Day and Night *panel*

his freedom. So instead, Michelangelo found a way to insert a cosmic put-down coming from the Almighty himself. Look carefully at this scene and you will notice that Michelangelo has God facing away from the viewer while creating the sun, and his purple mantle seems almost to part right over—well, there is no delicate way to describe this other vulgar gesture of the angry Florentine. It seems as if the Lord is *mooning* Pope Julius II from his own chapel ceiling, sticking out the divine backside over the papal ceremonial area.

The theme of the third panel has long been debated. Does it represent the Separation of the Water from the Dry Land, or as Pico wrote, the Separation of the Waters (upper waters from lower), or the Separation of the Higher Firmament from the Lower? No matter which interpretation is correct, its message clearly revolves around God's power over the elements, as shown by his control over the waters. Here we can discover yet another idea that Michelangelo ingeniously encoded. As we learned in chapter 6, Dr. Garabed Eknoyan, in his carefully researched article in *Kidney International,* theorizes that the artist might already have been suffering from a kidney problem at this time—specifically, uric colic, a kidney dysfunction that would have eventually led to the kidney stones and the kidney failure that caused his death years later. We cannot tell if this was a genetic malady that ran in the Buonarroti family, or if it resulted from the artist's mentally and physically trying way of life. We do know that kidney problems can come from a lack of vitamin D, often the result of lack of sunlight, lack of sleep, and too much calcium intake. This sounds very much like Michelangelo's life while toiling on the Sistine ceiling, spending all his time indoors, sleeping and eating badly and irregularly, and drinking the calcium-filled water of Rome. Whether or not he was in fact suffering from kidney problems in his thirties, we do know that he had been fascinated with human anatomy since his youth, even doing illegal dissections secretly since he was only eighteen. Dr. Eknoyan points out that Michelangelo would surely have learned what Galen taught about the function of kidneys: that they separated the solid waste in the body from the liquid (urine). In this panel on separating the solid earth from the waters of the sea, Buonarroti wanted to

pay tribute to Galen and to thank those who had helped him gain his forbidden mastery of the internal secrets of the human body. If you look carefully at the royal purple cape that envelops God in this scene, you will see the clear shape and several key details of the human kidney.

THE CREATION OF
THE FIRST HUMAN BEINGS

The next panel, the *Creation of Adam,* is unquestionably the most famous part of the Sistine ceiling. In fact, along with *La Gioconda* (the Mona Lisa) and *The Last Supper,* it is one of the best-known images in the world.

Here we see Adam, the first human being, freshly formed from the dust of the earth, looking languid and limp because he still lacks the vital *ruach HaShem,* the divine life force. He is not only Adam here, but according to both Neoplatonic and Kabbalistic thought, he is *Adam Kadmon,* the primordial human, the prototype for all human life and the microcosmic model for the universe.

We also see God here, not so much as the Almighty, but in his role of Creator, the One who in creating Adam is creating all of *us.* Michelangelo's rendition of God in this scene has caused much debate and questioning down through the ages: Who is the young woman under God's left arm? Who is the infant under his left hand? Why does God require so many angels around him, even, seemingly, to hold him up in the air? Why did the artist make this image so busy, with so many extra figures around God, and then add a huge purple cape and a blue-green scrap of cloth hanging down like the tail of a kite?

There are two prevailing opinions on the identity of the mysterious woman. One claims that she must be Eve, or the soul of Eve, waiting for her true soul mate, Adam. The other interpretation is that she is the Neoplatonic concept of Sofia, the Greek goddess and symbol of Wisdom. It is this second view that finds a measure of Kabbalistic support. In the daily prayers of traditional Jews, there is

Creation of Adam *panel. See Fig. 15 in the insert.*

a blessing that offers thanksgiving for our life and for the genius of our bodily functions. The prayer expresses gratitude to God *Asher yatzar et Ha-Adam b'Chochmah,* "who formed humanity with Wisdom." However, instead of using the more common Hebrew word *anashim* (men, humanity, people), the prayer reads *et Ha-Adam,* literally "the Adam," the one primordial human. The phrasing powerfully echoes the Kabbalistic insight that man was created through the *s'firah* of Chochmah, Wisdom, known in Greek as Sofia—the very idea that Michelangelo may also be expressing.

The infant under God's left hand is most likely the *soul* of Adam, about to be transmitted into Adam. Notice that the infant's body position is imitating that of Adam. It is about to be infused into Adam through Adam's left hand. According to tradition, the left hand is the one through which we receive blessings and benedictions, since its blood vessels lead directly to the heart. Even today, countless people around the world wear the red string of the matriarch Rachel's blessing—on their *left* wrist. Michelangelo knew that his talents, too, were a blessing received from God. Is it only a coincidence that the artist, who depicted Adam receiving his soul from the Creator through his left hand, was also himself left-handed?

The other questions—about why God's image is so complicated in this panel, with so many seemingly superfluous figures, a cape, and a hanging cloth—were solved by chance in the year 1975. A Jewish surgeon from Indiana, Dr. Frank Mershberger, entered the Sistine, looked up at the great fresco, and was suddenly struck not only by a sense of awe, but also by a sense of . . . strange familiarity. What the American surgeon noticed in the *Creation* panel was the distinctive shape of the cape and the dangling scrap of cloth. He mentally blocked out the colors and the mass of adjacent figures. And then he found himself picturing the diagrams he had studied in his Anatomy 101 textbook back in medical school. The cerebrum, the cerebellum, the occipital lobe, the cortex, the brain stem . . . of course. They were all there. What Michelangelo had hidden in the painting was a perfect cross-section of the human brain. But—why?

Again, he was showing to others "in the know" what he had learned surreptitiously through illegal dissections. The only people

who might have recognized the hidden internal organs in the ceiling would have been other seekers of knowledge who had pursued the same forbidden activities. Those who knew the secret kept silent, and so for many generations the secret was lost or forgotten. It is a testament to Michelangelo's anatomical expertise—and his subtle way of disguising his messages—that it took a professional surgeon to rediscover it in the twentieth century.

Michelangelo concealed this forbidden evidence of anatomical studies to convey the concept of creation rooted in wisdom; the "brain" of God, so to speak, is the source of humankind's appearance on earth. It is yet another illustration of an idea stressed in the Kabbalah—the brain is the organ mystically linked to the s'firah of Chochmah/Wisdom. Incredibly, Michelangelo was aware of an even deeper truth, noted long ago in Kabbalistic thought: it is not the entire brain that is linked to Chochmah/Wisdom but only its right hemisphere, *exactly the part that Michelangelo painted in this panel.* The artist found a way to echo visually the ancient Jewish prayer proclaiming that God created Adam with Chochmah, the right side of the divine brain.

Some experts think that the extra interlocking figures surrounding God are the major brain centers and the ganglia (intersections of the "highway" of the nervous system). However, there is also a far more fascinating mystical explanation. According to Talmud, Midrash, and Kabbalah, the drop of semen that impregnates the womb of the woman does not originate in the male reproductive system but comes from within the man's *brain* instead. According to this interpretation, all those figures surrounding the Creator are us, the future descendants of Adam and Eve, waiting to be conceived. That makes all of us direct descendants of God, awaiting birth from his brain—a powerful universalistic concept.

There is still more. Since we know that Michelangelo studied Kabbalah, he was surely aware of the concept of Mochah Stima'ah, the hidden brain. This is a mysterious facet of God, concealed behind and between the s'firot on the Tree of Life. It represents the Almighty's purpose and reasoning behind seemingly meaningless occurrences and commandments. When people of faith say "The ways of the Lord

are mysterious," they are implying a belief in this Mochah Stima'ah, God's camouflaged rationale, or divine plan, behind everything that transcends the understanding of our finite mortal minds. Even the word *mysterious* has its root in the Hebrew word *nistar,* which means "that which is hidden." The Mochah Stima'ah is also the unknown purpose behind the will to create. This "hidden brain" (also known as "concealed wisdom") inspires in human beings the will to create, to build, to design, and yes—to sculpt and paint. It is the source of our drive to imitate the Creator and to infuse the world with meaning and purpose. It is transfused into us, according to the Kabbalah, by both sets of emotions emanating from the Tree of Life. The upper emotions— those that are spiritual, transcendent, and self-controlled—are called *Yisrael Saba,* or the Israel the Elder.* The lower emotions—those that are material, ego-centered, and impulsive—are called *Yisrael Zuta,* or the Israel the Little One. In a highly passionate creative genius like Michelangelo, driven by the ceaseless will to create, both of these emotions—the upper and lower—definitely came into play. Small wonder, then, that he painted Wisdom/Chochmah in the female guise of Sofia, flanked by the now-classic figure of the white-bearded God representing Yisrael Saba, and the infant representing Yisrael Zuta, all enclosed inside the right hemisphere of the human brain, blessing the Man's left hand with the talent and the will to create. Seen in this light, hidden inside this world-famous scene is nothing less than a forbidden anatomy lesson, a journey into the depths of Kabbalah, and a secret self-portrait of Michelangelo as Adam—not by way of the artist's physical appearance but rather of his very *soul.*

THE CREATION OF EVE

Even in the smaller, simpler panel of the creation of woman, we can find a deep, hidden Judaic message. According to Christian translation and tradition, the Almighty created Eve, the mother of us all,

*The Aramaic word *saba,* meaning "wise elder," comes from the same Babylonian root as the word *sibyl.*

Creation of Eve *panel*

from Adam's rib. However, the biblical Hebrew does not say that; the word used there is *ha-tzelah, the side* of Adam. The rabbinic sages explained that she was not made from Adam's head, which could have made her feel conceited and above her mate, and not from his foot, which could have made her feel downtrodden and want to run away, but from his side, to be his *equal partner* in life. For that very reason, in the next verse after Eve is created and named, we read: "Therefore shall a man leave his father and his mother, and shall cleave to his wife; and they shall be one flesh" (Genesis 2:24). In almost every non-Jewish depiction of the birth of Eve, she is shown as rising out of one rib of Adam. Here, on the Sistine ceiling, however, she is shown following Judaic tradition, stepping out of the entire side of Adam.

THE FORBIDDEN FRUIT

The Forbidden Fruit section of the ceiling also holds secrets. It is a *diptych,* a painting made of two equal parts. On the left, we see Adam and Eve, still innocent, about to eat the forbidden fruit. The crafty

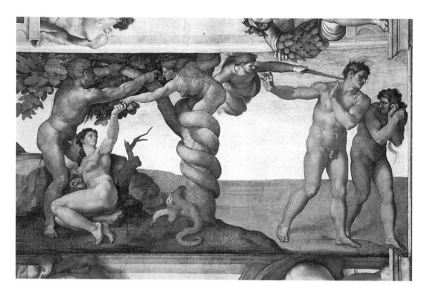

The Forbidden Fruit *panel. See Fig. 16 in the insert.*

serpent is in the middle, wrapped about the tree, tempting them into sin. On the right, we see them being exiled from the Garden of Eden, ashamed and already showing signs of the natural aging process, since part of their punishment was to lose their immortality and their eternal youthfulness. At first glance, this seems like a typical rendition of the story of what the Church calls the Original Sin, or the Fall from Paradise. However, looking deeper, we find many surprising and subversive elements, even in the format chosen for this panel.

First of all, let's look at the forbidden fruit itself. As we have previously pointed out, according to most traditions, it was an apple. In fact, in medieval Latin, the word for apple is *malum,* which in other cases becomes *male* and *mala,* synonymous with evil, as in the words *malicious* and *maleficent.* In modern Italian, the vowels have been reversed, making *mela* the word for apple. If you look at almost any other painting or fresco in Western art that depicts the forbidden fruit, you will find the standard image of the apple.

There was only one exception to this commonly held belief: the Jewish tradition. The Talmud (in Tractate Brachot, 40a) discusses the views of the rabbis and offers a strikingly different belief. The

sages base their conclusion on a mystical principle that God never presents us with a difficulty unless he has already created its solution within the very problem itself. Therefore, they propose that the Tree of Knowledge was a fig tree. After all, when the immediate result of Adam and Eve's transgression was shame, occasioned by their new awareness of their nudity, the Bible tells us that their recourse was to cover themselves with fig leaves. A compassionate God provided the cure for the consequence of the sin from the selfsame object that caused it.

It is hard to imagine many Christians being aware of this in Michelangelo's era, or even today. Only someone who had studied Talmud would have known such a thing. Yet, sure enough, there in the panel of the *Original Sin,* Michelangelo's Forbidden Tree of Knowledge is a fig tree. If you look closely, you will see that the fruits dangling from the serpent's hand, which Adam and Eve are about to pick, are all juicy green figs. Remarkably, Michelangelo chose a rabbinical interpretation of the biblical story over the one accepted by his Christian contemporaries.

Michelangelo also chose a unique way to show their innocence before eating the fruit. If you look at Adam's stance as he reaches into the tree for a fig, it is difficult *not* to notice that his sexual organ is positioned almost in Eve's face. If she were to turn her head even slightly in his direction, we would have an X-rated ceiling. The Church was not unaware of this, and so prohibited any reproductions of this one panel all the way up to the late nineteenth century.

There is still more Judaic teaching to be found here. Another shocking change from the standard imagery is that Adam himself is plucking the forbidden fruit off the tree, instead of the stereotype of the "evil temptress Woman" handing him the deadly apple and seducing him into eating it. This is to show that Adam shared as much responsibility in the sin as Eve. Why? The Almighty tells him that they are allowed to eat freely from all the trees in the Garden of Eden, except for the Tree of Knowledge of Good and Evil (Genesis 2:16–17). However, only a few verses later, at the beginning of Genesis 3, when the serpent is tempting Eve, we hear a different story:

*Now the serpent was more subtle than any beast of the field which
the Lord God had made. And he said to the woman, Has God
said, you shall not eat of every tree of the garden? And the woman
said to the serpent, We may eat of the fruit of the trees of the garden;
But of the fruit of the tree which is in the midst of the garden, God
has said, you shall not eat of it, nor shall you touch it, lest you die.
(Genesis 3:1–3)*

This is *not* what God had commanded Adam. The Almighty
specified the Tree of Knowledge of Good and Evil, not the "tree in
the midst of the garden." That is a different tree, the Tree of Life.
Furthermore, nothing had been said about not touching the tree.
What did the ancient rabbis derive from this? *Adam had not faithfully
passed on the true words of God.* He did not specify the right tree, and
he embroidered God's prohibition with an extra one of his own inven-
tion about not even touching the tree. This transgression on Adam's
part made Eve an easy prey to the serpent's lies. When the Almighty
confronted a frightened Adam after the sin, the Man tried to lay all
the blame on the Woman. When God confronted Eve, she was far
more truthful and simply said: "The serpent deceived me, and I ate."
Notice that she did not say "tempted me" but actually said "deceived
me." How was she deceived? The sages of over two thousand years
ago developed this midrash, which explains everything: As the ser-
pent enticed Eve to approach the forbidden tree, he gave her a shove
that made her touch the tree. When no bad consequence ensued, she
was easily convinced that God had lied to them. In fact, it was not the
tree situated exactly in the middle of the garden—that was the other
mystical tree, the Tree of Life—but because of Adam's careless trans-
mission of God's words, Eve did not know the true prohibition. In
this way, she was deceived and not merely tempted. So, Michelangelo
decided to show Adam sharing equally in the guilt—something not
seen in any other Western representation of the Original Sin.

In yet one more way Michelangelo chose to follow Jewish tradi-
tion. Only the Midrash described the serpent as originally having
both arms and legs. In the mainstream imagery of the Garden, the

serpent is usually shown as a huge snake looking much as we know snakes today. Sometimes, the serpent will have a human head, but that is it. Here, on the Sistine ceiling, Michelangelo again follows the Judaic teachings, giving his unique serpent arms and legs.

Next to the serpent, on the right side of this two-part panel, we see the angel with the sword banishing Adam and Eve from Paradise forever. Here we discover the last great hidden message of this scene. *The righteous angel is an exact twin of the evil serpent.* Even their gestures and body positions are mirror images of each other. Their bodies together form a sort of human heart. Michelangelo is returning to the subject of his earlier poem and the *Battle of the Centaurs*—the struggle of the two inclinations. According to Jewish philosophy, you might recall, each of us has a lifelong internal conflict, a "tug of war," between the *Yetzer ha-Tov* (inclination toward doing good) and the *Yetzer ha-Ra* (inclination toward doing evil). Notice that the twin inclinations—symbolized by the serpent and the angel—are on the two sides of the Tree of the Knowledge of Good and Evil in the Garden of Eden, since it is at this very spot that humanity learns the difference for the first time. What the artist is illustrating here differs from the standard Church concept of Original Sin—a concept foreign to Judaism. Rather, his rendering stresses the human potential for free choice and free will.

This is where the ceiling's first *par'shah,* or weekly cyclical reading portion of the Torah, leaves off. The next *par'shah* continues the story at the time of ten generations after the sin of Adam and Eve. At this point in history, humanity had begun to cover the globe but, unfortunately, was misusing its free will to follow almost exclusively the Yetzer ha-Ra, or evil inclination. That is the theme of the last triptych section of the ceiling, which Michelangelo began to paint in 1508. Let us see now how he chose to depict the story of Noah.

THE SACRIFICE OF NOAH

As we explained earlier, the three *Noah* panels are not in strict chronological order. This scene actually occurs after the floodwaters

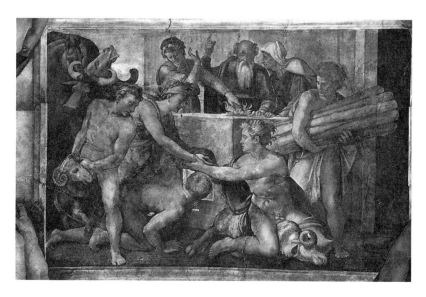

The Sacrifice of Noah *panel (pre-restoration)*

receded and Noah, his family, and the animals had disembarked onto dry land. To thank the Almighty for their salvation, Noah built the first altar in history. According to the Midrash, Noah—being a prophet—knew exactly which animals would later be permitted for sacrifice in the Holy Temple. In numerous paintings and frescoes of this scene, other Christian artists have shown Noah sacrificing all sorts of improbable, nonkosher animals: lions, camels, donkeys, and so forth. Michelangelo follows the Midrash faithfully, depicting only the biblically allowed animals that Noah would have used.

Noah himself is pointing up toward heaven with one finger, to show that this first sacrificial altar is being dedicated not for pagan idolatry but to the One God. You will also notice that two figures on the left seem to be in shadow—one of Noah's three sons and a mysterious female wearing a pagan Greco-Roman crown of laurel leaves, the symbol of Nike, goddess of victory. These two people are not in shadow. What happened was that the constant problems with mold and mildew in these early panels took their toll here. About a generation after the completion of the ceiling, this one section of plaster detached and crumbled to bits on the floor below. In 1568, a fresco painter named Domenico Carnevali had to climb up on a tiny

scaffold and replace the fallen section. Obviously, the chemicals in his paint or plaster did not match the quality of Michelangelo and his assistants' formula, and the repair darkened irreparably over time. This is probably for the good, as it allows us to distinguish easily between the original work and what was added later. We have no idea what Carnevali had in mind with the female figure, but it is doubtful that Nike appeared in Michelangelo's original version.

THE FLOOD

In the main scene for the last trio of the *Noah* panels, a piece of the fresco is missing, just above the stranded people under a makeshift tent on the right of the panel. This damage occurred in 1795, when ammunition stored in the papal armory in Castel Sant'Angelo accidentally exploded. The huge blast shook the entire neighborhood, and we are lucky that only this one chunk fell down, instead of the entire ceiling. Almost three hundred years after Michelangelo, nobody dared go up there and paint where the Maestro had; so out of respect, the patch was left blank.

The Flood *panel. See Fig. 17 in the insert.*

Once again a bit of Talmudic knowledge will help us better understand an aspect of this panel. There is a specific Hebrew word for "ark" in the original Torah text—*teivah.* The word *teivah,* however, does not mean a boat or sailing vessel. It really means "box." In just about every depiction you will ever see, artists have shown Noah's ark to be a gigantic seaworthy boat with a curved hull. According to Talmud and Midrash, however, it was a giant boxlike structure that could not possibly have floated on the floodwaters' surface, were it not for the Divine Breath or Heavenly Wind that held it up on the waves. Here, on the Sistine ceiling, Michelangelo painted the ark as a huge box, once more following Jewish tradition to the letter.

Of course, Michelangelo and his merry band of Florentines could not resist yet another jab at Rome. On the left edge of the panel, we see the head of a donkey. At the exact same height, on the right edge

Left: Flood *panel, detail from middle left. See Fig. 13 in the insert.*
Right: Flood *panel, detail from middle right. See Fig. 14 in the insert.*

of the scene, are two tiny figures that have just climbed out of the waters to find refuge on the rocks behind the makeshift tent. Little do they know that they will soon drown anyway for their sins, since the only humans destined to survive the Flood are those on the divinely ordained ark. These two sinners in the background look like two water rats; they are on their hands and knees, and wearing the unmistakable red and golden yellow colors of the city of Rome. Just in case someone didn't believe there was an insulting message here, the colors of the woman's dress that forms a backdrop for the ass's head are the very same Roman colors.

THE DRUNKENNESS OF NOAH

In the Bible, after Noah saves life on earth and builds the first altar, he plants a vineyard (shown in the background on the left) and invents wine. Shortly thereafter, he becomes his own best client, as we can see from his bloated body and reddened features in the later scene in the foreground. He falls asleep naked and is discovered this way by his son Ham, who rather than covering up his father's nakedness, runs to tell his brothers Shem and Japhet instead. They respectfully enter the place where their father is sleeping, carrying a garment and turning away their heads so as not to see him in his moment of disgrace. In Genesis 9:24, the Torah recounts: "And Noah awoke from his wine, and knew what his younger son had done to him." The sages of the Talmud wondered how Noah could have known upon awakening what Ham had "done to him," if it was just lewd mockery and disrespect while he was passed out. Rabbi Samuel (in the Talmudic Tractate Sanhedrin, 70a) found a textual link with a later episode in Genesis in which Shechem, a pagan prince, accidentally catches a glimpse of the body of Dinah, the only daughter of the patriarch Jacob. After seeing her exposed, Shechem cannot control himself and rapes Dinah (Genesis 34:2). Rabbi Samuel concluded that Ham had followed his animal impulse and similarly sexually molested his own father. This does indeed make more sense of Noah's statement upon awakening. It also makes far more

The Drunkenness of Noah *panel*

comprehensible the harshness of his response as he curses his son Ham for his actions.

Here, in Michelangelo's version, he has painted the other two sons, Shem and Japhet, coming into Noah's room to cover him with their heads turned away from their father's nudity. Ham has reentered behind them, gesturing toward Noah and not turning his head away. Ham is even grasping his brother (probably Japhet) from behind as if to try to dissuade him from covering up their father. The artist has given a definite homoerotic slant to Ham's embrace of his younger brother, making it seem as if now Ham would like to sexually molest Japhet as well.

The official explanations for this panel range from a foreshadowing of the Incarnation of Jesus (the planting of a new vine), to an allusion to the Passion (because of the blood-red color of wine) or the chance for redemption through Christ (the covering up of one's past sins). However, a clear, fresh look at this scene makes it seem more likely that Michelangelo was once again following Talmudic teachings and his own sexual tendencies as well.

There is one more reason that the central strip seems to end on this relatively minor, downbeat note. As we saw in the diptych (two-part panel) of *The Garden of Eden,* Michelangelo knew very

well the concept of the two sides of the human soul—the Yetzer ha-Tov and the Yetzer ha-Ra—the transcendent spiritual tendency versus the materialistic animal tendency. In that panel, he paired the serpent and the angel, mirroring each other, to represent this ongoing struggle between good and evil in the human soul. Here, in the *Noah* triptych, he put the Flood in the middle, framed by the transcendent, spiritual side of Noah (the sacrifice scene) before it and the sinful, hedonistic side of Noah (the drunkenness scene) after it.

The artist is not leaving us with a negative note, but—when we view the *Noah* triptych as a whole, the way he first designed it to be perceived—we can see that he is presenting us with a deep spiritual question as we leave the Sistine. Michelangelo is asking us which tendency we are following: our Yetzer ha-Tov or our Yetzer ha-Ra? Has his work inspired us to take a step closer to God or a step away from God?

The central Torah strip ends here. Before we leave the Sistine Temple tour, though, we will have to look at some powerful final secrets that Michelangelo concealed in the ceiling frescoes before he laid down his brush. It seems he had been saving up the strongest messages for last.

PARTING SHOTS

God is in the details.

—LUDWIG MIES VAN DER ROHE

A s THE HELLISH four and a half years of Michelangelo's enslavement to the Sistine ceiling drew to a close, the rebellious artist decided to make maximum use of the remaining frescoes for the hidden messages he wanted so desperately to leave as his legacy. That is why he hid an entire cluster of secrets in the section depicting the Jewish prophet Jeremiah.

SOMEONE ABOVE THE POPE

We need to pay especially close attention to the portrait of the gloomy seer, shown to us from his left side, the area referred to as the "sinister face," which represents the darker side of a person. In Kabbalah it is also the side of G'vurah and Din, power and judgment, the strict aspect of the Tree of Life that is concerned with judging sins and conferring punishment.

We see the prophet staring sadly and angrily down over the spot where the pope would sit on his sumptuous throne, under the regal

Jeremiah. *See Fig. 19 in the insert.*

canopy. As you will recall, Jeremiah was the godly messenger who warned the corrupt priests of the Holy Temple that their bronze and gold would be taken away and their Temple destroyed unless they cleaned up the corruption within. He is covering his mouth in the *signum harpocraticum,* a gesture signifying that a profound esoteric knowledge occupies his thoughts. (Michelangelo employs the same gesture in other works, including his funerary monument to Lorenzo de' Medici, a duke named after Lorenzo the Magnificent.)

Detail from the tomb of Lorenzo de' Medici (Sagrestia Nuova, Florence)

The entire panel is filled with foreboding. The two small figures in the background of Jeremiah are not the cute cherubic putti seen elsewhere. Instead, we have a mournful youth and a sad woman of indeterminate age, both starting to turn away from the chapel. The young man's golden hair and the woman's red hood whisper a coded message to us: "Look at the colors the prophet is wearing." Sure enough, Jeremiah is garbed in the very same red and gold. Why? They are the *giallorosso,* the traditional colors that symbolize Rome, the home of the Vatican. We have seen this before, hidden in tiny figures in the *Flood* panel, when the Florentine artist wanted to make fun of Rome. To this very day, centuries later, red and gold are the city's colors, found on taxicabs, official documents, and even the uniforms of Rome's soccer team. This is how Michelangelo wants to make it clear that he is addressing Rome and not ancient Jerusalem. The woman is wearing a hooded traveling cloak and is bearing a bundle; she seems to be leaving her home. The youth is gazing sadly down at his own foot, where, if we squint our eyes from far

below, we find something quite intriguing. The boy's foot is holding in place a faint trompe l'oeuil parchment scroll unrolling high above the regal papal platform.

Most Vatican guides never talk about the barely visible scroll. Many are not even aware of its existence; almost all the ones who do know of it will say that Michelangelo wrote the Greek letters alpha and omega (signifying the beginning and the end) on it, both in reference to Jesus and to the completion of the giant fresco. None of this is true. He was not yet finished; he still had another strip of ceiling to fresco. Also, the scroll contains no Greek letters.

It says, indisputably and in Michelangelo's own hand, ALEF, the name of the first letter of the Hebrew alphabet, written in Roman script. This is a reference that would be clear to someone who had studied the Scriptures from a Jewish perspective. Jeremiah is not only the author of his eponymous book of prophecies; he is also

Detail from the
Jeremiah *panel*

accepted in Jewish tradition as the author of the book of Lamenta-
tions. This plaintive book, which describes in gruesome detail the
destruction of Jerusalem by the Babylonians, is read every year on
the somber holy day of the ninth of the month Av (Tisha b'Av),
as Jews worldwide fast and mourn the destruction of the Holy
Temple. In Michelangelo's day, if any lay Christian read this book,
it would have been in Latin. Only Jews or Christians who had stud-
ied Hebrew and Judaism (such as Michelangelo's private teachers
Marsilio Ficino and, especially, Pico della Mirandola) would know
that the book of Lamentations is an acrostic, written verse by verse
in the order of the Hebrew alphabet, beginning with the alef. The
reason for this is based on a deep Kabbalistic concept: just as the Al-
mighty One created the entire universe with the twenty-two letters
of the holy Hebrew alphabet, starting with alef, so God can destroy
it as well.

Right next to the word *ALEF*, Michelangelo painted צ—the
Hebrew character for another letter, the ayin. Why? These two let-
ters are not commonly written together. Only someone very con-
versant with Judaic tradition can tell you the answer. The Talmud
teaches that if a high priest cannot distinguish in his pronunciation
between these two letters—alef and ayin—which are sounded al-
most identically, that priest is not fit to serve in the Holy Temple.
Why is this so? First of all, the High Priest must be a trustworthy
conveyor of God's Word to the world. The change from an alef to an
ayin in a word—or vice versa—may significantly alter its meaning.
The High Priest's improper diction can cause great harm to tradi-
tional teaching. The other, more profound reason is concerned with
the fundamental concepts that these two letters spiritually represent.
The letter alef (sometimes written as "aleph" in English—hence the
word *alphabet* from the first two Hebrew letters, alef and bet) is not
only the first letter in the Hebrew alphabet; it is also the first let-
ter of the Ten Commandments, whose message is monotheism. Ac-
cording to the mystic system of *gematria* (Hebrew numerology), the
value of alef is one. That is why it is often used to represent God,
whose defining characteristic is that he is One. The value for the

other letter on the scroll, ayin, is seventy. In biblical Hebrew, the number seventy is used to imply a great amount or diversity, such as "seventy languages in the world" and "seventy nations." Both the Talmud (Tractate Succah, 55b) and the Midrash (B'resheet Rabbah, 66:4) discuss the seventy-one descendants of the three sons of Noah. Seventy of them go on to found the seventy pagan nations of the earth, while only one goes on to found the Jewish people—at that time, the one and only monotheistic, *non*-pagan people in the world. It is therefore imperative for a high priest to be able to differentiate clearly between the Alef and the Ayin, between the "One" and the "seventy," between those who commit themselves to the purity of monotheistic faith and those who succumb to the immorality of paganistic practice. This message of one versus seventy serves as a strong warning not just to the Jewish high priests but to the custodians of any monotheistic faith, popes included, to maintain the purity of belief and of people in the face of challenges from materialistic and pagan cultures. In Jewish tradition, we find the cautionary adage "Be *in* the world, but not *of* the world." In the Gospels, Jesus says: "Render unto Caesar that which is Caesar's, and unto God that which is God's" (Matthew 22:21). Michelangelo was deeply troubled by a Church that was trying to imitate the grandeur of the Caesars while ignoring the humility and poverty of Christ. He recognized that the Vatican had become a place of unbridled corruption, greed, nepotism, and military adventurism. No longer was spiritual leadership concerned with delineating the differences between the "One" and the "seventy." And so Michelangelo dared to express his anger by way of the angry prophet Jeremiah, who predicted doom for precisely those who failed to heed this very message. Of course, it was an extremely dangerous and seditious statement.

How much more perilous to inscribe that message right over the pope's gilded throne in his own royal chapel. No wonder Michelangelo blurred the text and made the scroll itself almost invisible. But he left enough there to allow us to grasp his meaning. The rest of the scroll is still hard to decipher. Its harsh criticism of the Church, though, is confirmed by the fact that even now, in the twenty-first century, the Vatican has made sure that this panel does

not appear clearly featured in any authorized reproduction, nor is it ever pointed out or discussed in any official guidebook.

Ironically, Pope Julius II would sit below Jeremiah and his condemnation amid all his symbols of power and wealth, from the ground up: a marble platform, his royal court, his gilded throne, his precious rings, his velvet robes, his golden pastoral staff, his triple crown covered with jewels, and above his head, the *baldacchino,* the regal canopy of the papacy. That is why Michelangelo decided to set a series of his own symbols right over the canopy, to ensure that his message would always remain *above* the pope himself. As we will see, in addition to Jeremiah's face, the two figures behind him, his gesture, and the alef-ayin scroll, there is even more to discover.

As we described in chapter 9, almost all the Jewish ancestors are portrayed as members of content, tranquil families; these are positive portraits of biblical Jews. There are only two exceptions, two very strange figures. One we have already discussed: the angry young Aminadab, wearing the yellow badge of shame forced on

Salmon-Booz-Obeth *lunette (pre-restoration)*

the Jews and making the devil's horns pointing down toward the papal throne area. The second is the *Salmon-Booz-Obeth* lunette, which features a rage-filled old man yelling at a carved head atop the wooden staff he holds in his hand. The wooden head seems to be a portrait of the old man himself, pointy beard and all, mirroring his expression and seeming to yell right back in his face.

On the other side of the lunette is a beautiful young mother, gently covering her sleeping baby's ears to block out the angry ranting coming from the old man. Out of all the portraits of the ancestors on the ceiling, this furious elder is the only one who is not realistically depicted. He is more like a caricature—and on purpose. He is a satirical swipe at another bearded old man, the one who would sit directly below, also known for his bad temper—*Il Papa Terribile,* Julius II. A quick comparison of the pronounced cheekbones in this figure and in Raphael's much more flattering portrait of Julius will show that they are the same person. If Michelangelo had made the insult to the pope too obvious, it would have been the artist's head on display instead—on the executioner's block.

Right between the Boaz-Aminadab double jab at Julius is the name plate of Jeremiah, *Hieremias* in Latin. The other names of the sibyls and prophets are held up by cute little boys and putti. In this case, though, the name Hieremias is being held up in the manner of a strong man at the circus—by a muscular young *woman*. She is not very attractive, and her awkwardly exposed breasts are quite obvious—right above the papal throne. Julius, despite his priestly vow of chastity, was known to be a womanizer. In fact, while still a cardinal he had contracted syphilis from one of his trysts, and suffered from its symptoms throughout his papacy. Just like this young woman, Michelangelo is exposing everything here.

The papal throne area is the platform near the front of the Sistine, to the left of the altar area. It is under the fifteenth-century masterpiece fresco *Scenes from the Life of Moses,* by another gay Florentine artist linked with the de' Medici family—Sandro Botticelli. One scene in this painting depicts the moment when Moses the shepherd realizes he is near the Divine Presence. The Almighty tells him to

Detail below Jeremiah *panel, with his name in Latin: "Hieremias"*

remove his shoes, that where he is standing is holy ground (Exodus 3:5). Moses is shown taking off his shoes before he can approach the Presence in the burning bush. All the other Jewish prophets painted by Michelangelo on the ceiling have bare feet, to show that they are in a holy place, the replica of Solomon's Temple—with one exception. Jeremiah appears to be wearing dirty old boots. Dirty shoes over the head of the pope was an insult, but it also said that his conduct and his papacy, unless changed for the better, would eventually remove the holiness from this sanctuary. The artist was warning that the Divine Presence and its protection were getting ready to abandon the Vatican.

Exactly fifteen years after Michelangelo painted his prophetic warning, the Protestant Franks perpetrated the horrific, infamous sack of Rome in 1527, raping and murdering by the thousands. They seized and pillaged the Vatican, taking away all its bronze and gold that they could carry—just as Jeremiah and Michelangelo had predicted.

LAST TOUCHES

The reaction is almost always the same.

First-time visitors to the Vatican look up to the Sistine Chapel ceiling. Their eyes are drawn to the largest and most imposing figure in all the frescoes. They stare in wonderment. Often they literally gasp. What Michelangelo achieved in the portrait of Jonah that he planned as his final statement, the work he put off until the very end of his long, grueling project, is a masterpiece in purely artistic terms. However, for those who know of his genius for conveying the most profound messages in the seemingly simple strokes of his brush, the Jonah painting is a veritable gold mine. More than just a great painting, it is a powerful summary of Michelangelo's feelings as he brought to a close the project that he never wanted, for a pope who put him through a personal, physical, and artistic hell for almost a decade.

Knowing this, we have to ask: out of all the prophets and famous heroes in the Bible—why Jonah? Michelangelo saved the most prestigious spot, right above the altar, for him. He allowed Jonah the most space of any figure. And then he literally made him "stand out" in a way that viewers still have difficulty believing is merely two-dimensional.

The story has it that as Michelangelo was nearing the end of his work on the ceiling, his old rival Bramante (the architect who got him into this mess in the first place) went into the chapel to take a look at the almost-completed fresco. "*Va bene,* all right, you can paint," he begrudgingly conceded to Michelangelo, "but a *real* painter would impress the viewer with trompe l'oeuil figures." Michelangelo had indeed used trompe l'oeuil throughout the ceiling, in the faux architectural-design elements such as the vaulted ribs and the square white pedestals that seem to be three-dimensional seats for the *ignudi;* however, he had not yet done this with his human images. Now, after four years of on-the-job practice, he was more than up to the challenge. As an ultimate demonstration of his artistic

power—a talent that those who sought to denigrate him claimed Michelangelo was unable to transfer from his *true* profession as a sculptor—Michelangelo saved for last his most magnificent example of three-dimensional painting. Jonah seems to be actually dangling his legs out of the wall and over the altar, while his shoulders and head seem to be leaning back through the roof of the Sistine into the open sky beyond. It is incomparable technique. It resoundingly refuted Michelangelo's critics. But again, why did Michelangelo choose Jonah as his paradigm "stand-out" figure?

It was striking enough, and surely disturbing to the pope who commissioned him, that of all the prophets chosen to be spotlighted by Michelangelo, not one of the seven—Zechariah, Joel, Isaiah, Ezekiel, Daniel, Jeremiah, and Jonah—was a New Testament hero. But even among Hebrew Scripture personalities, Jonah hardly seems worthy of such illustrious company. His book is short, all of four short chapters totaling forty-eight sentences. In the Christian Bible, the book of Jonah is found in the section called "The Minor Prophets." In the Jewish version, Jonah isn't even given the courtesy of a book of his own; he is simply lumped in with eleven others in the work known as Trey Assar, "The Twelve."

Yet for Michelangelo, Jonah is the final and most eloquent spokesman of the Sistine Temple *because Michelangelo saw in Jonah his alter ego—a reluctant prophet forced by divine will into a mission he wanted at all costs to avoid.*

- Jonah is the very image of the unwilling prophet forced to accept a task against his own wishes. Just as Michelangelo was perfectly content to sculpt his statues under the de' Medicis of Florence, Jonah was content to live in Israel under the corrupt rule of Jeroboam, who according to the Talmud was the most evil and idolatrous of all the kings of Israel. (To this day in wine shops, one of the largest sizes—and thus the most decadent—of wine bottles is the jeroboam.)

- Jonah is called upon by the Almighty to go to the wicked city of Nineveh (located in what is modern Iraq) and to prophesy

to its corrupt pagan ruler and inhabitants. Michelangelo was called upon to give up both sculpting and his beloved city of Florence to remain at the Vatican for several years doing something that he disdained—painting.

- Jonah tries to escape from his calling by boarding a ship going in another direction, but he is pursued by God and ends up being swallowed by a giant fish for three days. Michelangelo attempted several times to flee from the pope's onerous commission but ended up being forced to paint the ceiling of the Sistine for more than four years of physical and emotional torture.

- Both Jonah and Michelangelo cried and prayed to heaven for their liberation "out of the depths." Jonah, once he is saved from the belly of the beast, fulfills his obligation by going to Nineveh and preaching to its citizens to repent. Amazingly, after only one day, the entire city—from the king to the lowest pauper—dress in sackcloth and ashes, fast and seek atonement. All of Nineveh forsakes the worship of idols. Jonah, upset that the repentance of Nineveh might discredit the truth of his warning, sulks outside the city. Michelangelo, despondent that he had not met with the same success in his efforts to purify the Church from its hedonistic excesses, sulked in the Sistine, intent on finishing the ceiling project and escaping the chapel as soon as possible.

And still there is more.

Michelangelo had a precedent for putting so much emphasis on Jonah and saving the message of this prophet for the very end of his work. It was a precedent that Michelangelo had almost certainly learned about as he studied the teachings of the Talmudic rabbis in the secret school of the de' Medicis. Because Michelangelo's focus on Jonah is *what the Jews have been doing for centuries, to this very day, on their holiest day of the year—Yom Kippur.*

Yom Kippur, the Day of Atonement, concludes a ten-day period of penitence that begins with Rosh Hashanah, the "Head of the

Year." The Talmud explains that on the first of these ten days God "writes" his decree for the coming year for every individual—who will live, who will die; who will be blessed, who will be cursed; who will be well, who will suffer. But the decree is not sealed until the conclusion of Yom Kippur. Repentance may still alter a harsh judgment. So these ten days are also known as the Days of Awe, each one bringing closer the moment when there is no longer any escape possible from the heavenly verdict.

As the sun begins to set on the Day of Atonement, the Jewish prayer book offers the image of the closing of the heavenly gates. The prayers change from the request to "write us down for a good year" to "seal us for a good year." And it is just before the gates close that Jewish tradition requires the recitation of one specific Scripture. It is the four chapters of Jonah, read in every synagogue around the world as the concluding message of the day. *The prophet the Jews chose to close the prayers of their holiest day is the very same prophet Michelangelo selected as his farewell spokesman for the Sistine.*

To understand the reasons for the choice of Jonah by Jewish tradition is to grasp what must have motivated Michelangelo as well.

The Talmudic rabbis felt that the story of Jonah is the quintessential message for the day on which Jews are most concerned to make their peace with God. It is a story that reminds us that God judges the whole world—not only Jews but the people of Nineveh and all the other nations as well. It emphasizes the truth that those who follow God have an obligation to help the wicked turn from their evil ways. No one can flee from this obligation without suffering the consequence of divine wrath. No one can hide from God no matter where he or she goes, even hidden in the belly of a whale at the bottom of the sea. We may never give up hope that the wicked, no matter how far gone, can be moved to change their ways. Repentance is always possible. And, most important, repentance is always accepted by God, even at the very last moment before imminent destruction. God doesn't desire the destruction of evildoers as much as he wants them to change their ways—and then to offer them his forgiveness.

Imagine how much these ideas must have meant to Michelangelo. Jonah was the one biblical prophet sent to preach to the gentiles.

That, Michelangelo understood, became his mission as well. Try as he might, he, too, just like Jonah, could not flee his appointed task. Michelangelo was deeply troubled by the corruption of the Church and its leaders. He could not bear to see how the lust for luxury and wealth dominated papal policy, and felt that the Church was in need of serious repentance and change. For many in Michelangelo's era, this was considered an impossible dream. Martin Luther and other like thinkers finally gave up entirely on reforming the Church and started their own forms of Christianity instead. After all, they thought, how could one realistically hope that a system so deeply sunk in sin would ever alter its course? Yet, the Bible tells us it happened once. Nineveh, a huge wicked city, repented at the very moment before its destruction. Jonah learned the all-important lesson: *we dare not give up on sinners—it's never too late to save them.*

And so Michelangelo closed his sermon on the Sistine ceiling with the prophet who discovered that, in spite of his doubts and forebodings, his message was taken to heart by those who heard him—and he thereby saved an entire people. Perhaps, Michelangelo prayed, the Church—just like the people of Nineveh—might listen to him as well.

UNDERSTANDING THE HIDDEN MESSAGES

We now know why Michelangelo chose Jonah to be his final messenger—but what exactly is his message? Look carefully at the accompanying reproduction and follow as we spot the clues so brilliantly hidden within.

Notice that over Jonah's left shoulder are two little angels, or putti, one above the other. Nowhere do they appear in the scriptural text. So what are they doing in this painting? The upper angel is holding up his outspread fingers, showing us the number five. The lower angel is looking directly at Jonah's bare legs, as if to say "Look for the five down below."

It is important to note that this is the *only* Hebrew prophet on the ceiling with bare legs, and the *only* figure on the ceiling with

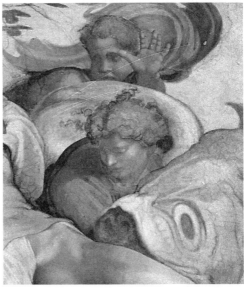

*Above: Jonah, with the Hebrew
letter he' formed by the projecting
parts of his legs and the Hebrew
letter bet formed by his hands. See
Fig. 20 in the insert. Right: Detail
of the two angels giving clues.*

outspread, exposed lower limbs to have his crotch covered up with a loincloth. As we have seen, Michelangelo had no problem with male nudity; in fact, he reveled in it all over the Sistine—much to the dismay of the Church. Thus, modesty is not the reason here for covering Jonah's crotch. However, if we look at the shape of the legs as they seem to stick out from the flat surface, they form a Hebrew letter—the letter that stands for the number five, the letter he'. This is what the Hebrew letter looks like: ה.

Michelangelo needed to put in the unusual loincloth in order to make the gap found in the middle of the Hebrew character. The angels are guiding our path, telling us to look at the he' and that it means "five."

And what is so special about the number five? Five is an extremely important number in terms of the Bible. In English, it gives us the word Pentateuch—*penta,* of course, is five—for the Five Books of Moses: Genesis, Exodus, Leviticus, Numbers, and Deuteronomy. In Hebrew these books are called the *Chumash*—root of the Hebrew word for five. The Church of Michelangelo's time tried to negate the importance of the Five Books of Moses; they were nothing more than the "Old Testament," a vestigial remnant whose old laws had been invalidated by the "New Testament" replacement. Michelangelo is sending a message to the Vatican that *a Church that ignores its roots in the Torah and the primacy of the Hebrew Scriptures will be lost.*

As we have learned, Michelangelo was an enthusiastic disciple of Neoplatonist philosophy, which sought to harmonize the faiths. For him Christianity was not meant to be an evolutionary, higher form of religion supplanting all others. It was meant to coexist with its mother religion, sensitive to its source. The Five Books would always remain the original key to understanding our link to the Creator. The Old Testament must be respected, if the New Testament is to have any validity.

See how Michelangelo reinforces this concept as you look at the unusual positioning of Jonah's fingers. Anyone familiar with Hebrew letters, as Michelangelo was, cannot fail to notice that the

blank space defined by Jonah's strangely crossed and twisted right and left hands clearly forms the shape of this letter: ‫ב‬—the Hebrew letter bet.

As every reader of the Bible in the original knows, *bet is the opening letter of the Torah,* the letter that begins the Five Books of Moses and is—in order to convey its significance—written large (i.e., double the size of all the letters that follow) in every handwritten scroll of the Bible that is read in every synagogue.

So let us summarize: Michelangelo has one angel holding up five fingers and the other angel guiding our gaze downward to Jonah's legs, which are spread out in such a way that they correspond to the Hebrew letter for five. This is the number that symbolizes the Torah, which the artist regarded as the common root of Judaism and Christianity. Jonah's fingers then contort themselves into the shape of the very first letter of the Five Books of Moses.

Kabbalists go on to explain why the letter bet deserves the honor of being first in the book authored by God. According to tradition, bet is not only a letter, it is also a word on its own. *Bet* means "house." In its holiest and most profound sense, it refers to the house of God, the *Bet Ha-Mikdash,* the Temple that would eventually be built in Jerusalem. The Torah starts its prescription for human connection with the Creator by hinting that our primary obligation is to allow God to find a home in our midst.

This concept is very significant in the context of where Michelangelo placed it. Let us not forget that the Sistine Chapel was built with one purpose in mind: to serve as a replica of the Temple, erected according to its biblical specifications. Michelangelo is completing the beautification of the *bet*— the house of God that was alluded to mystically in the first letter of the original Bible. Do not forget *that* book, says Michelangelo, in his final fresco, even as you build a Temple in Rome in place of the one in Jerusalem.

Michelangelo loved the Midrash, the ancient Jewish explanations of biblical texts. That's why he ignored the far more famous Christian commentary that Jonah was swallowed by a whale. After all, the text in the Hebrew simply said *dag gadol*—"a great fish." The

rabbis say that it was probably Leviathan, the gigantic sea beast that the righteous souls will eat to celebrate their redemption when the Messiah comes. So that's what we see alongside Jonah on the right.

Then, hovering over the prophet's left shoulder is a leafy bough obviously meant to suggest the *kikayon* tree that grew overnight over Jonah's head to shade him from the Babylonian sun, near the end of his story (Jonah 4). Here we have yet another example of Michelangelo showing us his background in Talmud and using it to convey a daring but coded message. According to all other interpretations of the story of Jonah, the *kikayon* is a "gourd tree"; however, there is not one gourd on the tree he painted over the pope's altar. According to the Talmudic sages, it is a tree related to the *ricinus* tree, and is the source of an oil considered ritually unfit for lighting the Menorah in the Holy Temple. Once again, the Florentine is making his own private statement to the corrupt Roman Church of his time: *not everything that seems to be holy is suitable for divine service.* Over the head of the prophet—and over the heads of the papal court below—rests the reminder that the profane has no place in the house of God.

And finally, Michelangelo's genius found a way to express one more biblical idea with a brilliant stratagem. Here is how God summarizes the sin of the people of Nineveh that almost spelled their ruin: "But Nineveh has more than a hundred and twenty thousand people who cannot tell their right hand from their left" (Jonah 4:11). Imagine being so confused that one cannot tell right from left—or, for that matter, good from evil, right from wrong. That is the way the Almighty depicted moral confusion.

Look again at Jonah's hands. See how strangely positioned and contorted they seem, the right and left hands crossed over each other. What was Michelangelo trying to express? Obviously, *the very point of the story.* A nation that has gone astray cannot even tell its right from its left. And that, Michelangelo felt, was what had happened to his own Church. Michelangelo could not bear to see the autocratic, syphilitic Julius II head a religion that had lost its way, that

was no longer true to the mission of its founders. The Church had become more like Nineveh and less like Nazareth. Yet, to denounce it publicly would have meant to risk the fate of Savonarola, who had been burned at the stake in Florence. No, the way of Michelangelo was to preach through his *art*. Given the opportunity of expressing himself in the very "Temple" of the Vatican, he made the most of it in the hope that his viewers would understand.

And at last Michelangelo had his revenge on Julius. The chapel was supposed to focus all attention and majesty on the pontiff, yet Jonah towers over him, stealing the scene . . . and Jonah is looking up toward an even Higher Power, in *the opposite direction from the pope below.*

Jonah's gaze is the key to one last secret—and this time a Christian one. Michelangelo surely must have known the other meaning of the prophet's name in Hebrew. Jonah (pronounced yo-NAH in Hebrew) can mean "God will answer," as we learned in chapter 11. However, it has another meaning as well—"dove." In Christian tradition, the dove flying down from heaven is the symbol of the Holy Spirit. It can been seen in most depictions of the baptism of Christ, when, according to Matthew 3:16, Jesus saw the Holy Spirit descend and alight upon him. A classic example is found in the Sistine in the fifteenth-century fresco by Pinturicchio and Perugino to the right of the altar. In fact, that is another standard location for the symbolic dove—on the wall over Christian altars, including the pope's altar in St. Peter's Basilica. The idea is that the Holy Spirit has descended onto the altar to illuminate and bless the sanctuary. Why, then, is Jonah looking upward? Michelangelo wanted to say that he felt the Holy Spirit was not present in the Sistine in the time of Julius's papacy. The artist was still waiting for the Divine Presence to descend on the Church and (to paraphrase Saint Francis of Assisi) to bring light where there were only shadows, to bring humility where there was only arrogance, to bring love where there was only intolerance. Jonah has leaned back and poked his head through the roof of the Sistine just to let some of heaven's pure light into what was then a very dark time in the Church.

Here we have the epitome of the artist's message—a Jewish prophet named "dove" sitting over the pope's altar, substituting for the Christian dove normally seen in that spot, looking up to the One Source of Light, and thus Kabbalistically linking through his position as the *s'firah* of Mercy (Chessed) the material world with the Divine. In one image, Buonarroti interwove art and religion, Jewish and Christian tradition, anger and mercy, heaven and earth.

In late October of 1512, after four and a half excruciating years, Michelangelo was finally liberated from the Sistine Chapel, elated that he would never have to return to paint anything in that place ever again. If he only knew what fate awaited him twenty-three years later . . .

BOOK THREE

Beyond the Ceiling

Chapter Fourteen

BACK ON THE SCENE

Love, with his very own hands, is drying my tears.

— MICHELANGELO

AT LONG LAST, after his "release" from the Sistine, Michelangelo happily threw away his paintbrush and once again picked up his beloved hammer and chisel. He must have been extremely excited to get back to his true passion, since he immediately started several large marble pieces for the pope's tomb—all at the same time. He had spent precious years of his energy up on the Sistine ceiling, forcibly removed from his love for sculpting, and was now desperate to make up for what he probably considered lost time. The huge blocks of marble that had been left lying on the ground next to the gigantic construction site for the new Basilica of St. Peter were finally being put to use. He set to carving six large male nudes, plus one colossal Jewish prophet. This explosion of creative energy marked a new period in his technique. Instead of following the classic approach of creating highly finished and polished statues, as he had done when carving the *Pietà* and the *David,* Michelangelo perfected his now-famous style of the *non finito,* the "not-finished" look. Centuries before the impressionistic and cubist movements in

art, Buonarroti pioneered the same concepts. He reduced his sculptured works to the bare minimum of their defined forms—to their very essence—in order to express his ideas and feelings, rather than merely to make pretty decorations in stone. Working in this futuristic fashion, and with enough assistants and no further interruptions, he probably would have been able to carve all the forty-plus figures required by the contract for Pope Julius's tomb.*

Michelangelo could also exploit this technique to hide even more ambiguous messages in his later works. Strangely enough, he never used the *non finito* style in his painted works. It seems that the artist was never able or willing to connect certain aspects of his sculptural genius to his two-dimensional works.

It was at this point in his life that Michelangelo decided to pour his heart and soul into what was almost certainly his own favorite sculpture—his depiction of Moses, the greatest of all the Jewish prophets.

From the very beginning of the tomb design, Michelangelo had planned a giant statue of Moses for the place of honor, which would be the center of the middle level of the pyramidal structure. According to the original plans, the Hebrew prophet would have been sitting on high in the heart of the new Basilica of St. Peter, directly under the giant dome—where the main altar is today. This would have certainly suited the artist's dream of permanently linking the two faiths in a highly visual and unforgettable manner.

To prepare for this task, the Florentine went back to the mountains of his childhood, to Carrara. It was very much akin to a pilgrimage—perhaps even a way to cleanse his body and soul after the horrors and tensions of painting the Sistine. He spent several months in the marble quarries, searching for the perfect piece from which to carve his *Moses*. This was to be his crowning achievement in stone, his great comeback to the world of sculpture. Whereas all

*If he had indeed been able to carry out the tomb in this manner, it would have been the world's first and biggest *impressionist* sculpted monument—hundreds of years before Picasso, Giacometti, or Rodin.

the other elements of the tomb were being left in his not-finished style, the *Moses* was the exact opposite—carved and lovingly buffed by hand for months, until it was perfectly finished and gleamed even brighter than the *Pietà*.

What almost nobody knows is that the *Moses* we see today is not the Moses that Michelangelo carved in 1513–15. The subversive artist was up to his old tricks of hiding mystical Jewish wisdom in artworks commissioned by the pope. In the Torah, in Exodus 34:29, we read: "And it came to pass—when Moses came down from Mount Sinai with the two tablets of Testimony in Moses's hand—that as he came down from the mount, Moses did not know that the skin of his face shone since God had spoken with him." In fact, this divine light was so intense that Moses subsequently had to put on a mask so as not to blind his fellow Israelites when he met with them. What was the source of this supernatural light? The Midrash and Kabbalah have an explanation. When Moses was up on the mount, pleading with the Almighty for forgiveness for his people after their sin of worshiping the golden calf (Exodus 32), nobody was able to accompany the prophet to the summit. The divine light of God was too intense. No mortal aside from Moses could survive it. Moses stayed on Mount Sinai forty days and forty nights, neither eating, drinking, nor sleeping, in order to achieve spiritual enlightenment—not just for himself but for all his people. It took supreme, superhuman effort to achieve atonement for the children of Israel's terrible sin of idolatry, a sin compounded by coming so soon after their miraculous redemption from Egypt. The word *atonement* can also be read at-*one*-ment—the spiritual goal of feeling at one with God and the universe. It is this level that Moses reached on the mountaintop. According to the Kabbalah, he broke through to the highest sphere ever reached on the Tree of Life by any living human being—the level of Binah, the most insightful and profound degree of comprehension and understanding. After Moses smashed the first tablets in response to finding the Israelites worshiping the golden calf, he was commanded to carve a second set to replace the pair carved by God. According to tradition, God then taught Moses the entire Torah,

the Talmud, and all the mystical secrets of the Kabbalah. That is what caused his face to be imbued with light; he had been enlightened directly by God and now shared in the glow of divinity. The Midrash adds that God also wanted to reveal to Moses the future history of the Jewish people and the world, up until the coming of the Messiah. To grant him this special vision, God bestowed on him a drop of the divine light—not ordinary light, but the primordial light with which God created the entire universe and the *s'firot* on the Tree of Life.

Michelangelo felt a deep affinity to Moses. After all, they were kindred spirits, men of the mountains who carved their messages in stone. Aware of this midrash, Michelangelo wanted to show Moses as he appeared with this gift of prophecy, looking all the way into the distant future of humanity. That is why he returned to the technique he had used so well in carving the *David*. He made the eyes slightly too far apart, extra deep, and not focused on the viewer. As you stare at the *Moses* statue today, no matter where you stand, you realize that he is not looking at you. That's because his gaze is fixed firmly on the future.

In the original plan for Julius's huge tomb, *Moses* would have been high above the floor, in the center of the pyramidal structure. Michelangelo planned to take advantage of the light streaming in from the windows of the dome over the funeral monument. He buffed the face of Moses to make it glow with the reflected rays of the sun that would descend to perfectly illuminate it. He even carved two points sticking out of the statue's head that would also reflect the sun's rays, making Moses seem as if the divine light were truly shining from his head. This is another secret of the statue—it never had horns. The artist had planned *Moses* as a masterpiece not only of sculpture, but also of special optical effects worthy of any Hollywood movie. For this reason, the piece had to be elevated and facing straight forward, looking in the direction of the front door of the basilica. The two protrusions on the head would have been invisible to the viewer looking up from the floor below—the only thing that would have been seen was the light reflected off of them. This is

another example of how far ahead of his time Buonarroti was—he had created the *Moses* as a magnificent *site-specific* artwork, a concept that became quite the rage in the late twentieth century. This is indeed how Michelangelo sculpted and finished the statue after he completed the Sistine ceiling—sitting straight, its legs side by side, and its face looking directly forward . . . and this is how it remained while sitting more or less in limbo for more than two decades while the giant tomb's future was being debated and changed with the transitory vicissitudes of power within the Vatican.

Buonarroti had put his heart and soul into the statue of Moses—so much so that, it is said, when he finished the colossal work, he held the carving by the shoulders and shouted, "Speak, damn it, speak." Now there was nothing to keep him in Rome any longer. Julius was dead, the ceiling was finished, and the plans for his monument had been canceled by the new pope, Leo X. Leo was none other than Giovanni de' Medici, the illegitimate son of Giuliano, the brother of Lorenzo the Magnificent. When Giuliano was assassinated, Lorenzo took in Giovanni and raised him as one of his own sons. Giovanni and Michelangelo had grown up together in the Palazzo de' Medici and had probably even slept in the same bed as boys. Now, after the death of their nemesis Julius II della Rovere, the de' Medici clan had figured out the perfect solution to defend themselves against the persistent attacks from the Vatican—they bribed enough cardinals to have one of their own elected as the new pontiff. They defeated the Vatican by simply taking it over. It is reported that while Leo/Giovanni was going up to take possession of the papal apartments, he chuckled to his brother Giuliano, "God has granted us the papacy—now let us *enjoy* it."

If Michelangelo had harbored any dreams of a de' Medici pope reforming the Church and turning Rome into a new Athens of art and philosophy, he must have been sorely disappointed by Leo's rule. Leo X was no Lorenzo the Magnificent. His papacy was even more corrupt than that of his predecessors. Rome under Leo became an endless series of banquets and orgies, while the de' Medicis drained the Vatican's coffers for their own family affairs and military

adventurism. Michelangelo carved the aforementioned pieces, even though he probably realized that Julius's tomb would never be built inside the new St. Peter's, just to get his sculpting eye and hand back in shape after the years of painting on the Sistine ceiling. The other reason was that the surviving relatives of Julius were still paying him a retainer of two hundred scudi per month, a kingly income.

When Leo released the artist from his contract for the della Rovere tomb, he commissioned him to create a façade for the unfinished family church of San Lorenzo in Florence. Michelangelo was more than happy to leave Rome and return to his beloved Tuscany.

We wish to avoid the temptation to detour into a long biography and artistic history of Michelangelo in these years, and stay as focused as possible on the secrets that he hid in the Vatican in Rome. However, it was during these years, 1513–1534, that both Michelangelo and the world around him went through great upheavals. Because these events left their mark on the artist, we must understand that part of his life if we are to appreciate the later secrets he would conceal when he was brought back to fresco again in the Sistine in 1534. Suffice it to say that in the twenty-one intervening years he created two permanent artistic legacies for the city of Florence—the Biblioteca Laurenziana, the library in memory of Lorenzo the Magnificent, and the Sagrestia Nuova, the new sacristy in the Church of San Lorenzo. Michelangelo designed the room, the candelabra, and the tombs and carved almost all the statues himself—an amazing achievement, considering that by the time he finished the sacristy— also called the de' Medici Chapel—he was almost sixty years old. Buonarroti's passions had not dimmed, however—he still hid secret symbols in these architectural wonders. For example, the magnificent staircase leading up to the library has exactly fifteen steps— a reminder of the curved stairway of the Levites in the Holy Temple of Jerusalem. Each step was symbolically a step upward toward repentance and spiritual enlightenment—in fact, in the book of Psalms, there are fifteen "psalms of ascent" (120–134), one for each stair. There are two side stairways, each consisting of nine steps. In the Jewish mystical tradition, nine is the symbol of Truth. The two

*Staircase entrance
to the Biblioteca
Laurenziana,
Florence*

side stairways added together make eighteen, the Jewish symbol for Life. Here, Michelangelo was paying a final enduring tribute to his great patron Lorenzo's love of life, his pursuit of truth, and his quest for spiritual harmony in a turbulent world.

And turbulent it was, indeed. While Michelangelo was working on these Florentine projects, one of his Roman prophecies came horribly true. As previously discussed, his *Jeremiah* fresco was a warning to the Vatican to cleanse itself spiritually and ethically so as not to suffer the fate of the original Holy Temple in Jerusalem. There, God had punished a corrupt priesthood with an attack by a ruthless enemy who carried away all its bronze and gold. Five years after Buonarroti finished the Sistine ceiling, an exasperated German cleric named Martin Luther nailed his protests against the papacy to a church door. Within only ten years, his religious movement became a tidal wave that swept over Europe, breaking into many groups and schisms, all of which, however, shared one hatred in common—the Vatican. One army of Lutheran soldiers under a coalition of German barons called the Lanzichenecchi took the city of Rome and sacked it mercilessly in 1527. More than twenty thousand unarmed civilians were slaughtered. The Vatican was seized and desecrated, and all its bronze and gold carted away, just as Michelangelo had foretold. This event traumatized the entire Catholic world but stimulated

the hopes of reformists everywhere that perhaps, finally, the Vatican would repent and change its corrupt ways. Michelangelo and others who shared this hope were all to be deeply disappointed. Inside the Apostolic Palace, business went on as usual.

Ten days after the sack of Rome, young freethinkers who wanted to restore Florence to her glory days rose up and threw out the corrupt descendants of Lorenzo de' Medici. Michelangelo, disgusted by the decadence of the new generation of de' Medicis, eagerly took part in the popular revolt. Perhaps also contributing to his commitment to their cause was the fact that the ringleaders of the uprising were mostly handsome youths whose company Michelangelo constantly sought out. He threw himself passionately into the role of revolutionary, working tirelessly elbow to elbow with these young men, designing new ramparts and defenses, rallying the troops, planning strategies, nursing his companions who were felled by the plague. Three years later, in 1530, through a series of unholy alliances, the de' Medicis and the Vatican were able to retake Florence and punish the rebels without pity. Michelangelo was publicly declared an enemy of the restored regime and of the Church, and a price was set on his head. He disappeared into thin air, only to reappear a month and a half later, when old mutual friends were able to convince the de' Medici pope Clement VII to pardon him so that he could finish the de' Medici Chapel in the Church of San Lorenzo. Thus, Buonarroti's talent was credited with saving his life. Only recently have we found that this was doubly true.

In 1975 the Italian art historian Paolo Dal Poggetto discovered how Michelangelo had disappeared in 1530, while papal and imperial killers were turning Florence inside out searching for him. The artist had managed to get back in time to his own work-in-progress, the de' Medici Chapel. Under his new sacristy was a secret bunker. We do not know whether Buonarroti had actually built it or just knew of its existence, but he convinced the prior of the church to let him hide there and to smuggle food and sketching charcoals to him for as long as he needed to stay there. Five centuries later, his sketches made while a fugitive still cover the walls of his hiding place. His chapel project did indeed save his life in more ways

than one; however, after this episode, Michelangelo decided he had had enough both of the de' Medici clan and of Florence itself. He finished the chapel by 1534, and did not even stay in town to oversee the installation of the statues or attend the inauguration. He went back to Rome the year that the de' Medici pope Clement died, and he never set foot again in Florence. The incredibly ambitious design for the façade of San Lorenzo—the original reason Pope Leo X de' Medici had allowed him to return to Florence—was a total fiasco, and left undone. To this day, the clan's family church has no façade, just raw stone—the revenge of history or of Michelangelo?

We should mention one other major event in the artist's life during this period. He fell in love. Oh, he had been in love many times before, with beautiful youths, models, singers, and apprentices. He was strongly attracted to much younger men, both for their muscular beauty and for their passion and enthusiasm for life. It seems that in some cases this love was physical and reciprocated, in other cases not. His preferences were certainly common knowledge in certain circles back then, but Michelangelo was still very cautious, especially after seeing how men who loved men had been punished under the fanatical reign of Savonarola and the Inquisition. Even the great Leonardo da Vinci had been forced to flee Florence the second time he was accused of being a "sodomite." Still, Buonarroti had written love poems to his favorite youths, and his contemporaries recorded that he produced great art, sketches, and poems when his love was requited and went into unproductive rages and depressions when he felt rejected.

In the spring of 1532, the great artist was in the thrall of one of the worst depressive periods of his life. The project for the San Lorenzo façade had fallen to pieces (literally, the huge central marble columns had smashed to bits in transport), he had been betrayed by his adopted family, he was by now a social outcast in his hometown, his dreams of a new golden age of Florence had been dashed, and the plan for the giant della Rovere tomb inside St. Peter's—a project that Michelangelo had come to consider more his own monument than that of Julius II—had been canceled. He was being sued by the surviving relatives of Julius to finish the late pope's tomb, even

though it would not be allowed inside the Vatican. His birth family was continually draining his money—to set up his incompetent brothers in businesses and then to bail them out when they failed, to settle their legal affairs, to restore lost family properties, to pay for their weddings, and on and on. His family never showed gratitude but only resented him for his success while demanding more and more money. In 1528 his brother Buonarroto died, followed three years later by Michelangelo's father, Ludovico (at the age of eighty-seven, remarkable for that era), leaving the artist with many unresolved emotions and the feeling of being ever more isolated.

Even his physical health was at an all-time low. He was laboring on the de' Medici Chapel, a project to glorify the very family that had betrayed him and had sought to have him killed. To finish the sacristy and move on to more agreeable commissions and patrons, he was yet again pushing himself beyond all human limits. This habit of working around the clock alone without eating or sleeping sufficiently might have worked for him when he was in his twenties and thirties, but now that he was in his fifties, it was taking its toll. Word traveled all the way to the Vatican that he had become skin and bones and was having vision problems, dizzy spells, and migraine headaches. The pope was so concerned for Michelangelo's life that he ordered him to stop working on the sacristy and come to Rome at once to resolve once and for all the nagging question of Pope Julius's tomb. The stubborn genius begrudgingly took a break from his labors, went to Rome, and there cleaned himself up to present himself at the papal court. This was in the spring of 1532. It would also be the spring of Michelangelo's life.

In the social whirl of the Apostolic Palace under Clement VII de' Medici, one figure instantly stood out to the artist's keen eye for male beauty, a young nobleman from an ancient Roman patrician family whose name was on everyone's lips that season: Tommaso dei Cavalieri. Strikingly handsome with the physique of an athlete, Tommaso was the epitome of the cultured gentleman. He was also passionately fascinated by art and architecture, dabbling in both fields when he could. He liked to dress in nostalgic outfits, including doublets made of shot silk and a golden belt with ancient coins

on it. To Michelangelo, this twenty-three-year-old courtier seemed to have stepped out of his most romantic dreams. For the lonely fifty-seven-year-old artist, it was not simply love at first sight, but a lightning bolt from heaven. To find a young man who was his ideal of masculine charm and who also shared his creative passions was a revelation. For the young Tommaso, to receive so much attention from the world's most famous artist and architect also seemed like a dream come true. Soon, the great maestro was behaving like a love-sick schoolboy: writing love notes and romantic sonnets, making sketches and drawings as gifts for his beloved.

Historians and other scholars have produced reams of speculation about whether Michelangelo and Tommaso ever physically consummated their mutual feelings. Most doubt it, but quite frankly, it does not matter nor is it even our business. What is important is that, while in the depths of his despair, Michelangelo found love, passion, and renewed inspiration. In fact, he was finally truly understanding his old tutor Marsilio Ficino's Neoplatonic theory of love, whereby the total, unselfish love for another soul—in this case, another male—would transport him ever closer to God. In one of his torrent of love poems to Cavalieri, Buonarroti wrote:

> *I see, through your beautiful eyes, a sweet Light that I*
> *Can't see through mine, with sight so poor. . . .*
> *Though without feathers, with your wings I fly*
> *And with your mind I am borne to Heaven more and more.*

Almost all of his poems to Tommaso reflect these deep feelings of sexual and spiritual awakening. Buonarroti went right back to Florence and not only finished up the huge de' Medici Chapel project, but also carved another masterpiece, his *Victory*. It does not seem to have related to any of his commissions, so the artist must have carved it for his own pleasure.

According to many experts, the enigmatic *Victory* statue is a hidden romantic double portrait. The handsome youth is taken to be the young Tommaso, who, armed with nothing but his beauty, has taken prisoner the older man beneath him—none other than the

Victory, *by Michelangelo, 1532–34*
(Palazzo Vecchio, Florence)

great maestro himself, finally mastered not by Power, not by Art, but by Love. Buonarroti himself supports this interpretation, with a double meaning hidden in a love poem written at this time:

> *If conquered and suppressed is the way I must be bless'd,*
> *It is no marvel that, nude and alone*
> *With a well-armed cavalier, as his captive, do I rest.*

The *cavaliere,* or noble knight, who has captured Michelangelo is, of course, the young Cavalieri. Throughout these lines, we find the following paired letters in the original Italian, at either the beginning or the end of the phrases: *t-o, m-a,* and *s-o*—for Tommaso.

What is interesting to note is that in the new sacristy, at the very same time, Michelangelo was finishing up the memorial statue to Giuliano de' Medici. Historians all agree that the face on the statue bears no resemblance to Giuliano's. What they do not mention is that it is almost identical to the face of *Victory.* Obviously, the love-struck artist could not stop thinking of Tommaso.

In 1534, as soon as he had finished his obligations in Florence, Michelangelo packed his belongings and moved to a city that he

Left: Detail from Victory. *Right: Detail from the tomb of Giuliano de' Medici, 1532–34.*

hated—Rome—to be near the man he loved. He wrote in letters and poems at this time that he felt like the phoenix. According to legend, this mythical bird, upon growing very ancient, burns up in a fire and is reborn young and anew from the ashes. Thanks to his flames of passion for Tommaso, he felt young and powerful again, ready to take on both Rome and the Vatican and even figuratively spit in their face, if need be. Right at this time, he wrote to his beloved:

> *I am more precious to myself than ever before,*
> *Now, with you in my heart, I am worth much more,*
> *Like sculpted lines added to a bare marble block*
> *Bring so much more value to the original rock. . . .*
> *Against water, against fire, I can endure;*
> *With the sign of your love shining bright I can give the*
> * blind sight,*
> *And with my spit each venom I can cure.*

Michelangelo would need all this newly rekindled energy very soon. Not only was his life's road leading him back to Rome, it would soon lead him into the Sistine Chapel again.

SECRETS OF
THE LAST JUDGMENT

What spirit is so empty and blind,
that it cannot recognize the fact that the foot
is more noble than the shoe,
and skin more beautiful than the garment with
which it is clothed?

— MICHELANGELO

BACK IN ROME, Michelangelo was immediately given an-
other herculean task. Pope Clement VII, Buonarroti's own
childhood "brother" Giulio de' Medici, summoned him to
the Apostolic Palace and gave him a daunting commission. Clement
wanted to make sure that his family had their original Michelangelo
monuments in Rome as well as in Florence. He craved something in
Rome that would rival the great masterpiece ensuring the memory
of the hated Pope Julius. So, he commanded the astonished artist to
redo the entire front wall of the Sistine Chapel.

This wall above the altar was already covered in precious master-
pieces of fresco, including panels from Michelangelo's own ceiling
project from twenty-two years earlier. In the middle, between two

large windows, was an irreplaceable fresco of the Virgin Mary ascending into heaven, with Pope Sixtus IV, the founder of the Sistine, kneeling at her side. This scene, painted by Pinturicchio, was the key to the entire original concept of the chapel in the fifteenth century, since it was dedicated to Mary and used by the papal court every Ascension Day (August 15, nowadays more of an Italian national cultural holiday when everyone heads out of town). Above the Virgin and Sixtus were some of the original popes painted by Botticelli's Florentine team in the fifteenth century, along with their two first panels in the Moses and Jesus cycles, also one-of-a-kind artworks in their own right.

Clement did not want the sly, subversive artist to do another Jewish-themed painting in the Church's most important chapel. After all, this pope was a de' Medici; he knew how Michelangelo had been taught in Florence and was onto his Neoplatonic tricks— or so he thought. Clement decreed that the front wall be a monumental version of the *Giudizio Universale,* the Last Judgment. In the Christian tradition, this is when Jesus returns to earth to discern between right and wrong, good and evil, and to judge all souls accordingly. The souls judged righteous will ascend to heaven, while the evil ones will be damned to eternal punishment in hell. For once, Michelangelo agreed to a theme without even putting up an argument. He was tired of fighting for the soul of the Church. He was disgusted by the hedonistic heirs of the intellectual, cultured Lorenzo the Magnificent. He was more than happy with the idea of Christ coming back to judge both the Vatican and the de' Medicis.

Michelangelo agreed to undertake the task, but on one condition. He told Clement that, to do justice to the important cosmic theme of the painting, he would need to block up the front windows and remodel the entire front wall first. Clement eagerly agreed. In this way, his commissioned artwork would be all the more impressive, since it would take up one huge, uninterrupted mass of wall. Shortly after the contract was signed, Clement went off to his own final judgment, dying at fifty-six years of age. He was succeeded by Cardinal Alessandro Farnese, who took the papal name Paul III.

The Farnese family was still another clan of wealthy nobles whose behavior was anything but noble. Paul III had been ordained a cardinal only because his gorgeous sister Julia had been the favorite concubine of Pope Alexander VI, the "poisoner pope" from the decadent Borgia family. Now that Paul was pope, it was the Farnese family's turn to enjoy the papacy and the Vatican's coffers of gold. His enormous palace, under construction while he was still a cardinal, would now be finished off with new designs for the façade, upper courtyard, and garden by Michelangelo himself.*

Pope Paul told Michelangelo also to go right ahead with *The Last Judgment* fresco on the Sistine's altar wall. Now, he thought, instead of a lasting tribute to the de' Medicis, it would glorify the Farnese family forever. However, without a suspicious Florentine like Clement to keep an eye on him, Michelangelo once again succeeded in permeating his fresco with many levels of hidden messages. Today, most visitors to the Sistine have no idea who Clement VII or Paul III were, but they come from all over the world because of Michelangelo Buonarroti. *The Last Judgment* has become a permanent testament to the artist's talent and philosophy.

The first step was indeed remodeling the wall. The windows were sealed up, the original frescoes were destroyed, and then the della Rovere crest under *Jonah* was removed, subtly reshaping the wall. Only then were several layers of new surface added to the whole wall. Michelangelo did this to prevent the cracking and mildew that had afflicted the ceiling, but he also had another, subtler reason. He actually made the immense wall *tilt inward* an entire foot. Only if you are inside the Sistine and look at the upper corners of the wall can you see that the fresco is leaning in over your head by a good

* When the Palazzo Farnese was finished, its upper hall hosted some of the most extravagant banquets in the history of Rome. All the dishes, bowls, goblets, and utensils were solid gold. At the end of each meal, the Farnese hosts would open the back window of the palace, which overlooked the Tiber River, and blithely toss the dirtied gold service pieces out the window. The guests were duly dumbstruck. What they did not know was that the Farnese servants were hiding in the bushes under the windows with large nets, to catch all the gold objects so that the same stunt could be pulled at the next banquet.

twelve inches. The familiar explanation is that the fussy artist did not want dust to gather on the surface of his fresco, so he leaned it inward. This theory does not make sense, though. The fact is that this tilt made the fresco all the more susceptible to soot from the countless candles in church processions, plus dirt and dust wafted up with humidity and human sweat. Before the massive cleaning in the late twentieth century, the front wall was as dirty as the ceiling. The real reason is that Michelangelo wanted to subtly—in fact, *subliminally*—make the viewer realize what he felt was the *true* arbiter between right and wrong. When you are standing in front of the altar gazing up at *The Last Judgment,* it is the *shape* of the wall tilting in, looming over you, that tells you what the artist believed should judge human behavior. Without a doubt the silhouette corresponds to what in Hebrew are called the *luchot,* the Tablets of the Law, but are more commonly known to us as the Ten Commandments.

Once the wall had been reshaped and prepared, Michelangelo set up a standard scaffolding and found a trustworthy pair of assistants to prepare the cartoons, the plaster, and the paints. This time, even the color scheme would be different from that of his previous effort. On the ceiling, as we discussed earlier, he had used almost no blue paint. The blue of choice for frescoing was extremely expensive, since it was made of hand-ground lapis lazuli, a semiprecious stone imported from Persia (today Iran). Julius II had made the artist pay for the materials out of his own funds, so costly blue and gold had been out of the question when Michelangelo painted the ceiling. Now, for the front wall, the wealthy Farnese family (and the Church) were covering the costs, so money was no object. The heavenly blue background for the hundreds of figures in the giant work makes this Last Judgment one of the most expensive paint jobs in history.

Michelangelo began at the top of the wall and slowly worked his way down for more than seven years, painting exclusively by himself, with only one or two assistants. He was trudging up and down ladders while he was in his sixties, an age at which most people in the sixteenth century were either retired or buried. When he finished,

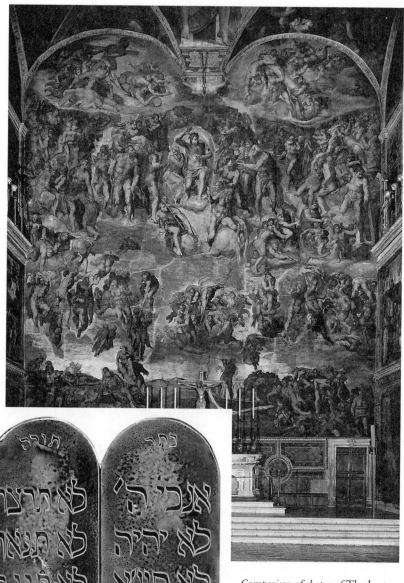

Comparison of shapes of The Last Judgment *and the tablets of the Ten Commandments. See Fig. 21 in the insert.*

it would be the largest Last Judgment depiction in the world—in fact, it is the largest fresco ever done by one painter—and at the same time the most precedent-breaking, mysterious, and symbolic. Buonarroti, now world-famous, rich, in love but still the angry rebel, broke every tradition with this work.

At the top, in the two curves of the tablet-shaped painting, he started with the angels holding the instruments of Christ's martyrdom: the cross, the crown of thorns, the column on which he was flagellated, and the stick tipped with a vinegar-soaked sponge. Oddly enough, neither the traditional nails nor the whip appears. The angels, typical of Michelangelo but very odd for any other painter, have neither wings nor haloes nor baby faces. They are all handsome, muscular youths with delicate faces. Almost all of them were originally quite nude, even displaying their very human-looking genitalia. It is not clear whether they are taking the signs of the Passion up to heaven or bringing them down for us to view. The range of movements, gestures, and expressions is astounding—each one is different.

Just below the level of these angels are the Righteous Souls, forming a circle over the head of Jesus. These are not the famous saints or popes or royal patrons that one would normally find in a painting of this kind. Instead, these are the true holy souls, mostly unknown in life and rewarded in the afterlife, mingling with the angels around Christ. One fascinating detail is something that flies in the face of Church teaching for many centuries. Directly over Jesus's head is a handsome golden-haired angel robed in red, pointing at two men in this inner circle of the righteous. They are obviously Jews.

One is wearing the two-pointed cap that the Church forced Jewish males to wear to reinforce the medieval prejudice that Jews, being spawn of the Devil, had horns. While speaking to the other, older Jew, he makes the very same gesture we find Noah making on the Sistine ceiling: pointing one finger upward, to indicate the Oneness of God. The other Jew is wearing a yellow cap of shame, the kind that the Church ordered Jewish men to wear in public in 1215. In front of them is a woman with her hair modestly covered,

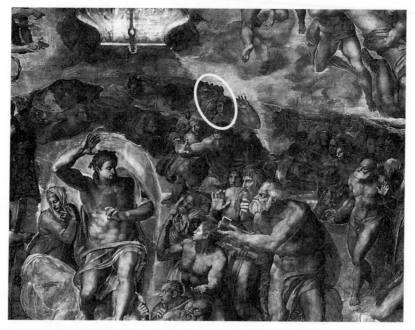

Detail from The Last Judgment *(pre-restoration) showing the Blessed*
Souls in the upper reaches of heaven, above Jesus. The angel in red is indicating
two Jews and Pico della Mirandola. See Fig. 18 in the insert.

who is whispering in the ear of a nude youth before her. The youth
resembles Michelangelo's young tutor Pico della Mirandola, who
taught the young artist so many secrets of Jewish mysticism. Ac-
cording to traditional Church teaching, as clearly expressed in the
first chapters of Dante's *Inferno,* this depiction of those granted
divine favor borders on blasphemy. Jews could never hope to have a
heavenly reward. Even their greatest heroes, such as Moses, Miriam,
Abraham, and Sarah, could only look forward to limbo at best. Yet
here they are, Jews in the center of Michelangelo's *Last Judgment,*
hovering over the head of Jesus. Even today, in the twenty-first cen-
tury, the question of whether or not there is room in heaven for
Jews remains a hot topic of debate among many Christians. Imagine
how daring it was for Michelangelo to take a stand on this issue
in the sixteenth century in a way that clearly contravened official
Church doctrine of his day. We need not wonder, in this light, why

Michelangelo chose to make his Jewish heavenly residents so very small and hard to notice.

Turning our attention next to the left side, under the cross, we see the Righteous Women, or the Female Elect. If it were not for the somewhat feminine faces and the not-very-credible breasts, this would look more like a male bodybuilders' convention. Michelangelo is doing again what he did with the sibyls, using muscular male models and then sticking women's hair, faces, and breasts on them. In a church in the sixteenth century, and in an era in which many theologians were still debating whether women had souls, Michelangelo shows us a vast array of striking women worthy of heavenly immortality, each with her own look and personality—and a vast amount of female nudity as well.

On the right side, under the column, are the Righteous Men, or the Male Elect. In previous depictions of the reward of the elect in heaven, other artists had shown a very reserved behavior among the blessed souls: they usually greeted each other in Paradise with

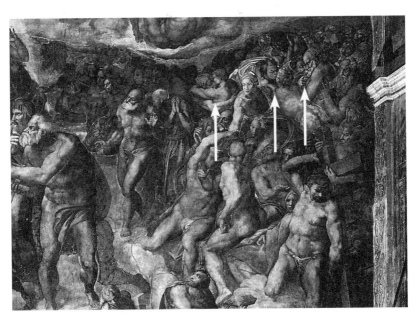

Very enthusiastic hugging and kissing going on in the Male Elect section of The Last Judgment *(pre-restoration). See Fig. 22 in the insert.*

a chaste handshake or at most by clasping each other's wrists in ancient Roman style. Here, the happy males who have been accepted into heaven are much more demonstrative, to say the least.

In the middle of the group, at the top, are two handsome young men in a naked, impassioned embrace, kissing. Just behind them is a shadowy figure who looks like Dante, gloomy and disapproving as ever. Next to them a strong nude man is hauling another nude male up to his cloud to join him. Next to him, we clearly see another pair of naked blond boys kissing, and then on the right, a youth gazing deeply into an older man's eyes while kissing his beard in reverence. Today, most visitors do not even notice this loving male section of the fresco or know it exists, but if it is pointed out to them, many become upset. We can only imagine how shocking and offensive it must have been in the sixteenth century.

Also in this section of the painting, just below the kissing couples, are many women interspersed next to and behind the men, almost hidden in this male-dominated zone. They are the wives and mothers, as if to show that these men did not achieve their blessed state alone, but only with the help of strong, pious women behind them.

In the middle, we find Christ, returning to bring human history to an end. Saint Peter is on his left (our right), returning the papal keys of rulership over heaven and earth, with the other patron saint of Rome, Saint Paul, at his side. On Jesus's right side (our left) is his mother, Mary. This Jesus is a complete break with all traditional depictions: beardless, extremely muscular, sensual and severe at the same time. He seems very un-Christian, more like a pagan Greek statue—and for good reason. In fact, he is a composite of two Greek statues, both famous and both on display in the Vatican Museums collection.

The head of Jesus is none other than that of Apollo, the golden-haired god of the sun. Originally, the Vatican statue—the *Belvedere Apollo,* as it is called—had pure gold–plated hair, until the gold was stripped off after the fall of the Roman Empire. The overpumped torso of Christ is that of the *Belvedere Torso,* which back in the time

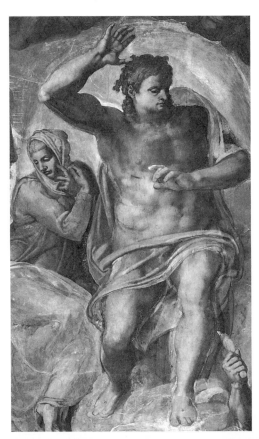

Left: Detail from The Last
Judgment—*Jesus and Mary
glancing down. See Fig. 23 in
the insert. Below, left: Head
from* Belvedere Apollo; *Roman
copy of Greek bronze original by
Leocaris, 330–320 BCE (Vati-
can Museums). Below, right:*
Belvedere Torso, *by Apollonios
of Athens, second century BCE
(Vatican Museums)*

of Michelangelo was called the Belvedere Hercules. The artist loved this torso so much that even in his last days, almost totally blind, he would be led by the arm through the maze of hallways in the Apostolic Palace to visit the ancient statue, to study and admire it one more time with his fingertips instead of with his eyes. Because of his passion for this muscular piece, it also came to be called Michelangelo's Torso. Once more, Michelangelo is satisfying his love of sculpture by including his favorite pieces in the painting.

According to Saint Matthew, Christ should be seated on his throne of glory at the Resurrection. According to Michelangelo, Christ is not risen—he is *rising*. He is in the act of standing up, about to execute his awesome, severe final judgment on humanity. Mary, his mother, is looking away; it seems as if she does not want to witness the punishments on the other side of the fresco. Her face holds another secret, unknown until the recent cleaning and restoration. Although all the other figures are painted in brushstrokes that imitate the sculpting strokes of Michelangelo's chisel, Mary's face is a mass of tiny, colored dots, almost like pixels in a digital image. Here, the artist is pioneering a new art technique, called pointillism, which most people think was invented by Georges Seurat in Paris in the late 1880s. With Mary, Buonarroti took one more leap into the future. In fact, it is here with Mary that Michelangelo's personal spiritual path—and that of the fresco—took a surprising, secret turn in the late 1530s.

VITTORIA COLONNA AND
THE FIFTH COLUMN

As we have already seen, Michelangelo was not alone in his disillusionment with the Vatican. Since Martin Luther's first protest against the Church in 1517, a large part of Europe had become Protestant. In Naples in the 1530s, a small but highly influential secret group formed, under the leadership and spiritual inspiration of Juan de Valdés. Valdés came from a Castilian family of *conversos,* Jews who had been forced to convert to Catholicism by the Spanish

Inquisition.* His parents and at least one of his uncles were later arrested and tortured by the Inquisition for either secretly maintaining or returning to their Judaism. Juan had been sent to Catholic universities, where he excelled in Hebrew, Latin, Greek, literature, and theology. He is considered one of the greatest Spanish writers of the sixteenth century. He was another Renaissance genius, sought after by emperors, popes, and the intellectuals of his day. To escape the dangers of the Inquisition in Spain, Valdés went to Italy, ending up in Spanish-ruled Naples in 1536. He was a handsome, extremely charismatic speaker, drawing crowds of eager listeners. His home became an early forerunner of the artistic-intellectual salons of a later age, such as the one hosted by Gertrude Stein and Alice B. Toklas in twentieth-century Paris. It was a magnet for the greatest artists, writers, and thinkers of the day—much as Lorenzo the Magnificent's home had been in Florence decades earlier. Some of the frequent attendees at these gatherings were Cardinal Reginald Pole, the last Catholic Archbishop of Canterbury, who had had to flee England when he opposed Henry VIII's divorce of Catherine of Aragon; Pietro Aretino, a bawdy intellectual poet, critic, and pornographer; Pietro Carnesecchi, one of the greatest diplomats, political advisers, and debaters of his day; Bernardino Ochino, a Capuchin monk and highly popular preacher; Giulia Gonzaga, the dazzling widow of the rich Roman nobleman Vespasiano Colonna; and her sister-in-law Vittoria Colonna. Vittoria was another Italian Renaissance genius, one of the few published female poets, who had a devoted following as great as that of any male poet of the age. After her husband's death in battle, she threw herself into her poetry and the intellectual whirl of the day. In this private circle of the intelligentsia of Naples, under the guise of seemingly harmless artistic dinner parties, the seeds were planted for a new underground movement with one goal—to reform the Vatican and the Catholic Church. In spite of the vastly differing backgrounds of

*It is a general rule of thumb that if a Spanish family name ends in *z* (e.g., Valdez), the family was probably always Christian, whereas if it ends in *s* (e.g., Valdés), they were probably originally Jews, forced to convert after 1492.

these plotters, many of them had something in common: they were either acquaintances or friends of Michelangelo Buonarroti, the pope's chosen artist and architect.

Valdés spoke out convincingly against the abuses of power and the hypocrisy of the Vatican. He wanted the Scriptures to be open and available to the average Christian, not used as an instrument of manipulation by the Church. He proposed an intellectual, questioning, analytical approach to the New Testament, in the same way that Jews interacted with their Scriptures by way of Talmudic reasoning and Midrashic insights. He believed that every Christian, free to delve into the Bible at his or her own level, would be illuminated spiritually by the holy text. In fact, this is what he called his philosophy: *alumbradismo,* or illuminism. Valdés regularly illustrated his teachings with Midrash and with metaphors from Moses Maimonides. Maimonides, according to Jews, Muslims, and Christians alike, was the greatest mind in all of Spain in the twelfth century. Also called RaMBaM (an acronym from his full name, Rabbi Moses Ben Maimon), he was a rabbi, teacher, Bible and Talmud commentator, philosopher, poet, and translator—and all the while working full-time as a much-sought-after anatomist and physician. Valdés was fond of citing Maimonides's description of the Divine Illumination as a huge royal palace. Some visitors would shyly stand at the front door, others would wander through the gardens, others would enter the foyer, others would stand off at a distance, others— those blessed with a profound encounter with illumination—would make themselves at home in the heart of the palace. However, he preached that *all* souls were blessed with divine grace, according to their level. Thus, it was impossible to condemn those souls who had not yet reached the level of entering into the core of the holy palace. He wrote: "They are not strangers, those who are still gazing at the divine palace from the outside." In this way, he both negated heresy and the existence of purgatory, which the Vatican was using mainly as a moneymaking gimmick, through the sale of the infamous indulgences. He taught that salvation did not come through baptism at birth and through unquestioning obedience to the Church, as

the Vatican taught, but through the grace bestowed on all people by a loving God, through baptism as an adult when one could understand and appreciate the act, through studying and delving into Scripture to the best of one's ability, and through humbly imitating Christ in one's daily life. Only with an understanding of the influence of Valdés's *illuminismo* on Michelangelo can we comprehend why the saved souls in the Last Judgment are ascending at so many different levels and in so many varied ways.

After Valdés died in 1541, his small circle of *alumbrados* (illuminated ones) scattered. The core of the group migrated north to Cardinal Pole's residence in Viterbo, today about an hour's drive north of Rome. The new leader of the group was not Pole—that would have been too obvious. The group had already been spied upon for some time, especially by a certain Cardinal Gian Pietro Carafa, a fanatical promoter of the Inquisition and its reign of terror. The true leader was a woman and a nun—Vittoria Colonna—who ran everything from her convent in Viterbo. Through her powerful family connections and influence, she set up an underground network that soon covered all of Italy and most of Europe. Free-thinking priests, politicians, diplomats, and intellectuals were secretly involved everywhere in one quest—to become a hidden "fifth column" inside the Vatican, to reform it from the inside, and ultimately, to harmonize Catholic and Protestant belief. This cabal of dreamers took on a new name: *Gli Spirituali,* the Spiritual Ones. Their ultimate goal: to reunite the two Christian faiths before the schism became too great, and to bring about one Church, cleansed and reborn.

Years before, while still living in Rome, Vittoria had become friendly with Michelangelo, and their bond would become ever stronger until her untimely death. They wrote lengthy personal letters to each other, composed poems in each other's honor, and often exchanged gifts and favors. Many historians who sought to deny Buonarroti's love of men tried to use his poems to Vittoria as proof of his heterosexuality. Their love, however, was the epitome of what we today would label "platonic." They loved each other's

minds. Michelangelo was thrilled to find an intellectual peer and fellow spiritual traveler in Vittoria. Just as he had thrown himself so passionately into new ideas and movements in the past, he now became heart and soul one of the Spirituali.

In *The Last Judgment,* just as Mary is turning away from the severe judgment of Jesus, there is a deeper meaning: Michelangelo is symbolically turning away from the Church as well. This had to be kept secret, of course, since only Catholic artists were allowed to work inside the Vatican, and especially in the pope's chapel. If it had been discovered that Buonarroti had denied the Church and veered into Valdesian Protestantism, he would not only have lost his career, but also his freedom—and possibly his life. Only a few years earlier, the Vatican had put a price on his head for supporting Florence's independence movement. Still, the rebel in him could not be silent, and he continued to fill the giant fresco with more and more hidden messages.

If we look carefully at Mary, we see that she is looking downward at only one figure, a woman who is peering over the shoulder of Saint Lawrence and his grill. In fact, Mary's foot is resting on the top of the grill. The woman's face is mostly obscured by the grill—and for good reason. *She is the secret leader of the underground movement—Vittoria Colonna herself.*

Jesus also is gazing down at only one figure—an unnamed man peering over the shoulder of Saint Bartholomew, who like Saint Lawrence, is seated in a place of honor at Jesus's feet. From the handsome profile and the large eyes, the same that we saw on the statues that Buonarroti carved in Florence after 1532, we can recognize the other great love of Michelangelo's life at this time—Tommaso dei Cavalieri. Here, in the fresco, he appears to be too old, with gray hair and a receding hairline—even though his face is young and almost completely unlined. This was probably done on purpose, either by Michelangelo or by his friend Daniele da Volterra, who did some retouching when he was ordered to censor the painting in 1564. In Naples, there is one copy of the original *Last Judgment,* the way it looked before the censoring. The copy, an oil painting, was done by Michelangelo's trusted friend Marcello Venusti in 1549,

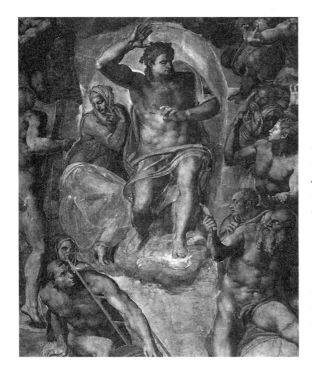

Mary above Saint Lawrence with his iron grill; Jesus above Saint Bartholomew, who holds his own skin (pre-restoration). The woman over Saint Lawrence's shoulder is Vittoria Colonna and the man over Saint Bartholomew's shoulder is Tommaso dei Cavalieri. See Fig. 18 in the insert.

under the direction of Buonarroti himself. In Venusti's copy of the fresco, we can find the same young man, but with a full head of dark hair, looking very much the handsome thirty-eight-year-old Tommaso was at the time Michelangelo was helping Venusti create this painting.

Why did Michelangelo choose these two particular saints to guard his two great loves? Saint Lawrence's name in Italian is Lorenzo, just like the artist's first patron and protector, Lorenzo the Magnificent. Also, Saint Lawrence, the treasurer of the early Christian Church in Rome, said that the true wealth of the Church was not its gold but its common folk of faith. This is part of Michelangelo's message to the papal court of his day, going all the way back to his work on the Sistine ceiling.*

* The pagan Romans who wanted the Church's gold did not appreciate this response and grilled Lawrence alive, which is why he is always depicted with an iron grill. Today, he is officially the patron saint of chefs and barbecues. Who says the Church does not have a sense of humor?

Saint Bartholomew, besides being the patron saint of taxidermists and leather tanners, is also the protector of plasterers. After Michelangelo's traumatic problems with the plastering of the ceiling, he wanted all the help he could get with this enormous fresco work and had good reason to include this saintly protector.

Saint Bartholomew was not martyred in Rome but skinned alive in Armenia. According to tradition, his skin is inside the altar of his church on the Tiber Island, between the areas that were the two main Jewish neighborhoods of Rome in the Renaissance. Dressed up as Saint Bartholomew is a friend of Buonarroti, a man who got in trouble for portraying too much skin in his prints that accompanied his lewd poems—Pietro Aretino, pornographer and fellow Spirituali conspirator. Buonarroti is not making fun of Saint Bartholomew but showing his belief that a man like Aretino, in trouble with the hypocritical Church, was closer to God than many so-called religious authorities of his day.

Saints are almost always shown with the signs of their martyrdom for the faith. (The main exception is Peter, who is shown with the keys he received from Jesus, instead of being portrayed crucified upside down.) Bartholomew is always shown holding his entire intact skin and the knife with which he was flayed. The skin here holds another intriguing mystery: whereas the figure of Bartholomew/ Aretino is completely bald with a long gray beard, the face on the skin is clean-shaven with a full head of dark unruly hair. They do not match. This is because the face on the skin is none other than Michelangelo himself. As we discussed in the story of the *Pietà,* artists were forbidden to sign works commissioned by the Vatican. Here, instead of his name, Buonarroti secretly signed the fresco *with his own face.* It is also one more protest from the sculptor who hated to paint. He seems to be saying that being commanded to return to paint in the Sistine again was a fate as awful as being skinned alive.

That is not all that this symbolic skin is saying, though. The figure of Tommaso—the only person in direct eye-to-eye contact with Jesus in the whole gigantic painting—has his fingers pressed together in supplication. (It was not until the recent cleaning that one

Above: The Last Judgment, *fresco copy by Marcello Venusti (Museo Nazionale di Capodimonte, Naples). Detail showing Tommaso dei Cavalieri's face with dark hair. Right: Detail from* The Last Judgment— *the skin with Michelangelo's face.*

could clearly see where Jesus's and Tommaso's eyes were focused.) Michelangelo, feeling himself a sinner unworthy of heaven, believed that his one hope of salvation was his true, unselfish love of Tommaso. Here, he placed Tommaso as his intercessor, pleading his case before Christ the Judge. Just to make sure we understand that he felt that a man's love—even for another man—could lead to redemption, he placed next to his skinned body yet another male couple passionately kissing in Paradise. The identity of Tommaso here is not mere conjecture. For once, we have a surviving clue, written in Buonarroti's own hand. In 1535, just when he was plotting out his designs for the fresco, he wrote another love poem to Tommaso. In this sonnet, Michelangelo likens himself to a lowly silkworm, whose protective covering becomes the clothing for another being:

To enfold my noble lord, I would wish the same fate;
To clothe my lord's living skin with mine that is dead;
As the snake passes through rocks in order to shed,
Thus would I pass through Death to better my state.

THE SAVED AND THE DAMNED

At the bottom of the left-hand side of the fresco, below Mary and the Blessed Women, is the Resurrection of the Good Souls. They are climbing out of the ground as their flesh slowly returns to their bodies. The demons of the underworld are trying desperately to haul some of them back, but the angels seem to be prevailing. In the corner we see a priest blessing these adult souls—possibly a sign of Michelangelo's new illuminist faith, in which baptism was for adults. Another symbol of this early form of Italian Protestantism is the rosaries that are being used in this corner of the fresco, to save and lift up to salvation several of the souls. Valdés and his followers believed that divine grace was the key to salvation, as opposed to blind obedience to the Church; in fact, we get the expression "saving grace" from this concept. The rosary is an act of humble, daily faith in which the Ave Maria prayer is recited. It begins: "Hail, Mary, full of *grace. . . .*" This was another break with traditional representations of the Last Judgment, in which the saved souls showed the *acts* that had earned their redemption, such as sponsoring the construction of a church or chapel, proselytizing to bring more followers into the Church, or conquering a city for the pope.

At the bottom middle, beneath the trumpeting angels, and on the right-hand side, beneath the Blessed Males and the Martyr Saints, we see visions of hell: fire and brimstone, dark caverns, Charon ferrying the damned across the River Styx, and demons dragging the evil souls down to their eternal doom. One of the most famous images of all is a soul finally realizing the enormity of his sins while being bitten by a demonic creature. Michelangelo is making a pun in Italian here—to be bitten is *morso*. This poor damned soul is the picture of remorse—in Italian, *rimorso*.

Detail from
The Last Judgment
(pre-restoration)—Remorse

To the right of this image, a battle is going on. Furious angels are literally beating down some of the worst souls, some of them symbolizing sins or vices. One of these is commonly identified as the image of Greed, since there is a heavy money bag dangling down at his side.

Another sin rampant at the time, but now long extinct in the Church, was the sin of simony, described and punished at length in Dante's *Inferno,* one of Michelangelo's favorite texts. Simony was the practice of selling priestly positions in the Church hierarchy. In the Renaissance, it was the usual modus operandi for popes to raise money by selling to the highest bidders the titles of cardinal, archbishop, and so on. This only added to the mess of corruption and confusion in the Church of Michelangelo's era. As expressed in Michelangelo's poem of 1512, in which he described the Vatican as selling Christ's blood for money, this was something that particularly enraged the artist. We see the proof here: the cursed figure is upside down, a sad parody of the martyrdom of Saint Peter; the money purse is gold in color, tied with red cords—the exact same

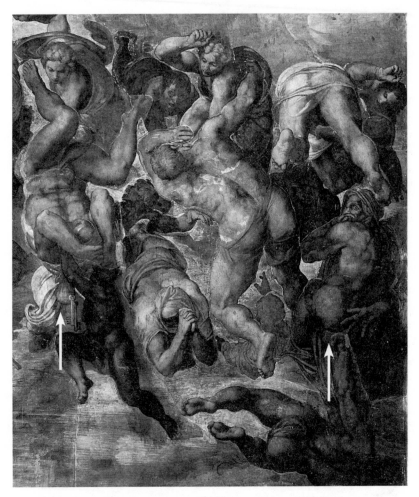

Detail from The Last Judgment *(pre-restoration) — Simony (commonly identified as Greed) upside down with dangling money bag on the left, and Lust being dragged down by his testicles on the right. See Fig. 24 in the insert.*

giallorosso colors that Michelangelo had used before to insult Rome and the Vatican. The pair of lead keys hanging by the cursed figure's side are also a sardonic parody of the twin keys of Vatican City and the papacy. Buonarroti painted the angriest, strongest angel of them all to batter this corrupt soul's buttocks down to hell.

On the far right is another naked figure, but with a face that is more like a caricature than a real person. He is the symbol of Lust,

sex without love. In this case, the artist let the punishment fit the sin; if we look carefully, we can see that Lust is being dragged down to perdition by his testicles. Small wonder that he is biting his knuckles to keep from screaming in agony.

THE KABBALAH OF THE JUDGMENT

Of course, Michelangelo did not leave out his cherished Kabbalah in *The Last Judgment*. This fresco contains the same balance of the universe that he concealed in the ceiling. On Mary's side of the twin tablet-shaped fresco, we find the symbols of Chessed, the female, merciful side of the Tree of Life. On Jesus's side, to his left or *sinister* side, are the signs of G'vurah and Din, the male aspects of strength and judgment, found on the opposite side of the Tree of Life. On the Chessed side, we find: souls being saved through grace, the Merciful Virgin, the Blessed Female Souls, and the Cross of Salvation at the top. On the G'vurah/Din side, we find souls being damned and punished, Christ the Judge, the Blessed Male Souls, and the Column of Flagellation at the top. On the Judgment side, even the Martyred Saints seem angry, pointedly showing the instruments of their torture and death to the very comfortable Vatican hierarchy that would gather there beneath their gaze, as if to say: "This is what *we* did for the faith—how about you?"

This time, instead of hiding Hebrew letters in the work to signify the balance of female and male, mercy and power, Michelangelo hid other ancient mystical symbols of femininity and masculinity at the top of the fresco . . . in plain view. The cross and the circular crown of thorns at the top of the female tablet of Chessed is from this symbol: ♀. It is the cross of the love goddess Venus, very popular in his day as a symbol in astrology as well as in alchemy.

The column at the top of the male tablet of G'vurah is decidedly male. On careful inspection, we can see that the artist purposely exaggerated the muscular back of the angel raising the base of the column so that the rounded, divided back looks just like a scrotum,

complementing the phallic angle of the column. Viewed as a whole, it is very clearly the male symbol of the war god Mars: ♂.

To achieve proper balance in the universe, there must be a center as well. According to the Kabbalah, there is indeed a central point to the universe: it is the Ladder of Jacob. In Genesis 28:12, Jacob dreams of a divine ladder, by which the angels descend to earth and ascend to heaven. This is the link between heaven and earth, humanity and angels, the material and the spiritual worlds. The Kabbalah teaches that the entire creation revolves around this ladder. Most people who view *The Last Judgment* fresco think that Jesus is the center of the painting—but they are mistaken. The true center is just below Jesus, where Saint Lawrence is sitting with his grill. Down through the centuries, critics have complained that the martyr's grill has no legs and that it resembles a ladder more than a grating. They are right. It *is* a ladder—Jacob's Ladder, to be exact. The bottom rung of the ladder is at the *exact center* of the huge picture, and if you look carefully, you will see that the dynamic motion of the painting revolves perfectly around the angle of the ladder. Once again, Michelangelo embedded a central teaching of Jewish mysticism in one of the most famous Catholic artworks of all time.

This time, Michelangelo managed to incorporate a significant number of daring ideas into his work. He found a way, as we have

seen, to include his male lover, respect for Jews, contempt for the Vatican's corruption and immorality, experimental painting techniques, and his underground, subversive neo-Protestant faith. This last is possibly the biggest secret of them all—that while Michelangelo was creating this masterpiece for the Church, he had left the Church and personally subscribed to another faith.

Amazingly enough, the millions of visitors to the Sistine Chapel each year do not notice any of this. The clever Florentine once again succeeded in overwhelming the visitor with so much color and imagery that only those who are lucky enough to spend a good deal of time inside have a chance to notice any details. One man who did spend much time inspecting the fresco was the pope's *cerimoniere,* or master of ceremonies, while Michelangelo was toiling away on it. The *cerimoniere* is basically the papal chief of staff, running the day-to-day operations of the Vatican for the pontiff. In the time of Paul III, the master of ceremonies was a pompous, self-important cleric by the name of Biagio da Cesena. He reviled Michelangelo publicly, even before the fresco was finished, for filling the holy papal chapel with an "orgy of pagan obscenities and heresies." The artist replied with the quote at the top of this chapter, and then followed it up with paint. In the bottom right-hand corner of the fresco, just over the exit door (through which the public enters today), is the damned soul in hell, King Minos of Greek mythology. Minos loved gold and despised human beings, thus assuring him eternal damnation. He is depicted here with donkey ears, crushed by a huge serpent that is chewing his genitals forever. The cursed king is the very last figure that Michelangelo painted at the end of his seven years' toil on the wall fresco.

When the work was finally unveiled in 1541, all Rome came to see the latest marvel of the great maestro. Immediately, the reactions split the city in two; half of the viewers thought that this was one of the most inspirational, deeply religious, and artistic works ever seen; the other half thought that it was pagan and obscene. While the debates raged in front of the painting, one person suddenly started giggling . . . then another . . . and another. Soon all of Rome was

Detail from The Last Judgment
(pre-restoration) —
King Minos with the face of
Biagio da Cesena, the papal
master of ceremonies

laughing hysterically because, sure enough, the flabby body and ugly profile of King Minos was an obvious portrait of none other than Biagio da Cesena, the master of ceremonies who was second only to Pope Paul III himself. According to contemporary reports, Biagio had to prostrate himself in tears in front of the pope, begging the pontiff to get him out of the fresco. The pope, who respected Michelangelo (and who was probably also fed up with Biagio's pretentiousness), replied: "My son, the Almighty has granted me the keys to rule over heaven and earth. If you wish to get out of hell, go talk to Michelangelo." Obviously, they never made their peace, and now Biagio is stuck in hell forever.

Chapter Sixteen

LATER SECRETS

*Many believe—and I believe—that I have been designated for this
work by God. In spite of my old age, I do not want to give it up;
I work out of love for God and I put all my hope in Him.*

— MICHELANGELO

P ERHAPS MICHELANGELO had covered his angry messages *too* well. Immediately after finishing *The Last Judgment,* the artist was commanded by a very proud Paul III to fresco an entire chapel, the brand-new Cappella Paolina, commissioned by Pope Paul III Farnese and named for himself. Buonarroti unhappily consented, but on the condition that he would be allowed to sculpt as well. He wanted to finish the often-postponed, on-again-off-again funeral monument to Pope Julius II. Michelangelo longed to get this unfinished commitment off his conscience—and Julius's surviving relatives off his back. Pope Paul did some hard negotiations on behalf of the artist, with the result that the tomb contract was reduced even more, down to a requirement of only three statues from the hands of Michelangelo himself. This was quite a comedown from the original forty-plus statues and the monumental pyramid that Julius had decreed almost four decades earlier. Yet it was clearly still a considerable labor for a sculptor in his late sixties.

Buonarroti immediately started planning the final tomb designs, while also designing his fresco cycle to cover every inch of a completely new chapel. Just as when he got out from under the burden of painting the ceiling, Michelangelo now exploded in a burst of sculpting energy. Strangely enough, he easily had enough finished figures to satisfy the terms of the contract. He could have followed the original design and flanked Moses with two of his prisoner or slave pieces. Instead, he petitioned the pope for permission to do two new figures that he felt would better suit this more modest tomb. According to contemporary reports, he carved the two new full-size statues in just one year. Also, as before, he eagerly returned to

Left: Rachel *(Receptive/Chessed). Right:* Leah *(Active/G'vurah).*

images from the Jewish Bible. This time, he picked two matriarchs from the Torah: Leah and Rachel.

In the book of Genesis, they are the sisters who both marry Jacob, the third Hebrew patriarch. The two sisters, along with their two maidservants, become the mothers of the Twelve Tribes of Israel. Here, in his fifth and final design for Julius's tomb, Michelangelo put them on either side of the monument. In a letter to Pope Paul III, Buonarroti, in what for him was an uncharacteristic move, explained some of the symbolism of his design. The secretive artist for once was constrained to give an explanation, since he was petitioning the pontiff to order the della Rovere family to allow this one last change in the tomb design. In this private letter, Michelangelo quoted from Dante's *Purgatory,* in which the poet encounters Leah. Leah, whose Hebrew name means "weak eyes," complains to Dante that she must constantly check her looks in her mirror and weave garlands of flowers to make herself attractive, while her younger sister Rachel does not have to do anything, being naturally graced with beauty. For this reason, Leah symbolizes Active Faith—a faith that requires human initiative in order to make oneself more attractive before God. Leah stands in contrast to Rachel, graced with beauty bestowed without any effort on her part. Rachel is the paradigm of Contemplative Faith, a faith that requires no further action. In the finished pieces, we clearly see Leah holding her garland and pensively glancing at her mirror, while the beautiful Rachel simply looks up to heaven to receive her blessing. In this, too, Michelangelo is again illustrating a powerful mystical idea of the duality of the universe: Mercy versus Strength, and active versus receptive meditation. In the middle, in the place of cosmic balance, he placed his statue of Moses, carved almost thirty years earlier. One side of Moses—his right, next to Rachel (Contemplative)—is seated, while the other side, next to Leah (Active), is in motion, in the act of turning to stand up.

The final location for the monument was not to be the Vatican, however. The della Rovere clan had been out of power and out of favor for a long time. Moreover, Julius had not been forgiven for

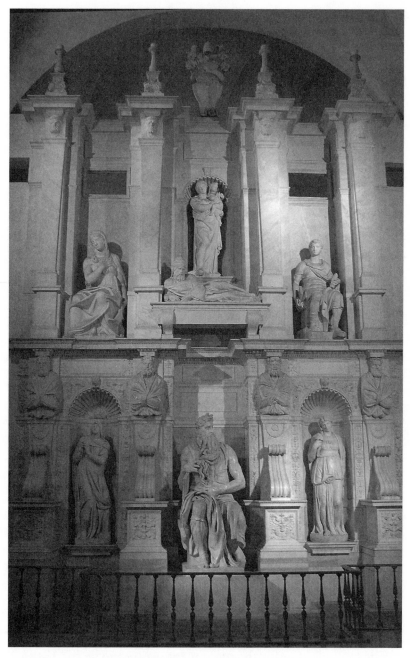

Monument to Julius II *(Church of San Pietro in Vincoli, Rome)*

destroying so many tombs of previous popes when he ordered the demolition of the first Basilica of St. Peter. Thus, his body and his monument ended up in a much more modest place—his family church of San Pietro in Vincoli (St. Peter in Chains), tucked away on a hilltop overlooking the Colosseum area.

This new setting, of course, gave the artist a fresh problem. His original *Moses* was meant to interact with its setting, perched high up in the center of St. Peter's, directly beneath the light that would enter from the windows of the dome above. As we discussed, Buonarroti had made two nodes on the top of the statue's head and buffed the face to a reflective finish, in order to make it seem that the divine light was emanating from the head and face of the great prophet. Now that the *Moses* would be sitting at floor level, in a niche off to the right side of the altar, this brilliant special effect would no longer work.

Once more, Michelangelo broke the rules. He actually *recarved* his favorite statue that he had finished three decades earlier. He moved Moses's left foot and lower leg back a pace and lowered the left thigh (on the viewer's right), to make the statue seem about to stand up and walk out the door to bring the *luchot* to humanity—the same two Tablets of the Law that he had just completed on *The Last Judgment* fresco. In this way, he conceptually linked this side of Moses to the Active/G'vurah symbol of Leah. Even more incredible than this, however, is what he achieved with Moses's head. Michelangelo made the statue's head *turn* ninety degrees to its left by carving a brand-new head within the already-completed head. This is the reason that the head of Moses seems a bit misshapen and the so-called horns twisted. He was adapting the old statue to interact with its new environment, in order to salvage his cherished special effect. After making the statue change its bodily position, Buonarroti cut a rectangular hole in the ceiling of the church to funnel the sunlight onto the new face and the reconfigured nodes on the head that he twisted around to better reflect the descending rays of light.

Once the monument was set in place, reports from the time describe how the Jewish families of Rome would come on Sabbath

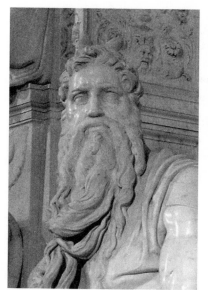

Left: Detail of Moses. *Right: Faux window over the* Moses, *with Michelangelo's hole sealed up (center top of painted window).*

afternoons to gaze at Moses and recount to their children the stories of the great prophet and the righteous matriarchs Leah and Rachel. We do not know if it was because of too much attention from the Jews, or if it was because the Catholic visitors were ignoring Saint Peter's chains in the main altar and just admiring the Jewish-themed statues on the side—but for whatever reason, the Church authorities decreed that Michelangelo's hole in the ceiling be sealed up forever. Now, just as with his *David,* the *Moses* statue no longer performs its special optical effect. For centuries, people thought that Michelangelo was actually anti-Jewish, or had misunderstood a faulty translation of the Torah, and purposely gave a pair of horns to poor Moses. They could not have been more wrong.

There is one more secret that was only recently discovered about the tomb. The reclining statue of Julius II above Moses has at last been decisively attributed to Michelangelo himself, and not one of his assistants. After the sculpture was cleaned and restored, it became evident that only the great maestro could have carved it.

There is one more proof—the face on the statue is not that of the late pope, but a self-portrait of Michelangelo, gazing proudly down on his gnarled sculptor's hands and on his favorite statue. In the end, the artist got the better of the pontiff.

Back in the Vatican, he painted two big frescoes in the new Cappella Paolina—the *Conversion of Saint Paul,* facing the *Martyrdom of Saint Peter* across the room. Since this chapel is off-limits to the public, we will not go into the various secret messages that Michelangelo embedded in these two works. Suffice it to say, they made Pope Paul and his court so uncomfortable that they canceled the rest of Buonarroti's contract and never asked him to paint in the Vatican again. There is no record that this turn of events upset the artist at all.

After this, Michelangelo was entrusted only with architectural projects for the Vatican. The Church hierarchy must have reasoned that there was no way to hide an insulting or subversive messages in buildings. Of course, they were mistaken.

Buonarroti was later given the job of designing the huge dome of the new Basilica of St. Peter. It is well known how much he loved the simplicity and perfection of ancient Roman architecture. His favorite building of all was the Pantheon, the central shrine to the Greek and Roman idols, built by Hadrian in the first half of the second century. Michelangelo proposed to the pope that he make a large copy of the Pantheon dome on top of the new St. Peter's. The horrified pontiff replied that Hadrian's dome was *pagan*—the Vatican cathedral had to have a Christian-looking dome, like the one built in Florence a century before by Brunelleschi. The disappointed artist designed the famous egg-shaped dome that the whole world knows today . . . with one little detail that most of the world does *not* know.

It is a Catholic tradition that the *cupola,* or dome, of any city's cathedral must be both the tallest structure and the widest dome, to show its authority.* When Michelangelo died at age eighty-nine, the

*The Capitol Dome in Washington, DC, is the tallest building in the U.S. capital for the same reason.

massive *tamburro,* or drum-shaped base, for the dome had already been completed. Of course, construction was halted for several weeks. As any contractor or engineer will tell you, whenever there is a long pause in a building project, it is important to remeasure everything, because of possible shifting, contraction, or expansion of the structure. When they remeasured Michelangelo's base for the dome, they discovered that he had once more outfoxed the Vatican. The diameter was a good foot and a half *narrower* than the pagan Pantheon. There was nothing to be done, except finish the dome and hope that nobody would find out. To this day, the Vatican dome is the *second*-widest dome in Rome.

In his last years, Michelangelo worked on new pietà sculptures— not for any pope, but for his own diversion and probably for his

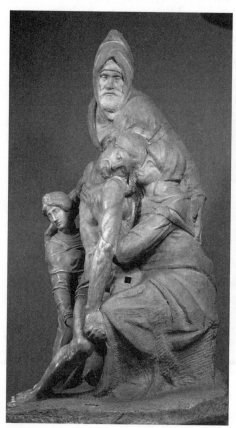

Left: The Bandini Pietà, *by Michelangelo, 1550–55 (Museo dell'Opera del Duomo, Florence). Above: Detail of the face of Nicodemus on the* Bandini Pietà.

own tomb. His eyesight had never recovered from his torment on the ceiling of the Sistine, and by this point in his life he was almost blind. He was sculpting more by feel than by sight—and yet he persevered, even trying new carving techniques right up until six days before his death. His best-known pietà from this last period is the one now housed in the Museo dell'Opera del Duomo in Florence. He had put all his remaining energy into the top of the sculpture, and by the time he had worked his way down more than halfway, he found more and more defects, both in the marble and in his own carving. Frustrated that his hands and eyes could no longer match what he envisioned in his mind, he smashed the legs of Jesus in a fit of rage and gave the pieces to his servant. Fortunately for us, the servant saved all the pieces and sold them to a merchant who had the whole thing put back together again.

We can also see why he had put all his energy into the top of the grouping. Holding up Jesus from behind is the hooded figure of Nicodemus. According to Christian tradition, he is the symbol of hiding one's true faith in order to survive and serve God. Juan de Valdés had instructed his secret followers, the Spirituali, to practice what he called *nicodemismo,* disguising their underground illuminist faith, in an attempt to infiltrate the Church and reform it from the inside, while avoiding capture and execution by the Inquisition. When we take a good look at the face of Nicodemus, we see the last self-portrait of a man who hid so many of his true beliefs throughout his long life—Michelangelo Buonarroti.

Chapter Seventeen

"A WORLD TRANSFIGURED"

*A beautiful thing never gives so much pain as
does failing to hear and see it.*

— MICHELANGELO

Within the fall, we find the ascent.

— KABBALISTIC PROVERB

ROME IN WINTER, 1564.
The great maestro Michelangelo Buonarroti, the last sur-
vivor of the golden age of Florence, lay dying at the age
of eighty-nine. With him were being extinguished the last embers
of the Italian Renaissance. Leonardo, Raphael, Bramante, Botticelli,
Lorenzo de' Medici—all the other great figures had passed away
long before. Now art and science were being stunted and censored,
books burned in public, freethinking forced to go deep underground.
The Jews of Rome were walled up alive in the prison known as the
ghetto, and all their venerable sanctuaries and centers of learning
outside the ghetto walls destroyed without a trace. Wars covered

the face of Europe. It seemed that the world was sliding back into darkness. How had things fallen to such a depth?

Back in the 1540s, Pope Paul III had started the repressive measures of the Counter-Reformation to crack down on the growth of reformers, Lutherans, and freethinkers in the Catholic world. One impetus for this puritanical backlash was the outrage expressed by fundamentalists in response to the unveiling of Michelangelo's *Last Judgment,* with its hundreds of stark-naked figures right in the heart of the Vatican. The relentless Cardinal Carafa and his spies started hunting down the Spirituali all over Europe. Those who were not arrested and executed had to run for their lives and died in exile. The lucky ones, such as Giulia Gonzaga and Vittoria Colonna, died of natural illnesses before they could be rounded up and burned in public. The Spirituali's last hope had been Cardinal Reginald Pole, their man deep inside the Church hierarchy. When the Council of Trent was convened, he led the large contingent of reformist delegates. They had hoped to meet with Martin Luther in person and somehow reach an accord that would have allowed the two faiths, Catholic and Protestant, to merge again into one new Church. The Vatican hardliners, however, were able to stall the proceedings so long that Luther died shortly after the opening session. That was the beginning of the end.

When Pole saw that Vatican rejectionists had taken over the council, he pretended to be ill and fled before he could be arrested. The Council of Trent became the death knell for any reconciliation between Protestants and Catholics. It also destroyed any hopes of tolerance for the Jews of Europe. The Inquisition gained much more power, and soon the dreaded Cardinal Carafa was able to establish the Index of Forbidden Books, as well as torture chambers in the heart of Rome. Artwork was also condemned, and a large amount of the council's time and energy was spent discussing Michelangelo's "obscenities and heresies" in his Sistine frescoes. The Holy Inquisition was revitalized and expanded, to terrorize most of Europe, publicly burning copies of the Talmud as well as paintings, together with freethinkers, Jews, artists, and homosexuals.

There had been one last-ditch attempt at reconciliation in 1549. When Pope Paul III Farnese died, the conclave stood poised to elect none other than Cardinal Pole, the secret member of the Spirituali, as the new pope. He had the necessary two-thirds majority of cardinals about to vote him into office when, at the last moment, late-arriving cardinals from France brought about a stalemate. Amid a flurry of bribes, politicking, and at least one possible poisoning, a compromise pope was elected—Julius III del Monte. This new Julius did not care about religious reform or art—or anything intellectual, for that matter. He had fallen in love with a thirteen-year-old boy of the streets four years earlier and forced his wealthy brother to adopt the lad. His first act upon being crowned pope was to ordain the boy, now seventeen, with his adoptive name, as Cardinal Nephew Innocent Ciocchi del Monte. While the Inquisition was persecuting and burning homosexuals around Europe, the pope and his almost illiterate teenaged lover were holding private parties in their newly constructed pleasure palace of Villa Giulia (today the Etruscan Museum in Rome). During this do-nothing papacy, the fanatical Cardinal Carafa became more and more influential, leading Cardinal Pole, in fear for his life, to return to England in 1554, when the Catholic Queen Mary took the throne. Under Mary's reign, Pole abandoned the ideals of the Spirituali and wreaked his revenge on the Protestants, whom he blamed for the torture and murder of his family. The man who might have been the great reforming and reconciling pope died instead as a mass murderer in 1558. Pietro Aretino, Michelangelo's other surviving ally from the underground group, turned against the artist publicly and vociferously condemned him for the very same *Last Judgment* in which he had been immortalized as Saint Bartholomew, and for which he had earlier praised Buonarroti. Julius III's papacy was also the first time in fifty years that Michelangelo's talents in sculpting and painting were ignored by the Vatican. Only his architectural work for the cathedral under Paul III was allowed to continue; other than that, the aged artist was ignominiously shunted aside.

The last ramparts of free art and free thinking fell in 1555. When Julius III died, the next conclave elected Cardinal Marcello Cervini.

Cervini was the last great hope of the Renaissance and the reformers. He was a brilliant, modest, open-minded Tuscan, respected by all and poised to clean the Vatican and make peace with the Protestants. A desperate conclave of cardinals immediately and unanimously elected him on the first ballot. To the horror of his supporters, the humble Marcello announced that in spite of his new power he would not change his name as pontiff. For centuries, it had been the custom for a cardinal to assume a new name as pope, since it was considered bad luck to retain one's original name (past popes who had kept their birth names had all had disastrous papacies). Marcello rejected superstition, and was crowned Pope Marcellus II. Instead of indulging in coronation parties and banquets, he gave all the celebration funds to the poor. Hope sprang up again. At last, here was a pope who seemed capable and determined to redeem the Vatican, bring back the Renaissance of ideas, and create peace between the conflicting faiths. He proclaimed that there would be a new Church, returning to Scripture and spirituality. Twenty-two days later, he was dead—according to official sources, from "exhaustion." Suffice it to say that Marcellus was the very last pope to refuse to change his name.

The pope who followed was none other than Cardinal Gian Pietro Carafa. As we have already noted, he turned out to be a monster for Catholics and Jews alike. For Michelangelo, it was his worst nightmare come to life. Carafa, as Pope Paul IV, established the Index of Forbidden Books, banned all women from entering the Vatican, burnt volumes of Talmud and Kabbalah, threw the Jews of Rome into the ghetto, drained the Church's savings while overtaxing the faithful in order to enrich his nephews and mistress, tortured and burned homosexuals in public, ordained two nephews (ages fourteen and sixteen) as cardinals, and banned the potato—recently brought to Europe from the New World by Sir Francis Drake—as a fruit of lust sent by Satan. In the Sistine, Paul IV Carafa wreaked more havoc. He ordered the partition grill, symbol of the Veil of the Holy of Holies, to be uprooted and moved several feet east, to break the chapel's perfect correspondence with the Jewish Holy Temple. He hauled in Michelangelo, commanding the aged maestro to make the

naked figures in *The Last Judgment* "suitable" for the papal chapel.
Michelangelo hotly replied: "Let His Holiness make the world a
more suitable place, and then the painting will follow suit." That
was the last time Buonarroti had anything to do with Carafa. The
next pope, Pius IV, was no better. The only project Michelangelo
was commissioned to do for him was a new gate to the city of Rome,
the Porta Pia.

Begun two years before the artist's death, the Porta bears Pius's
name, plus an unusual design element—strange circular indenta-
tions with tassels.

It took the Vatican more than a century to find out that, with these
designs, the artist-architect was insulting yet another pope. Pius IV, in
spite of his pretensions, came from a modest family background: his
father was a barber and blood-letter. The unusual decorative motif
on the Porta Pia was discovered to be none other than an itinerant
barber's basin, with a towel draped over it. Michelangelo had taken
one more slap at an inflated papal ego. Pius, even though ignorant
of this public reminder of his humble roots, was responsible for a

*Left: Porta Pia, Rome. Below: Detail
of one of Michelangelo's odd decora-
tions on the Porta Pia.*

horrible affront to the great artist. As Michelangelo lay on his death-bed, his last surviving student and assistant, Daniele da Volterra, was given an unthinkable ultimatum. Since the Council of Trent had actually taken much valuable time and energy to condemn for-mally the "various obscenities and heresies" in *The Last Judgment* in the Sistine, Volterra was offered two choices: either witness the utter destruction of the masterpiece or censor it himself. With a heavy heart, Daniele began the awful job of adding loincloths and drapery over the objectionable parts of his mentor's masterpiece. This was the beginning of the "cover-up" of Michelangelo's secret messages to the world. The already world-famous ceiling of the Sistine Chapel was also under threat of censorship or destruction, but in the end it remained untouched, for one reason only. Nobody could figure out how to reconstruct Michelangelo's futuristic "flying bridge" scaf-folding, the only way to work on the ceiling without putting the en-tire chapel out of commission for years. Michelangelo's masterpiece of painting was saved by his extraordinary engineering skill.

The hidden messages' next descending step into darkness came from the dying man himself. At his side at the end in his simple apartment were only four or five of his most intimate friends and assistants, including the love of his life, Tommaso dei Cavalieri (now married with children). One of his deathbed requests was that they burn all his notes and designs. Priceless sketchbooks, codices, writ-ings, and images thus went up in smoke. His poems were already being altered and censored by his own nephew so that they could be published. The final insult to the Florentine's memory was his funeral arrangements. His body was prepared to be entombed as a *Roman* artist in the nearby Church of the Holy Apostles—built by Sixtus IV and Baccio Pontelli, the very same pope and architect who had constructed the Sistine Chapel, the source of the worst tortures in his long life. Besides being a church built by the men whose chapel had made his life so miserable, the edifice itself in the time of Michelangelo was a dark, low-lying structure off the beaten path. It was already an insult to the artist that he was not considered worthy of burial inside the Vatican, or even inside the Pantheon,

where Raphael had been entombed. In addition, the decision to keep his body in Rome, a place that everyone knew he hated, instead of sending it home with honors to Florence, was very disrespectful. This low point of his fall from favor actually contained the seeds of Michelangelo's reascension after death.

Faced with the enormous insult of his burial in Rome, the citizens of Florence finally realized their cultural and spiritual debt to Buonarroti. They hurriedly collected public donations to hire the services of Florence's best *burglars*. The two thieves rode to Rome in an oxcart. After sundown, they broke into the church, stole the famous artist's body, rolled it up with cords, and disguised it as a bale of rags. They put it in the back of the cart and rode like blazes back to Florence, arriving at dawn. The joyous Florentines immediately entombed their Michelangelo inside the Basilica of Santa Croce, where his tomb can still be seen today.

As an ironic footnote, in the 1850s, almost three hundred years after Michelangelo's burial there, the church finally got its well-known façade. It was designed by a Jewish architect, Nicolò Matas. Since Matas was told that his name would not appear on the church, he insisted that a large Star of David be placed over the front door. Today, the church that houses the tomb of the most famous secret supporter of Talmud and Kabbalah bears a giant Jewish star.

The defeat and disappearance of the Spirituali and other free-thinkers effectively ended any hope for passing down the meaning of Michelangelo's secret symbols. Soon, they were forgotten. Generation after generation, dust, dirt, sweat, and candle soot slowly covered and darkened the bright Sistine frescoes and further extinguished the illuminated messages embedded within. With the onset of the industrial age, air pollution added another layer of dark filth on the Sistine frescoes. A final blow to the revelation of any of the artist's true intentions came when the Vatican's official guidebooks to the Sistine were published early in the twentieth century. It was not simply that the Vatican itself was unaware of what the Sistine frescoes really meant; it was just that an official publication effectively curtailed any further independent analysis or non-Catholic interpretation for a long time to come.

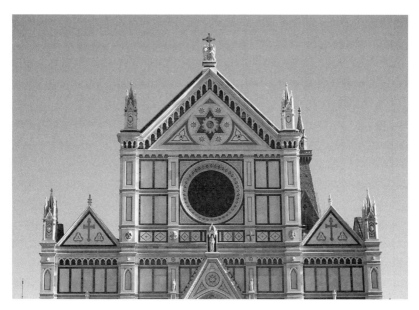

Façade of the Basilica of Santa Croce, Florence

Light began to filter into the Church with the papacy of John XXIII, a jovial, loving man whom the Italians to this day call *Il Papa Buono,* the Good Pope. During the Holocaust, as a cardinal, he saved tens of thousands of Jews by illegally counterfeiting and distributing certificates of baptism to anyone he could find. When he became pope (by a fluke) in 1958, he started a major "housecleaning" of the Church. He convened the Second Vatican Council—commonly called Vatican II—in which the Church's institutionalized teachings against the Jews and Judaism were brought to an end. Thanks to Pope John, Catholics no longer refer to Jews as "perfidious" but as "our elder brothers and sisters." He started the reconciliation and tolerance that Michelangelo had been preaching in his artworks four centuries earlier. Today, *Il Papa Buono* has another name—*Saint* John XXIII.

The next major step in the liberalization of the Church was the surprising election in 1978 of the first Polish pope—John Paul II. He became the first pope to enter a synagogue, and in the Catholic Jubilee Year 2000, the first pope to travel to Israel. This was only

fitting, since the word *jubilee* comes directly from the Hebrew word *yovel,* the Holy Jubilee celebrated every fifty years in ancient Israel. To set the stage for this important year, Pope John Paul had decreed the definitive cleaning and restoration of the Sistine Chapel in 1980. There had been some previous—and bizarre—attempts to restore the ceiling to its original beauty. So-called experts over the centuries had climbed rickety ladders to wipe parts of the ceiling with bread, milk, and even Greek wine—all in vain. The twentieth-century project took two decades, ending just in time for the new millennium. After many attempts to construct a modern, state-of-the-art scaffolding to enable work on the ceiling, the world's top engineers came to the conclusion that the only solution was to re-create a metal version of Michelangelo's original "flying arch" bridge. They even uncovered and reused the holes the maestro had made in the side walls in the early sixteenth century.

As the restoration was nearing completion, Pope John Paul II announced a public "rehabilitation" of Michelangelo and his Sistine frescoes, in a mass held in the chapel itself:

> *It seems that Michelangelo, in his own way, allowed himself to be guided by the evocative words of the Book of Genesis which, as regards the creation of the human being, male and female, reveals: "The man and his wife were both naked, yet they felt no shame" (Genesis 2:25). The Sistine Chapel is precisely—if one may say so— the sanctuary of the theology of the human body. In witnessing to the beauty of man created by God as male and female, it also expresses in a certain way, the hope of a world transfigured. . . .*
>
> *If we are dazzled as we contemplate* The Last Judgment *by its splendor and its terror, admiring on the one hand the glorified bodies and on the other those condemned to eternal damnation, we understand too that the whole composition is deeply penetrated by a unique light and by a single artistic logic: the light and the logic of faith that the Church proclaims, confessing: "We believe in one God . . . maker of heaven and earth, of all things seen and unseen." On the basis of this logic in the context of the light that comes from God, the human body also keeps its splendor and its dignity. (April 8, 1994)*

Thankfully, some of Michelangelo's visionary views had found acceptance by a modern head of the Church. Today, the Vatican is catching up with the seeds of thought that Buonarroti planted in its walls five centuries ago. The corrupt and fanatical popes of the past are long gone, but the artist's vision in the Sistine Chapel of a far more universal and loving faith seems to be growing brighter, clearer, and stronger than ever.

SO, WHAT *IS*

THE SISTINE CHAPEL?

*Lord, grant that I may always desire more
than I can accomplish.*

—MICHELANGELO

*Look beneath the surface; do not let the multiple qualities
of a thing nor its value escape you.*

—MARCUS AURELIUS, *Meditations*

S UCCESS, IT HAS OFTEN BEEN SAID, means different things
to different people.

Measured by the throngs of visitors who are moved to make personal pilgrimages to Rome and the Vatican, the Sistine Chapel is a success beyond compare—a place that some have suggested should be listed as one of the wonders of the world.

But there is another way to determine whether a human effort has achieved its goal. It is important to take note of what its creators sought to accomplish. We need to know not only what the Sistine Chapel is today, but also what it was meant to be by its founders.

Would *they* feel their chapel is a success today? As we have seen, the chapel has been altered, expanded, decorated, and, yes, even partially defaced down through the ages. It has undergone not only structural alterations but also philosophic and theological modifications. Unlike Saint Paul, the Sistine never became "all things to all men," but it has spoken with many voices and preached many different messages. Its strongest messages undoubtedly come from Michelangelo, the man most responsible for the Sistine's enduring fame. However, his messages—"things seen and unseen"—have been obscured, misinterpreted, censored, overlooked, and forgotten over the centuries, only to come back to light in our time. Buonarroti once prayed, "Lord, grant that I may always desire more than I can accomplish." We have to ask: would *he* feel that he accomplished his goal with his frescoes? For Michelangelo, could the Sistine be considered a success?

Jonah, the prophet who appears over the Sistine's altar, was asked by the sailors: "What is your occupation? From where do you come? What is your land? And to which people do you belong?" To assess the success of the Sistine, we must think in terms of its history, its prime architects, and its contemporary relevance. What was it first meant to be? What were its functions over the course of time—practically, spiritually, and conceptually? Perhaps most meaningful of all, we need to ask: what did Michelangelo want the Sistine to teach humanity? What was *his* vision for it—not only for his time but for posterity? Did he succeed?

Let's start with Michelangelo's predecessors. What did they want the chapel to say, and what relevance, if any, do these ideas still have today?

THE PALATINA:
THE PRE-MICHELANGELO CHAPEL

Pope Sixtus IV, the original founder of the Sistine Chapel in the fifteenth century, ostensibly wanted it above all to proclaim the miracle of the Assumption of the Virgin Mary. Of course, with the egotism that

also marked so many of his predecessors and immediate followers, he was very concerned that at the same time it would assert the triumph of his family's taking over the papacy. To accomplish both messages, he had a fresco of the Virgin's ascent into heaven placed at the very front of the chapel with himself beside her. Knowing his vanity and family pride, we can assume he probably would have entitled the Sistine "The Chapel of the Holy Assumption, Shedding Perpetual Glory on the House of della Rovere."

Today, both of Sixtus's messages have met an inglorious fate. The Sistine is not at all the paean of praise that he commissioned to glorify himself and his family, the della Roveres, and their messianic pretensions. The only trace that remains of him, aside from the chapel's name ("Sistine" for Sixtus IV), is the family symbol of the oak tree and the acorns scattered around the room. Instead of an everlasting testimony to his greatness, there still linger the various insults to the papal family from the Florentine artists. The sabotage job so brilliantly executed by the original fresco team sent by Lorenzo de' Medici ensured that the Sistine would never fulfill Sixtus's dream of a positive public relations image for the della Rovere clan.

The other original theme of the chapel, depicting the Assumption of the Virgin Mary into heaven, is also no more. Since the 1530s, when Michelangelo destroyed Pinturicchio's original fresco of Mary's ascent on the front altar wall, there has not been a trace of that subject matter left in any of the room's imagery.

So, with the passage of time, the first two major rationales (or "occupations," in the Jonah questions) for the Sistine became irrelevant. To replace them, another concept was stressed to validate the chapel's uniqueness. Vatican theologians turned the Sistine into "The New Holy Temple of the New Jerusalem." Its role, they explained, was to replace with a Christian counterpart the original Temple in Jerusalem demolished by the Romans in 70 CE. What was lost to the Jews would be shown to have been transferred to the Church. That is why, as we previously indicated, the Sistine has exactly the measurements and proportions of the Holy Temple of Solomon as described by the prophet Samuel in the Bible.

Interestingly enough, this correspondence between the Jewish Temple and the Sistine Chapel was later purposely diminished by the Church itself. The rabidly anti-Semitic Pope Paul IV (the same Cardinal Carafa who spied on and persecuted the Spirituali) decided that the Sistine was *too Jewish,* and therefore decreed that the marble partition grill had to be moved several feet east. That partition originally had marked exactly where the Veil hung in the Holy Temple. The Veil served as the separation curtain between the regular sanctuary and the *Kodesh Kodoshim,* the Holy of Holies, a spot so sacred that only the High Priest was allowed to enter on but one day of the year. As visitors enter the Sistine today, they will find a small ramp in the middle of the hall between the area of the Holy of Holies and the slightly lower regular half of the room. That is where the marble partition stood for almost a century, until the hateful Paul IV. This pope was loathed by Catholics and Jews alike. He brought the tortures of the Inquisition into Rome itself, created the Index of Forbidden Books, set a heavy tax on Christians to pay for colossal statues of himself worthy of any pagan emperor, set up a debtors' prison for those who could not pay, and walled up the Jews of Rome in a hellish ghetto. Thankfully, he never lived to realize his other desired changes in the chapel—the censoring of the ceiling and the complete destruction of Michelangelo's *Last Judgment.* The angel of death took Paul IV before he could fulfill this wish.*

With the destruction of the original demarcation of the Holy of Holies and the permission granted today for streams of visiting tourists to flow freely through these premises, this concept of the Sistine as a replacement for the Temple of Solomon has also been rendered almost totally obsolete.

*The day he died, the elated Christians of Rome ripped down the gates of his debtors' prison and freed about four hundred poor souls within. Then they ran to the ghetto, destroyed the barred gates there, and liberated their Jewish friends and neighbors. Catholics and Jews together then smashed all the hated statues of the pope all over Rome. They took the head off one of his giant statues, placed a Jewish "cap of shame" on its head, and danced around it, singing "Haman is dead, Haman is dead."

THE SISTINE AND "THE CONCLAVE"

There is another very important rite that is identified with the Sistine Chapel. It is where the Conclave, the election of a new pope, is held. The word *conclave* comes from the Latin *con clave*, "with a key," meaning that the College of Cardinals is actually locked inside the Apostolic Palace until a new pope has been chosen. Before the Sistine, the voting was held secretly in many venues, often outside Rome to avoid rumormongering and political pressures. Once, in the ducal palace of the city of Viterbo, the cardinals wrangled for so many months that the exasperated Duke of Viterbo locked them in the palace, fed them only bread and water, and even had the palace's *roof* removed to force them to choose a new pope. Since the Papal Conclave was moved centuries ago to the Sistine, there has been no threat that anyone would remove *that* famous ceiling.

Should the Sistine today be linked primarily with this function and perhaps even be named after this papal purpose, as some have suggested? Would it be proper to refer to it as the Conclave Room? There are two reasons why this is inappropriate. First, Michelangelo's frescoes have very little or nothing to do thematically with the process of papal succession. Moreover, popes traditionally stay in office for the rest of their lives, thus making Conclaves very infrequent events, especially in the modern age of better medicine and longer life spans. In fact, in Rome, when one wants to describe an event as occurring very rarely, instead of saying "once in a blue moon," one says *ogni volta che muore un papa*—"whenever a pope dies."

MICHELANGELO'S SISTINE CHAPEL

With the work of Michelangelo, the Sistine Chapel took on entirely new meaning. It now was completely filled with a veritable treasure of paintings meant to appeal not only to the eye but also to the mind. The goal was to teach and spiritually transform its viewers. But in

what way? We have already unveiled many of the artist's secret messages hidden throughout the frescoes; but was there one overall statement he was trying to convey? Did he deliver it? In order to decide if Michelangelo succeeded, we will first need to probe into his innermost thoughts and find the key to his master plan, his "hidden brain" in the artwork. We have to do no less than answer the question, What was Michelangelo really trying to accomplish with his Sistine Chapel frescoes?

"THE FUNERAL MONUMENT"?

If we could put ourselves into Michelangelo's mind as he labored, what unspoken thoughts would we find about what he was thinking? One clue is the project Michelangelo was forced to abandon when Julius II ordered him to paint the ceiling. He was engrossed in his true passion—sculpting. Specifically, he was busy carving pieces for the gigantic pyramidal tomb that the pope wanted in the middle of the new St. Peter's. Even though we only have a few finished and semifinished, scattered elements of the monument, we know what the original design was, thanks to rare sketches and Michelangelo's memoirs dictated to Condivi. The broad rectangular base was to have been a Greco-Roman architectural pattern of alternating niches and ribs, with Classical figures representing the arts and sciences in the niches and pagan nude "prisoners" decorating the rib columns. This was to demonstrate that *Il Papa Terribile* was actually a great patron of the arts (true) and a towering intellectual (false), that he liberated the world from ignorance and Europe from what was then considered "the Turkish menace" (false), and that with his passing, the world of Culture would suffer (possibly, but only those artists and architects who were on his payroll). Of this lower level, Michelangelo did manage to begin statues of six prisoners and slaves, four of which are in the Accademia in Florence, and two of which are in the Louvre in Paris. There is debate as to whether he finished any of these figures, since they all seem to be still trapped inside the marble, an amazing effect when viewed in person.

Prisoners in Stone *(Accademia, Florence)*

The next, or middle, level of the pyramid was to have had four co-lossal biblical figures—two Hebrew prophets and two Christian saints. We do not know all of Julius's choices for these four giant sculptures, but we do have the only one that Michelangelo created—his justifi-ably world-famous *Moses,* as described earlier in this book.

At the summit of the pyramid monument, Julius ordered the images of two angels, one smiling and one crying, both holding up a funeral bier with Julius lying on top. This is an obvious refer-ence to the Holy Ark of the Covenant in the Temple of Solomon. On the lid of the ark were two cherubs, between which would ap-pear the Divine Presence. This sacred spot was called the Glory Seat. Julius II, in a classic example of his megalomania, wanted Michelan-gelo to sculpt him as permanently dwelling in the Glory Seat of God.

This design was also an illustration of the Church's theory of spiritual evolution known as successionism. Just as Darwin's theory described a line of progression from dinosaurs to apes to human beings, successionism held that humanity evolved from pagan philos-ophy to Judaism and finally achieved full spiritual development in Christianity. Thus, Julius's plan for his gigantic monument envisioned the viewer's gaze being drawn upward from classic Greco-Roman figures to Jewish and early apostolic heroes and finally reaching its apex in the person of Giuliano della Rovere, Pope Julius II himself.

The overblown project called for more than *forty* large sculptures, all by Michelangelo himself. It would have taken several other artists several lifetimes to bring this mad scheme to completion. When the sculptor was then forced to stop work on the tomb to fresco the Sistine ceiling, he knew that the interruption of several years spent in painting the ceiling would definitively ruin any possibility of finishing the papal pyramid. Ironically, by ordering Michelangelo to paint the Sistine, Julius destroyed his own plans for his gigantic funeral monument.

The savvy Florentine must have realized this right from the beginning, because he made the ceiling of the chapel become a *two-dimensional version* of the tomb project. The best proof of this comes from the hands of the great artist himself. We are lucky enough to have a surviving sketch of the lower part of the original design, preserved in the Uffizi Galleries in Florence.

For anyone who has seen the Sistine ceiling frescoes, either in person or through reproductions, the elements in this sketch will be familiar: reclining male nudes in various positions, larger Classical male nudes in poses that show off their musculature, female symbols of intelligence in various Classical modes of dress, the marble pedestals and architectural elements, the imposing prophets seated above, and also the white putti holding up the upper pedestals.

Even the esteemed Professor Howard Hibbard, in his very traditional explanation of the Sistine ceiling, concludes: "Michelangelo invented an alternation of architectonic thrones and sculpturesque figures that translates the forms of the Julius tomb into paint."[1] Bizarre as it may seem, this is one of the many layers of meaning of the Sistine Chapel: it is a gigantic *funeral monument* to the equally gigantic ego of Julius II. This also helps explain how Michelangelo got away with his drastic change of the pope's cherished design of Christ and the Apostles for the ceiling fresco. While Julius was officiating at the first Mass at the unveiling of the ceiling, he could happily gaze at his own image dressed up as the prophet Zechariah, seated in a place of honor at the top of the glorious royal portal of the chapel, much like the Glory Seat on his impossible tomb.

Sketch for the Monumental Tomb of Pope Julius II, *by Michelangelo*
(Uffizi Galleries, Florence)

So, for the egomaniacal pope, the Sistine ceiling may indeed have been a funeral monument. To save his life and to get away with completely straying from Julius's plan, Michelangelo was able to convince his papal patron that he was merely following a different approach to glorifying him. But we know that is far from the truth. Considering the numerous ways we have seen that Michelangelo inserted vulgar insults to Julius and used secret messages to point out his corruption and abuse of power, the artist's real purpose was certainly *not* to heap praises upon the head of the Church of his time.

So what was Michelangelo's *real* message?

"SELF-PORTRAIT OF THE ARTIST"?

A more profound and legitimate explanation of the Sistine is that perhaps it is nothing less than a huge self-portrait of Michelangelo.

The images are meant to reflect his life and beliefs: his feelings torn between his love for Judaic lore and wisdom and his passion for pagan art and design; his inner conflict between his spiritual love of God and his physical love for men; his respect for Christianity (even after he was no longer a Catholic) and his righteous anger at the pope and at the corruption of the Vatican in the Renaissance; his love of Classical traditions and his passionate defense of freethinking and new ideas; his Kabbalistically inspired mysticism joined to his Neoplatonism and his carnal earthiness.

It is likely that this very maelstrom of conflicted impulses is what has foiled all previous attempts to come up with a "unified theory" of the chapel's meaning. Any true portrait of a human being must be multifaceted. To portray the turbulent passions, loves, and hatreds of the great Michelangelo required the whole ceiling and front wall of the Sistine. As the famed British architect Sir Christopher Wren summed up his own life and works with the words, "If you want to see *my* monument, look around you," Michelangelo may have chosen to write his autobiography on the chapel ceiling.

Yet, to view the Sistine primarily as a self-portrait doesn't ring totally true. In spite of his arrogance regarding his artistic skill, Michelangelo was a very unassuming man. He lived an extremely humble life. Even though he was the highest-paid artist of his day, he dressed poorly and lived in a simple apartment, sending almost all his income to his family in Florence. Yes, he slipped his face into *The Last Judgment,* but unlike Julius II, he did not need an entire chapel or basilica to proclaim his ego. Furthermore, he considered himself first, last, and always a sculptor, not a painter. If he had made one piece the summary of his life, it would certainly have been a statue, not a fresco.

"AND HE CALLED THE NAME OF THAT PLACE . . ."

We believe we come closest to a correct answer if we direct our attention to *the single most glaring oddity of Michelangelo's ceiling frescoes.* It

is something that has hardly been noted by the painting's millions of viewers. Yet it is almost certainly the strongest clue to Michelangelo's true intentions—a clue that confirms the major premise of this book that the artist used his work to conceal countless messages that he did not dare to express openly.

Let's reveal it by way of a simple—but far from trivial—question. What is the name of Michelangelo's painting on the ceiling of the Sistine Chapel? If you think it doesn't matter, you are mistaken. Very often, the title given to an artwork is the key to unlocking its hidden meanings. For example, for centuries no one could discover the true identity of the Mona Lisa. In the year 2006, however, experts were finally able to solve the mystery, thanks to the real title of the painting—*La Gioconda*. Historians had thought that *gioconda*, or "joyous woman," referred to her enigmatic smile. Instead they definitively established that she was the bride of a rich merchant named Giocondo. Leonardo had made a pun on her new married name. Artists gave a great deal of thought to the title they would bestow on their work. It presented them with an opportunity succinctly to convey to the viewer their message and purpose. A name proclaims, "*This* is what I had in mind when I put all of my effort into this piece."

So what did Michelangelo call his giant fresco? Don't be upset if you can't remember; it's a trick question. The remarkable and almost unbelievable truth is—*there is no title.* To appreciate the significance of this fact, you need to know that this was extremely rare in large artworks of the time. We need only look at other big frescoes, both by Michelangelo and by his contemporaries. In the same room, by the same artist, the front altar wall is *Il Giudizio Universale*—in English, *The Last Judgment.* Also in the Vatican, just a few steps from the Sistine, are the four renowned Raphael Rooms, in which every single fresco has a title. Leonardo's famous fresco in Milan is *Il Cenacolo,* or *The Last Supper.* The second-largest ceiling fresco in Rome, located in the Great Salon of Palazzo Barberini and painted by Pietro da Cortona, has borne the same title from its inception in 1632. In fact, the title is almost as big as the massive fresco itself:

The Triumph of Divine Providence and the Fulfillment of Her Goals Under the Papacy of Pope Urban VIII Barberini. Only by knowing this oversized name can one comprehend the confusing hodgepodge of imagery in the overblown painting. Without a title, it would be impossible to understand the piece's real meaning.

Of course, this raises the question of why, after four and a half tortured years of slaving on his ceiling fresco, Michelangelo did not give a name or a written explanation for this superhuman effort? It is nearly unthinkable that it was a mere oversight. We cannot explain the omission by claiming that it was not his way to entitle his works because we know the precise names of his other master-pieces: *The Last Judgment,* the various *Pietà*s, the *Moses,* the *David,* the *Conversion of Saint Paul,* the *Martyrdom of Saint Peter,* and on and on. For his other projects, he often left behind poems and personal letters explaining them. Later in his life, he dictated his memoirs to his amanuensis Condivi, in order to clarify his artistic intentions—and to even some old scores. But for the name of the frescoes on the Sistine ceiling there was only silence. No title was added to help us understand what Michelangelo was trying to convey.

Why? How can we explain this lack of information about the content of the giant ceiling project by an otherwise communicative artist eager to have his works understood? We do know, from private letters to his family and friends, that he was obsessed with this project, constantly writing about it—indeed, complaining bitterly about aspects of it—while on the job. However, he never clearly revealed what he was trying to say with this work. Not only that, as soon as the ceiling was finished, he burned his notes and many of the preparatory sketches.

In light of what we have come to realize about Michelangelo's secret agenda in the Sistine Chapel, it seems obvious that *the purposeful omission of a title for his most important work was the clearest way of expressing that what he* really *meant to say was far too dangerous to utter.* As Cicero famously put it, "Silence speaks louder than words." A glaring exclusion of a name for a laborious task that consumed four and a half years of his life could only mean that Michelangelo

felt a true statement of his intent would almost certainly doom him. Better no name than one that, if honest, would have to betray his Neoplatonic and philo-Judaic beliefs. Michelangelo couldn't allow the papal court or the casual viewer to catch on to the fact that there were countless secret messages hidden within the overwhelming mélange of images, nor could he even hint at this critical aspect of his work. So he let his silence speak for him. It secretly whispered, "There is far more here than dares to be named." Thankfully, we have at last been privileged to "decode" many of Michelangelo's messages. When we now look at the incredible work of art with no name, we agree with the profound observation of Emily Dickinson that "Saying nothing sometimes says the most."

WHAT MICHELANGELO MIGHT HAVE CALLED IT

We can only wonder what Michelangelo's title for the giant fresco work would have been if he had felt free enough to make it public. Without fear of the Church's retribution, what would have summarized for him in but a few words the true meaning of the biblical panorama that conveyed his daring vision, his universalistic idealism, his contempt for ecclesiastic corruption and Vatican immorality?

Michelangelo knew that the Florentine architect Baccio Pontelli, along with the anonymous designers of the Kabbalistic cosmatesque floor, had created a sanctuary linked to the Jewish Temple in Jerusalem. In the Talmud, that Temple was described with a remarkable metaphor. It was called "the neck of the world" (Tractate Megillah, 16b). The neck connects the head with the body, the upper with the lower. So, too, the Temple serves as the link between heaven and earth, between the spiritual and the material, between God and humanity. The original team of fresco artists, almost all Florentines sent under the direction of Lorenzo de' Medici, were intrigued by the concept of linkage. They connected the life of Moses with the life of Jesus. That paved the way for Michelangelo to develop much

further his recognition of the Judaic roots of the Christian faith. The relationship between the two faiths, the "mother religion" and its offspring, and the more inclusionary outlook this perspective engendered were of paramount importance to the great student of Pico della Mirandola. The idea of the neck as symbol must have appealed to Michelangelo, especially if Pico had taught him its deeper meaning in Kabbalah: "The neck turns the head." This means that the head, the thoughts, the mind, and the intellect all revolve in accord with the direction the neck imposes. The Temple is "the neck of the world"; its moral imperatives must guide the intellectual decisions of humanity.

Were it not for its odd-sounding and ungainly imagery, one might almost imagine "The Neck of the World" as a suitable title for Michelangelo to describe his message. However, given his love for both ancient Roman simplicity and Italian poetry, it is quite unlikely. Fortunately, there is a far more fitting word that can do justice to the artist's aspirations. In fact, it is a word that played a crucial role in the very creation of his Sistine masterpiece. Understanding how high Michelangelo was aiming with his frescoes, we modestly suggest that if he had dared to give the giant artwork a title he might have called it "The Bridge."

THE BRIDGE

There is a land of the living and a land of the dead and the bridge is love, the only survival, the only meaning.

— THORNTON WILDER, *The Bridge of San Luis Rey*

When Michelangelo came along a generation after the original fresco masters, he took on the almost-impossible task of linking the whole Sistine Chapel together. To accomplish this, he had to engineer an amazing "flying arch" bridge scaffolding from which to create his works. No one else was able to figure out how this could be done. No one after him could replicate his amazing feat. Michelangelo's

bridge is regarded as an engineering miracle to this day. How appropriate for the very same Michelangelo to have accomplished a similar miracle in creating the bridge between faiths that is perhaps the major message of his masterpiece.

With his genius, Michelangelo built many bridges of the spirit. He infused his ceiling fresco with Kabbalistic images that reflected the Kabbalistic pavement design below. He linked the Jewish ancestral tree to Jesus. He connected pagan philosophy and design with Judaism and Christianity. He joined his love of male beauty to his love of God. He narrated the entire story of the universe, beginning with creation, in a way that makes us realize humanity's common ancestry.

Michelangelo knew that for the Church to fulfill the will of God, it had to become a paradigm of true brotherhood. There had to be a bridge between rich and poor, between privileged and downtrodden, between those who ostensibly spoke for God and those who desperately needed divine assistance. Thus, Michelangelo filled the chapel with hidden messages of his passionate loves and his righteous rages, along with mystic symbols of divine justice and divine mercy. For him, the Sistine was indeed the Sanctuary, the neck of the world, but more than that, it was "The Bridge"—the bridge meant to unite people with God, with their fellow humans, and, perhaps most difficult of all, with their own spiritual selves.

All the world is a very narrow bridge / The point is this—to have no fear.

These are the words of an ancient Hebrew song. They have become more appropriate with every passing generation. Almost exactly five hundred years ago, a tormented soul named Michelangelo built a very narrow bridge in the middle of the air in the middle of a chapel in the middle of Rome. This resulted in a masterwork that would change the world of art forever. However, that was not his goal. What this lone artist wanted to do was construct a giant bridge of the spirit, spanning different faiths, cultures, eras, and sexualities. With this book, we humbly hope to lay the last piece in place—to make his bridge, his message, and his dream complete.

ACKNOWLEDGMENTS

Jacob went along his way and angels of G-d met him. . . .

— GENESIS 32:2

Behold, I am sending an angel ahead of you, to protect you on the way and to bring you to the place that I have prepared.

— EXODUS 23:20

When journeying, a traditional Jew recites these verses as part of the traveler's prayers. While we were traveling on the path of this book, many "angels" helped us along the way as well.

We both want to thank our resolute agent, Don Gastwirth, for his passionate enthusiasm for this project from the beginning, to Michael Medved for recommending him, and to Hugh Van Dusen for being our "good shepherd."

Words alone can't fully express the depths of our gratitude—and admiration—to the wonderful team at HarperOne that brought it all together and helped make it happen. We have the feeling that Michelangelo himself must have pulled heavenly strings to link us with people like our incomparable editor and unflagging friend, the *maestro* of the HarperOne *bottega,* Roger Freet, and his assistants Kris Ashley and Jan Weed; the amazing Claudia Boutote and Patricia Rose, who continue to surprise us with their ability to get the news out about the importance and historic significance of this book; to Terri Leonard, Lisa Zuniga, and Ralph Fowler for their magnificent production work and interior design; and to Jim Warner and Claudine Mansour for a cover design the likes of which has never been seen before and which we are certain will become a collector's item.

Heartfelt thanks to Jack Pesso for bringing us together, and to Milly and Vito Arbib for hosting our crucial first meeting.

Roy would like to add special thanks to many friends and scholars for specific insights, especially Raffaele Donati and Simone Mimun, and to Francesco Giuffrida for his invaluable technical advice and moral support. Also, to David Walden and Brenda Bohen and the cultural association Rome for Jews (www.romeforjews.com) for their vital support, and to Luca Del Giudice for hosting during my stays in Rome. *Mille grazie* to the gracious staff of the Vatican Museums, and to the Halfon, Voci, and Bassano families for their *gentilezza* that has made Rome a home for me. *Toda rabba* to my co-author for the enormous honor and pleasure of learning and writing together. Of course, no mere thanks could suffice for all the love and support from my two guardian angels, Martha and Marvin Usdin. Last, a thank-you to the skeptics for asking the most difficult and thought-provoking questions.

In addition to the above, Rabbi Blech wants to express profound thanks to Gary Krupp, whose dedication to the ideals of Pave the Way—the organization he founded to "embrace the similarities and savor the differences" of every religion in order to foster brotherhood and understanding between all faiths—made possible my being in Rome, meeting with Pope John Paul II, and ultimately getting together with Roy on what I truly consider a divinely ordained project. Special angels behind the scene were Dr. Ed Steinberg, Norman Weisfeld, and Jim Reckert. There are no words for me to convey my respect, admiration, and friendship for my coauthor; working with him was both a joy and a privilege. Finally, not a day goes by that I do not thank God for the gift of my wife, who by her constant encouragement made all my accomplishments possible and with her love made them meaningful.

—*Benjamin Blech*
Roy Doliner

NOTES

Chapter 2: The Lost Language of Art

1. Federico Zeri, *Titian: Sacred and Profane Love* (Rizzoli, 1998).
2. Francesca Marini, *Uffizi* (Rizzoli, 2006), 85.

Chapter 3: A Rebel Is Born

1. Giorgio Vasari, *The Lives of the Artists,* translated with an introduction and notes by Julia Conaway Bondanella and Peter Bondanella (Oxford Univ. Press, 1991).

Chapter 4: A Very Special Education

1. Roberto G. Salvadori, *The Jews of Florence* (Giuntina Press, 2001), 30.
2. Matilde Battistini. *Losapevi dell'arte* (book series under the direction of Stefano Zuffi) *Simboli e allegorie-prima parte* (Mondadori Electa, 2002), 6.
3. Ross King, *Michelangelo and the Pope's Ceiling* (Penguin Books, 2003), 22.
4. Jack Lang, *Il Magnifico* (Mondadori, 2002).
5. Ascanio Condivi. *Vita di Michelagnolo Buonarroti* (Giovanni Nencioni, 1998).
6. Ascanio Condivi. *Vita di Michelagnolo Buonarroti* (Giovanni Nencioni, 1998).

Chapter 5: Out of the Garden and into the World

1. Howard Hibbard, *Michelangelo* (Westview Press, 1974), 16.

Chapter 6: As Fate Would Have It

1. Garabed Eknoyan, "Michelangelo: Art, Anatomy, and the Kidney," *Kidney International* 57, no. 3 (2000); www.nature.com.
2. *The Sistine Chapel* (Edizioni Musei Vaticani, 2000), 26.
3. Wikipedia, s.v. "Sistine Chapel."
4. James M. Saslow, trans., *The Poetry of Michelangelo: An Annotated Translation* (Yale Univ. Press, 1991).

Chapter 8: The Vault of Heaven

1. Philo, *De Opificio Mundi,* in *The Works of Philo,* trans. C. D. Yonge (Hendrickson, 1993).
2. Porphyry, *Life of Plotinus 2.*

Chapter 9: The House of David

1. Edward Maeder, "The Costumes Worn by the Ancestors of Christ," in *The Sistine Chapel: A Glorious Restoration* (Abradale Press, 1999), 194–223.

Chapter 12: The Middle Path

1. Gershom Scholem, *On the Kabbalah and Its Symbolism* (Schocken Books, 1965).

Conclusion : So, What *Is* the Sistine Chapel?

1. Howard Hibbard, *Michelangelo* (Westview Press, 1974), 105.

BIBLIOGRAPHY

The Baal Ha-Turim Chumash. Mesorah Publications, 1999–2004.

Battistini, Matilde. *Losapevi dell'arte* (book series under the direction of Stefano Zuffi) *Simboli e allegorie-prima parte.* Mondadori Electa, 2002.

Bruschini, Enrico. *In the Footsteps of Popes.* William Morrow, 2001.

Buranelli, Francesco, and Allen Duston, eds. *The Fifteenth Century Frescoes in the Sistine Chapel.* Edizioni Musei Vaticani, 2003.

Busi, Giulio. *Qabbalah visiva.* Einaudi, 2005.

Cheung, Luke L. "The Sentences of Pseudo-Phocylides." Copyright 1997. E-mail: llc1@st-andrews.ac.uk.

Condivi, Ascanio. *Vita di Michelagnolo Buonarroti.* Giovanni Nencioni, 1998.

De Vecchi, Pierluigi, ed. *The Sistine Chapel: A Glorious Restoration.* Harry N. Abrams, 1994.

Eknoyan, Garabed, M.D. "Michelangelo: Art, Anatomy, and the Kidney." *Kidney International* 57, no. 3 (2000). www.nature.com.

Forcellino, Antonio. *Michelangelo: una vita inquieta.* Laterza & Figli, 2005.

Gamba, Claudio. *Musei Vaticani.* R.C.S. Libri, 2006.

Garin, Eugenio. *L'umanesimo italiano: filosofia e vita civile nel Rinascimento.* Laterza & Figli, 1993.

Il Giardino dei Melograni: botanica e Kabbalah nei tappeti Samarkanda. Textilia ed. d'Arte, 2004.

Il Giardino di San Marco: maestri e compagni del giovane Michelangelo. Amilcare Pizzi, 1992.

Goldscheider, Ludwig. *Michelangelo.* Phaidon Press, 1953.

Hibbard, Howard. *Michelangelo.* Westview Press, 1974.

King, Ross. *Michelangelo and the Pope's Ceiling.* Penguin Books, 2003.

Lang, Jack. *Il Magnifico.* Mondadori, 2003.

The Last Judgment: A Glorious Restoration. Harry N. Abrams, 1997.

Maeder, Edward. "The Costumes Worn by the Ancestors of Christ," in *The Sistine Chapel: A Glorious Restoration.* Abradale Press, 1999.

Marini, Francesca. *Uffizi.* Rizzoli, 2006.

Martinelli, Nicole. "Michelangelo: Graffiti Artist." www.virtualitalia.com.

Masci, Edolo. *Tutti i personaggi del Giudizio Universale di Michelangelo.* Rendina, 1998.

Michelangelo pittore. Rizzoli, 1966.

Michelangelo scultore. Rizzoli, 2005.

Nachman Bialik, Chaim, and Y. H. Rawnitzky. *Book of Legends/Sefer Ha-Aggadah: Legends from the Talmud and Midrash.* Schocken Books, 1992.

Pacifici, Riccardo. *Midrashim: fatti e personaggi biblici.* R.C.S. Libri, 1997.

Partridge, Loren. *Michelangelo: la volta della Cappella Sistina.* S.E.I. Torino, 1996.

Pasquinelli, Barbara. *Il gesto e l'espressione.* Mondadori Electa, 2005.

Pocini, Willy. *Le curiosità di Roma.* Newton & Compton, 2005.

Rendina, Claudio. *I papi: storia e segreti.* Newton & Compton, 1983.

Rocke, Michael. *Forbidden Friendships: Homosexuality and Male Culture in Renaissance Florence.* Oxford Univ. Press, 1996.

Roth, Cecil. *The Jews in the Renaissance.* Jewish Publication Society of America, 1959.

Salvadori, Roberto G. *The Jews of Florence.* La Giuntina, 2001.

Salvini, Roberto, with Stefano Zuffi. *Michelangelo.* Mondadori Electa, 2006.

Saslow, James M., trans. *The Poetry of Michelangelo.* Yale Univ. Press, 1991.

Scholem, Gershom. *On the Kabbalah and Its Symbolism.* Schocken Books, 1965.

The Schottenstein Talmud. Mesorah Publications, 1990–2005.

The Sistine Chapel. Edizioni Musei Vaticani, 2000.

Steinsaltz, Rabbi Adin. *Opening the Tanya.* Jossey-Bass, 2003.

Tartuferi, Angelo, with Antonio Paolucci and Fabrizio Mancinelli. *Michelangelo: Painter, Sculptor and Architect.* ATS Italia, 2004.

Tueno, Filippo. *La passione dell'error mio: il carteggio di Michelangelo. Lettere scelte 1532–1564.* Fazi, 2002.

Tusiani, Joseph, trans. *The Complete Poems of Michelangelo.* Noonday Press, 1960.

Vasari, Giorgio. *The Lives of the Artists.* Oxford Univ. Press, 1991.

Yonge, C. D., trans. *The Works of Philo.* Hendrickson, 1993.

Zeri, Federico. *Titian: Sacred and Profane Love.* Rizzoli, 1998.

Zizola, Giancarlo. *Il Conclave: storia e segreti.* Newton & Compton, 1997.

ILLUSTRATION CREDITS

INDEX

Page references followed by *fig* indicate an illustration.

Index